A Chronology of Photography

EDITED BY **Paul Lowe**

A Chronology of Photography

**A Cultural Timeline
from Camera Obscura
to Instagram**

Thames & Hudson

Contents

Introduction

When Sir John Herschel, the noted scientist and astronomer, delivered his lecture to the Royal Society in London on 14 March 1839, entitled 'Note on the Art of Photography, or the Application of the Chemical Rays of Light to the Purposes of Pictorial Representation', he effectively gave the name to the new medium that was about to change things forever, transforming how we understand and represent the world around us, and ushering in a new age where the visible realm became a dominant form of communication. He could not have foreseen how ubiquitous the photographic image would become in just over 175 years, with an estimated 1.3 trillion images taken in 2017, of which a staggering 24 billion were selfies taken with smartphones. Taken from the Greek roots φωτός (*phōtos*), meaning 'light', and γραφή (*graphē*), meaning 'drawing', photography exploded in popularity almost instantaneously, in one of the fastest adoptions of a new technology in human history. The earliest practitioners of the medium, arguably an early form of 'open source' technology, who included Herschel, along with Joseph Nicéphore Niépce, Louis Daguerre, Hippolyte Bayard and William Henry Fox Talbot, rapidly established the fundamental characteristics that continue today, with some form of optical lens focusing light reflected from the subject on to a light-sensitive surface that can record the image permanently. In their work, they also effectively established the terrain of photographic inquiry and its application as both a science and an art, as well as a documentary representation of the world.

Within just a few decades, the new medium had a wide range of uses, with scientists and engineers, chemists, astronomers, botanists and inventors, as well as artists and more commercially minded entrepreneurs, exploring how it could be used: for portraiture, both populist and symbolic; for recording landscapes, both for a sense of the topography of distant lands and for the appreciation of the sublime beauty of nature; for documenting historic events; for making visible scientific phenomena that the human eye was unable to perceive unaided; for state control and surveillance of society; and for pure aesthetic expression of ideas and concepts. Indeed, the roots of many of the visual strategies of modern photographers that appear to be innovative and radical, such as staging complex tableaux using digital image manipulation, can be traced back to the earliest

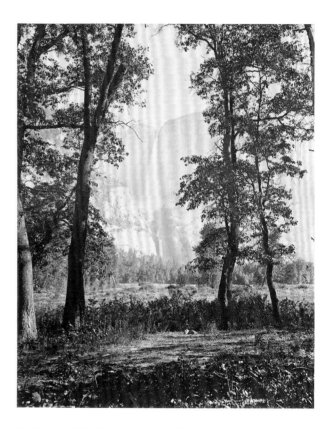

Carleton E. Watkins – *Yosemite Falls*
The stunning vistas of Carleton E. Watkins (1829–1916) are emblematic not just of the power of photography to convey the beauty of nature, but also of its potential to influence social policy. His images of Yosemite Valley were taken on a 'mammoth-plate' camera, which produced albumen prints of incredible detail and tonal quality. His command of the technical aspects of the medium is demonstrated by his use of a deep depth of field and careful framing, using the trees in the foreground to lead the eye to the waterfall in the distance. Watkins' photographs fuelled the demand for images of the idealized American Wilderness, albeit ignoring the rights of the Native American peoples who were forced off their land to make space for waves of settlers.

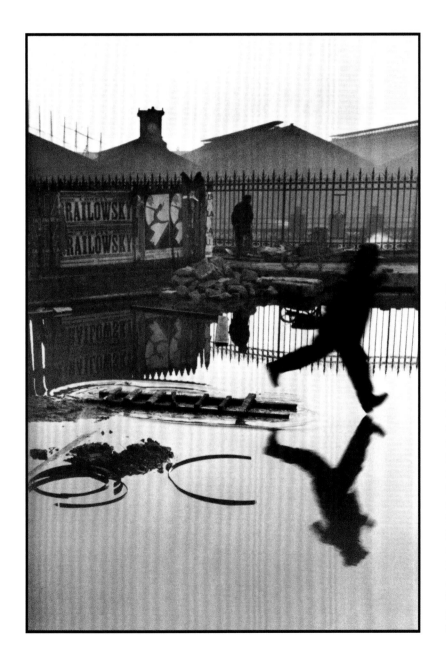

Henri Cartier-Bresson – *Behind the Gare Saint-Lazare* (1932)
Henri Cartier-Bresson is the epitome of the agile street photographer, constantly tuned in to the complex and ever-changing geometry of the world around us, and able to orchestrate the frame into tightly composed photographs that capture in a fraction of a second the essence of the scene. Originally trained as a painter and influenced by the Surrealists, Bresson was a master of the 35 mm Leica camera that in the 1930s revolutionized the ability of photographers to shoot on the move. His 1950s book, originally titled in French *Images à la Sauvette* ('Images on the Run'), but better known in English as *The Decisive Moment*, summed up his philosophy that great images are made when the photographer puts 'on the same line of sight the head, the eye and the heart'.

practitioners, as can many of the debates around the ethics of representation, in particular the rights and wrongs of image manipulation in the post-production of the photograph.

Although the two approaches of Daguerre and Talbot were quickly overtaken by improvements in technology, they did set up one of the key features of the subsequent development of the medium: the contrast between the camera's ability to record the minutest trace and to offer a seemingly perfect representation of reality, and the expressive power of the photograph to convey the atmosphere of an event more than its factual detail. While appearing to be a faithful record of what was before the lens, the fixed surface of the image is far from an objectively neutral one; it is highly selective, fragmentary, momentary and subjective. This debate about the merits of the essential qualities of how the photograph represents the world can be then traced through the Pictorialists and Photo Secessionists, with their emphasis on mood, through the members of Group f.64, who regarded 'straight photography', as rendered by the large-format camera, as supreme, through to the radical vision of William Klein, with his use of blur and coarse grain, which epitomized the energy of the 1950s and 1960s.

This book therefore sets out to trace the growth of photography from its earliest days to the present, with the narrative driven by the photographs and their creators. Through their stories and their images, the book explores the major moments, developments and themes in the history of photography, giving a concise and focused guide to the medium. Selecting some 320 images to represent the entire history of photography was a daunting task, but we have endeavoured to include as many of the photographers in the established canon as possible, while also bearing in mind its diversity both in terms of the range of genres and subject matters, as well as the important and often underestimated role women photographers and those from outside of the Western-centric world have played. We also sought to include some works by lesser-known photographers, especially from today, to signpost the directions the medium might take in the future. For each photographer selected, an image was chosen that represents a particular feature of their work, contributing an important element to the story. As this is a book about photography, not about history, many famous images have been excluded, as they tell us less about the medium and more about the situation, but a significant number

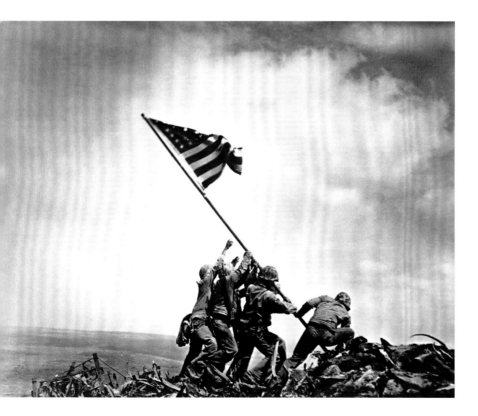

Joe Rosenthal – *Raising the Flag on Iwo Jima* (1945)
Joe Rosenthal's photograph of US Marines planting a giant American flag on the top of Mount Suribachi to signal the capture of the island of Iwo Jima from Japanese forces in February 1945 is perhaps the definitive iconic image. Despite the fact that this was the second flag to be raised on the spot after an earlier, smaller one was removed, the photograph came to symbolize not just the immediate victory of that battle, but also the success of the American war effort against the Axis powers in general. The photograph was used on 3.5 million posters for war bonds to raise money for the armed forces, became a US postage stamp, the model for the memorial to the Marine Corps in Washington, D.C., and the subject of the Hollywood movie *Flags of Our Fathers* (2006), directed by Clint Eastwood. It also, however, became a symbol of US imperialism for the activists in the counterculture movement, who subverted the image by replacing the flag with both the peace symbol and the Coca-Cola logo.

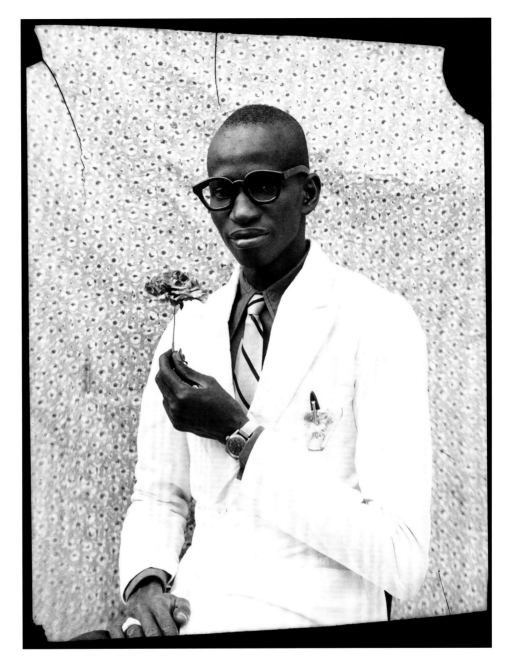

Seydou Keïta – *Young Man With a Flower* (1959)
Seydou Keïta opened his portrait studio in Bamako, Mali, in 1948, where he skilfully used careful compositions and daylight to create an extraordinary archive of the faces of Africans, presenting themselves and their personalities to his camera. Self-identity and clothing are central to his photographs, with his subjects often dressing in the European styles fashionable in the 1960s and 1970s as well as more traditional Malian fabrics. Remarkably, he worked with a 13 x 18 inch view camera with a broken shutter, which he had to operate by manually removing the lens cap for exactly the correct time to properly expose the film. Keïta's work was brought to the attention of the international photographic world when it was presented at the influential photographic festival, Rencontres internationales de la photographie in Arles, France, in 1992, after which his work was globally recognized as a unique contribution to the art and history of photography.

of iconic images have been included – those that fuse together a powerful aesthetic form and a highly charged moment to create symbolic images that can stand in for more than just the event itself. They transform a specific moment in time into something universal and far-reaching, such as Robert Capa's dynamic vision of the D-Day landings from 1944.

The book therefore serves as an ideal introduction to the breadth and depth of photography and of photographers, and acts as an entry point to discover more about individual practitioners, but also about photographic technologies and processes, and the major movements in the medium. Books and exhibitions and their respective writers, editors and curators have also played a significant role in the story of photography, and key texts, monographs and shows are also highlighted throughout the flow of the story. A guide to further reading and a glossary are provided at the end of the book to facilitate further exploration.

The book is divided up into historical periods, and while the lengths of these timeframes are in some sense arbitrary, they also define broad periods during which photography underwent major changes. Each chapter is introduced with a short text that highlights some of the most significant developments of that period, followed by a more in-depth exploration of key innovations in the technology of photography at that time. In brief, the timeframes deal initially with the birth of the medium between 1826 and 1850, and its subsequent rapid and massive growth in the second half of the nineteenth century between 1850 and 1900, when it became a popular form of expression across a huge range of areas that included commerce, art, journalism and science. As the story enters the twentieth century, the first timeframe explores how the two World Wars that bookended the period led to an explosion of creativity, as well as setting the stage for the dominance of the medium in the period immediately after the Second World War, defining the way in which information about the world was brought into people's living rooms. The post-war period then saw the rise of a more personal, intimate form of expression as documentary photographers explored how a more metaphoric, symbolic visual language could be used to represent the world around them, while the Vietnam War challenged the role of the media in reporting conflict. The mid-1970s saw the emergence of a more conceptual approach

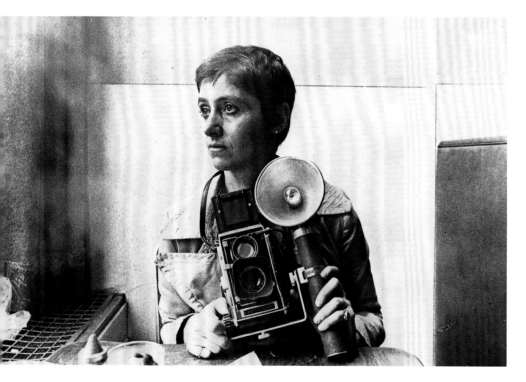

Roz Kelly – *Portrait of Diane Arbus* (1968)
Arguably the intimate and direct portraits of those on the fringes of American Society made by Diane Arbus tell us as much about her as they do about her subjects. Arbus found in the camera a passport into the most intimate lives of people she found interesting. She is seen here in this portrait by Roz Kelly with her trademark square-format Rolleiflex, which she often used with direct flash, seemingly transfixing her subjects to reveal deep emotional and psychological truths. She was fascinated with penetrating the hidden lives of others, arguing that 'A photograph is a secret about a secret. The more it tells you the less you know.' Since her suicide in 1971, Arbus's work has become a touchstone for how a deeply personal photographic vision can still tell us important lessons about the world around us.

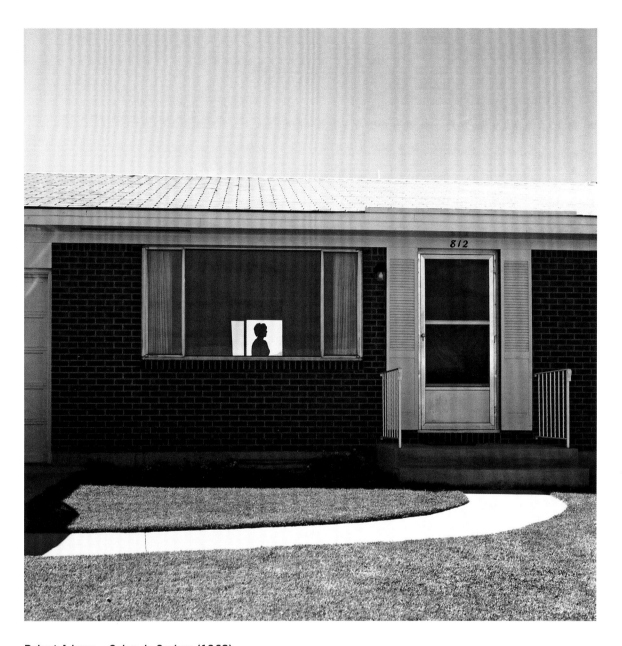

Robert Adams – *Colorado Springs* (1968)

Robert Adams is not just one of the greatest documentarians of the contemporary landscape of America, but also one of the most eloquent writers on the art and craft of photography. He sums up the visceral pleasure of photography succinctly in saying that 'One does not for long wrestle a view camera in the wind and heat and cold just to illustrate a philosophy. The thing that keeps you scrambling over the rocks, risking snakes and swatting at the flies is the view. It is only your enjoyment of and commitment to what you see, not to what you rationally understand, that balances the otherwise absurd investment of labour.' Like the other photographers of the New Topographics movement with which he was associated in the 1970s, his work draws heavily on the influences of nineteenth-century photographers such as Timothy O'Sullivan, William Henry Jackson and Carleton E. Watkins, updating their views of the American West, now defaced by the urban sprawl of ever-growing cities.

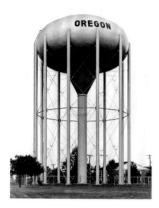 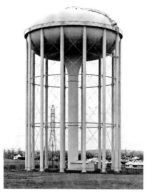 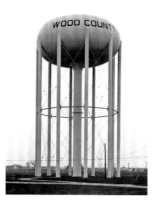

Bernd and Hilla Becher – *Water Towers* (1988)

The influence of Bernd and Hilla Becher on contemporary photography cannot be overestimated. They began working together after meeting at the Kunstakademie Düsseldorf in 1957 as students, and collaborated for over forty years on a systematic documentation of the forms and structures of the architecture of the modern industrialized world. Their approach of producing seemingly objective records of the comparative shapes of what they called *Grundformen* ('basic forms') was rooted in a desire to catalogue the rapidly disappearing industrial heritage of Western capitalism. Their visual typology of what they termed 'anonymous sculptures' was at once highly conceptual as well as socially significant. Their work as educators was also important, with Bernd joining the faculty at the Kunstakademie Düsseldorf, where he influenced what became known as the 'Düsseldorf school', a generation of German photographers that included Andreas Gursky, Thomas Ruff, Thomas Struth and Candida Höfer.

to the medium, as a generation of photographer-artists and artist-photographers responded to the challenges of postmodernism. This saw the increasing acceptance of photography as an art form in the institutions of museums and galleries. Finally, as the story enters the twenty-first century, the dominant driver of change has been the digital revolution and the rise of the internet, which have broken down barriers to entering the world of photography, allowing anyone to post and share their images online, while at the same time witnessing an incredible growth in the depth and diversity of practice by serious photographic practitioners.

A series of features on important themes, moments and concepts are interspersed through the timelines, and in these a more comparative approach has been used to show how photographers responded to similar questions of representation over the longer term. Indeed, this aspect of how photographers reference the work of their peers, both historical and contemporary, is vital to understanding the internal dynamics of how the medium has developed. This is frequently a process of innovation in the form, but often based on a deep understanding of the nature and history of the medium.

Also central to this are the ways in which photographers have responded to the changing technology of the camera, and the differences in the final image that are generated by the various formats and choices of film available at any given time. A continuous tradition of the critical depiction of the American social landscape can be traced, for example, from the work of nineteenth-century topographic photographers of the American West, such as Timothy O'Sullivan, who used large-format glass-plate cameras, through Walker Evans in the 1930s, who used every format of camera then available, to Robert Frank in the 1950s and William Eggleston in the 1970s, who both used the fluid and agile 35 mm format, to Stephen Shore and Joel Sternfeld in the 1980s and Alec Soth in this century, who all returned to using the large-format view camera because of its incredible ability to render the tiniest detail. Photographers have always found new and exciting ways in which to use the essential nature of the medium to explore how it uniquely represents and interprets the world. The Magnum photographer Gilles Peress sums up this complex relationship between the technology, the photographer and the world from the perspective of the photographer, arguing that a photograph 'has a multiplicity of authors, the photographer, the camera, each has a different voice, a Leica with 28 mm, a Nikon with a 24 mm, everything speaks, cameras speak. Then there is reality and reality always speaks with a vengeance, with a very forceful voice, then there is the reader, the viewer. So the more the images are open, the more the participation of the audience, the photograph is about an open text and a multitude of authors.'

As the visual theorist Patrick Maynard points out, the camera has all the typical characteristics of a human-made machine to extend our physical powers. In the same way as the internal combustion engine extended human movement and the radio hearing, the photographic process amplifies our ability to see things that would

Ivan Frederick – *Abu Ghraib* (2003)

It is perhaps ironic that one of the most widely published and symbolic images of the twenty-first century was never intended for public consumption. This disturbing image was taken by a serving US Army soldier as a 'trophy picture' to be shared among the guards at the Abu Ghraib prison in Iraq, where inmates were routinely tortured and beaten by their guards. The 'Hooded Man', as the picture became known, was later revealed to be Ali Shallal al-Qaisi, and his unintentionally Christ-like pose became a focal point for critics of the US military's involvement in Iraq. Again ironically, the thousands of photographs taken by the guards, on their personal digital compact cameras, show much more graphic scenes of abuse, with naked prisoners being forced to simulate sexual acts on each other, but perhaps because it does not show nudity, this is the one that became infamous. When the abuse came to public attention, the date and time stamps on the photographs taken by the soldiers became a vital piece of evidence in their prosecution.

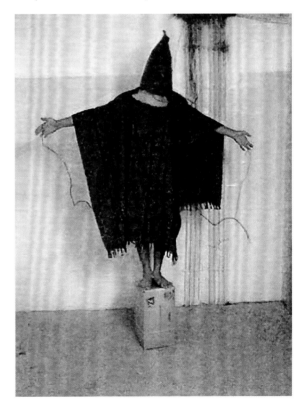

otherwise remain unobserved. This 'engine of visualization', to use Maynard's phrase, allows the eye to extend its vision through technological enhancement to perceive objects, events and people that are distant from the perceiver both in space and time. The camera therefore serves as a visual prosthesis, allowing representations of the world to be captured, stored, transmitted, distributed, archived and interpreted long after the image has been made. The camera thus truly operates as a 'clock for seeing', as Roland Barthes poetically called it. Photographs are therefore durable encapsulations of the past, serving as essential markers of both our personal and collective memory, able to represent the past in the present. This extraordinary ability of the still photograph to capture the essence of the world is the product of both form and content, and technology and aesthetics, all moderated by human imagination and vision. Few have described its magic better than Oliver Wendell Holmes, the American physician, writer, poet and amateur photographer, who wrote in 1859 of the invention of photography: 'This triumph of human ingenuity is the most audacious, remote, improbable, incredible, the one that would seem least likely to be regained, if all traces of it were lost, of all the discoveries man has made. It has become such an everyday matter with us, that we forget its miraculous nature, as we forget that of the sun itself, to which we owe the creations of our new art.'

Ellen DeGeneres and Bradley Cooper – *Ellen DeGeneres Oscar Selfie* (2014)

Known as the photo that 'broke the internet', this selfie taken by Ellen DeGeneres and Bradley Cooper at the 2014 Oscars was retweeted over a million times in the first hour after it was posted on the star's feed, and has gone on to be the most widely shared image in history, with a total of 3.3 million shares. A testament to the way in which the photograph has now become the evidence of our presence at an event, the image also struck a chord in showing that even Hollywood megastars get carried away with the excitement of the moment.

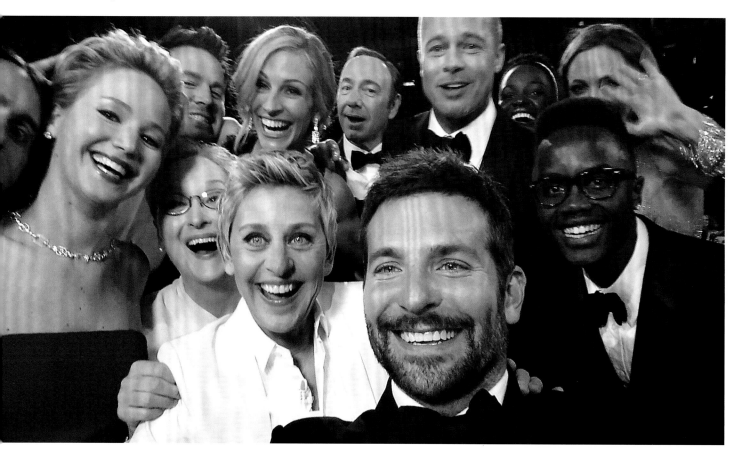

Taryn Simon – *Chapter VII* **from** *A Living Man Declared Dead
and Other Chapters I–XVIII* **(2011)**

The American artist Taryn Simon is a particularly important example of the shift in photographic practice towards what has been termed 'conceptual documentary', for the way its proponents successfully blend journalistic subject matter with production techniques and modes of dissemination more often associated with fine art. In her series *A Living Man Declared Dead and Other Chapters*, Simon traces the bloodlines and descendants of a series of people across the world, ranging from a key figure in the creation of the State of Israel to a Chinese family selected on her behalf by an agency of the state. Consisting of portraits and research arranged in a grid form akin to a family tree, Simon's work alludes to complex themes of inheritance, religion and state power, and references anthropological, ethnographic and archival museum practices to create a typology of suffering.

1

BIRTH
TO 1850

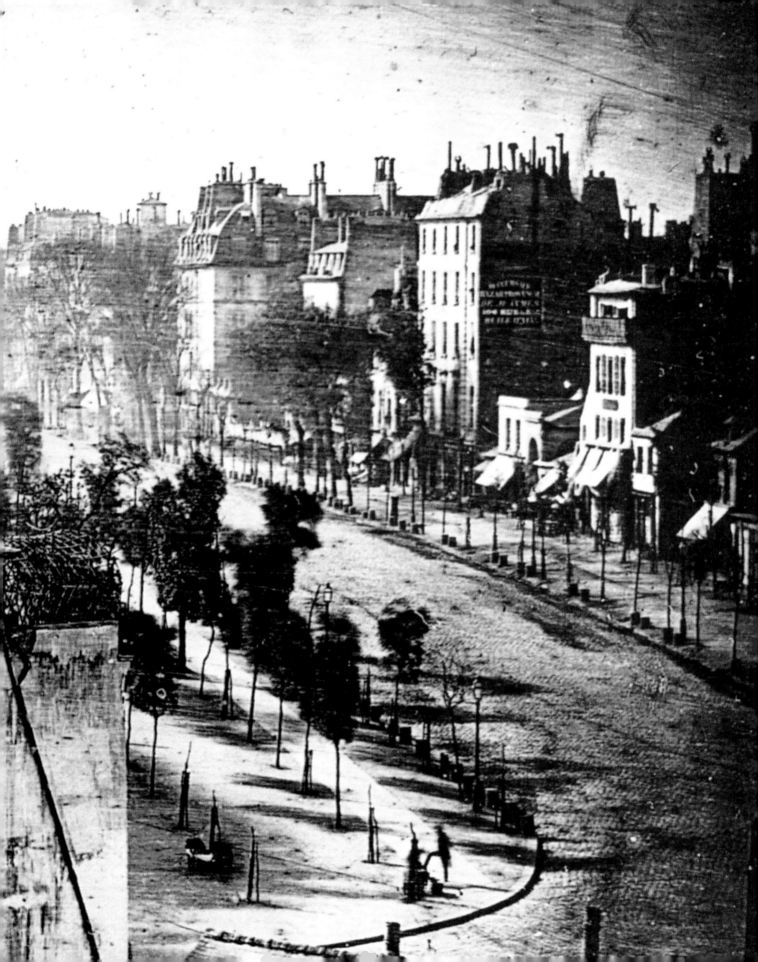

The nineteenth century saw an almost unimaginable revolution in human communication. The inventions of telegraphy and later telephony, the railways and steamships transformed the ability of humans to transcend both time and space. It is hard to imagine how radical the advent of the photograph must have been to a nineteenth-century audience. The innovation of a tangible object that could reproduce a vision of the real world appeared suddenly and fully formed. Photography emerged as a medium seemingly overnight, and the basic characteristics of an optical device focusing light on to a sensitive surface have remained unchanged to the present day.

Proponents of the possibilities of the medium imagined how it might be used not just for portraiture, but also for scientific investigation, with one of Louis Daguerre's (1787–1851) main supporters, François Arago (1786–1853), imagining that this 'objective retina' (*rétine physique*) could be used to study the qualities of light, and to document the archaeological ruins of ancient Egypt. It is remarkable that although Nicéphore Niépce's (1765–1833), Daguerre's and William Henry Fox Talbot's (1800–77) approaches are the ones that found a foothold, they were not the only ones to work out how to fix the image more permanently on to a surface. Fundamentally the process was

relatively simple, with Hippolyte Bayard (1801–87) creating a paper positive image at around the same time as the announcement of Daguerre's patent, while Sir John Herschel (1792–1871) wrote in February 1839 to Talbot of his success in creating 'photographic specimens'. A year later, he developed the concepts that the medium was to rely on until the digital age, writing that 'to avoid much circumlocution, it may be allowed me to employ the terms positive and negative, to express respectively, pictures in which the lights and shades are as in nature, or as in the original model, and in which they are the opposite, i.e. light representing shade, and shade light'. The two main processes emerged at almost the same instant, each with its own history of development and its own method to fix light on to a sensitive surface, and each with its own characteristic as a material object. Each had contrasting strengths and weaknesses. The daguerreotype provided an incredible level of detail, which Herschel called 'miraculous', claiming to Talbot that the method 'surpass[ed] anything I could have conceived as within the bounds of reasonable expectation … every gradation of light and shade is given with a softness and fidelity which sets all painting at an immeasurable distance'. Talbot, meanwhile, maintained that the reproducibility of his

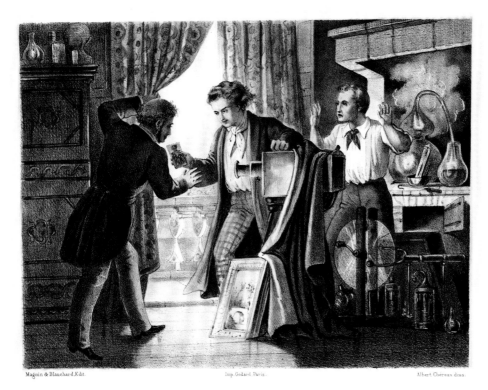

Magnin & Blanchard, Edit. Imp. Godard, Paris. Albert. Chereau deas.

Daguerre et Niepce de St Victor.

PREVIOUS PAGE. Louis Daguerre – *Boulevard du Temple* (1838)

LEFT. *Daguerre and Niépce de Saint Victor* (c.1851)

RIGHT. Théodore Maurisset – *Daguerreotypomanie* (1839)

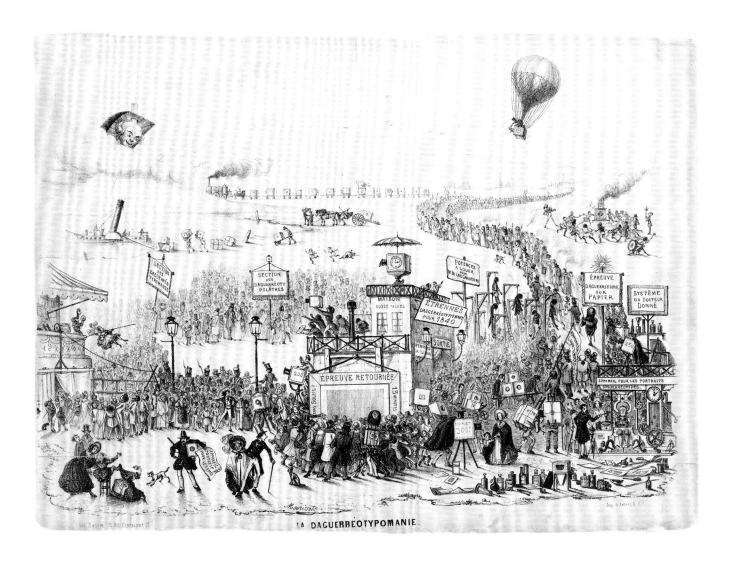

LA DAGUERRÉOTYPOMANIE.

method gave it the advantage over the daguerreotype, despite its softer, less detailed level of reproduction. Talbot also experimented with direct printing, making what he called 'photogenic drawings' or 'skiagraphy' (shadow writing), the forerunner of the photogram that became popular in the early twentieth century. The shortcomings of these methods were overcome by the 1850s with the introduction of the wet-collodion process. Compared to many other technological innovations of the industrial age, the development of photography was relatively swift, and within just a few years an entire industry had grown up, with photographers, their assistants, technicians and factories to produce the necessary materials. The age of photography coincided with the age of technology and of the middle classes, and quickly established the medium as one to be regarded as both an art and a science. However, these early experimenters, who were fascinated with the remarkable qualities of the medium as a form of expression,

were also aware of its commercial potential, as their desire to patent their inventions in order to profit from their hard work demonstrates.

The profession of photographer was created almost overnight. Inspired by the marketing of the process that claimed that it 'required "no knowledge of drawing" and that "anyone may succeed … and perform as well as the author of the invention"', within just a scant few years of the announcement of the daguerreotype, thousands of photographic studios had been established in Europe and America, creating a sensation and an instant popular success. What had previously been a laborious process of having a portrait made by drawing was transformed into a process that could be completed in a matter of moments by comparison. 'Daguerreotypomania' became a craze overnight, as described in this French engraving from 1839 (above), where the entire production process of the medium is satirically described in detail, including a painful and dangerous-looking

contraption to keep the sitter in the correct position. A new occupation was created, that of the photographer, and photographic studios, often known as 'glasshouses' because of the huge windows needed to provide enough light, became a fixture on many high streets. With over seventy daguerreotype studios in New York City alone by 1850, daguerreotypists invited politicians, celebrities and the local elite to pose for them in order to display their images in the window to drum up trade, with their studios becoming galleries to which the public flocked.

The persona of the photographer as an artist was widely promoted, with the standard uniform of a fez or other eccentric oriental headgear, a velvet smoking jacket and a handkerchief drooping out of a pocket becoming a caricature in the illustrated press. The Frenchman Nadar (1820–1910) was an exemplar of the new photographic entrepreneur, becoming almost as famous as the celebrities he photographed. With his trademark red hair and red robes, he even decorated his studio in red and advertised his services with his name displayed in giant red gaslight letters outside. The strategy was successful in enticing visitors to his studio, as he described: 'Each nightfall, we set our lights in the window. The crowd on the boulevard was attracted like moths to light, many curious friends or indifferent, could not resist climbing the stairs to see what happened there. These visitors, from all classes, unknown or even famous, were more than welcome, providing us free stock models quite ready for the new experience.' In 1858 he took the first-ever aerial photographs from a hot-air balloon, and pioneered the use of artificial flash lighting to photograph the catacombs and sewers of Paris.

Because of its unique material qualities, with its silvered mirror-like surface, and weight and tangibility as opposed to the fragility of the paper calotype, the daguerreotype itself had a material presence that was enhanced by the method of presenting the images, which were often enclosed in beautiful and highly crafted and decorated cases. The possibilities of the medium as a vehicle for political propaganda were also quickly realized, with this portrait of John Brown (above right), the leading campaigner for the abolition of slavery, which combined the hand raised in a solemn oath with the flag thought to be that of the Subterranean Pass-Way, his companion to the underground railway that allowed freed slaves to escape into the North. The image was taken by the African American photographer Augustus Washington, a fellow abolitionist, who eventually emigrated to Liberia, where he set up several studios as well as serving in Congress.

Within just a decade of its invention, then, photography rapidly established itself as the dominant form of recording the world, whether that be news and historical events, natural and human-made phenomena, the faces of the rich and famous, or the loved members of one's own family.

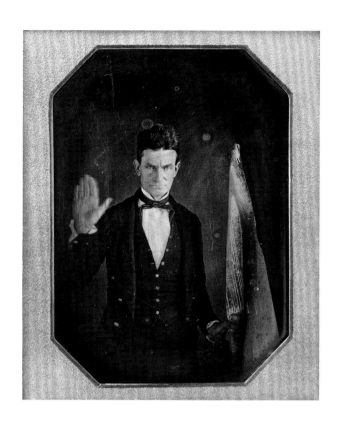

ABOVE. Augustus Washington – *Portrait of John Brown* (c.1846)

RIGHT. 'Nadar raising photography to the heights of art' (c.1850)

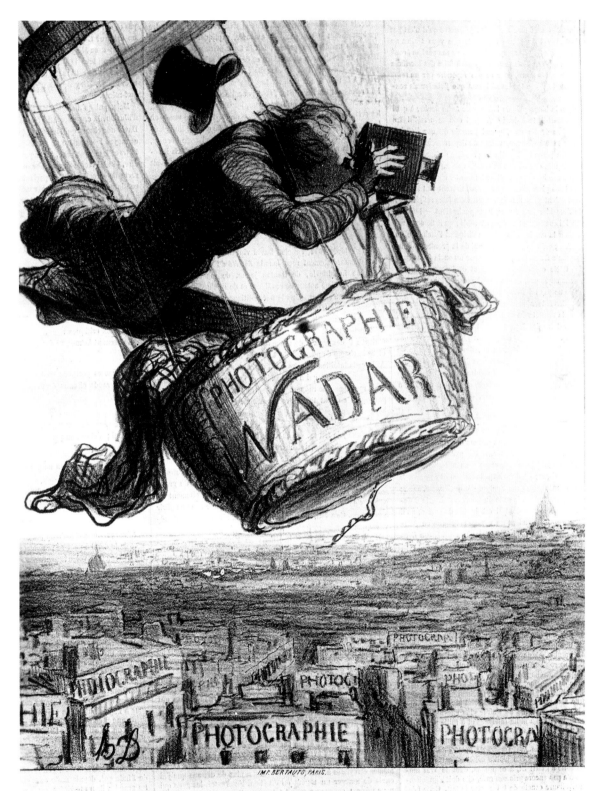

NADAR élevant la Photographie à la hauteur de l'Art

THE DAGUERREOTYPE

The development of a successful process to fix the image produced by a lens on to a light-sensitive surface was a complex one, and relied on a range of innovations in chemical formulations as well as the ingenuity, interest and inspiration of a mix of scientists, artists and entrepreneurs. The Italian physician and chemist Angelo Sala wrote in the early seventeenth century that powdered silver nitrate could be blackened by the sun, but could not think of how this might be practically used. In the late eighteenth century, Thomas Wedgwood, son of the potter Josiah Wedgwood, experimented with capturing the image projected by a camera obscura. Along with his friend, the scientist Sir Humphry Davy, he published an account of the research in the *Journal of the Royal Institution* (1802), entitled 'An Account of a Method of Copying Paintings upon Glass, and of Making Profiles, by the Agency of Light upon Nitrate of Silver, with observations by Humphry Davy.'

Invented by T. Wedgwood, Esq.' However, they were not able to permanently preserve their experiments, recording that the image 'immediately after being taken, must be kept in some obscure place. It may indeed be examined in the shade, but in this case the exposure should be only for a few minutes; by the light of candles and lamps, as commonly employed, it is not sensibly affected.' By the 1820s the discovery and commercial availability of the halides (iodine, bromine and chlorine) made the possibility of using a silver-based process viable, leading Louis Daguerre to discover that by using the vapour of heated mercury, the latent image on an exposed copper plate coated with silver could be brought out – 'developed' – in thirty minutes rather than several hours. In 1837, he found a way of 'fixing' the photographic images with a solution of common salt, and in 1839, following the lead of Sir John Herschel, he began to use hyposulphate of soda as the fixing agent, and the daguerreotype was born.

LEFT. Standing photographic clamp (nineteenth century)
This engraving depicts a device used to clamp the head of the subject firmly in place so that it does not move during the long exposures needed at the time to correctly expose the photograph. Even more elaborate contraptions were advertised, such as the Otis C. White posing chair of 1889, which offered an infinite amount of variation by using a system of ball-and-socket arms to support the subject in whatever pose the photographer desired.

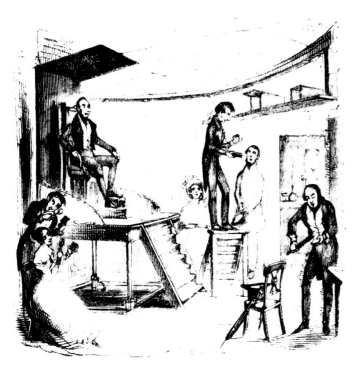

LEFT. Richard Beard's daguerreotype studio (c.1841)
Richard Beard opened Europe's first public photographic studio at the Royal Polytechnic Institute in Regent Street, London, in March 1841, although it is uncertain whether he had much to do with the actual taking of photographs or was more the entrepreneur behind the business. This engraving shows his studio, typical of the time, with the glass roof to let in as much light as possible, and the posing chair to support the subject. The daguerreotype process is also depicted, from the assistant sensitizing the metal plate in the right-hand corner, to the darkroom to process the image in the background, and the final image being viewed with the aid of a magnifying glass in the centre.

BELOW. Frédéric Martens – *La Seine, la rive gauche et l'île de la Cité* (1842)
Martens pioneered panoramic photography with his Megaskop camera, which produced a 150-degree field of view by deploying a set of fourteen curved daguerreotype plates. His breakthrough innovation was a hand-cranked set of gears that enabled the smooth movement of the lens across the plates, and an aperture behind the lens that narrowed towards the top, to prevent the sky being overexposed.

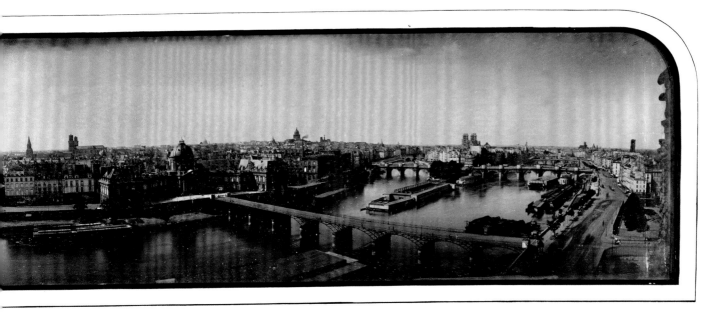

THE CALOTYPE

Like all of the early photographic processes, the preparation of a calotype was an elaborate affair.
Firstly, a sheet of high-quality paper was selected with as smooth and uniform a texture as possible. Working by candlelight, this was then washed with a solution of silver nitrate to create what Talbot called iodized paper. When almost dry, it was then soaked in potassium iodide, rinsed and fully dried. The resulting sensitized paper was relatively stable, so could be batch-produced ahead of time. Just before taking the photograph, a solution of gallo-nitrate of silver was prepared. This was highly unstable and had to be used immediately. The prepared sheet of paper was coated with this solution and ready for use. In near-darkness, the calotype paper was loaded into the camera, then exposed for between ten seconds and several minutes. The latent image projected on to the paper then had to be revealed by washing it again in fresh gallo-nitrate, which developed the image in a matter of seconds. It was immediately fixed permanently by using a solution of potassium bromide, and then washed and dried. This produced a negative image, a deep brown or black in colour, which could in turn be contact printed by sunlight on to photogenic paper, itself treated with salt and silver nitrate, producing what is commonly known as a salt print. The advantage this gave the calotype over the daguerreotype was that multiple copies could be made of each photograph. However, despite their innovations in fixing the photographic image on to a light-sensitive surface, both of the methods of the early pioneers Talbot and Daguerre were relatively short-lived in popularity as they were quickly overtaken by more permanent and repeatable techniques.

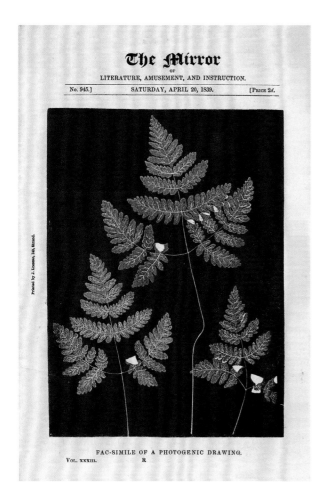

LEFT. Dr Golding Bird – *Facsimile of a Photogenic Drawing* (1839)
This delicate image of ferns is the first recorded publication of a photograph. It was displayed on the cover of the illustrated journal *The Mirror of Literature, Amusement, and Instruction* of 20 April 1839 to accompany an article by the eminent medical doctor, Golding Bird (1814–54). A noted chemist as well as a doctor and an amateur photographer, Bird was also credited with the invention of the flexible stethoscope. The journal printed the woodcut with the following explanation: 'Thus to *The Mirror* falls the honor of having first published a reproduction of a photograph.' The facsimile which was presented to its readers was the work of a draughtsman, who made a drawing of the photograph, and a wood engraver, who cut the block. The *Mirror*'s editors took the elaborate step of overprinting the page with brown ink to mimic the look of the calotype process.

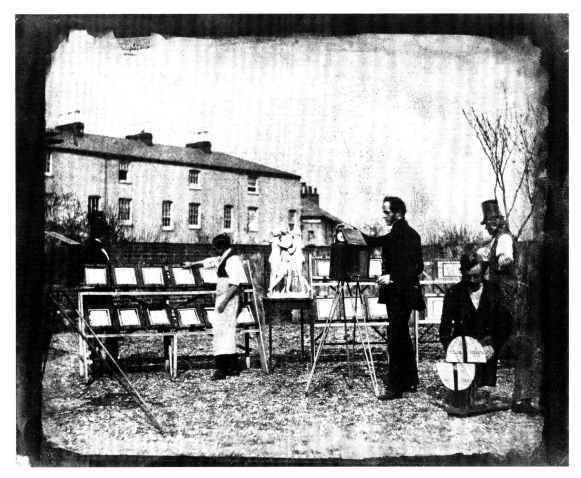

ABOVE. Talbot's studio (1846)
On the left of this image of William Henry Fox Talbot's printing establishment, an assistant lays out wooden frames to contact print photographs from paper negatives using sunlight. In the centre, Talbot's manservant Nicolas Henneman is seen photographing a sculpture of the Three Graces. Henneman frequently posed as a subject for Talbot, but was also employed by him to help manage his short-lived printworks, overseeing the publication of *The Pencil of Nature*. He attempted to branch out on his own, opening a studio in London, but gave up the profession in the mid-1860s.

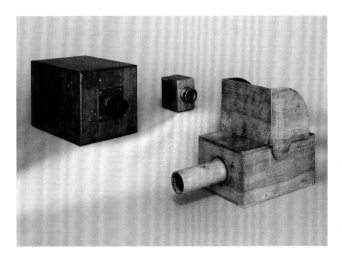

LEFT. Talbot's cameras
William Henry Fox Talbot used at least thirty different cameras to make his photographs, many made by his local carpenter, Joseph Foden. Shown here are (left to right): a calotype camera with lens and metal focusing cover of 1841–42; a small experimental camera with lens of 1834–36, and a camera obscura of *c*.1820 with a frame to hold the tissue paper for copying views by hand.

BEFORE PHOTOGRAPHY

Artists and scientists alike had long used technology to better understand the world, with the earliest known reference to the camera obscura dating back to Chinese texts known as *Mozi* from the fourth century BC.

The camera obscura was popularized by the Italian Giambattista della Porta (1535–1615) in 1558, who recommended using the device as an aid to more accurate drawing. Many artists made use of the technology, with some experts claiming for example that the Dutch painter Johannes Vermeer used some form of optical device to create the compositions in his paintings. Along with the camera obscura, another tool that was used to aid drawing was the camera lucida, patented in 1806 by William Hyde Wollaston (1766–1828). This consisted of an adjustable metal arm with a glass prism and mirror array at one end, while the other was fixed to the artist's drawing board. The apparatus reflected the outline of the scene on to the paper, which could then be traced.

LEFT. Bauchardy – *Physionotrace of a Man* (c.1808)

The physionotrace was an ingenious instrument that was used to draw the physiognomy of the subject by means of a pointer attached by a system of levers to an engraving tool, which traced the outline of the subject on to a copper plate. This could then be used to make multiple prints of the image, an improvement on the hand-cut silhouettes that had become popular at the end of the eighteenth century. Variations of the device were patented in France by Gilles-Louis Chrétien around 1783–84, and by John Isaac Hawkins in America in 1802. The engraved drawings became very popular, allowing portraits of luminaries such as George Washington to be sold to the mass market. This particular print was made by an engraver known only as Bauchardy at the Palais-Royal, Paris, France.

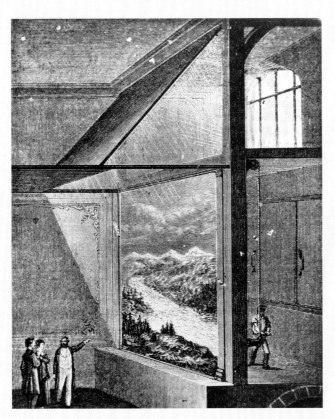

LEFT. Louis Daguerre – *Diorama* (1823)
Before he became involved with photography, Daguerre worked as a painter and architect, and was known particularly for stage sets for the theatre and opera. He further developed his skills in this regard when, along with Charles Marie Bouton, he opened one of the first 'multimedia' experiences, the Paris Diorama, in 1822. The diorama featured huge paintings displayed in a darkened, rotating auditorium that were then lit from the front and the back. The paintings were translucent and opaque, and a variety of methods were used to manipulate and control natural light to fall on both the front and the back of the images, creating a live spectacle that was the forerunner of the cinema.

BELOW. Camera obscura, from
The Magazine of Science Vol. I (1840)
In use since the seventeenth century, the phrase 'camera obscura' is derived from the Latin *camera*, 'chamber or room', and *obscura* – 'dark'. It uses the natural optical phenomenon that is created when light passes through a pinhole in a screen, projecting an inverted image of the world outside. Camera obscuras were often darkened rooms with white-painted walls to make the image easier to see. They were used to view eclipses of the sun without endangering the eyes, and as an aid to accurate drawing, enabling the artist to trace the outline of the subject on to a sheet of paper. Portable versions were also developed for use in the field to allow landscapes to be accurately rendered. As the process improved, mirrors and lenses were used to better focus the light, as depicted in this engraving from 1840.

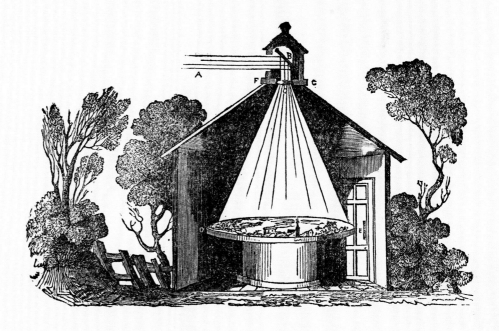

1826–1834

Joseph Nicéphore Niépce has the distinction of producing the first permanent images with an optical device. Born in 1765 in Chalon-sur-Saône, France, Niépce serves in the military and works as a teacher until returning home to manage the family estate, Le Gras, in 1801. With his brother, Claude, he develops a scientific interest that leads him to experiment with techniques to capture the images he sees in the camera obscura, an optical device of the time used by artists to make detailed drawings. His earliest attempts date to 1816 and, as early as 1822, Niépce successfully makes an image from an engraving of Pope Pius VII, which was sadly later destroyed. In 1826 he succeeds in capturing the view from his home at Le Gras, the first surviving photograph of the outside world. In 1827 he travels to England to promote his discovery, where he meets botanist Francis Bauer, who encourages him to present his heliographs to the Royal Society. Niépce describes his early examples as 'the first results obtained spontaneously by the action of light', but they are rejected by the Society because he would not fully disclose his process. In 1829 he begins collaborating with Louis Daguerre, who continues his work after Niépce's death and receives much of the credit for his invention. PL

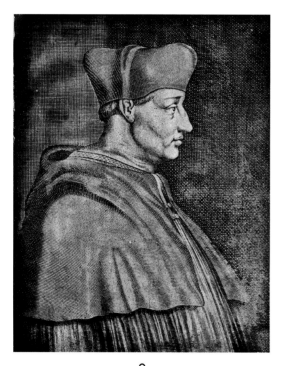

Joseph Nicéphore Niépce –*Cardinal Ambrose*
As early as 1814, Joseph Nicéphore Niépce (1765–1833) was experimenting with the lithographic process, using a light-sensitive varnish to try to make copies of engravings and drawings. This culminated in 1826 with the successful reproduction of an engraved portrait of the sixteenth-century Roman Catholic Cardinal d'Amboise. The process involved coating a pewter plate with light-sensitive bitumen of Judea, which was then exposed to light and washed to remove the unexposed parts, leaving an image etched into the metal. The process was dubbed 'heliography', and this was the first time that an image had been permanently fixed on a surface. This is one of only sixteen surviving heliographic plates by Niépce, and it is held in the collection of the Royal Photographic Society in England.

1826

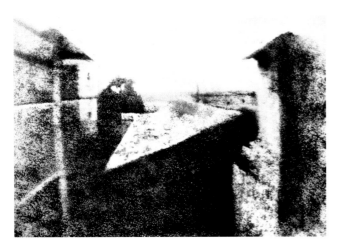

Joseph Nicéphore Niépce – *View from the Window at Le Gras*

This faint and blurry image has the distinction of being the earliest surviving photograph. Niépce made the image by using a camera obscura from a window overlooking the courtyard of his house, focusing the light on to a 16.2 cm × 20.2 cm (6½ in × 8 in) metal plate, with the exposure taking some eight hours. Niépce's remarkable image was rediscovered by the eminent photographic historians Helmut and Alison Gernsheim, who made this enhanced print from the original pewter plate. Now held at the Harry Ransom Center in Texas, it still retains its extraordinary, ethereal quality as a remarkable scientific and artistic breakthrough.

William Henry Fox Talbot – *Sketch of Villa Metzi, 5 October 1833*

This is perhaps the most important drawing in the history of photography. It was made by William Henry Fox Talbot while on his honeymoon on Lake Como in Italy. Talbot used a camera lucida to survey the scenic view, but was left bitterly disappointed with the results, claiming that the 'faithless pencil had only left traces on the paper melancholy to behold'. This then led him to ponder 'on the inimitable beauty of the pictures of nature's painting which the glass lens of the camera throws upon the paper in its focus … destined as rapidly to fade away.' This train of thought led him naturally to reflect on how 'charming it would be if it were possible to cause these natural images to imprint themselves durably, and remain fixed upon the paper!'

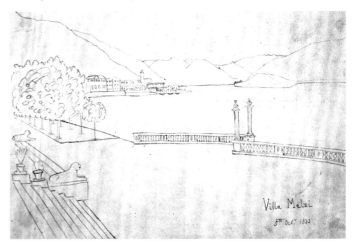

The first railway station in America opens in Baltimore, Maryland.

The war between Russia and the Ottoman Empire ends with the Treaty of Adrianople, granting Greece independence.

Charles Darwin sets sail as an unpaid naturalist on HMS *Beagle*'s five-year voyage to South America, New Zealand and Australia.

Parliament passes the Abolition of Slavery Act, ending the practice across the British Empire.

| 1829 | 1830 | 1831 | 1833 |

1835-1837

Along with Daguerre and Niépce, the English amateur scientist and gentleman William Henry Fox Talbot (1800-77) is one of the earliest pioneers of photography. Talbot was a true polymath and innovator, who published twenty-seven scholarly articles and four books on a wide range of subjects including chemistry, optics, botany, mathematics, astronomy and philosophy. A graduate of Trinity College, Cambridge, he became a fellow of the Astronomical, Linnean, and Royal Societies, and served as the Liberal Member of Parliament for Chippenham between 1832 and 1835. His ancestral family home, the medieval Lacock Abbey, in Wiltshire, England, is now preserved as a museum by the National Trust as the birthplace of photography. It became the focal point for his photographic experimentations, and served as a forum where he and his wide range of friends could meet to experiment with the potential of the new medium. PL

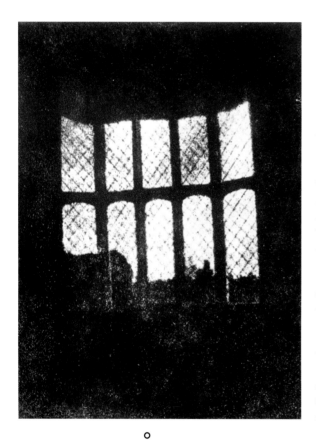

William Henry Fox Talbot—
The Latticed Window

In the summer of 1835 William Henry Fox Talbot fitted lenses taken from telescopes to small wooden boxes, into which he placed sheets of paper coated with silver salts to make them light sensitive, and then positioned them around Lacock Abbey. His wife, Constance, referred to the contraptions as 'mousetraps', and they did indeed succeed in capturing the sun, albeit on tiny squares of paper the size of postage stamps that showed the image reversed as a negative. Talbot described the resulting print from the paper negative thus: 'When first made, the squares of glass about 200 in number could be counted, with help of a lens.' The delicate and fragile negative is now stored in the archives of the National Science and Media Museum in Bradford.

Samuel Colt sets up a firearms company to manufacture his invention of the Colt revolver.

1835

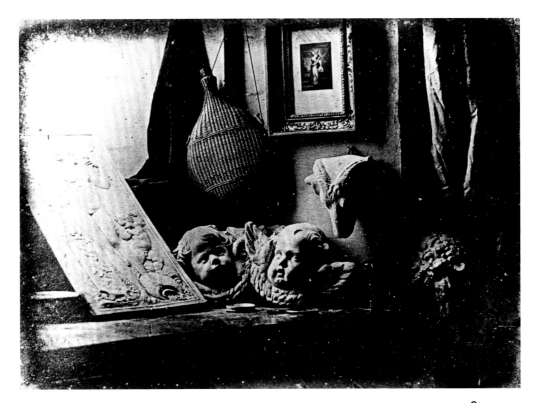

Louis Daguerre – *The Artist's Studio*

Daguerre continued the work he had begun with Niépce, and by 1835 had probably succeeded in creating the prototypes of what would become known as a daguerreotype. However, none of these early experiments survives, so this detailed still-life study of a corner of his studio, lit by the chiaroscuro light from the window, is the earliest known example of the process. Before he became involved with photography, Daguerre worked as a painter and architect, and was known particularly for stage sets for the theatre and opera, later combining his skills to create the 'multimedia' Paris Diorama in 1822. To help with his designs, he made frequent use of the camera obscura, which led him naturally into experimenting with trying to fix the optical image on to a light-sensitive surface.

The Battle of the Alamo is fought between Texan settlers and the Mexican Army. It is a pivotal event in the Texas Revolution.

Following his wife's sudden death, for which he was unable to be present, Samuel Morse patents the telegraph – a new method of rapid long-distance communication.

1836

1837

STILL LIFE

Arrangements of objects, whether staged for the camera or found in the world, have provided photographers with the opportunity to explore the aesthetics of how light and form in three-dimensional space can be translated into two dimensions, and also how things can convey a sense of the person who owned them.

Early photographers took inspiration from the well-established genre of still-life painting, with some like Henri Le Secq (1818–82) coming from an artistic background, having studied painting under Paul Delaroche. He made a portfolio of studies of objects in 1856 that included an arrangement of glasses and a half-full bottle of wine that can be viewed both as a formal composition and as a commentary on the culture of France, and on his own life. Similarly, after his return from the rigours of the Crimean War, Roger Fenton (1819–69) embarked on a new departure in terms of subject matter. Taking inspiration from the work of English still-life painters such as George Lance, he made arrangements of fruit that were exhibited to great acclaim, with one critic noting in the *British Journal of Photography* that Fenton had 'come out in an entirely new character, and may now be regarded in the photographic world in the same light as Lance among painters'. Other photographers found inspiration in the beauty of flora, with Edward Weston, Imogen Cunningham and Robert Mapplethorpe making exquisite studies of flowers and even vegetables, imbuing them with solidity and delicacy of tones. Conversely, some have studied objects for what they could tell us about human and social life. In 1955, Walker Evans (1903–75) published a portfolio piece entitled 'Beauties of the Common Tool' in *Fortune* magazine. Shot against a plain grey background, in the style of museum artefacts, these images elevate ordinary tools to works of art, with a monumental, sculptural quality and a ravishing attention to tone and detail. They become almost three-dimensional, as if one could reach out and pick them up, and have weight and solidity that belies their flat representation on the page.

BELOW. Karl Blossfeldt—*Allium ostrowskianum/Dutch hyacinth* (1929)
Karl Blossfeldt (1865–1932) was a trained sculptor and amateur botanist, and these two interests inspired him to produce a comprehensive study spanning three decades of over 6,000 photographs of flowers, seeds and vegetables. He used the images in his classes at the Museum of Decorative Arts in Berlin, where he taught architects and artists. Working with large glass-plate negatives that allowed him to reproduce the flora several times larger than life, and long exposure times with daylight as the light source, he created stunning images with a richness, depth and three-dimensional quality that transcended their original intention as teaching aids to become extraordinary studies of natural forms.

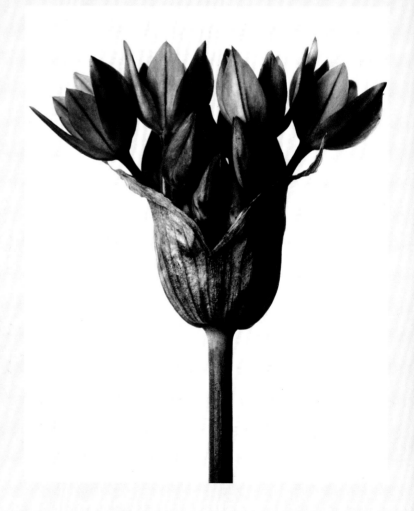

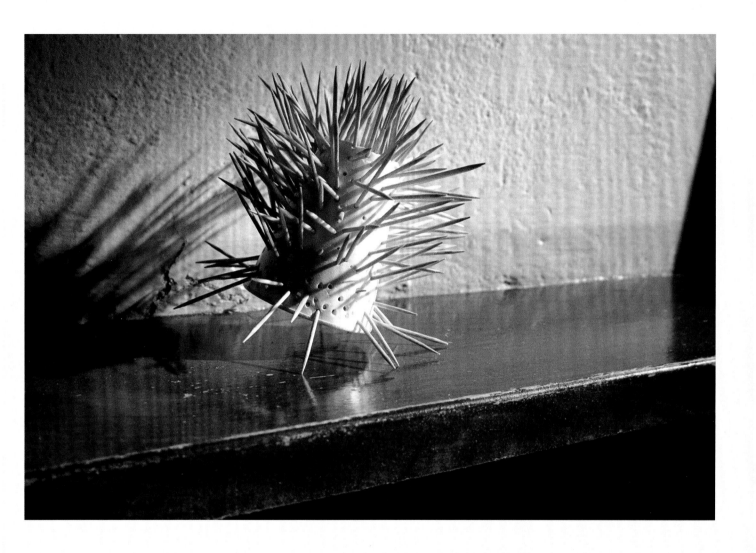

ABOVE. Peter Fraser – *Untitled* **(2006)**

Peter Fraser's (1953–) work explores how the material world we inhabit
can provide deep psychological insights into human mentality. He argues
that the 'world as I found it was an infinitely more complex, compelling and
mysterious subject than any notion I had of how it should look through my
own manipulation'. His working method is to go out into the world and tune
into the vibrations it gives off, to connect with it in a meditative process,
looking for small details that can trigger deep psychological insights. He is
fascinated by inspecting objects close up, feeling that 'small things are really
important, not least because everything in the universe is made up of matter
so small we can't see it with the naked eye. I almost never interfere with my
subjects: there are mysterious forces at work in the world and they know,
better than I do, how things should be placed.'

1838–1840

Having privately demonstrated his process to interested parties, including the American inventor Samuel Morse, Louis Daguerre introduces his discovery at a meeting of the Academy of Sciences and then to the general public at the Academy of Fine Arts in Paris on 19 August 1839. Along with Niépce's son and heir, Isidore, Daguerre is granted a lifetime pension by the French government in return for the rights to the process. This is then made freely available to the world as a gift (except, bizarrely, in England, where five days earlier a patent had been filed on Daguerre's behalf). Entitled *Patent No. 8194 of 1839, A New or Improved Method of Obtaining the Spontaneous Reproduction of all the Images Received in the Focus of the Camera Obscura*, it meant that a licence was needed to take daguerreotypes in Great Britain. Tragically, Daguerre's studio was destroyed in a fire in March 1839, and very few of his works exist today, with fewer than twenty-five attributed examples. PL

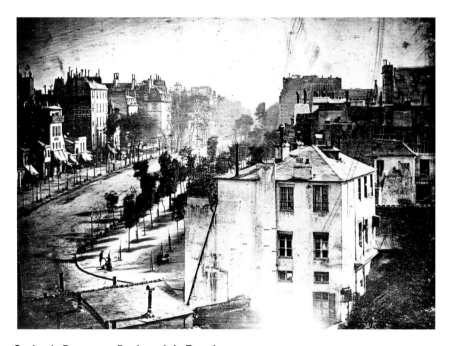

Talbot publishes a description of his photographic process in 'Some Account of the Art of Photogenic Drawing'.

Sarah Anne Bright makes a series of photograms, the earliest surviving photographic images created by a woman. Six are known to still exist.

Louis Daguerre – *Boulevard du Temple*
This early-morning Parisian street scene captured by Louis Daguerre appears strangely deserted, the effect of the long 7–15-minute exposure time needed to record the image on the light-sensitive copper plate that became known as a daguerreotype. The ghostly figure of the man having his shoes shined gives it the distinction of being the first recorded representation of a human figure in a photograph. The original daguerreotype was of course a unique image and not reproducible, which limited the appeal of the process, although contemporary critics marvelled at the level of detail in the view, with even the roof tiles clearly visible. That this ordinary scene, bereft of celebrity or drama, has become so famous is a mark of the way that photography has democratized vision.

1838 | 1839

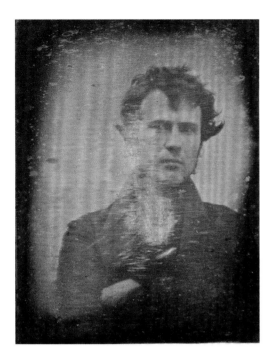

Robert Cornelius – *Self-portrait*
This compelling image by Robert Cornelius
(1809–93) is one of the earliest recorded
portraits, and indeed perhaps the original
'selfie'. He wrote on the back of the image that
it was 'The first light Picture ever taken. 1839'.
Cornelius first worked in his father's business,
specializing in silver plating and metal polishing,
and his skills transferred easily to the production
of silver plates for daguerreotypes. He took up
photography, and between 1841 and 1843
opened two of the earliest photography studios
in America. Despite initial success, he quickly
abandoned the profession in favour of the more
profitable family gas and lighting company.

Louis Daguerre publicly
introduces his daguerreotype
process.

Hippolyte Bayard – *Self-portrait as a Drowned Man*
This photograph initially appears rather disturbing, but was in fact a joke
about the fickle nature of photographic celebrity. Its originator, Hippolyte Bayard
(1801–87) wrote on the back of the print, 'The corpse you see here is that of
M. Bayard, inventor of the process that has just been shown to you. As far as I
know this indefatigable experimenter has been occupied for about three years
with his discovery. The Government, which has been only too generous to
M. Daguerre, has said it can do nothing for M. Bayard, and the poor wretch has
drowned himself. Oh the vagaries of human life … !' Bayard was upset that his
experiments with direct positive printing had not received the same recognition
as those of his competitor, Daguerre, and so staged this image of his death.

Alexander Wolcott receives the first American patent
issued in photography for his camera, and opens the
world's first ever photographic studio in New York.

1840

1841–1843

The daguerreotype rapidly becomes a craze, and spreads globally. Technological advances in lenses and in the chemical process allow for shorter exposure times, meaning that portraits can more easily be taken. The relative cheapness of production means that a wide range of social classes flock to have their likenesses reproduced. Samuel Morse introduces the process to America, which quickly becomes the largest consumer of the new medium. The American writer Oliver Wendell Holmes eloquently describes the daguerreotype as the 'mirror with a memory'. In 1841 William Henry Fox Talbot introduces his patented calotype (or 'talbotype') paper negative process, reducing the exposure time and creating a reproducible image, unlike the unique daguerreotype. However, the success of the calotype is hampered by his own patent that seeks to extract royalties from commercial users; not until 1852 does he relinquish control of his invention. PL

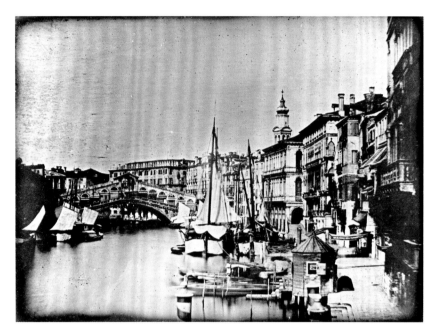

The US Supreme Court rules that the Africans who had been aboard the ship *Amistad* are not legally slaves and that they are free to return to Sierra Leone.

○ **Alexander John Ellis**–*The Rialto Bridge, Venice*

Alexander John Ellis (1814–90) documented his travels on the 'Grand Tour', the traditional rite of passage for young English gentlemen who wished to savour adventures in Europe. He was an early pioneer of the daguerreotype process, and planned to publish his studies of the sights in a volume provisionally titled *Italy Daguerreotyped*, which he claimed would demonstrate 'that verisimilitude which is required by the traveller to all who wish to know what the buildings of Italy really are'. Although he never did actually publish the book, he made over 100 photographs on his travels, forming the earliest known views of Italy, and carefully noting the date, time and location of each one. This scenic view of the Rialto Bridge was taken from an upstairs window in the White Lion Inn between 3.29 and 3.42 pm. The resulting 13-minute exposure makes the streets appear eerily quiet.

Sir John Herschel invents the cyanotype process.

1841

Joseph-Philibert Girault de Prangey – *The Athenian Temple of Olympian Zeus*

In 1842 Girault de Prangey (1804–92) embarked on a three-year odyssey through Italy, Greece, Turkey, Syria, Egypt and Palestine, during which he made over 800 daguerreotypes of architectural details and scenic views. On his return, he published a limited edition of lithographs of his images, but never publicly exhibited them. They then remained undiscovered until the 1920s, when they were found after his derelict family home was sold. Eighty years later they came to global attention when they were sold at auction to Sheikh Saud Al-Thani of Qatar, for the colossal sum of £3.8 million ($6.2 million). This particular photograph set a world record price at the time for photography of any type, of £565,250 ($922,488).

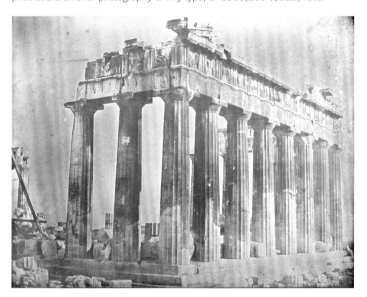

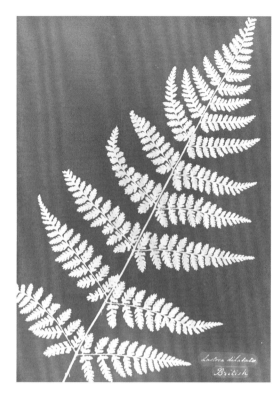

Anna Atkins – *Cystoseira granulata*

Anna Atkins (1799–1871) was a pioneer of scientific photography, and her volume of cyanotypes, *British Algae: Cyanotype Impressions*, is seen as the first published book to be illustrated with photographs. A member of the Botanical Society of London, she was an excellent draughtswoman, but soon realized that photography could produce more accurate results in much less time. In 1843 she began her catalogue of algae, making contact prints that display the blue tint produced by the oxidation of the iron salts used to make the exposure.

The world's first illustrated weekly news magazine is launched, entitled *The Illustrated London News*.

The first advertisement with a photograph is published in Philadelphia.

Charles Thurber invents the typewriter in America.

1842

1843

THE NUDE

As in art, depicting and exploring the naked human form has been one of the central themes of photography, and has also been the subject of intense debates and arguments about censorship and taste. Photographers must tread a fine line between aesthetics, erotica and pornography, testing the limits of what is deemed to be socially acceptable, while celebrating the beauty of the nude.

From the very earliest days of photography, the nude has been one of the great subjects of the medium, with practitioners exploring the camera's ability to capture the delicacy, detail and texture of light falling on both male and female skin. However, this exploration has also led to significant controversy about matters of taste and decency, with some photographers deliberately challenging social mores, especially in the depiction of genitalia. Oscar Gustave Rejlander's (1813–75) *The Two Ways of Life* (1857) was the subject of great controversy when it was exhibited in Scotland in 1859, leading to a schism in the Photographic Society of Scotland, with the secessionists founding the Edinburgh Photographic Society in 1861 after the picture was exhibited with one half covered in drapes to conceal the nude figures. However, the reputation of the photograph was confirmed in high society when Queen Victoria purchased a copy for Prince Albert after viewing it at the 1857 Manchester Art Treasures Exhibition. Later, Bill Brandt (1904–83) made a surreal series of female nudes, where he used the distorting effect of a super-wide-angle lens on his Hasselblad camera to create complex forms akin to Henry Moore sculptures, setting his subjects in claustrophobic interiors or against the more open landscape of the coast in Sussex, England.

BELOW. Jean Louis Marie Eugène Durieu – *Nude* (1858)
After retiring from his career as a lawyer, Jean Louis Marie Eugène Durieu (1800–74) took up photography, becoming president of one of the earliest photographic societies in the world, the French Société française de photographie (SFP), founded in 1854. He collaborated with his close friend, the painter Eugène Delacroix, in one of the earliest systematic explorations of the naked human form. Delacroix had immediately recognized the potential of the photograph as an aid to artists, noting that they are 'an intermediary charged with initiating us more deeply into the secrets of nature … a copy. In some ways false by being exact'. He would select and direct the models, while Durieu took the photographs on which Delacroix would then base his drawings and paintings.

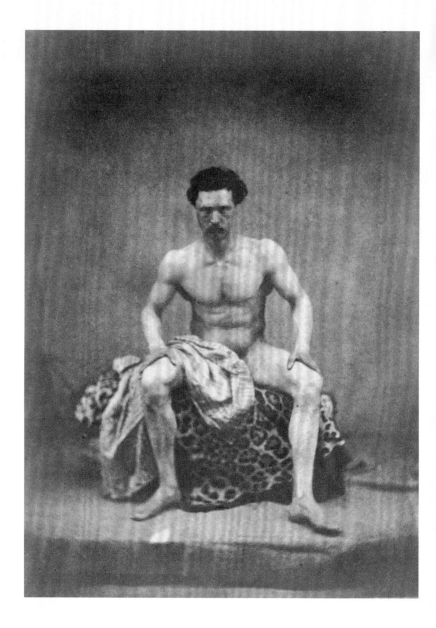

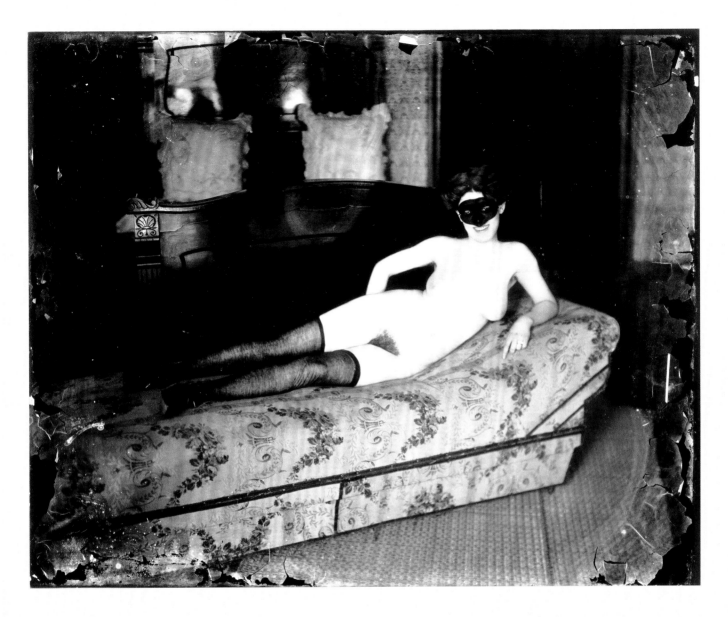

Helmut Newton (1920-2004)

After fleeing Germany to escape Nazi persecution, Newton began his career as a fashion photographer in Melbourne, Australia, before moving in 1961 to Paris, where he worked for *Vogue* and *Harper's Bazaar*. He developed a distinctive stylized eroticism in his work that combined elements of sadomasochism and fetishism with high fashion. Shot mostly on location in jet-set locations such as historical mansions and elegant hotels, his highly staged and directed black-and-white images drew on the visual style of 1930s film noir and New Wave cinema, with overtones of voyeurism, to depict statuesque women in glamorous settings. His work was highly controversial, with feminists critiquing his work as exploitative and demeaning, while supporters saw them as sexually charged icons.

ABOVE. E. J. Bellocq – *Untitled* (1912)
Little is known about E. J. Bellocq (1873–1949), and his intimate and sexually charged images only became well known after they were exhibited in 1970 at the Museum of Modern Art in New York following the purchase of the collection by Lee Friedlander, a champion of the work. Bellocq was a regular visitor to Storyville, the red-light district of New Orleans, named after politician Sidney Story, who had implemented a policy to concentrate all the brothels in one district. Despite the fact that many of the women's faces were scratched out, or, as in this photograph, masked, the images succeed in depicting the subjects as individuals with strong and independent characters, and are often more playful than erotic.

1844–1846

William Henry Fox Talbot's historic publication, *The Pencil of Nature*, is the first commercially produced book illustrated with photographs.

Produced between 1844 and 1846 in six instalments, the portfolio contains twenty-four calotype prints, accompanied by an explanatory text. The publication includes observations and notes by Talbot on the process, in which he notes that 'The picture, divested of the ideas which accompany it, and considered only in its ultimate nature, is but a succession or variety of stronger lights thrown upon one part of the paper, and of deeper shadows on another … the variegated scene of light and shade might leave its image or impression behind, stronger or weaker on different parts of the paper according to the strength of weakness of the light which had acted there.' Just fifteen complete copies of the original edition still exist. PL

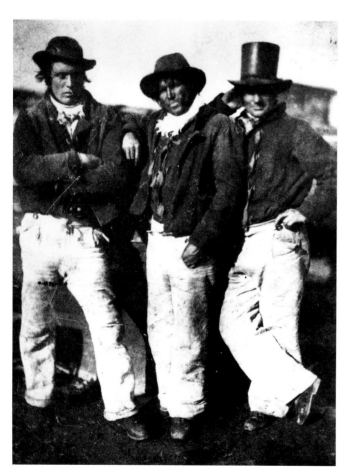

David Octavius Hill and Robert Adamson –*Alexander Rutherford, William Ramsay, and John Liston* (c.1843–47)

Robert Adamson (1821–48) and David Octavius Hill (1802–70) opened the first photography studio in Scotland in 1843. Adamson was an engineer, and Hill a painter, and they combined their technical and artistic skills in a remarkable collaboration that produced 3,000 photographs in just four years. Adamson operated the camera and developed the calotype prints while Hill directed the compositions and controlled the lighting. In their studio, they made portraits of the great and the good of Scotland, and also took their camera on location, as in this example showing fishermen of Newhaven, part of arguably the first independent documentary photography project.

In Australia, the Aboriginal Orphans Act is passed, allowing church missionaries to kidnap aboriginal children in an attempt to 'civilize' them.

Part 1 of William Henry Fox Talbot's *Pencil of Nature* is published.

1844

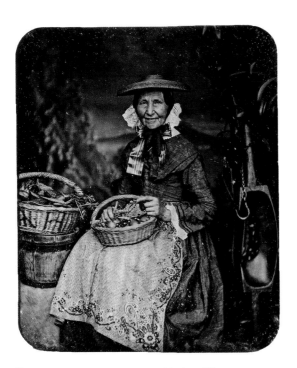

Carl Ferdinand Stelzner – *Mother Albers, the Family Vegetable Woman*

Originally a painter, the German Carl Ferdinand Stelzner (1805–94) travelled to Paris to learn the techniques of photography directly from Louis Daguerre, the inventor of the daguerreotype process. Along with fellow daguerreotypist Hermann Biow (1804–50), Stelzner opened a studio. They made some of the earliest news photographs when they recorded the devastation caused by the Great Fire of Hamburg that burned from 5 to 8 May 1842. For this portrait, Stelzner posed an idealized version of a vegetable seller against a painted backdrop in a romanticization of the working classes. Sadly, Stelzner went blind and had to abandon photography by 1858.

Reverend Calvert Jones – *Santa Lucia, Naples*

The Reverend Calvert Jones (1804–77) came from a landowning family in Wales, and after leaving the priesthood in 1837 he developed interests as a watercolour painter and draughtsman, skills he then brought to the new innovation of photography. In 1841 he met Hippolyte Bayard, the French inventor of direct positive prints on paper, whom he introduced to his close friend Talbot, bringing together seminal figures in the development of the medium. Calvert Jones used the calotype process in a series of images made on his travels across Europe. In this innovative example, he used his painter's eye for composition to make a wider panoramic image by taking two photographs spaced marginally apart. Talbot was so impressed by his friend's work that he made a set of prints for sale from them through his Reading business. After the death of his father in 1847 Calvert Jones inherited the family business, and his interest in photography waned. He had abandoned it completely by 1856, although he continued to paint.

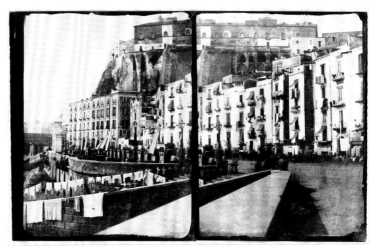

The increased speed of transporting potatoes across the Atlantic to Europe from America enables the survival of mould arriving with the produce, leading to crop failures across Europe and starvation in Ireland.

The Italian chemist Ascanio Sobrero synthesizes nitroglycerin.

1845

1846

1847–1849

The popularity of the daguerreotype portrait instantly creates a huge market for entrepreneurs, and thousands of studios open up across America.

Demand is driven by the Gold Rush and the exploration of the West, with pioneers wanting photographs of themselves with all their mining equipment to leave behind with loved ones, and images of their families to carry with them on their adventures. Mondays are seen as particularly favourable days for business, as romantic meetings over the weekend create a demand for exchanges of portraits between couples. It is estimated that by 1853 over 10,000 photographers were working across America, with another 5,000 workers supplying the industry with materials, and an entire town on the Hudson River called Daguerreville dedicated to the process. In 1853 the *New York Daily Tribune* calculates that three million daguerreotypes are being made annually, almost all of them private portraits. PL

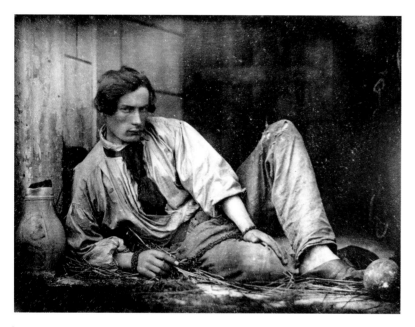

Louis Adolphe Humbert de Molard – *Louis Dodier as a Prisoner*
Typical of the wealthy gentleman photographer, Baron Louis Adolphe Humbert de Molard (1800–74) could afford to explore the expensive new medium. Starting with daguerreotypes in 1843, by the mid-1850s he had become one of the first French photographers to use calotypes. He often evoked peasant life, with his family, friends and servants serving as models. Influenced by the pictorial tradition, this staged portrait of his steward, Louis Dodier, is typical of his carefully composed genre scenes; he made several variants on the theme, experimenting with different poses.

The studio of Southworth & Hawes in Boston creates daguerreotypes to record early operations at Massachusetts General Hospital.

Karl Marx and Friedrich Engels publish *The Communist Manifesto.*

The Langenheim brothers in Philadelphia introduce the first photographic lantern slide.

1847

Albert Sands Southworth – *Self-portrait*

Albert Sands Southworth (1811–94) together with his partner, Josiah Johnson Hawes (1808–1901), ran one of the earliest and most famous photography studios in the United States. Based in Boston, Southworth & Hawes photographed the city's rich and famous, claiming in their advertisements that '[A] likeness for an intimate acquaintance or one's own family should be marked by that amiability and cheerfulness, so appropriate to the social circle and the home fireside. Those for the public, of official dignitaries and celebrated characters admit of more firmness, sternness and soberness.' The dramatic image here is probably a self-portrait by Southworth, although Hawes may have made the actual exposure, as it shows his characteristic use of vignetting the corners of the image to highlight the main subject.

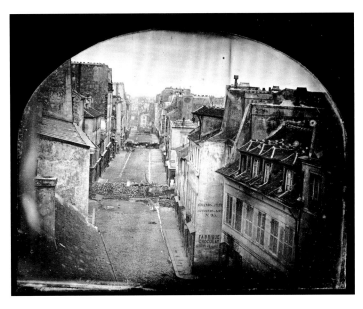

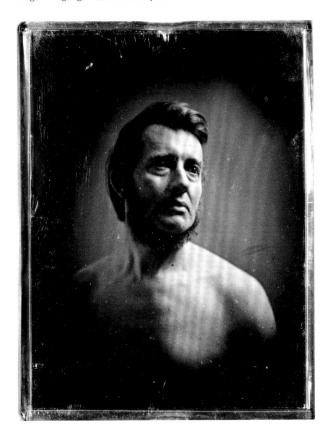

Thibault – *The 1848 Revolution*

Perhaps the earliest examples of what has become known as the 'aftermath' genre of photography, this is one of a pair of daguerreotypes by the daring photographer known only as Thibault. Taken before and after the attack in which General Christophe Lamoricière's troops broke through revolutionary barricades on the rue Saint-Maur-Popincourt in Paris, the images leave the horror of the violence inflicted to the imagination. The photographs were quickly printed in the weekly newspaper *L'Illustration* in one of the earliest instances of photojournalism.

Sir David Brewster, inventor of the kaleidoscope, makes the lenticular stereoscope, a hand-held device allowing stereographic photographs to be easily viewed.

1848

1849

2

—

1850
TO 1900

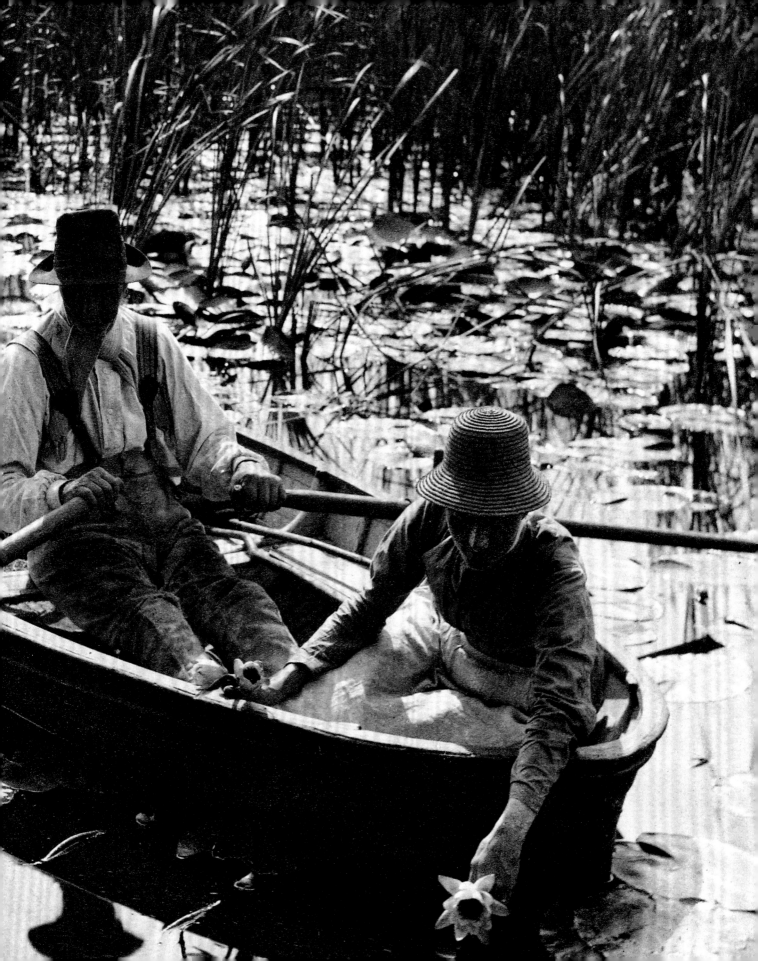

The year 1851 marked the opening of the Great Exhibition of the Works of Industry of All Nations, held in London's Hyde Park, with photography playing a central role in the celebration of British achievements. Over 700 photographs were displayed as part of the event, and 140 specially commissioned albums were created to be given to foreign governments as a record of their participation in the celebration of Britain's industrial and scientific prowess. Photography soon became an accepted art form, and in 1859 the first ever photography exhibition in a museum was put on by the Photographic Society of London at the South Kensington Museum – now the Victoria & Albert Museum. With 1,009 photographs on display, the show included works by Roger Fenton, Francis Frith and Gustave Le Gray, and was documented by the museum's official photographer, Charles Thurston Thompson (1816–68), his work becoming the earliest known image of a photographic exhibition. These two exhibitions demonstrated the value of photography as both an art and a science, and were evidence of its growing popularity to a general audience as a means of exploring the world, understanding it and interpreting it.

One of the notable aspects of this was the network of societies that emerged in the mid-nineteenth century, allowing the art and craft of the medium to be widely discussed and debated. The world's first photographic society, the Société héliographique, was founded in 1851, and included painters, writers and public figures as well as photographers among its ranks, evidence of how quickly photography was permeating other art forms and social discourse. Like similar societies that sprang up in the rest of Europe and America, the group held regular meetings at which its members could learn from and with each other about new techniques and approaches. It was soon followed in 1854 by the Société française de photographie, which was more populist in its approach, and counted Camille Silvy (1834–1910) among its ranks. His work typifies the blend of aesthetic sensibility and the solution of technical problems that the society's members explored; by combing two negatives together to expose the sky and the water separately he was able to overcome the limitations of the sensitivity of the photographic emulsions of the day. Five of the members of the Société héliographique – Édouard Baldus, Hippolyte Bayard, Gustave Le Gray, Henri Le Secq and Auguste Mestral – were also commissioned by the French government to form the Missions héliographiques, which sought to document and preserve the nation's architectural heritage, one of the

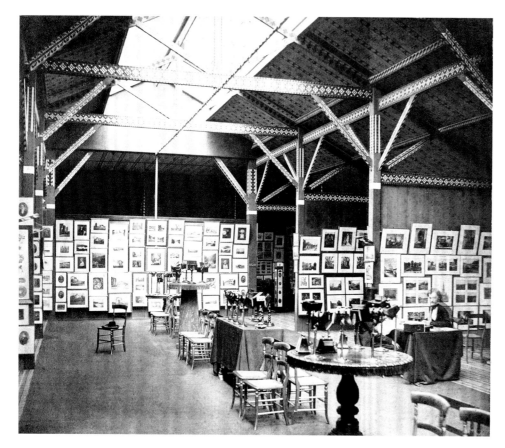

PREVIOUS PAGE. Peter Henry Emerson – *Gathering the Water Lilies* (1886)

LEFT. Charles Thurston Thompson – *Exhibition of the Photographic Society of London* (1858)

RIGHT. Camille Silvy – *River Scene, France* (1858)

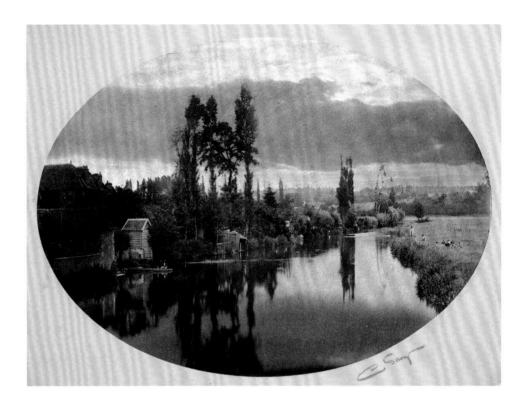

earliest state-supported efforts to use photography to promote national interests.

However, as well as being used as propaganda to celebrate the success and heritage of the nation, a darker side of the potential of photography became apparent: it was employed as an instrument of state power, surveillance and control, both as a means to control crime and to suppress political dissent. A particularly troubling governmental abuse of photography occurred in the aftermath of the Paris Commune of 1871, when, during the insurrection against the French government, Bruno Braquehais took photos of the Communards manning the barricades in the city in an early example of photojournalism. However, once the uprising had been quelled, the Paris police obtained copies of Braquehais's images and used them to identify and then execute the revolutionaries under martial law. This brutal event marked the founding of an era when the camera became a tool of oppression as well as of journalism.

The nineteenth century was also the century of empire, and photography seemed to the British colonial officers and administrators ideally suited to the needs of documenting and cataloguing their activities, including the exploration of foreign landscapes and aiding military strategy. However, more problematically, they saw it as a tool in the newly emerging science of anthropology, and as a way of demonstrating the moral superiority of the 'white man'. For the Victorian ruling classes, bringing 'civilization' to the colonies seemed a worthy cause, and photography seemed to offer the opportunity for a detached scientific rationalism that could classify 'racial types' and survey the 'uncivilized' cultural practices of native populations, with a notable example being *The People of India*, an eight-volume photographic study that was compiled between 1868 and 1875, seeking to provide a comprehensive survey of the native castes and tribes of India. This pseudo-scientific propaganda posited the subjects of the colonial gaze as inferior and therefore supported the arguments that they could morally be exploited for the profit of the Empire. The engraving overleaf, purportedly depicting the reaction of the Quimbandes tribe to the expedition photographer accompanying Henry Morton Stanley on his mission to find Dr Livingstone, shows how African tribes were seen as terrified of the new technologies that were deployed by colonialism. This negative and racially motivated stereotyping sadly continued well after the age of empire, with visions of Africa still being dominated in the present day by conflict and violence rather than a more nuanced and balanced view of the continent.

However, some photographers did challenge the monopoly of the state narrative of Africans as a commodity to be exploited without valuing their rights. When Alice Seeley Harris (1870–1970) travelled to the Congo Free State as a missionary for the

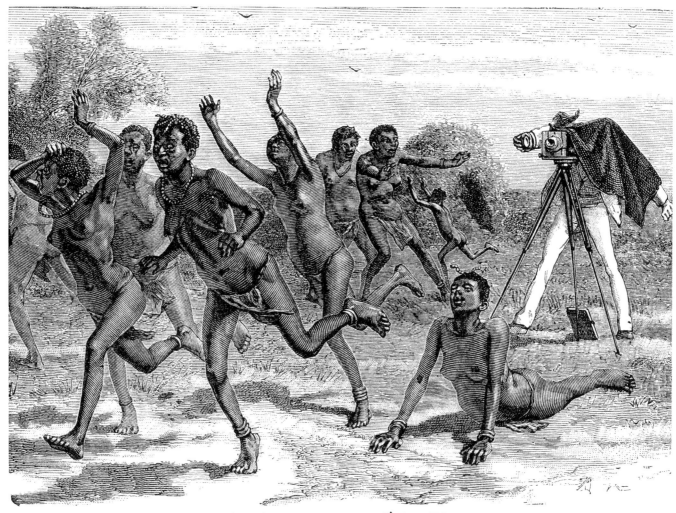

SCARED BY MR. WILLIAMS' CAMERA.

Congo-Balolo Mission, she was shocked by the brutality of the regime, which was the personal fiefdom of the Belgian King Leopold II, using a systematic policy of rape, mutilation and murder to suppress the population and to force them to meet quotas for the lucrative production of rubber. Harris's depiction of the horrors she witnessed is one of the earliest examples of a systematic documentation of human rights abuse, even more striking given her gender. Given the patriarchal nature of Victorian society, it is remarkable how many women were able to establish themselves as photographers, both as professionals and as keen amateurs. The craft of photography was seen as

socially acceptable for women among the wealthier elites, with the Scottish Lady Alice Mary Kerr becoming one of the finest portrait photographers of the period. Although she may well have been influenced by her friend Julia Margaret Cameron's groundbreaking work, and few of her photographs have survived, she was capable of producing powerful and intense images, such as her study of the radical English poet Wilfrid Scawen Blunt, who stares back at the viewer with an intense gaze. The landed gentry had the financial resources to use the medium to record their lives in detail, as in the case of Lady Augusta Crofton Dillon, who, along with her daughters Edith, Ethel and

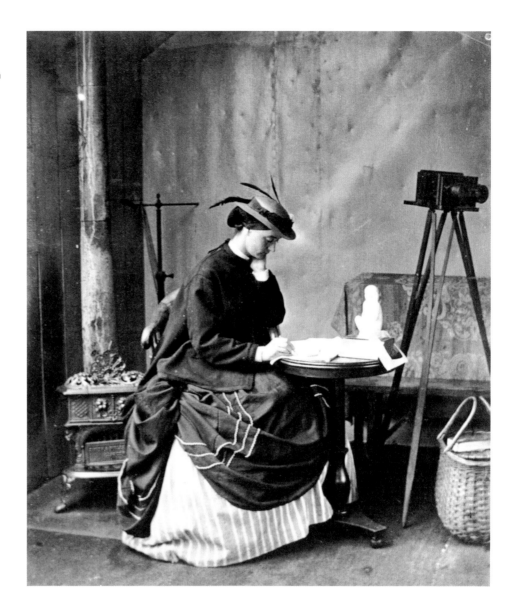

Georgiana, amassed a comprehensive survey of daily life on a landed estate in Ireland. Known as the Clonbrock Collection, over 3,000 glass plates were produced by the family between 1860 and 1930. Lady Crofton was photographed at her writing desk, with a camera on a tripod prominently displayed behind her, symbolic of the acceptance of photography as a suitable pastime for a noblewoman. Similarly, Lady Clementina Hawarden was able to use her family's wealth to provide her with the time, money and space to pursue her interest in the medium. She set aside the entire first floor of her elegant house in South Kensington, London, where she created a series of sensual, even sexual, studies of her daughters, Isabella Grace, Clementina Maude and Florence Elizabeth. Lady Hawarden created elaborate settings for her portraits, often using mirrors and ornate costumes, and displayed a sophisticated use of natural light that makes her images stand out in comparison to those of most of her contemporaries. As a member of the Photographic Society of London, she was awarded a Silver Medal for her work, with her fellow amateur photographer Lewis Carroll being particularly impressed, as he recalled, 'Went to the Photographic Exhibition … I did not admire Mrs Cameron's large heads taken out of focus. The best of the life-ones were Lady Hawarden's.'

CAPTURING THE DETAIL OF THE WORLD

As cameras and photographic emulsions became more sensitive, photographers were able to record more and more detail of the world around them. The advent of glass plates and the collodion process – described in theory by Gustave Le Gray in 1850 but developed as a workable process by Frederick Scott Archer, who published his findings in *The Chemist in March* (1851) – allowed photographers to capture the fine detail of the daguerreotype on a negative like the calotype that could be reproduced, simultaneously undermining both of the earlier processes. The wet-collodion process involved coating a glass plate with a light-sensitive emulsion of a mixture of soluble iodide and collodion (cellulose nitrate). The plate was then immersed in a silver nitrate solution to form silver iodide. While still wet, the plate had to be exposed in the camera within ten minutes. It then had to be immediately developed by pouring a solution of pyrogallic acid over it, and fixed with sodium thiosulphate or potassium cyanide. The whole process had to be undertaken in the field, necessitating a portable darkroom. The resulting negatives are highly detailed, with the largest known glass plate measuring an immense 1.35 m (53 in) by 94 cm (37 in), held at the State Library of New South Wales.

BELOW. Henry Hamilton Bennett – *Ashley Bennett Leaping across Stand Rock in Wisconsin Dells* **(1886)**
Henry Hamilton Bennett (1843–1908) had the distinction of inventing a shutter that moved fast enough to freeze motion. To demonstrate this advance, Bennett captured this dramatic image of his son jumping across the gap between two rock formations in the popular tourist destination of the Wisconsin Dells, with audiences gasping in amazement when he projected the image in public magic lantern shows in Boston in 1890.

PHOTOGRAPHED AND PUBLISHED BY H. H. BENNETT.

WONDERS AND BEAUTY OF WESTERN SCENERY.

IN AND ABOUT THE DELLS OF THE WISCONSIN RIVER.
97. Leaping the Chasm at Stand Rock, Instantaneous.

RIGHT. Eadweard Muybridge – *Sallie Gardner at a Gallop* (1878)

To answer the then-ongoing debate about whether or not all four hooves left the ground when a horse was at full gallop, industrialist Leland Stanford hired the photographic innovator Eadweard Muybridge (1830–1904) to try to establish the truth photographically, as the movement was too rapid for the human eye to perceive unaided. In 1878, in front of an audience of journalists, Muybridge succeeded in capturing the movement of the racehorse Sallie Gardner, showing that all four hooves do indeed clear the ground, but at the moment they are pulled in together, not at full stretch. Muybridge used an array of sixteen cameras with high-speed shutters spaced out at regular intervals along the racetrack, triggered in sequence by a trip wire as the horse passed by.

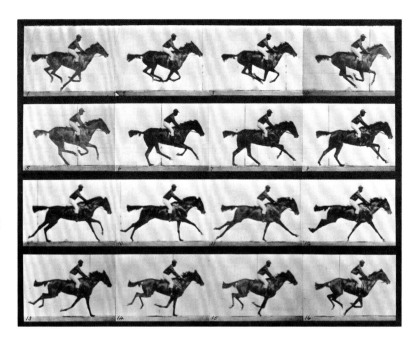

LEFT. Gustave Le Gray – *Solar Effect in the Clouds, Ocean* (1856)

Early landscape photographers were faced with a serious obstacle to their attempts to capture both the sky and the ground below. The emulsions used at the time did not have the contrast, range and sensitivity to record the range of tones that became possible later. If the sky was correctly exposed, the ground would be underexposed and dark, and if the ground was correctly exposed the sky would be completely overexposed and appear white. To solve this problem, Gustav Le Gray (1820–84) made two separate exposures for each part of the image, then combined the two together into one final print that held all the subtle detail in the bright highlights of the sky. The resulting seascapes were highly regarded when they were exhibited in 1857, with one reviewer claiming that they were the 'most successful seizure of water and cloud yet attempted … There is a plain, unbroken prairie of open sea, lined and rippled with myriad smiling trails of minute undulations, dark and sombrous and profoundly calm, over the dead below – smooth as a tombstone.'

PHOTOGRAPHY GAINS MASS APPEAL

The widespread introduction of roll film in the late nineteenth century revolutionized photography, as it allowed multiple exposures to be made in rapid succession without having to change the film, and the portability and flexibility of the format meant that photographers could shoot their images and then send them to be processed by a lab, greatly expanding their ease of use, and creating a mass market for photography. Roll film was initially often called 'cartridge' film because of its similarity to a shotgun cartridge. Two main formats were developed: the 135 formats, commonly known as 35 mm, packed in a small metal tube; and the 120 formats, also known as 6 x 6 or square format, with the negative measuring 6 cm (2½ in) on each side. 120 format films can also produce negatives of 6 x 4.5 (645), 6 x 7, 6 x 9, and 6 x 17 and 6 x 24 panoramic. With 120 film a spool of paper-backed roll film is loaded on one side of the camera and pulled across to an identical take-up spool on the other side of the shutter as exposures are made. George Eastman, founder of Kodak, was quick to see the potential of roll film, and developed a series of cameras that dominated the industry with their ease of operation. The early models were known as 'string-sets' because of their mechanism that used a string to cock the shutter. They came pre-loaded with film, and once the photographs were exposed, the customer simply posted the whole camera back to Kodak, who made prints, reloaded the camera with fresh film and shipped it back.

LEFT. Frederic Church – *George Eastman on Board SS Gallia* **(1890)**
This unusual circular photograph was produced using the Kodak #2, introduced in 1889. This was the company's third production camera, with the maker claiming that the unusual format meant that the user did not have to worry about holding the camera level, or about vertical or horizontal alignment. Taken by the painter Frederic Church (1826–1900), it depicts the founder of the company, George Eastman, on the deck of the transatlantic ocean liner SS *Gallia*.

RIGHT. André-Adolphe-Eugène Disdéri –
Prince Lobkowitz **(1859)**

When André-Adolphe-Eugène Disdéri (1819–89) patented his technique for printing multiple images on the same sheet of paper on 27 November 1854, he created an enormous new mass market for what became known as the *carte de visite* ('visiting card'). Using a camera with four lenses and a sliding holder for the glass plates, his camera printed up to ten photographs, each measuring 6 x 9 cm (2.4 x 3½ in). The concept allowed for photographs to be printed cheaply and in vast numbers, with portraits of celebrities such as his 1859 portrait of Napoleon III selling in huge quantities. It also allowed for multiple poses to be recorded in the same session, as in this set of series of Joseph Franz von Lobkowitz, Prince of Bohemia. Disdéri is also credited with the invention of the twin-lens reflex camera, but despite his early successes he died a pauper in 1889 in the Hôpital Sainte-Anne in Paris; his process was too easily copied by his competitors.

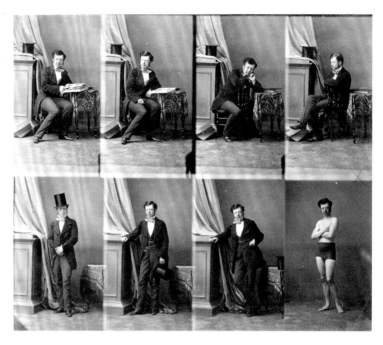

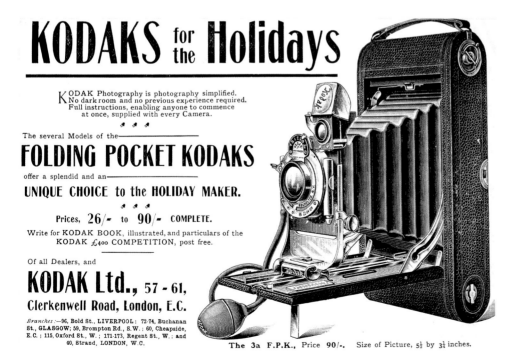

LEFT. Folding Kodak camera, nineteenth century

The folding camera, developed in the late nineteenth century, was the compact camera of the day, small enough to be slipped into a jacket pocket. More than two million of the Vest Pocket Kodak camera, or 'VPK' as it was generally known, were sold before the model was discontinued in 1926. Advertised as 'the Soldier's Kodak', it was popular with soldiers in the First World War trenches, especially the American 'doughboys', who were encouraged to 'Make your own picture record of the War'.

1850–1852

The early 1850s is a time of continued development in technical photographic processes, with some of the most important being the invention of the wet-collodion process, and the rise of albumen printing – a process invented and promoted by Louis Désiré Blanquart-Evrard using egg whites. This becomes the dominant means of paper printing from the 1850s right through to the early twentieth century, most notably, perhaps, in its use for the wildly popular Victorian *cartes de visite* ('calling cards' or 'visiting cards'). Candid photography of daily life is not yet possible due to the limitations of exposure time (too slow to record natural movement), but portraiture, often using brace devices to hold heads still, continues to have huge social and commercial significance. This is also a time of exploration, when photography is used in concert with the imperial expeditions of Britain and France to record views of newly conquered territory. JG

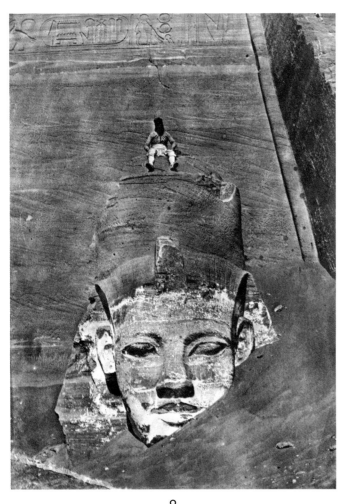

Maxime Du Camp – *Abu Simbel, Westernmost Colossus of the Great Temple*

In 1849, Maxime Du Camp (1822–94) was commissioned by the French government to photograph the monuments of Egypt, accompanied by the novelist Gustave Flaubert. The two men hired a boat to take them up the Nile, exploring archaeological sites along the way. For this photograph of part of the colossal rock-cut temples built by Ramesses II, Du Camp arranged for the face of the statue to be dug out of the sand and instructed one of his assistants to sit on top of it to illustrate its scale. His was the first photographic record of the ancient monuments of the Middle East.

Frederick Scott Archer, a British sculptor, invents the wet-collodion process, and the albumen paper printing technique is introduced by Louis Désiré Blanquart-Evrard.

The Great Exhibition in London exhibits photographs for the first time.

1850

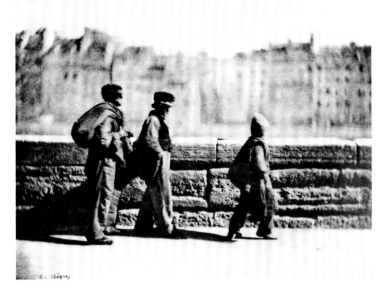

Charles Nègre – *Chimney Sweeps Walking*

Charles Nègre (1820–80) was a painter who roamed the streets of Paris using photography to capture scenes of daily life as a basis for his paintings. This image is not a spontaneous scene but has been staged – long exposure times made it impossible to photograph figures walking, even on a sunny day. The boy in front has bent his knee to imitate walking, but all three figures had to hold their poses for some time. To shorten the exposure time, Nègre used a lens with a very wide aperture, resulting in shallow depth of field, hence the blurred background.

Henri-Victor Regnault – *The Ladder*

Henri-Victor Regnault (1810–78) is a very significant figure in early French photography. A founding member of the Société héliographique, he was also founding president of the Société française de photographie in 1854, and one of the first in France to use William Henry Fox Talbot's calotype process. In 1852 Regnault was appointed director of the Sèvres porcelain factory, where he established a photography department. It was in the grounds of the factory that he made this still-life study, showing a quiet corner, where a carefully arranged collection of objects creates a picturesque composition, the frame beautifully divided by light and shadow.

The **Société héliographique** is founded in Paris.

Napoleon III becomes Emperor of France, and the Palace of Westminster is opened in London.

1851

1852

1853–1855

1854 sees a great milestone in the social history of photography, with the patenting of the technology for making *cartes de visite*.

Typically, *cartes de visite* had been made using a camera with eight lenses, which captured a sequence of moments resulting in eight variations on a portrait, exposed on one photographic plate. They become hugely popular for the first time, making it possible for people of modest income to own and exchange photographs of themselves, which often reflect an idealized and aspirational image. In the meantime Roger Fenton (1819–69), who has just helped found the Royal Photographic Society in 1853, travels to the Crimea to become the first war photographer, along with the lesser-known James Robertson (1813–88). Though their cameras are not able to capture the action of battle that audiences later came to expect from the reportage of conflict, they lay the foundations for the mediation of war by governments and independent journalists. JG

The Photographic Society of Great Britain (later the Royal Photographic Society) is established.

André-Adolphe-Eugène Disdéri of Paris introduces the *carte de visite* form of portraiture.

Eliphalet M. Brown – *Yendo Matazaimon and His Attendants*

This imposing group portrait shows Matazaimon, the governor of Hakodate, Japan, with his associates, Ishuka Konzo and Kudo Mogoro. It was made by Eliphalet M. Brown (1816–86) on one of two visits to Japan, and is one of the earliest recorded photographic images of the country. Brown was the official photographer for the historic American expedition led by Commodore C. Perry. He is thought to have made up to 400 daguerreotypes, most of which have been lost, but a series of lithograph reproductions did appear in an 1856 publication, *Narrative of the Expedition of an American Squadron to the China Seas and Japan*.

1853

1854

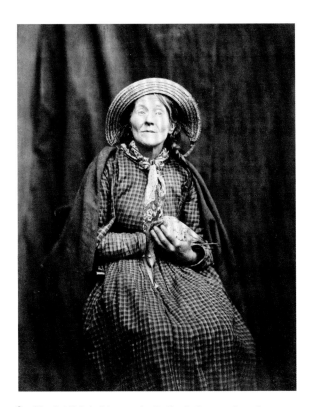

Hugh Welch Diamond – *Patient, Surrey County Lunatic Asylum*

In the 1840s, Hugh Welch Diamond (1809–86) studied psychiatry at the Bethlem Royal Hospital in London, and later became superintendent of the female department at the Surrey County Lunatic Asylum. Here he began the unusual practice of photographing his patients. Using simple poses and a plain background, the pictures echo conventional studio portraits of the time. In 1858, Diamond went on to open a private asylum in Twickenham, where he stopped taking portraits.

Roger Fenton – *Valley of the Shadow of Death*

The Crimean War was the first armed conflict ever to be systematically photographed. It was an unpopular war, and Roger Fenton understood his role as influencing public opinion back in Britain. His achievements are all the more remarkable given that he had to carry a mobile darkroom made from a converted wine merchant's wagon while avoiding Turkish artillery and using camera technology that was not yet advanced enough to capture any kind of moving subject. What he could do, however, was evoke the haunting and desolate aftermath of battle, as in this most famous landscape scene, the title of which refers to Psalm 23 of the Bible.

The United Kingdom declares war on **Russia**, instigating the Crimean War.

The *Daily Telegraph* newspaper begins production in London.

1855

WAR

Conflict in all its various forms of destruction and despair has been an overriding concern of photographers since the earliest days of the medium. While some viewers have criticized the work of photojournalists in situations of extreme suffering as exploitative, and potentially leading to compassion fatigue, others see the work of such eyewitnesses to devastation wrought on both humanity and the landscape as a vital antidote to militarism and essential to the prevention of war crimes.

The representation of the casualties of war has been one of the most controversial issues in the photography of conflict. In the aftermath of the Indian Mutiny in 1858, Felice Beato made a starkly powerful image of the skeletal remains of the rebels in front of the Bara Imambara 'Royal Palace' in Lucknow that is still one of the most graphic scenes of destruction today. Similarly, the bodies of the dead of the American Civil War were displayed in public exhibitions at the time to great effect. Later, however, during the Second World War, images of dead American soldiers were censored from publication until September 1943, when after sustained lobbying of the authorities, *Life* magazine published the harrowing photograph taken by George Strock of the landing beaches at the Battle of Buna–Gona in New Guinea, strewn with corpses. In fact, the depiction of the military casualties of war has arguably become more censored than before, with strict government rules now covering what can be shown by the reporters embedded with US and British forces in the Iraq and Afghan wars, for example.

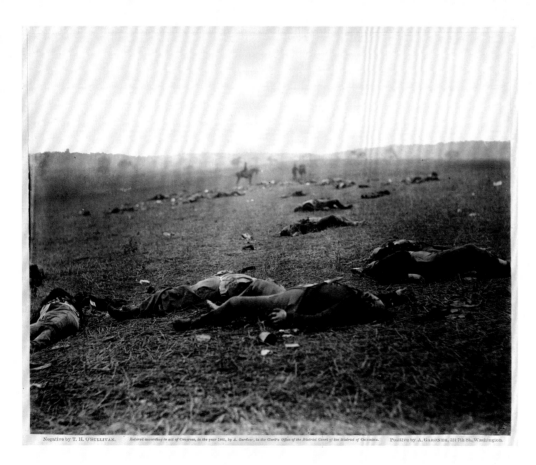

Negative by T. H. O'SULLIVAN. *Entered according to act of Congress, in the year 1865, by A. Gardner, in the Clerk's Office of the District Court of the District of Columbia.* Positive by A. GARDNER, 511 7th St., Washington.

**LEFT. Timothy O'Sullivan –
*'A Harvest of Death' Gettysburg,
Pennsylvania* (1863)**
This haunting photograph of the rotting dead awaiting burial after the Battle of Gettysburg was published in Alexander Gardner's *Photographic Sketch Book of the War* (1866) with a tragically poetic caption that read 'It was, indeed, a "harvest of death."' Taken by Timothy O'Sullivan (1840–82), this image and the others like it in the *Sketch Book* taken by Gardner and his team of photographers graphically documented the human cost of the Civil War, and received widespread coverage when they were exhibited, with the *New York Times* reporting that 'there is a terrible fascination about it that draws one near these pictures, and makes him loth to leave them. You will see hushed, reverend [*sic*] groups standing around these weird copies of carnage, bending down to look in the pale faces of the dead, chained by the strange spell that dwells in dead men's eyes.'

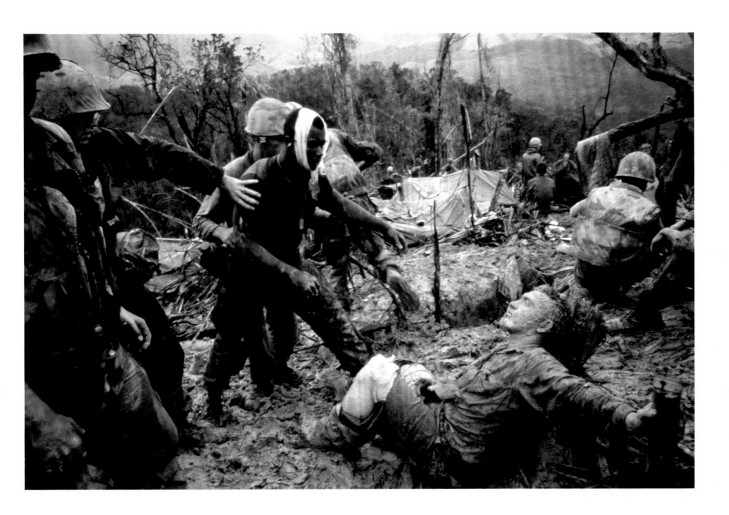

James Nachtwey (1948–)

James Nachtwey has been the pre-eminent documenter of conflict in the late twentieth and early twenty-first century. The five times recipient of the Overseas Press Club's Robert Capa Gold Medal, his powerful images of the famine in Sudan and the aftermath of the Rwandan genocide were selected as the World Press Photo of the Year in 1993 and 1995. A contract photographer with *Time* magazine since 1984, Nachtwey has covered conflicts all over the globe including in Latin America, Northern Ireland, the Middle East, the Balkans, Africa and Russia. In 2001 the reality of war came to his adopted home city of New York when the World Trade Center's twin towers were destroyed, and his imagery of the devastation became a tragically iconic record of the event. He was injured in Baghdad in 2003 when a grenade was thrown into the US Army Humvee in which he was travelling, but he made a full recovery and continued to cover the world's hotspots.

ABOVE. Larry Burrows – *Reaching Out* (1966)
This is a defining image of war from one of the greatest chroniclers of conflict in the history of photography. Although English by birth, Larry Burrows is best known for his visceral and emotive coverage of the American involvement in Vietnam, nowhere better demonstrated than in this iconic image of the cost of war and the destruction of human life. Taken on Hill 484 after a vicious firefight with the North Vietnamese forces, it depicts US Marine Gunnery Sergeant Jeremiah Purdie as he reaches out to his wounded colleague. The muted tones and muddy clothing combine to create a scene of utter destruction, and the wide-angle perspective brings the viewer into the heart of the action, emphasizing the suffering of the soldiers. Burrows himself was killed when a helicopter he was travelling in with other photographers Henri Huet, Kent Potter and Keisaburo Shimamoto, was shot down over Laos in February 1971.

1856–1858

In 1857 the tintype is patented in America by Hamilton Smith and in the United Kingdom by William Kloen.

Often known as the ferrotype, the tintype process is much cheaper than the daguerreotype and soon begins to usurp the dominance of the earlier method. The photographer is able to prepare, expose, develop and varnish a tintype plate for the customer in a matter of minutes, and the format becomes popular with booths at fairs and carnivals as well as with itinerant pavement touts. The durability and small size of the tintype mean it can be carried in a jacket pocket, and it becomes extremely popular during the American Civil War. 1858 sees the establishment of the Raj in India, initiating a period in which the British Empire will rule the subcontinent for almost ninety years. JG

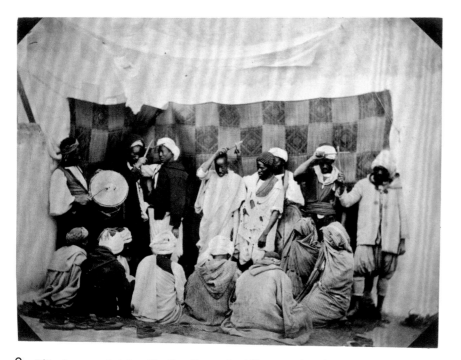

Félix-Jacques Antoine Moulin – *Danse des bâtons par les nègres*
In 1856, Moulin (1802–75) was commissioned by the French government to produce photographs of Algeria, then its colonial territory. Despite the North African heat and humidity, which were not conducive to developing daguerreotypes, he returned with a substantial collection of images. Among them was this portrait of a group of musicians, posed somewhat awkwardly against a backdrop of traditional African fabric. His pictures went on to be published in a book entitled *L'Algérie photographiée*, which was, in effect, official merchandise and propaganda in support of the colonial rule of Napoleon III, to whom the work was dedicated.

John Benjamin Dancer invents the stereoscopic camera, featuring two lenses side by side.

William Thompson makes the first underwater photograph.

1856

Robert Howlett – *Isambard Kingdom Brunel and the Launching Chains of the 'Great Eastern'*

Hero of the Industrial Revolution, Isambard Kingdom Brunel poses in front of the colossal 'launching chains' of the SS *Great Eastern*, the world's largest steamship, which he created and engineered. This backdrop, on location at Millwall shipyard rather than in a conventional portrait studio, makes it one of the first 'environmental portraits', in which a location is chosen to provide insights into a subject and their occupation. Robert Howlett's (1831–58) picture reveals a lot about Brunel, capturing a nonchalant attitude, quirky pose and enigmatic expression. It was commissioned by the *Illustrated Times* as part of a story on the ship's construction.

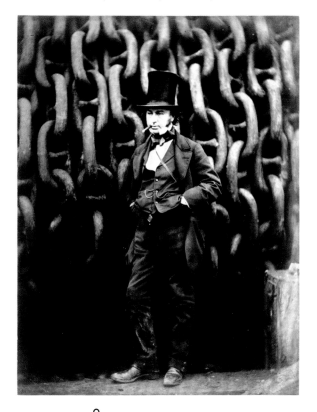

Henry Peach Robinson – *Fading Away*

This photograph is a 'tableau', composed of five different negatives used together in a single print. Sentimental and romantic subjects such as this were a common theme for Henry Peach Robinson (1830–1901) and his contemporaries, who used combination printing as an elaborate tool by which to demonstrate photography's legitimacy as an art form. The scene shows a young woman dying of tuberculosis. Her mother sits at her feet, her sister at her head, and a man – perhaps her father or fiancé – looks forlornly out at the sunset. The book in the mother's hand is closed – her story has come to an end.

The 'Indian Rebellion', or 'India's First War of Independence', leading to the dissolution of the East India Company.

Nadar takes the first aerial photograph from a hot-air balloon over Paris.

1857

1858

1859–1861

The dawn of the 1860s is a time of important developments in photography in the United States of America. It sees the first photographic expeditions to document the great western 'wilderness' that would become the National Parks, and on the other side of the country the Civil War rages, leaving an important photographic legacy of its own. Connecting the two, the birth of the railroad begins to have profound implications for the nation's sense of location, time and speed. President Ulysses S. Grant will later describe this as 'annihilating space', because it effectively transforms the size of the country forever, collapsing all prior sense of distance. Meanwhile, Scottish physicist James Clerk Maxwell (1831–79) creates the foundations for colour photography, using a method of separate black-and-white exposures projected together through red, green and blue filters. He first demonstrates it in 1861 using an image of, appropriately enough, a tartan ribbon. JG

The American Photographic Society is formed.

Charles Darwin publishes *On the Origin of Species*, twenty-one years after it was written.

Mathew Brady –*Abraham Lincoln*

Abraham Lincoln was a little-known Congressman when he arrived in New York City in February 1860 to speak at the Cooper Union, hoping to progress towards his national ambitions. On the way to the podium, he stopped by the photography studio of Mathew Brady (1822–96), a celebrated portraitist who would go on to chronicle the American Civil War. Brady knew how to present him in a way that flattered. In Lincoln's own words, the photographer 'made me into a man of human aspect and dignified bearing,' later adding, 'Brady and the Cooper Union speech made me President of the United States.'

1859

John Jabez Edwin Mayall – *Queen Victoria and Prince Albert*

As the first British monarch to be photographed, Queen Victoria embraced the possibilities of the medium. In July 1855 she wrote in her journal, 'From 10 to 12 was occupied in being photographed by Mr. Mayall, who is the oddest man I ever saw, but an excellent photographer.' She was apparently so taken with the experience that she asked Mayall (1813–1901) to make a series of *cartes de visite* – not only this one of herself and husband Albert, but also other members of the royal family – which would be for sale to the public.

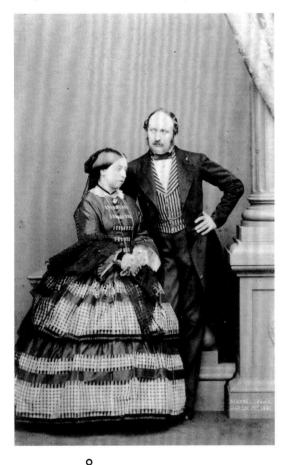

Les Frères Bisson – *The Ascent of Mont Blanc*

Louis-Auguste (1814–76) and Auguste-Rosalie (1826–1900) Bisson, known as Les Frères Bisson, learned photography directly from Louis Daguerre, one of its inventors, in the 1840s. Later they became associated with the industrialist Daniel Dollfus-Ausset, who funded a number of photographic expeditions to the Alps. The brothers made two unsuccessful attempts to climb Mont Blanc, until in July 1860, the younger brother, Auguste-Rosalie, finally scaled the mountain with a guide and a group of porters carrying his photographic equipment: glass plates, chemicals, cameras and darkroom tent. This frame was actually made on his return from the summit, with the climbers posed as if they were ascending.

Mathew Brady and Alexander Gardner begin photographing the American Civil War.

Carleton E. Watkins makes the first 'mammoth-plate' landscape photographs of the Yosemite Valley.

1860

1861

EXPLORATION

The camera provided the ideal vehicle to bring back dramatic images of faraway lands, and to celebrate the achievements of intrepid explorers. Of course, this was often a Western, colonialist view, with all the dangerous assumptions that entailed about the discovery of 'new' lands that were in fact inhabited by indigenous populations who were forcibly removed or exploited.

Photographers found a rich source of material in the Middle East, which combined biblical sites and those of classical antiquity. Their 'picturesque' interpretations of the ruins of civilization were widely published and circulated in commercially made albums, with Maxime Du Camp's *Egypt, Nubia, Palestine and Syria* (1852) being one of the earliest to contain actual photographic prints rather than engravings. These expeditions were not without difficulty: Francis Frith wrote of working in a 'smothering little tent' as his portable darkroom, and how the collodion boiled and fizzed in the intense heat; he even retreated to the cool interior of an Egyptian tomb to develop his glass plates. Samuel Bourne later travelled into the mountains of India with a team of up to eighty porters, carrying 650 large glass plates and all his chemicals, and driving a herd of goats. Major drivers of exploration were the topographical surveys carried out by governments as they extended their control. The expansion of the railway network in the United States was documented by Civil War veteran Alexander Gardner, while his colleague Timothy O'Sullivan made an epic series of landscapes of the American West. One of the most significant feats of endurance and photography was achieved by Herbert Ponting, who accompanied the ill-fated *Terra Nova* expedition of 1910 to Antarctica, led by Robert Scott. He was almost killed himself, when, in 1911, the ice floe on which he had positioned himself to take photographs was broken up by a pod of killer whales, but he returned safely to England on the *Terra Nova* with 1,700 glass-plate negatives, hoping to use them when Scott returned from his epic adventure. Tragically, his dramatic photographs of the vast icy wastes instead became a testament to the memory of Scott and his fellow explorers.

BELOW. Francis Frith – *Interior of the Hall of Columns, Karnac, Egypt* **(1858)**
Francis Frith (1822–98) was quick to appreciate the potential of photography as both an art and a business. He sold the results of his three extended journeys to Egypt and the Holy Land in a wide range of formats. The photography and printing company he founded in Reigate, Surrey, in 1859, became one of the world's largest suppliers of topographical images, and remained a family business until the 1960s. In this image of an Egyptian temple, Frith used the strong verticals and the bright sunlight and deep shadows to create a powerful composition with a strong sense of vanishing perspective. *The Times* of London wrote of his photographs that they 'carry us far beyond anything that is in the power of the most accomplished artist to transfer to his canvas'.

ABOVE. Samuel Bourne – *The Manirang Pass between the Spiti Valley and the Ropa Valley of Kinnaur District in India* (1866)
The epic scale of this dramatic image is matched by the extraordinary enterprise it took to achieve. For the third of his extensive expeditions across the Indian subcontinent, Samuel Bourne (1834–1912), along with his team of porters, climbed to the top of the Manirang Pass, in Himachal Pradesh, on the way to the remote valley of Spiti. Taken at an elevation of over 6,500 m (18,600 ft), at the time the image held the record for the highest-altitude photograph ever taken. Over a period of seven years, Bourne created an archive of over 2,500 glass-plate negatives, the single most extensive survey of India in the nineteenth century. The photographic studio he founded with Charles Shepherd was arguably the world's oldest surviving photography business when it closed its doors in 2016.

1862–1864

Each of the three images reproduced here illustrates the extraordinary capacity of photography to capture, express, reveal and also manipulate the image of the human face. They also raise questions that still endure today regarding the power relations that surround the representation of people. The portrait is an 'intersection of gazes': that of the photographer, the subject and the viewer being the most prominent. These three portraits also exemplify the variety of agendas that continued to be negotiated by photography in the 1860s, most notably those of art on the one hand and science on the other. But behind both of these was an ever-present and perhaps even more forceful agenda: finance. So-called spirit photography captured the imaginations of so many because it used the creative sensibility of studio portraiture together with the purported evidentiary authority of the camera: a highly profitable combination. JG

William H. Mumler – *Bronson Murray*

William H. Mumler (1832–84) was one of the best-known 'spirit photographers' of his time – a group who profited from the public's limited understanding of photographic processes by purporting to capture the spirits of the dead using double exposures and trick photography. These images were readily embraced by the spiritualist movement, as well as by the many thousands of people who had been bereaved by the American Civil War. By offering to reveal lost loved ones through the medium of photography, Mumler was able to charge large amounts of money, but was eventually exposed as a fraud by a court in 1869.

The Battle of Antietam
becomes the single bloodiest
day of the American Civil War.

1862

Guillaume-Benjamin-Amand Duchenne de Boulogne – Plate 64 from *Mécanisme de la physionomie humaine*

In the early 1860s, the use of electrical currents in medicine was a new and imperfectly understood science. Duchenne de Boulogne (1806–75) is best known for his experiments in using it to reveal new information about the human body, by stimulating the action of nerves and muscles in living patients. Initially recording his extensive experiments through drawing, he later turned to photography, making images of facial muscle stimulation that were eventually published in his 1862 volume *Mécanisme de la physionomie humaine*. The book went on to be influential in the field of neurology and other sciences.

Pierre-Louis Pierson – *Countess Virginia Oldoni Verasis di Castiglioni*

The Countess was photographed over 400 times during a forty-year period spent in the court of Napoleon III, by the Emperor's court photographer, Pierre-Louis Pierson (1822–1913). It was a productive collaboration, as the countess adopted a range of personalities, poses and costumes, projecting herself variously as seductress, virgin and coquette, and directing the photographer according to her own self-expressive vision.

President Abraham Lincoln's Emancipation Proclamation becomes law in the United States.

Samuel Bourne arrives in Calcutta. He was later to become one of the pre-eminent photographic recorders of British India and the Himalayas.

Julia Margaret Cameron takes up photography after being given a camera for her birthday.

1863

1865–1867

In the early 1860s it is not yet possible to reproduce photographs with the efficiency, durability or quality required to print them in books. Small editions of photographic prints, often presented in folios or albums, are therefore very valuable, and are only to be seen by a relatively privileged few. That all changes when Walter Bentley Woodbury (1834–85) patents a new process that essentially allows for the first mass-production of photographs. His Woodburytype prints are photo-mechanical (rather than photographic), meaning that light sensitivity is not part of the process, and the prints do not fade because they are made from stable pigment suspended in gelatin. The results are very high-quality continuous-tone reproductions, which come to be used most commonly for fine books of photographic portraits. It becomes the dominant means of photographic reproduction until it is overtaken by the much cheaper but lower-quality halftone process. JG

Adolphe Braun – *Flower Study*

Adolphe Braun (1812–77) was originally a textile designer whose photographic practice was merely a tool. He made studies of flowers for use in the design of printing blocks, wallpapers and fabrics. But his work caught the attention of the Paris art scene, and in 1857 he set up a photography studio in which he expanded his repertoire to include a range of other subjects. This photograph shows his technical skill and also an artistic eye that sets him apart from photographers who were making botanical studies meant for more scientific ends. It is full of rich tones and attention to detail, elegantly composed.

The American Civil War ends, having claimed approximately 750,000 lives.

Walter Bentley Woodbury patents the Woodburytype process, a means of mass-producing photographic prints.

1865

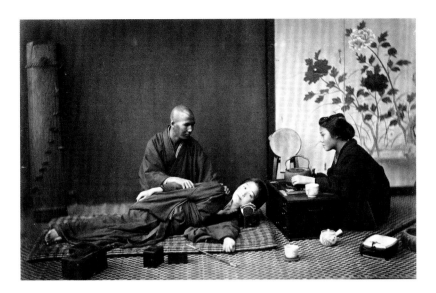

Felice Beato—*Mode of Shampooing*

Italian-British photographer Felice Beato (1832–1909) had a prolific career covering conflicts and major events in diverse parts of the globe. However, the country he spent the longest period in was Japan, where he gained access to and intimacy with members of Japanese society that had been unknown to most Westerners up to that point. What set him apart is that as well as making outdoor studies of architecture and city life, he set up a studio, in which he photographed roles and traditions that were soon to disappear. This included people across society, from samurai, geishas and sumo wrestlers to basket weavers and sake vendors.

Julia Margaret Cameron— *Iago, Study from an Italian*

Julia Margaret Cameron (1815–79) is best known for her intense, ethereal portraits. In many cases these featured influential artistic and literary figures from her social circle, but this is one of the very few that she made using a professional model. The 'Italian' has been cast in the role of Iago, the villain from William Shakespeare's *Othello*. Close up and tightly framed, the emotional intensity of the portrait is conveyed by the dark shadows, downcast eyes and soft focus. Only one print of this famous image is known to exist.

In New Zealand, one of many Maori rebellions is crushed by white British settlers.

Alfred Nobel invents dynamite.

The work of photographers including Eadweard Muybridge and Alexander Gardner exploring the Western United States prompts Congress to create the National Parks scheme.

1866

1867

STAGED PHOTOGRAPHY

Photographers have exploited the potential of constructing images since the advent of the medium, staging scenes in the studio and combining negatives and digital files to create complex statements about the world from their imagination.

Although staged photography has become prevalent since the work of conceptual artists like John Baldessari in the 1970s, and Cindy Sherman and Jeff Wall in the 1980s, early artists such as Henry Peach Robinson and Oscar Gustave Rejlander quickly realized the potential of creating *tableaux vivants* photographs to comment on social mores in the mid-nineteenth century. Digital technologies have made possible more ambitious and seamless images, and with strong aesthetic and formal links to portraiture and fashion, constructed imagery can deal with complex narratives and ideas. Duane Michals (1932–) has worked since the late 1960s on narrative sequences that deal with themes of guilt, sexuality and love, as in his 1968 *Fallen Angel*, where a naked winged male figure observes and then seduces a sleeping woman, before transforming into an ordinary man in a suit. Michals' comment that 'people believe in the reality of photographs, but not in the reality of paintings' helps explain the effect that such staged images can have on the viewer as they create 'realistic' photographs of impossible events, challenging Cartier-Bresson's idea of the 'decisive moment'.

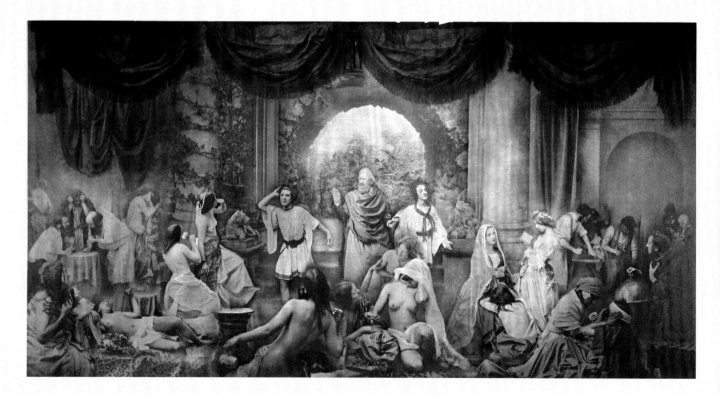

BELOW LEFT. Oscar Gustave Rejlander – *The Two Ways of Life* (1857)
Oscar Gustave Rejlander (1813–75) pioneered the complex and time-consuming technique of combination printing, where numerous negatives were joined together to make one seamless final image. Consisting of more than thirty separate exposures shot in the studio, *The Two Ways of Life* was an allegorical morality tale, depicting the choice between virtue and vice, with an elderly sage offering guidance to two young men. The image was highly controversial at the time because of its explicit nudity. Rejlander was a close friend of fellow photographer Charles Lutwidge Dodgson, better known as the author Lewis Carroll, and made one of the most famous and penetrating portrait studies of his ally.

BELOW. Jeff Wall – *Dead Troops Talk (a vision after an ambush of a Red Army patrol, near Moqor, Afghanistan, winter 1986)* (1992)
In *Dead Troops Talk*, Jeff Wall works on creating his meticulously arranged and planned compositions to create images with deep resonance and themes. This disturbing photograph depicts the imagined aftermath of a deadly ambush in Afghanistan, creating a surreal and hallucinatory effect that combines cinematic references from war movies with the traditions of epic history painting. Shooting entirely in the studio, Wall used a team of special-effects technicians, who reportedly 'pored through graphic forensics imagery, studying sinew, bullet damage, bone fracture, ripped and shredded flesh' to create the realistic gore. The epic image, measuring over 2 x 4 m (6 ft 10 in x 13 ft), sold at auction for $3.6 million in 2012.

Sandy Skoglund (1946–)

The American photographer and installation artist Sandy Skoglund creates vividly coloured images that use the repletion of identical objects to create surreal tableaux. Each photograph takes weeks or even months to create, with Skoglund meticulously arranging the elements in room sets. *Revenge of the Goldfish* (1981), for example, features a monochromatic blue bedroom filled with bright orange goldfish, while a child sits on the edge of the bed and an adult lies sleeping. Skoglund claims that her installations create an ambiguous world where nothing is quite as it seems, blurring reality and fiction, creating 'a realistic component and another, unreal one that, intruding on reality, interferes with it'.

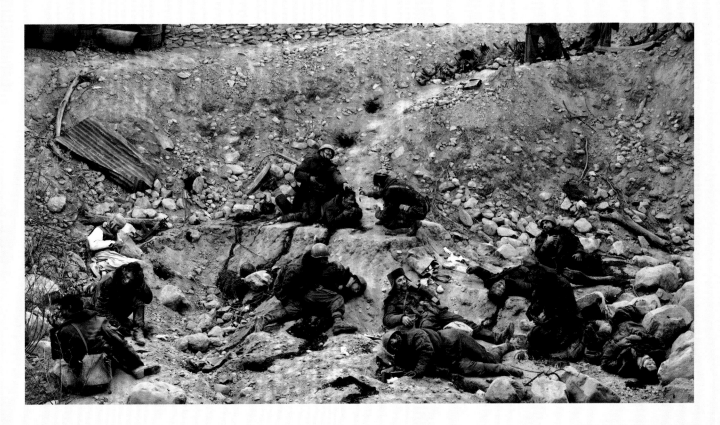

1868–1870

The 1860s is a time of increasing industrialization in photography.
Rather than hand-coating their papers and mixing chemicals according to individual formulas, photographers can now buy commercially prepared and ready-made materials. Prints can be produced more cheaply and in greater quantities, and appreciation for artisanal fine-art prints decreases. In addition to the *carte de visite*, which perfectly exemplifies this change, comes the craze for the stereograph, invented some years previously. Stereoscopic cameras use two adjacent lenses to create images designed to be viewed with a special hand-held apparatus, creating a rudimentary version of three-dimensional vision. They are hugely commercially successful because of their novelty value, and stereoscopic postcards of far-away destinations and modern engineering marvels are particularly popular. In fact, they are the first ever mass-produced photographic images. JG

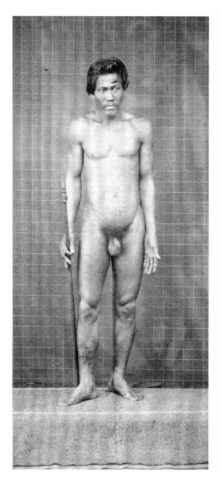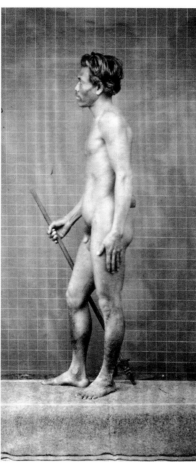

John Lamprey – *Ternate, Malagasy, Male, 25 Years Old; Full Length; Full Face*

John Lamprey (*c*.1815–90) was librarian of the Royal Geographical Society and assistant secretary of the Ethnological Society of London, at a time when photography was being used as a tool of the British imperial project to make visual records of its colonial populations. Its usefulness in this ethnological role was undermined, however, by the inconsistency with which it was employed. In response, he created the Lamprey grid: one of the first systematized methods of making anthropometric portraits. Full-frontal and profile portraits were made in front of a backdrop of silk threads, allowing for consistency and accurate comparison of subjects.

The foundations of colour photography continue to be laid, as Louis Ducos du Hauron patents a number of ideas based on the three-colour principle.

1868

Thomas Annan–*Close, No. 118 High Street*

The Industrial Revolution brought wealth to Glasgow, but with the influx of workers – a population increase of 400 per cent – came overcrowding, poverty and disease. The poor were crammed into squalid slums, which by the 1860s had become so bad that the city authorities founded the Glasgow City Improvement Trust, tasked with slum clearance and housing reform. Thomas Annan (1829–87) was hired by the Trust to photograph the slums before their demolition, which he did despite considerable technical challenges. His pictures are now recognized as an important early example of social documentary photography.

William Henry Jackson–*Old Faithful*

After fighting in the Union army during the American Civil War, William Henry Jackson (1843–1942) travelled the American West, photographing the landscape that was being opened up by the newly laid railroad. Between 1870 and 1879 he documented Utah, Wyoming, Montana and Colorado as a member of the US Geological and Geographical Survey of the Territories. On these arduous trips he used 'mammoth-plate' glass negatives, each of which took around an hour to prepare, expose, develop and dry. This photograph shows Old Faithful, the geyser at Yellowstone Valley that erupts more than 52 m (170 ft) around eleven times a day.

The Fourteenth Amendment to the Constitution is ratified in the United States, but the civil rights it affords are not extended to 'Indians' or officers of the Confederacy.

Henry Peach Robinson publishes *Pictorial Effect in Photography* – an influential practical handbook on aesthetics and creative effects in photography.

The Suez Canal opens.

1869 **1870**

1871–1873

On 10 November 1871, Henry Morton Stanley utters the famous words 'Dr Livingstone, I presume?' when he finds the renowned missionary who had disappeared six years previously during one of his attempts to bring Christianity to Africa. This event is not photographed, but the public appetite for photography of international exploration is so great during this period of the nineteenth century that Stanley sees fit to produce a *carte de visite* commemorating it, by posing (with his personal slave) in the clothes he was wearing at the time. John Thomson, a prominent Scottish expeditionary photographer, writes, 'No expedition, indeed, now-a-days, can be considered complete without photography to place on record the geographical and ethnological features of the journey'. He himself spends the 1870s travelling in the Far East, documenting parts of China never before seen by Westerners. JG

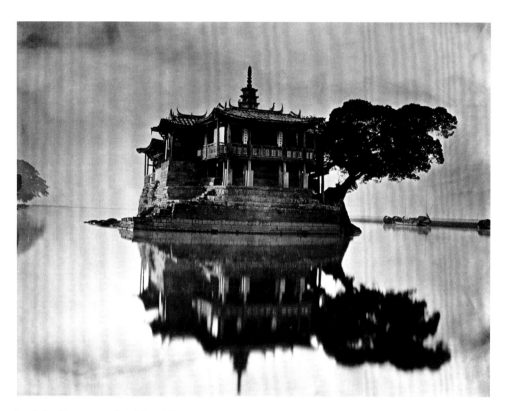

Richard Maddox invents gelatin emulsion, a dry coating for photographic plates, replacing the wet-collodion process.

John Thomson – *The Island Pagoda*

As well as being one of the most prominent photographer-explorers of the nineteenth century, John Thomson (1837–1921) is famous for his street photography of London, a classic work of early social documentary photography. This image is from his extensive travels throughout China, specifically a voyage along the Min River through the Fukien region, a spectacular part of the country. The trip was documented in the book *Foochow and the River Min*, published in 1873. Thomson's work in China was challenging – not only technically, but also because many of the people he met had never seen a Western person or a camera before.

1871

André-Adolphe-Eugène Disdéri – *Dead Communards*

André-Adolphe-Eugène Disdéri (1819–89) recorded the violent events of the Paris Commune, the attempt by a group of revolutionaries (the Communards) to create a socialist government in France. The Communards controlled the capital from March to May 1871, until they were defeated by government troops in the *semaine sanglante* ('bloody week'). Much of the city was destroyed in the process, and estimates of the total number of casualties vary from 6,000 to 20,000. Disdéri moved through the city in his mobile darkroom, photographing the architectural and human destruction, including this disturbing image of Communards laid out in their coffins.

Giorgio Sommer – *Eruption of Vesuvius*

The eruption of Mount Vesuvius on 26 April 1872 was one of the most violent of the nineteenth century. Some years later, John Wesley Judd wrote that 'on the occasion of this outburst, the aid of instantaneous photography was first made available for obtaining a permanent record of the appearances displayed at volcanic eruptions'. Giorgio Sommer (1834–1914), a German photographer based at a studio in Naples, is credited with making a number of images of the event. Sommer's studio also provided photographs of the ruins of Pompeii, caused by a much earlier eruption of the same volcano, to tourists in the area.

The German Empire is founded.

The Metropolitan Museum of Art opens in New York.

Levi Strauss & Co. begin manufacturing jeans.

1872

1873

SELF-PORTRAIT

Turning the camera on to themselves has been a continuing fascination for some of the greatest image-makers, who have explored their personality and their relationship to the world by examining the reflection of their own image.

Although the rise of mobile phone cameras has created a world in which a 'selfie' has become a requirement to prove one's presence in the world, and in which Kim Kardashian can publish a whole book of her own face, entitled *Selfish* (2015), the concept of the self-portrait was established right at the beginning of the medium's history by photographers such as Albert Southworth, Hippolyte Bayard and Nadar. Although Vivian Maier (1926–2009) was unknown until a vast collection of her images was discovered after her death by historian John Maloof, which included her obsessive photographs of her reflection in shop windows in New York, she had created a document not just of her own visage but also of the world around her, seen in reverse as in a mirror. Likewise, Lee Friedlander (1934–) has shot himself in an ongoing series of explorations in which his shadow, face or form becomes an integral part of the world around him, in an ironic, often self-deprecating, but always

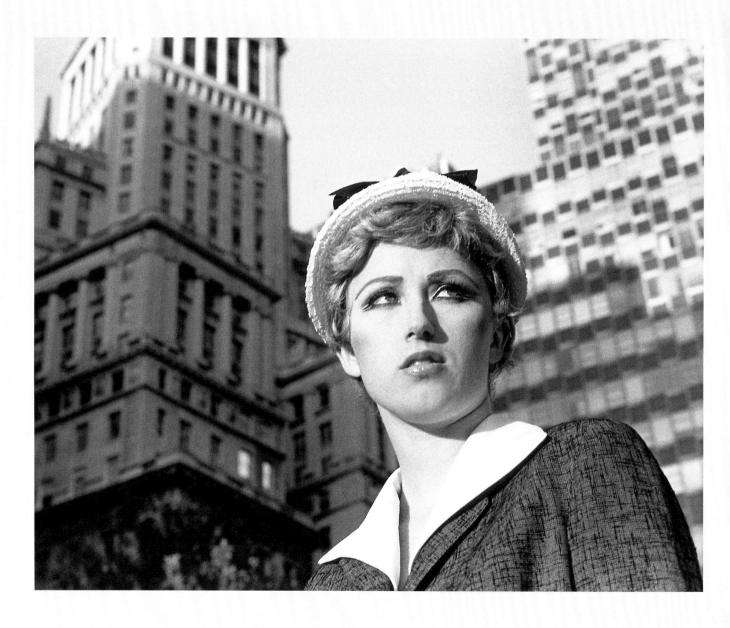

insightful chronicle of his presence in the world. And for Robert Mapplethorpe, the self-portrait was a way to explore different aspects of his psyche, with the studio enabling him to create a range of personas ranging from the Devil to an angel.

Jo Spence (1934–92)

Jo Spence used photography as a form of personal therapy and political activism. In 1974, together with Terry Dennett, she founded the Photography Workshop, an exhibition and education platform, and later the Hackney Flashers, an East London collective of photographers. When she was diagnosed with breast cancer in 1984 she used the camera self-reflectively to explore her own feelings about the illness and to critique the problems in the National Health Service in Great Britain. In a searingly honest image, *Property of Jo Spence?* (1981) she posed naked from the waist up, with the title of the image written across the breast that was due to be removed in surgery. She wrote that 'Through photo therapy, I was able to explore how I felt about my powerlessness as a patient, my relationship to doctors and nurses, my infantilization while being managed and "processed" within a state institution, and my memories of my parents.' The work was published as part of *The Picture of Health?* (1982–86), in which she collaborated with Terry Dennett in a powerful portrayal of her experiences. She survived the initial cancer, but died of leukaemia a decade later.

LEFT. Cindy Sherman – *Untitled Film Still #21* **(1978)**
Cindy Sherman (1954–) is a master of self-disguise, who has adapted her persona through a long series of self-portrait projects to explore the role of the female in modern society. Her seminal 1977–80 series *Untitled Film Stills* saw her invent sixty-nine scenes referencing a wide range of cinematic stereotypes and icons, making the viewer feel like they had probably seen the movie, but were not sure quite which one it might be. Variously playing the part of a *femme fatale*, a blonde bombshell, a housewife, a murder victim and, in this image, an uncertain and vulnerable career girl, Sherman tapped into a powerful vein of shared cultural imagery.

RIGHT. Nadar – *Revolving Self-portrait* **(1865)**
Gaspard-Félix Tournachon (1820–1910) was a renowned caricaturist, which earned him the nickname *Tourne à dard* (one who stings or twists the dart), which he later shortened to 'Nadar', by which name he is better known. He was a remarkable showman and entrepreneur, and his Paris studio entertained a long list of celebrities including the actress Sarah Bernhardt, the painter Eugène Delacroix, the composers Franz Liszt and Giuseppe Verdi, the poet Charles Baudelaire, and novelists Victor Hugo, George Sand and Alexandre Dumas. This unusual 360-degree self-portrait may have been a study of the ways in which the human physiognomy changes when viewed from a variety of angles.

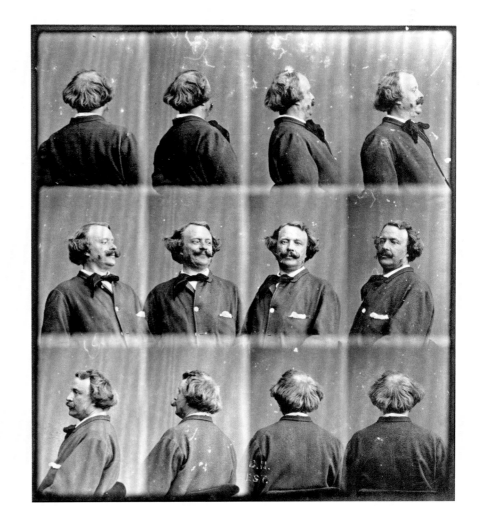

1874–1876

Through the 1870s, a number of photographers, including Lewis M. Rutherford and James Nasmyth, dedicate themselves to astronomical photography, particularly the study of the moon. This is a difficult task, as the limited photographic technology of the day struggles to respond to the challenges of low light, the movement of the Earth and the variability of photosensitive materials. Nasmyth and James Carpenter resort to creating plaster casts of the moon's surface and photographing those instead. In 1874, a remarkable international effort in astronomical photography takes place when scientists in Germany, France and Britain stage a friendly competition to capture the transit of Venus across the face of the Sun. This is representative of a great increase in efforts to use photography to capture and explain the natural world and the experience of humans within it. This will go on to include panoramic photography, the psychological study of human expression, and studies of human and animal locomotion. JG

J. Nasmyth (Woodbury) J. Nasmyth (Woodbury)

BACK OF HAND & WRINKLED APPLE.
TO ILLUSTRATE THE ORIGIN OF CERTAIN MOUNTAIN RANGES,
RESULTING FROM SHRINKING OF THE INTERIOR.

James Nasmyth – *Back of Hand & Wrinkled Apple*

These images appeared in 1874 in *The Moon: Considered as a Planet, a World, and a Satellite*, a book which James Nasmyth (1808–90) co-authored with James Carpenter. The pair of photographs was intended 'to illustrate the origin of certain mountain ranges by shrinkage of the globe', supporting a theory that explained the rough surface of the moon. They suggested that the moon had once been actively volcanic, but as it lost this energy and began to cool, its core shrank, causing the surface to contract and wrinkle like the skin of a desiccated apple.

South Africa becomes the largest diamond-producing area in the world.

1874

○

Lewis Carroll – *Xie Kitchin as Penelope Boothby*

Alexandra or 'Xie' (pronounced 'Ecksy') Kitchin was a favourite photographic subject of the Reverend Charles Lutwidge Dodgson, better known as Lewis Carroll (1832–98). He photographed her over fifty times between the ages of four and sixteen. Carroll was a writer, mathematician, photographer and clergyman, but is best known for his classic children's book *Alice's Adventures in Wonderland* and its sequel *Through the Looking Glass*. He photographed young girls often, including Alice Liddell, who was the inspiration for his literary masterpiece. Meanwhile, Xie appeared in a range of tableaux, costumes and fictional scenes, this one based on Joshua Reynolds's famous painting of Penelope Boothby (1788).

John Thomson – *London Nomades*

John Thomson's groundbreaking work of early social documentary, *Street Life in London*, first appeared in a monthly magazine in 1877, and later as a book. It was a collaboration with journalist Adolphe Smith, who wrote essays to accompany the pictures which presented a sympathetic account of London's poor. Though the subjects and circumstances he photographs are all authentic, each of Thomson's photographs had to be carefully posed and staged because spontaneous street photography was not yet technologically possible. Here, a group of travellers sit on the steps of their traditional wagon, with two young children inside.

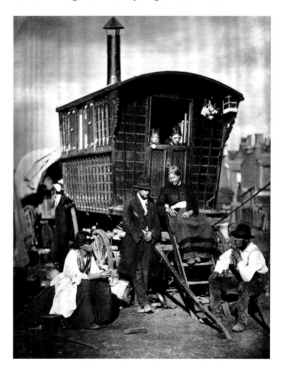

The **telephone** is invented.

Pavel Nikolayevich Yablochkov develops the first practical arc lamp.

The Battle of the Little Bighorn leads to the death of General Custer.

1875

1876

1877–1879

In the mid- to late nineteenth century, photography's status as a medium of reliable evidence begins to take hold.

For governments, armies and courts of law, it becomes a tool to cement authority, creating records that are intended both to serve as proof and to stand for posterity. This is at odds with the medium's creative function, and much discussion is dedicated to unravelling, or understanding, the relationship between the two. The public appetite for commemorative photographic records of events, such as the construction of the Statue of Liberty, increases as photography begins in itself to denote the significance of world events. As in the present day, events that are not photographed are seen as unnoteworthy (such as the devastating Madras Famine of the late 1870s, and slavery in the Southern United States), while engineering marvels and celebrities are deemed much more picturesque. JG

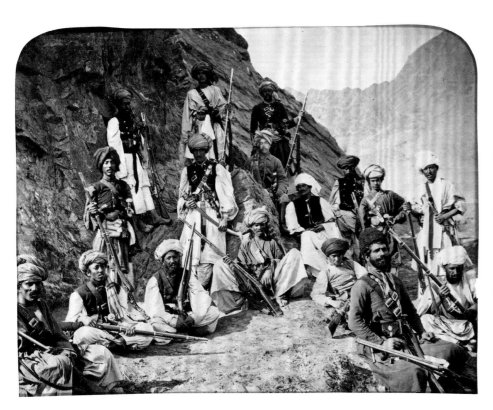

John Burke – *Peshawur Valley Field Warriors Resting Against a Hillside*

John Burke (1843–1900) was the first photographer to make pictures of Afghanistan. From 1878 to 1880, he accompanied British forces during the Anglo–Afghan War, making scenes of the landscape, military encampments and group portraits of soldiers. He mainly made these to sell to the officers and units of the campaign, but he was also working for *The Graphic*, a London weekly newspaper. It is likely that Frederic Villiers, the newspaper's war artist, copied directly from Burke's photographic plates and sent the drawings back to London. The timescale, from Burke making the exposure to its publication as an etching in the newspaper, was six to eight weeks.

William Henry Fox **Talbot**, inventor of the calotype process, dies.

The first electrically lit **photographic studio** opens in Regent Street, London.

1877

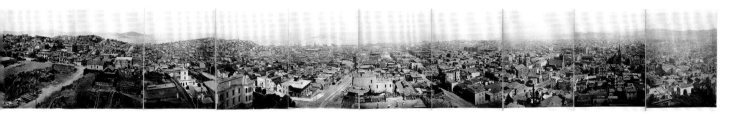

Eadweard Muybridge – *Panorama of San Francisco*

This enormous panoramic montage was a huge achievement for its time. Eadweard Muybridge had already made his name in San Francisco for his technical achievements in photography, including his famous motion studies of galloping horses. But this image pushed his photographic abilities and equipment to new limits. Taken from Nob Hill and composed of thirteen separate images, each using a mammoth-format wet-collodion plate, the result is a highly detailed 360-degree view of the city at the heart of the West's new frontier. San Francisco was the hub of the Gold Rush, and Muybridge, like many others, found his fortune there.

Charles Marville – *Public Exhibition of the Statue of Liberty's Head*

Charles Marville (1813–79) was born in Paris and lived there for most of his life, becoming the city's official photographer in 1862. Alongside Albert Fernique and Pierre Petit, he was one of the photographers chosen by sculptor Frederic Auguste Bartholdi to document the construction of his greatest work, the Statue of Liberty. This picture shows Liberty's head on its completion in 1878, on display on the Champ de Mars as part of the third Paris World's Fair. Below it is the souvenir stand. The completed statue was eventually shipped to New York and presented as a gift to the United States from the people of France.

The addition of heat allows gelatin emulsion to be exposed in much less time and with greater sensitivity, making 'instantaneous' photography possible.

Eadweard Muybridge first captures a galloping horse in motion.

1878

SCIENCE

In its ability to accurately record details and motions often invisible to the human eye, the camera immediately became a valuable tool for scientific investigation and exploration, revealing worlds within worlds that had hitherto been unknown.

Many of the earliest promoters and exponents of the medium of photography saw its value not in its aesthetic qualities, but rather in its ability to record details of the natural world that could otherwise not be documented, placing scientific enquiry as central to the development of the camera. As Samuel Morse noted of the daguerreotype in 1839, 'the exquisite minuteness of the delineation cannot be conceived. No painting or engraving ever approached it.' Astronomer Sir John Herschel immediately realized that photography was far superior to drawing for recording his observations of the night skies through the telescope, leading

him to develop light-sensitive chemistry and the glass-plate negative. Scientific breakthroughs have also been popularized by photography. For example, in 1965 the astonishing image made by pioneering medical photographer Lennart Nilsson of an 18-week-old foetus inside its amniotic sac made the cover of *Life* magazine, with the headline 'This is the first portrait ever made of a living embryo inside its mother's womb'. Many artists such as László Moholy-Nagy, Man Ray and the Bechers have also been drawn to the formal qualities of scientific photographs, seeing in them the abstract language of Modernism.

LEFT. Arthur Clive Banfield – *The Life History of a Splash* **(1900)**
Arthur Clive Banfield (1875–1965) further developed the pioneering work of the early chronophotographic practitioners Eadweard Muybridge and Étienne-Jules Marey. He used very short bursts of light discharged from a series of Leyden jars that stored static electricity to illuminate the motion of an object in a sequence on a single negative. This early anticipation of stroboscopic photography is exemplified by the image of a splash created by a small steel ball dropped into a container of milk from a height of 12 cm (5 in). It was regarded as a revelation at the time, allowing scientists and artists alike to gain a far greater understanding of the motion of fluids.

BELOW. Berlyn Brixner – *Trinity Site Explosion, 0.016 Seconds after Detonation* **(1945)**
This peculiar image, reminiscent of a giant jellyfish, was captured by one of a bank of ultra-high-speed movie cameras deployed to document the first ever atmospheric test of an atomic bomb in the New Mexico desert at 5.29 am on 16 July 1945. Masterminded by the chief photographer for the Manhattan Project, Berlyn Brixner, the array of cameras included the Fastax camera, which used rotating prisms to record as many as 10,000 frames per second. In some cases, Brixner's cameras were thought to have gone through 30 m (100 ft) of film in little more than a second, and this single test produced vast amounts of photographic material. The apex of the hemisphere of the explosion in this image is approximately 200 m (660 ft).

Larry Sultan and Mike Mandel, *Evidence* (1977)

In 1977 photographers Larry Sultan and Mike Mandel published their hugely influential book, *Evidence* – a surreal and complex postmodern journey through the archives of a range of commercial and scientific companies' image libraries. Describing the work as a 'poetic exploration upon the restructuring of imagery', between 1975 and 1977 they pored over millions of photographs from more than 100 American corporations, government agencies and educational institutions, including the General Atomic Company, the Jet Propulsion Laboratories, the San Jose Police Department and the United States Department of the Interior. From this they culled fifty-nine images, presenting them without captions or any information about the source or nature of the photograph. The images are often surreal, bizarre and humorous; taken out of their original context they provide a challenging and complex interpretation of the modern world, and leave much to the imagination of the viewer to decipher their meaning.

1880-1882

Burrow-Giles Lithographic Co. vs Sarony is a historic legal case in which the Supreme Court of the United States upholds the power of Congress to extend copyright protection to photography for the first time.

The subject of the case is Napoleon Sarony's photograph of literary legend Oscar Wilde, taken in 1882. Sarony files a copyright infringement suit when he discovers the company marketing unauthorized lithographs of his picture. The Copyright Act of 1865 had included photographs, but the company's defence is that this is unconstitutional because a photograph does not qualify as the product of an 'author'. The court rules to uphold the Act, however, and Sarony is awarded $610. A few years earlier, in Britain, another historic court case helped shape public understanding of photography's evidential or documentary value, when charity founder Thomas John Barnardo was accused of artificially staging photographs of children in the care of his famous orphanages. JG

The halftone engraving process is first used by the *Daily Graphic* in New York, making way for the mass-reproduction of photographs in newspapers.

The first twin-lens reflex camera is made in London. Rolleiflex becomes its best-known manufacturer.

Frances Benjamin Johnston – *Self-Portrait with a Bicycle*

Frances Benjamin Johnston (1864–1952) was a pioneering female photographer, working across genres during a career that spanned sixty years. During this time she was at one point the only professional photographer working in the US capital, and served as official White House photographer. Johnston was given her first camera by George Eastman, inventor of the Kodak camera, and worked for him developing films and repairing cameras before setting up her own studio. In 1900 she went on to curate an exhibition of photographs at the Exposition Universelle, showcasing the work of twenty-eight female photographers, which subsequently toured Russia.

1880

Étienne-Jules Marey – *Man Walking*

As a doctor and inventor, Étienne-Jules Marey (1830–1904) was primarily interested in photography's capacity to record elements of the natural world that were difficult to perceive with the naked eye. He is thought to have been impressed and influenced by the motion studies of Eadweard Muybridge, following in his footsteps by developing the technology to capture multiple high-speed exposures on a single plate, as seen here. This image foreshadows the later work of Italian Futurist painters such as Giacomo Balla and Umberto Boccioni, and perhaps most famously, Marcel Duchamp's *Nude Descending a Staircase* (1912).

Napoleon Sarony – *Oscar Wilde No. 18*

In his day, Napoleon Sarony (1821–96) was the most highly sought-after celebrity portraitist in New York City. His studio at Union Square was a complex operation employing over thirty technicians. Of his unique approach, he wrote, 'In order to take a good photograph one should know something about the sitter's habits and surroundings. This he must learn at a single glance or by an adroit question.' When a rival company stole this portrait of Oscar Wilde and published it as its own, Sarony sued, and won. This legal victory established copyright protection for photography in the United States for the first time.

Frederick E. Ives invents the trichromatic halftone plate: a process for making colour reproductions.

Tsar Alexander II is assassinated in St Petersburg, Russia.

1881

1882

1883-1885

The influence of Eadweard Muybridge's famous motion studies is now spreading, and causing a stir not only within the scientific and photographic communities, but also among painters. As his celebrity status grows, he travels internationally and across America, giving lectures about his work. One of his supporters is the American realist painter Thomas Eakins, a teacher of painting at the University of Pennsylvania. They work together for a time in 1884, and Eakins uses Muybridge's motion studies in both his teaching and his own art, demonstrating his belief that modern art must take the findings of science into account. Muybridge is invited to continue his research at Pennsylvania in a specially built outdoor studio. The developments he makes here are considerable, and include studies of female nudes that make a curious addition to his research, representing a hybrid of artistic and scientific references, possibly influenced by Eakins. JG

Thomas Eakins – *The Swimming Hole*

Thomas Eakins (1844–1916) made photographs not for their own sake, but as a basis for his paintings. This picture is an example of an *académie*: a photographic nude study to be used by artists as an alternative to live models. Eakins is quoted as saying that a naked woman 'is the most beautiful thing there is – except a naked man'. The figure on the left here is Eakins himself, and the others are his students from the Pennsylvania Academy of the Fine Arts, where he taught from 1873. It is the basis of one of his most famous paintings, *The Swimming Hole* (1884–85).

The *Orient Express*
opens between Paris and
Constantinople (now Istanbul).

1883

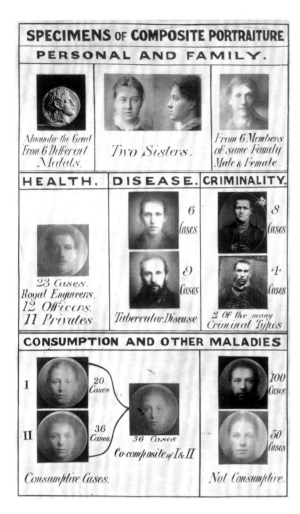

SPECIMENS OF **COMPOSITE PORTRAITURE**

PERSONAL AND FAMILY.

Alexander the Great From 6 Different Medals.

Two Sisters.

From 6 Members of same Family Male & Female.

HEALTH.

23 Cases. Royal Engineers. 12 Officers. 11 Privates.

DISEASE.

6 Cases

9 Cases

Tubercular Disease

CRIMINALITY.

8 Cases

4 Cases

2 Of the many Criminal Types

CONSUMPTION AND OTHER MALADIES

I 20 Cases

II 36 Cases

56 Cases Co-composite of I & II

100 Cases

50 Cases

Consumptive Cases.

Not Consumptive.

Francis Galton – *Specimens of Composite Portraiture*

As well as being the inventor of the process of finger-printing, Sir Francis Galton (1822–1911) created innovative (but scientifically and ethically dubious) photographic methods to measure and classify human faces. He was a proponent of the pseudo-science of eugenics – the belief that the human race can be improved through selective breeding. His theory was that desirable or undesirable propensities could be identified in the facial features. This chart is an example of his use of composite portraiture, combining mug-shot photographs taken at very faint exposure which, layered on top of one another, resulted in identifiable 'types'.

William Notman – *Sitting Bull and Buffalo Bill*

William Notman (1826–91) was born in Scotland and moved to Montreal, Canada, in 1856. There he established a photography studio and became noted for his various innovations, many of which he patented. He also used complex techniques for combining multiple photographs into single images. This study of Buffalo Bill and Chief Sitting Bull was made when their famous 'Wild West Review' show visited Montreal. The cowboy's pose appears forced and awkward, while the chief looks contemplative. But both are showmen, certainly aware of the publicity value of such a picture.

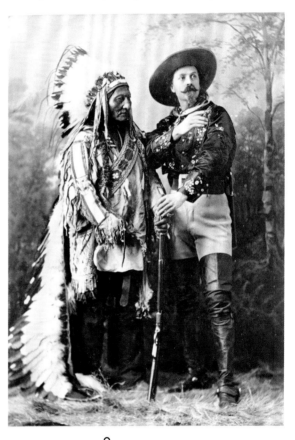

France acquires Vietnam as its colonial territory.

Wilson 'Snowflake' Bentley, an amateur photographer from Vermont, devises a method of photographing snowflakes. Over his lifetime he captures 5,000 of them.

European powers strengthen their colonial hold over the African continent, with the division and acquisition of many African countries, particularly into British rule.

1884

1885

CRIME

The state quickly realized the potential of the photograph in the documentation of criminals, and in the gathering of evidence for their prosecution, with the police 'mug shot' becoming a ubiquitous cultural symbol.

The first photograph taken in a prison was used for political propaganda, when in 1844 lithographs taken from daguerreotypes of the leaders of the Young Ireland movement imprisoned in Dublin Gaol were distributed among their supporters. In 1852 the Swiss federal government authorized the police to photograph all the vagrants and beggars found outside their own administrative canton, claiming that verbal descriptions were insufficient to identify the offenders. Soon after that the first public 'wanted' poster using a photograph was circulated in 1854 in France, and in 1870 the British Parliament passed the Prevention of Crimes Act that made compulsory the photographing of every prisoner in England and Wales. Between

1871 and 1872, photographs of 30,463 inmates were received at the national police headquarters at Scotland Yard. Sir Francis Galton, the pioneer of fingerprinting, also developed a system based on anthropomorphic measurements of the face that combined mugshots of classes of people. A believer in eugenics, Galton proposed that these composite portraits could be used to identify criminal and deviant tendencies. Now totally discredited, the method did gain significant popularity, along with the Bertillon identification system. Alphonse Bertillon is also credited with the invention of forensic photography. Terming it 'metric photography', he systematically documented the crime scene from several

**RIGHT. Alphonse Bertillon –
The Bertillon System (1909)**
Alphonse Bertillon (1853–1914) was the director of the Paris police photography department, which led him to devise his identification process based on the measurements of key elements of the face and body. Using a card-based filing methodology, this information was combined with front and profile photographs of each subject to create a system that could quickly be cross-referenced. The Bertillon system was soon taken up by police forces around the world, leading to Sir Arthur Conan Doyle dubbing him the 'father of scientific detection' in *The Hound of the Baskervilles* (1902). Although untold numbers of criminals were documented using the system, it was far from perfect and led to several miscarriages of justice.

vantage points, including from above, utilizing a special super-wide-angle camera mounted on a 2 m (6 ft) high tripod. The resulting prints were supplied with a scale that could be used to determine precise measurements. The police mugshot also became the cultural symbol of law enforcement, with famous prisoners including Frank Sinatra, Elvis Presley and David Bowie. The criminal underworld has also been recorded by photographers such as Letizia Battaglia, whose raw and brutal images documented the Sicilian mafia in the 1970s, and Jocelyn Bain Hogg, whose intimate portraits of the British underworld and the legacy of the infamous Kray twins were published in the book *The Firm* (2001).

BELOW. Weegee – *The First Murder* (1941)
As a freelance news photographer for tabloids like the *Daily News* and *PM Daily*, Weegee (1899–1968) prowled the streets of New York, earning his nickname for his uncanny ability to turn up at the scene of a crime before anyone else, as if he used a ouija board to predict the future. In fact his edge was due to the fact that in 1938 he became one of the first private citizens to be granted a permit for a radio to monitor police communications. Mounted on his trusty Speed Graphic 4 x 5 camera, his powerful flashgun exposed the brutality of gangland executions, grieving relatives and police investigations. This image was published in his book *Naked City* (1945), opposite a contrasting image of the bloody corpse of the victim lying in the street, along with the text: 'A woman relative cried ... but neighborhood dead-end kids enjoyed the show when a small-time racketeer was shot and killed.'

1886–1888

Pictorialism, an international photographic movement that emerges in the mid-1880s and persists into the 1920s, is based on the passionate belief in photography's legitimacy as an art form. It promotes a style of photography that manipulates, stylizes and intervenes in the process in every way possible as a means of demonstrating the creative hand of the photographer. Its proponents, who include Clarence H. White, Julia Margaret Cameron and Henry Peach Robinson, overlay their pictures with shadow and fog, paint their negatives with expressive brushstrokes, and make use of soft focus, dramatic lighting and complex processes that result in varied mid-grey tones. Their subjects are predominantly romantic, sentimental and nostalgic, above all indicating a desire not only to compete with painters past but also to imitate them formally. All of this is a reaction against the growing 'snapshot' aesthetic epitomized by Kodak and its advertising slogan, 'You Press the Button, We Do the Rest'. JG

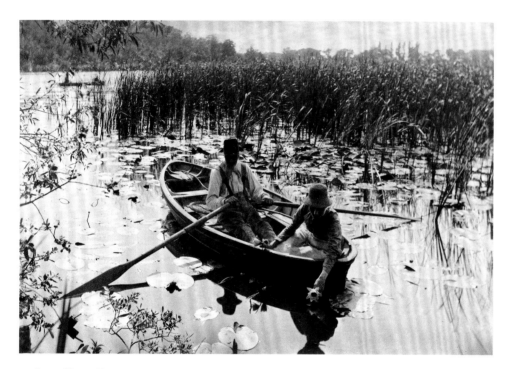

Frederick E. Ives develops the halftone engraving process so that images can be mass-reproduced simultaneously with text.

○ **Peter Henry Emerson –*Gathering the Water Lilies***

Peter Henry Emerson (1856–1936) championed a style of photography which he called 'naturalistic'. In opposition to many of his Pictorialist contemporaries, he believed that photography's value as an art form came from its ability to imitate nature, not the paintings of the past. In his controversial book *Naturalistic Photography for Students of the Art* (1899), he argued that nature is not always in sharp focus, and demonstrated how to use limited depth of field to vary the focus within photographs. This beautiful picture is from his 1886 book *Life and Landscape on the Norfolk Broads*, showing the people of the area at work.

1886

Francis Meadow Sutcliffe – *Water Rats*

In his home town of Whitby, where he spent most of his professional life as a commercial portraitist, Francis Meadow Sutcliffe (1853–1941) created this photograph when he came across of group of young boys truanting from school and asked them to pose for him. They are arranged around an empty rowing boat in Whitby Harbour, and Sutcliffe's photograph of them demonstrates his skill in the kind of naturalist photography promoted by his contemporary, Peter Henry Emerson. Although he embraced the faster and more spontaneous 'instantaneous' photography of the era, he occasionally posed his subjects, as here, when he sensed an opportunity.

Lyddell Sawyer – *In the Twilight*

Lyddell Sawyer (1856–1927) was a member of the 'Linked Ring', the photographic association dedicated to promoting the values of Pictorialism in Britain, but not many of his photographs are well known. Sawyer was born in the north-east of England and worked in a studio in Newcastle before establishing his own in the same city in 1895, and later in London's Regent Street. He soon earned a reputation as one of the foremost 'art photographers' in Victorian England, as seen in this carefully composed genre scene in which he incorporates a romantic, dream-like atmosphere, balancing contrivance and naturalness.

Muybridge publishes his landmark book *Animal Locomotion*.

The Eastman Company in the United States produces the Kodak No.1 camera and roll film.

Brazil becomes a republic.

1887

1888

1889–1891

Each of the photographers featured here is a practitioner of what we know today as photojournalism, or documentary photography, though at the time their work would not have been given those titles. Jacob Riis, in particular, is an early example of the photographic advocate or 'social reformer', campaigning for social justice issues using a wide range of innovative distribution vehicles to reach his audience. This foreshadows the modern-day alliances that frequently operate between photojournalists and charities or campaign groups to raise awareness and effect change. By the time George Trager and Fred Kuhn photograph the aftermath of the massacre of the Lakota people at Wounded Knee, the 'Indian Wars' between Native American people and the US government are at their bloody peak. Photographs like Trager's, and particularly their erroneous captioning (as battle aftermath), foreshadow the revisionism that has characterized mainstream accounts of American history, and the role of photography in this process. JG

Adolf Hitler is born.

The Eastman Company begins selling Kodak celluloid roll film.

Jacob Riis–*Lodgers in Bayard Street Tenement, Five Cents a Spot*
Jacob Riis (1849–1914) was a Danish immigrant who became a journalist and crime reporter for the *New York Tribune*. This work brought him into contact with some of the poorest people in New York City, and he became determined to address the dire living conditions that he saw. In 1887 Riis began to experiment with photography as a way of conveying what he felt could not be captured in words, but he was limited by gloomy light conditions. This changed with the arrival of flash-powder technology, which enabled him literally to shed light on his subjects, making them visible to a wide audience.

1889

George Trager – *Burial of the Dead of the Battle of Wounded Knee*

This image records the aftermath of a brutal event that was not in fact a 'battle', but a massacre. On 29 December 1890, the 7th Cavalry Regiment of the US Army killed between 150 and 300 fleeing men, women and children of the Lakota tribe at Wounded Knee Creek, South Dakota, after the accidental discharge of a rifle by a deaf Lakota man. It was the most notorious armed confrontation between the US government and Native Americans. George Trager (1906–92) and his partner Fred Kuhn were specialists in documenting Native American culture, and were present to make this picture of the aftermath.

Alice Austen – *Trude and I, Masked, Short Skirts, 11pm, Thursday Aug. 6th, 1891*

This subtly subversive photograph depicts the photographer with her lover, Gertrude Tate. Tate and Austen (1866–1952) lived together until Austen's death, though their families did not allow them to be buried together. Austen was the first woman on Staten Island, New York, to own a car, and she made use of it to pursue her successful photographic career. She travelled widely as a documentary and street photographer, perhaps best known for her coverage of the Quarantine Station, through which all immigrants to the United States had to pass. This work prefigured the photojournalism that would flourish in the next century.

Photographs finally begin to replace hand-drawn engravings in newspapers and mass-market publications.

The 'kinetiscope', a motion-picture viewing device, is invented by William Kennedy Laurie Dickson.

1890

1891

HUMAN RIGHTS

A concern with social justice has been a major part of many photographers' agenda, and has seen them aligning themselves with non-governmental organizations to produce powerful work that exposes abuse and campaigns for change.

Photography, with its emotional impact and descriptive power, has been vital in uncovering injustice, and many photographers have seen their role as an ethical one, campaigning for social reform. In 1908, Lewis Hine left his teaching job to take up a position as a photographer for the non-profit National Child Labor Committee, working for reform of child labour laws. He recorded the problems of underage workers across a wide range of industries, showing in emotionally charged portraits the exploitation of children and the dangers to which they were exposed. To gain access to many of the locations, Hine had to employ subterfuge and disguise; he variously posed as a fire inspector, industrial photographer, postcard vendor and even a Bible salesman. His work was published in newspapers and pamphlets, and was used in public lectures and slide shows, playing a significant role in changing American

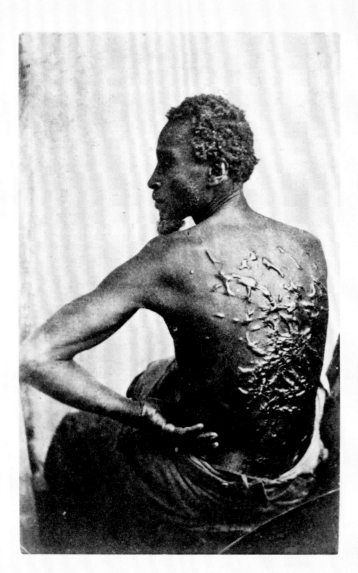

LEFT. McPherson & Oliver–*The Scourged Back* (1863)
The vicious nature of the violence of slavery is graphically portrayed in this famous image of an escaped slave known only as Gordon, who had fled his plantation after suffering a severe beating. Taken during the American Civil War (1861–65) in a Union encampment in Baton Rouge, Louisiana, the image was widely reproduced at the time to justify the fight against the South and the oppression of African Americans, with the abolitionist newspaper *The Liberator* eloquently writing, 'Upon that back, horrible to contemplate! is a testimony against slavery more eloquent than any words. Scarred, gouged, gathered in great ridges, knotted, furrowed, the poor tortured flesh stands out a hideous record of the slave-driver's lash.'

employment laws. More recently, photographers such as Marcus Bleasdale and Gilles Peress have explicitly associated themselves with the work of non-governmental agencies, working with Human Rights Watch (HRW) on investigative projects to indict abusers. Peress worked closely with HRW field investigators to gather evidence of the atrocities committed against the ethnic Albanian population of Kosovo by Serbian paramilitaries acting under the orders of Slobodan Milošević during the 1999 conflict, while Bleasdale has collaborated with them to produce a damning report on the role that illegal gold mining, supported by Western banks, has had in intensifying the conflict in Congo, leading to widespread poverty, rape and the use of child soldiers. In 2014 his powerful images of the region were instrumental in a change in US law banning the use of conflict minerals in electronic goods.

BELOW. FFR – *#Not a Bug Splat* (2014)
The disturbing title of this image refers to the slang used by US Predator drone operators to refer to the victim of a targeted 'kill', as viewing the grainy video from their aerial position gives the impression of crushing an insect to death. The artists' collective FFR (Foundation for Fundamental Rights) installed this giant portrait spanning 30 x 20 m (90 x 60 ft) in a field in the Khyber Pakhtunkhwa region of Pakistan to protest against the use of drones, which have killed over 2,000 civilians, including over 200 children, since 2004. The portrait is of a girl who had lost her parents in 2010 to a missile strike, and the image went viral with over 3.5 billion web views, contributing significantly to the pressure to restrict the use of drones.

As seen from a drone.

1892–1894

In 1893, Abdulhamid II, ruler of the Ottoman Empire, learns that his dominion is perceived unfavourably, and responds by creating elaborate propaganda in the form of photographic albums, which he sends to France, Britain, Germany and the United States. They feature scenes of fashionable shops, modern military and factories from around the Empire. The modern concern for appearance, and the attendant questions surrounding the authenticity of those appearances, proliferates. Some photographers, such as Alfred Stieglitz, dedicate themselves to exploring these contradictions. While he begins as a proponent of the romantic illusions of Pictorialism, in the 1890s his work moves further towards urban realism. Later, he creates his famous studies of clouds, which he calls 'Equivalents', because they are approximations of a state of mind for which there are no words. He is influenced by the French philosopher Henri Bergson, who stresses the importance of intuition – the ability to perceive beyond appearances. JG

Paul Martin – *Trippers at Cromer*
One of the first photographers to take advantage of the speedy new 'instantaneous' camera technology to capture daily life was Paul Martin (1864–1944), a Frenchman working in Britain. In 1892 he bought a hand-held camera and modified it so that it could be hidden under his arm, making it possible to collect candid scenes of Victorian life, taken without his subjects' knowledge. He wrote, 'It is impossible to describe the thrill which taking the first snaps without being noticed gives one.' At the time some doubted the value of such pictures, but now Martin is recognized as a pioneer of social documentary.

The 'Linked Ring' society is formed, dedicated to the practice and promotion of photography as an art form.

1892

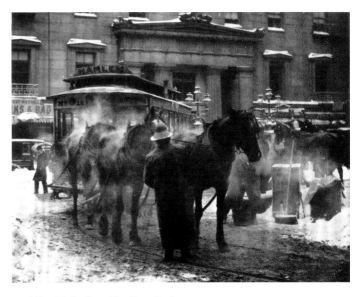

Alan Archibald Campbell-Swinton – *Negative Discharge on Gold-Coated Paper*

Alan Archibald Campbell-Swinton (1863–1930) was an electrical engineer who carried out research into the transmission of sound and images, including work with cathode ray tubes, which foreshadowed television long before its actual invention. He used photography in his experiments with electricity, and was also credited with making some of the first X-ray images in England, very soon after the technology was first created. This picture shows the effect of introducing an electrical current to the surface of gold-coated photographic paper, with the metal reacting to the path of the electrons as the charge spreads across the paper's surface.

Alfred Stieglitz – *The Terminal*

Alfred Stieglitz (1864–1946) was a seminal figure of art and culture in the early twentieth century. He is best known for his association with the Pictorialist movement, but rather than soft-focus images of romantic or nostalgic subjects, Stieglitz was interested in the everyday scenes of urban modernity that surrounded him in New York. This picture was taken on Fifth Avenue at the southern end of the Harlem streetcar route. He later recalled: 'I often walked the streets of New York downtown, near the East River, taking my camera with me … it was extremely cold. Snow lay on the ground. A driver in a rubber coat was watering his steaming horses.'

New Zealand gives women the vote in national elections – the first country in the world to do so.

Juan Vucetich, an Argentine chief police officer sets up the world's first fingerprint bureau.

Coca-Cola is sold in bottles for the first time.

1893

1894

1895–1897

At the end of the nineteenth century, scientists are increasingly looking to photography and related technologies to document ever more ephemeral and invisible processes. Many of the images they create are not only records of scientific progress, but also objects of great beauty. In late 1895, physicist Wilhelm Conrad Röntgen observes the ability of what he calls 'X-rays' (because they are unknown to science until that point) to pass through solid objects, including living organisms. Further experimentation reveals that the resulting impressions can be recorded photographically – a huge leap forward for a whole range of scientific fields, especially the training and practice of medicine. But in its early years, X-ray imaging is a source of great popular fascination and novelty. Department store customers can pay to look 'through' their own hands, and it is also associated with occult and spirit photography, and even erotica, due to its 'revealing' power. JG

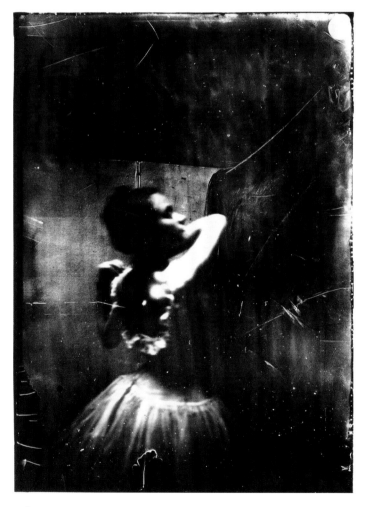

Edgar Degas – *Dancer (Adjusting Her Shoulder Strap)*

Known primarily for his paintings and sculptures, French artist Edgar Degas (1834–1917) came to photography late in his career. He took photographs of landscapes, street scenes, nudes and the ballet dancers that appear throughout his artworks in painting and other media. This picture was taken soon after he took up photography, and is one of a series of partially solarized images, the negatives of which were found in his studio after his death by his brother René. It was made using a single light source and a long exposure time, which results in an atmospheric and sombre mood.

The Lumière brothers demonstrate the 'cinematograph', a cinema projector capable of showing 16 frames a second.

X-ray photography is invented.

1895

Eduard Valenta and Josef Maria Eder – *X-ray of Angelfish and Surgeonfish*

Before the invention of X-ray imaging, the only way to see inside living organisms was to cut them open in surgery or post-mortem examination. But X-ray photography made it possible to see the structures and movements of bodies without these invasive methods. Eduard Valenta (1857–1937) was a chemist and Josef Maria Eder (1855–1944) a photographic historian, and together they were among the first to use this technology to make images of fish, reptiles, rats and humans. Fifteen of these pictures were published in a portfolio titled *Experiments in Photography by Means of Röntgen's Rays*, naming the inventor of the X-ray imaging process.

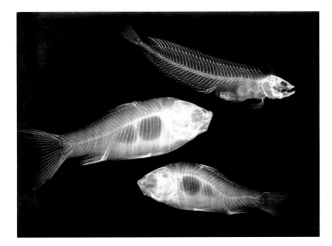

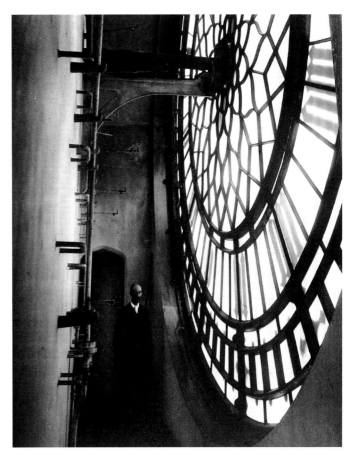

Sir Benjamin Stone – *Houses of Parliament, the Inner Side of Dial Clock Tower*, 1897

Sir Benjamin Stone (1838–1914) was a British Member of Parliament and industrialist from Birmingham. In 1897 he founded the National Photographic Record Association (NPRA), intended to be a kind of 'national memory bank', capturing ancient buildings, folk customs and other aspects of culture for posterity. He took many of the photographs added to the collection himself, including this one, which shows a man standing behind the face of the 'Big Ben' clock at the Houses of Parliament. Stone used his position as an MP to make an extensive record of the building. The NPRA archive is now housed at London's Victoria & Albert Museum.

The world's first underground passenger system, or 'subway', is introduced in Boston.

Alfred Stieglitz becomes editor of *Camera Notes*, the publication of New York's Camera Club.

1896

1897

1898–1900

The history of amateur photography is shaped by a single corporation: the Eastman Dry Plate Company of Rochester, New York, later known as Kodak. In 1888 it begins manufacturing a camera intended for casual use by middle-class consumers. Simple to use, these cameras do not require the photographer to focus the lens or even look through a viewfinder, and they come pre-loaded with film. Kodak's true breakthrough, however, comes in 1900, with the introduction of the 'Brownie'. Initially marketed to children, it embodies the true 'snapshot' revolution, with the powerful Kodak slogan, 'You Press the Button – We Do the Rest'. Ordinary people are encouraged to carry a camera with them throughout their daily lives, capturing spontaneous scenes of family and friends. Photography has been accessible before this point, but mainly mediated by professionals in portrait studios. Such studios decline rapidly after Kodak puts cameras into the hands of the customers themselves. JG

John Joly – *Arum Lily and Anthurium*
This photograph was made using the 'Joly colour process', invented by John Joly (1857–1933), an Irish physicist. It is part of the complex history of colour photography, for which many different theoretical methods were devised in the late nineteenth century, some of which were more successful than others. Joly's method involved the use of a glass filter screen printed with fine red, green and blue stripes, which was placed inside a camera. The method was introduced commercially in 1895 but was not successful, mainly because the commercial emulsions available at the time were not sensitive enough to produce a natural-looking result.

Britain extends the territory of Hong Kong from China on a 99-year lease.

1898

Theodor and Oskar Hofmeister – *Evening*

Theodor Hofmeister (1868–1943) and Oskar Hofmeister (1871–1937) were brothers and amateur photographers who worked jointly to become leading figures in the German Pictorialist movement. Oskar took the photographs and Theodor made the prints, often of peasants working in the farms and villages around Hamburg. Their images were moody and romantic yet realistic, avoiding the overt sentimentality of many of their Pictorialist counterparts. They exhibited widely and became members of two of the leading artistic photography groups of the time: The Brotherhood of the Linked Ring in Britain and the Photo-Secession in America. They gained a reputation for helping aspiring photographers by sharing their technical expertise.

Fred Holland Day – from *The Seven Last Words of Christ*

As well as being a photographer, Fred Holland Day (1864–1933) was a millionaire publisher and famous aesthete. In his photographic work he courted controversy, particularly when he cast himself in the lead role in a large series depicting the life of Jesus Christ. It took three months to make and consisted of almost 250 images. His friends and professional actors played the roles of Roman soldiers and onlookers. Day starved himself for several months beforehand, and had a cross made from specially imported Lebanese cedar wood crafted by a Syrian carpenter. When exhibited, the pictures were condemned by many as sacrilegious.

'The New School of American Photography' is the first major exhibition of American Pictorialist photography, held at the Royal Photographic Society in London.

The electrically triggered flash is patented by Joshua Lionel Cowen.

Kodak introduces the Brownie, an inexpensive camera that revolutionizes amateur photography.

1899

1900

3

—

1900
TO 1950

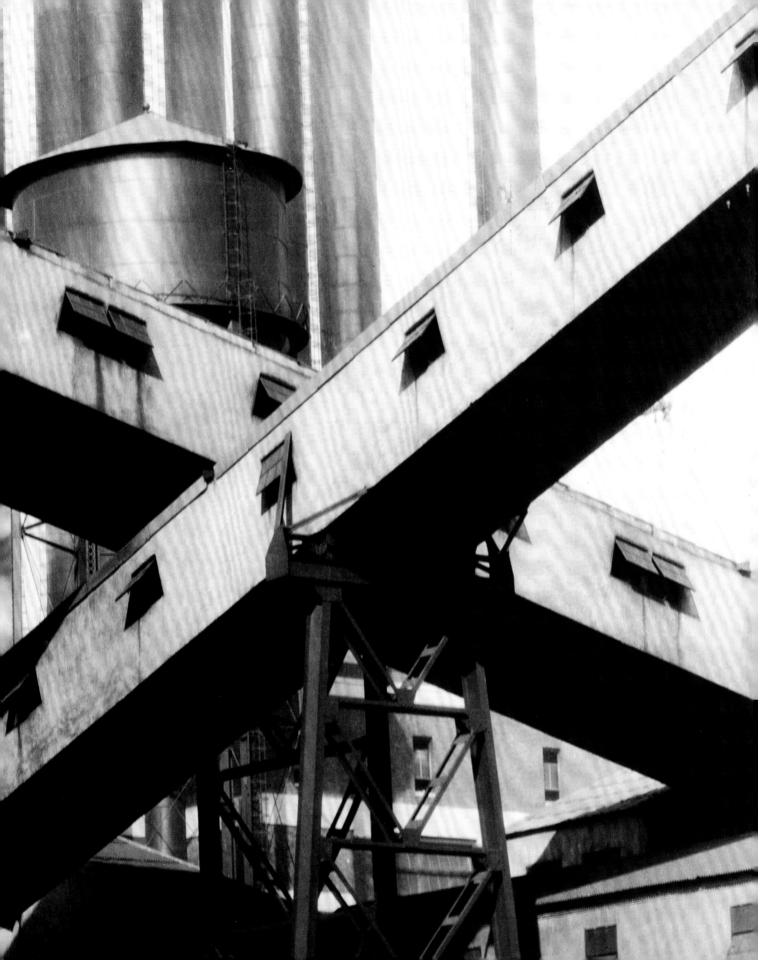

The first half of the twentieth century saw an unprecedented acceleration in technological and political development, with the two World Wars bookending a period of revolutionary social change combined with both economic growth and financial hardship. These turbulent times accelerated the development of photography as a medium of artistic expressive force and as the primary vehicle for documenting the lived experience of the world. In the two decades following the so-called Great War, the first truly global and industrialized conflict, a combination of journalists, avant-garde artists and commercially minded photographers developed the medium through which they could express the essence of modern life.

Before this period of extraordinary change, however, one figure stands out as transitional, standing between the slower pace of life of the nineteenth century and the energy of the twentieth century. Relatively unknown during his lifetime, the Frenchman Eugène Atget (1857–1927) quietly and tirelessly recorded the texture, fabric and character of urban Paris at the turn of the century. Beginning in 1898, Atget began his monumental project to document the streets of what he called 'Old Paris'. Over the next three decades, working alone, he exposed over 10,000 large-format glass-plate negatives detailing the architectural space and details of the city's streets. His images were devoid of people, yet full of their presence, with the empty streets of his images becoming spaces where the imagination could be let loose. This tension appealed greatly to the Surrealists in the 1920s, especially the artist Man Ray and his then assistant Berenice Abbott, who promoted his work, helping it eventually to be acquired by the Museum of Modern Art in New York in 1969. Abbott summed up the reaction to his photographs in a statement that captures the power of straight photography to both describe and interpret the world, writing that on seeing the images, 'the impact was immediate and

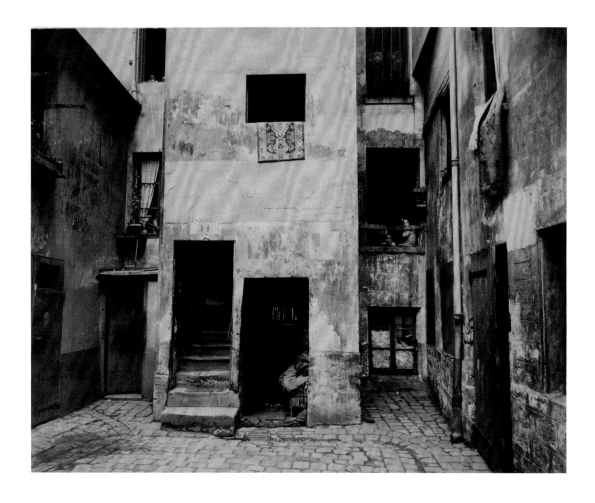

tremendous. There was a sudden flash of recognition – the shock of reality unadorned. The subjects were not sensational, but nevertheless shocking in their very familiarity. The real world, seen with wonderment and surprise, was mirrored in each print. Whatever means Atget used to project the image did not intrude between subject and observer.' His work became hugely influential for later photographers, including the New Topographics and the genre of Aftermath photography.

The world of Atget was overturned by the conflicts that followed, and the experience of the war and the revolutionary forces it unleashed had a huge impact on artists, with many of them having direct experience of the conflict, giving them an urgent sense of the need for social change while also freeing them from the traditions of conventional visual representation. A movement generally known as the 'New Vision' emerged across a range of avant-garde movements that included Surrealism and Constructivism. The line between artists, photographers and illustrators was blurred, with practitioners experimenting with a dizzying array of techniques that included photomontages, abstract photograms, typography and graphic design, and using the press as a vehicle to reach a greater audience than the gallery alone, with László Moholy-Nagy arguing that 'it must be stressed that the essential tool of the photographic process is not the camera but the light-sensitive layer'. This image (right) by El Lissitzky is emblematic of the New Vision, positioning the act of vision at its very centre. Made up of six separate photographs, the image uses montage to visually combine layers of meaning into the very fabric of the frame.

The early twentieth century also saw the rise of photography as the pre-eminent method of selling and promoting through magazines and advertising, which also tapped into the zeitgeist in its aesthetic. The work of Baron Adolph de Meyer drew heavily on the use of wax mannequins by the Surrealists as symbolic of the 'uncanny'. De Meyer became the first 'staff' photographer at American *Vogue* in 1914, his ethereal photography using a range of techniques to convey the elegance of the goods he was hired to promote. This image of a woman's face transformed into a mask was used as part of a series of advertisements he shot for Elizabeth Arden that appeared in *Harper's Bazaar* during the 1920s, and demonstrates the overlap between the worlds of avant-garde art and commerce of the period. The popularity of the illustrated magazine provided a vibrant vehicle for photography to become the dominant way in which life was visualized in all of its incarnations, from documenting everyday life, to the horrors of the Spanish Civil War, to the high fashion of Paris and New York. Magazines like *Picture Post*, *Life* and *Vu* used dynamic layouts of images that still look fresh and innovative today. The philosophy of the time is summed up by the founder of *Life*, Henry Luce, who wrote in the introduction to the first issue of the magazine that its aim was 'To see life;

PREVIOUS PAGE. Charles Sheeler – *Criss-crossed Conveyors, River Rouge Plant, Ford Motor Company* (1927)

LEFT. Eugène Atget – *Cour, 41 Rue Broca* (1912)

ABOVE. El Lissitzky – *The Constructor* (1924)

to see the world; to eyewitness great events; to watch the faces of the poor and the gestures of the proud; to see strange things ... to see and take pleasure in seeing; to see and be amazed; to see and be instructed.'

However, the inter-war years also saw enormous economic hardship after the impact of the Wall Street Crash triggered the Great Depression. One of the most significant documentary projects in the history of photography emerged in response to the problems of representing the impact that the financial crisis was having on ordinary people. The Farm Security Administration (FSA) was established to combat rural poverty in America, and as part of its efforts established an Information Division to produce educational materials and press material to the educate the public about the plight of the poor, with the goal of 'introducing America to Americans'. Led by the visionary editor Roy Stryker, the FSA recruited an impressive array of photographers, commissioning them to travel across the United States to document everyday life, resulting in Walker Evans and James Agee's extraordinary combination of photography and documentary non-fiction, *Let Us Now Praise Famous Men*. The team also included Arthur Rothstein, Theo Jung, Ben Shahn, Dorothea Lange, Carl Mydans, Russell Lee, Marion Post Wolcott, Jack Delano, John Vachon and John Collier, and was tasked with providing evidence that could be used to promote social reform through the interventions of the New Deal programme. In all, the FSA photographers produced over 250,000 images, many of which are now preserved for the future in the Prints and Photographs Division of the Library of Congress. In February 1936 Dorothea Lange created an image that became one of the most iconic in the history of photography, and a symbol of the harshness of the times but also of the resilience of the human spirit. While on assignment for the Resettlement Administration (RA), she halted at a camp for migrant workers in Nipomo, California, where she later noticed a 'hungry and desperate' woman who told her story, recalling 'She told me her age, that she was thirty-two. She said that they had been living on frozen vegetables from the surrounding fields ... There she sat in that lean-to tent with her children huddled around her.' Lange made six exposures with her large-format camera, the last of which became known as *Migrant Mother*. Combining the powerful symbols of motherhood, childhood, poverty and fortitude, the image has become a universal symbol of the struggles of the poor, and has been reworked countless times including as a US postage stamp. It is a powerful example of how the photograph represents both a specific individual at a specific moment in time, but also can represent a generic social movement. Sadly, however, the subject of the image, Florence Owens Thompson, later felt that she had been exploited by the experience, and received no benefit from becoming a national icon.

ABOVE. Baron Adolph de Meyer –
Elizabeth Arden Advertisement
(1927)

RIGHT. Dorothea Lange –
Migrant Mother (1936)

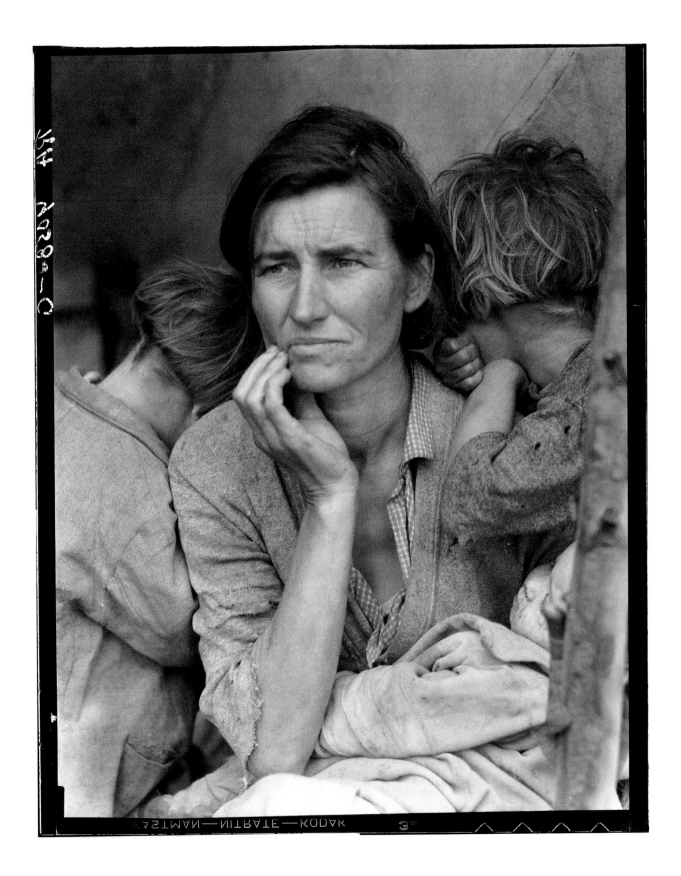

THE DEVELOPMENT OF COLOUR PHOTOGRAPHY

Prior to the late 1890s, colour photography was limited to a few innovators and experimenters who had the patience, time and resources to build and test their own equipment, colour-sensitize their photographic emulsions, and make and test their own colour filters. In 1891 Gabriel Lippmann (1845–1921) developed a process based on light interference – the interaction of light waves that produces the brilliant colours seen in soap bubbles – that later won him a Nobel Prize, in 1908. However, this was too complex and time-consuming a method for commercial use. Instead, the three-colour approach that mixed the primary colours of light came to dominate advances in the medium. The early twentieth century saw the emergence of practical ways to produce colour photographs that could be mass-produced and printed. Perhaps the ultimate iconic brand in colour photography, Kodachrome, was the first colour film that used a subtractive colour method to

be successfully mass-marketed. First sold in 1935 as a 16 mm movie film with an ASA/ISO of 10, it was quickly introduced in 35 mm format for stills cameras. The faster and sharper Kodachrome II with the faster speed of 25 ASA/ISO was developed in 1961, followed by Kodachrome-X at ASA 64 in 1962. The film produced positive transparencies, also known as slides, and became famous for its intense, saturated colours. The look of Kodachrome was a trademark of the photographs published in *National Geographic* magazine. However, with the rise of digital photography, sales of slide film declined, and on 22 June 2009, Kodak announced it would no longer manufacture Kodachrome film. The last roll Kodachrome ever manufactured was ceremonially shot by Steve McCurry, a *National Geographic* and Magnum photographer and long-term user of the film. Prints of the thirty-six slides he made are permanently housed at the George Eastman House in Rochester, New York.

LEFT. Heinrich Kühn – *Walter and Edeltrude* **(c.1912)**
In 1907 Alfred Stieglitz introduced his friend Heinrich Kühn (1866–1944) to the newly developed Autochrome colour process, invented by the Lumière brothers in France. This involved coating the glass plate with a layer of starch grains dyed red, green and blue, with a layer of emulsion on top. This produced a positive image, or transparency. Kühn took hundreds of Autochromes in and around his family home close to Innsbrück in the Austrian Tyrol, often photographing his children Hans, Walter, Lotte and Edeltrude, and their English nanny, as in this image dated *c*.1912. He even went as far as to have special colour-coordinated clothes made for them in red, white and blue, to contrast with the green of the grass.

LEFT. Kodachrome slides on a lightbox
Colour slide films like Kodachrome or Fujichrome produce a positive image, not a negative. Slide film has a narrower contrast range than negative film, and mistakes in exposure cannot be corrected in the darkroom by selective dodging and burning. Photographers therefore have to get the perfect exposure in camera. To edit slide film, a lightbox is used to illuminate the images from behind, in conjunction with a loupe or magnifier to make the details in the photograph visible to the eye.

RIGHT. Russell Lee – *Saying Grace Before the Barbeque Dinner at the Pie Town, New Mexico Fair* **(1942)**
Colour images from the 1930s and 1940s have an uncanny effect, as if we are conditioned to think of the past only in black and white. The colours in this photograph, taken by Russell Lee as part of his work for the FSA, challenge the stereotype of the Depression with their vibrancy and dynamic realism. In June 1940 Lee travelled to Pie Town, Catron County, where he took this beautifully composed and sensitive image. Lee shot hundreds of photographs on Kodachrome, many of which have only recently been rediscovered.

THE DOMINANCE OF ROLL FILM CAMERAS

The widespread introduction of roll film in the 1920s revolutionized photography, as it allowed multiple exposures to be made in rapid succession without having to change the film, and the portability and flexibility of the format meant that photographers could shoot their images and then send them to be processed by a lab, greatly improving ease of use and creating the mass market for photography. Roll film was initially often called 'cartridge' film because of its similarity to a shotgun cartridge. Two main formats were developed, the 135 format, commonly known as 35 mm, packed in a small metal tube, and the 120 format, also known as 6 x 6 or square format, with the negative measuring 6 cm on each side. 120 format film can also produce negatives of 6 x 4.5 (645), 6 x 7, 6 x 9, and 6 x 17 and 6 x 24 panoramic. With 120 film a spool of paper-backed roll film is loaded on one side of the camera and pulled across to an identical take-up spool on the other side of the shutter as exposures are made.

ABOVE. Cartier-Bresson with Leica (1956)
The compact Leica camera, along with the similar Contax, transformed the ability of photographers to capture the energy of the world around them, freeing them of the cumbersome and slow limitations of a plate camera that could only shoot one image at a time. The company was founded by Ernst Leitz in 1924, and the name is a combination of his surname and the first two letters of the word 'camera'. One of the key innovations of these cameras was the sideways orientation of the film, contrary to the cine film tradition of running from top to bottom, giving a negative size of 24 x 36 mm with a 2:3 aspect ratio, instead of the 18 x 24 mm of cinema cameras. The compact and light cameras had interchangeable lenses and, with the introduction of the Leica II in 1932, a separate rangefinder that allowed for quick and accurate focusing, even in low light and with fast-moving subjects. The cameras were compact with collapsible lenses, for hiking and biking.

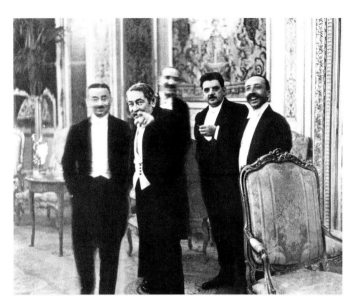

LEFT. Erich Salomon – *The King of the Indiscreet* (1931)
Known as the 'Houdini of Photography' for his ability to gain entry to the highest levels of diplomatic, political and social activity, Erich Salomon (1886–1944) was one of the first to realize the potential of the smaller cameras, appreciating that they allowed him to work discreetly without flash, as the quintessential unseen observer and 'fly on the wall'. Salomon used a range of tricks and subterfuges to gain access to the corridors of power, including hiding his camera variously in a bowler hat, a mathematics textbook and an attaché case. His intimate photographs of world leaders engaged in their negotiations were a revelation compared to the stiff, posed images to which audiences were accustomed.

BELOW. Rolleiflex cameras
First introduced in 1929, the Rolleiflex is a twin-lens reflex camera, with the top lens for focusing and composition, and the other for actually taking the image. Unlike a single-lens reflex (SLR) camera or rangefinder, this means that the photographer looks down on to a ground-glass screen to take the picture, rather than looking through the lens of the camera at eye level. This gives a very different relationship with the subject, which, combined with the fact that the Rolleiflex has no mirror, makes for a very quiet and discrete camera, perfect for candid portraits. The relatively large 6 x 6 cm negative allows for high-quality prints to be made. Lisette Model, for example, used the unique features of the Rolleiflex to great effect in her masterful street photography. Model often cropped her images from square to rectangular, removing distracting background elements.

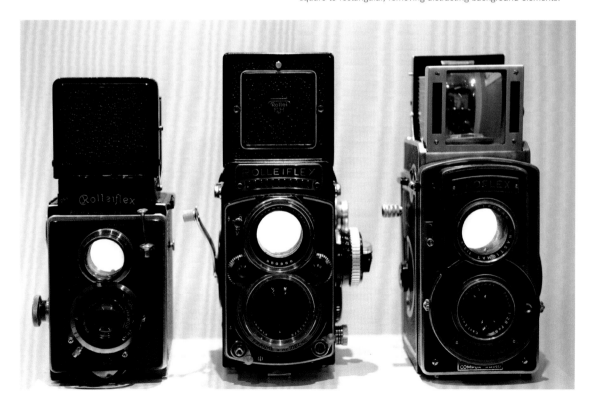

1900–1902

The dawn of the twentieth century sees seismic changes around the world. The death of Queen Victoria comes at the peak of the British Empire, which rules over nearly a quarter of the world's population. The following year the Second Boer War ends with a British victory over the South African Boers, but the message the uprising sends about the weakening power of European empires is unmissable to other colonies. In the realm of technology Guglielmo Marconi transmits the first transatlantic radio signal, which demonstrates the feasibility of wireless global communications. Photography, meanwhile, continues to expand into more areas of life. Kodak's Brownie camera, the first consumer camera designed with simplicity in mind, is a major landmark. The Brownie gives rise to a flourishing culture of amateur photography, and for many later well-known photographers this simple box camera will be their first introduction to the medium. LB

William van der Weyde – *Electric Chair At Sing Sing*

An early photojournalist, William van der Weyde (1871–1928) made his name capturing images to illustrate news stories and producing portraits of writers, poets and other celebrities. Making use of newer, quicker cameras and chemicals, van der Weyde's work was more dynamic than that of his predecessors. This photograph depicts a man being strapped into the electric chair at New York's Sing Sing, the first prison to make use of such a device. It had first been proposed as a means of humane execution in 1887 by dentist and experimenter Alfred P. Southwick. The proposal was accepted the following year, and the first person to be executed in this way was William Kemmler, on 6 August 1890. Eddie Mays would become the last person to be executed in New York State on 15 August 1963. Two years later the state abolished capital punishment.

Kodak introduces the **Brownie**, an inexpensive box camera that uses prepared roll films.

1900

Frances Benjamin Johnston – *Untitled*

Frances Benjamin Johnston was born into a wealthy family, and initially worked as a print journalist before becoming one of the first female photojournalists. In 1899 she established her own portrait studio. This photograph was taken as part of a commission for Hampton Institute, which had been established following the American Civil War to provide education and training for former slaves. While this image appears to be an action shot of the Institute's students practising crafts, the basic camera technology of the time meant that Johnston in fact had to pose each of her subjects and used an exposure time of several seconds to capture the scene.

Gertrude Käsebier – *Gargoyle*

Gertrude Käsebier (1852–1934) originally studied painting, and like many art students of that time, decided to travel to Europe in order to study further. Here she learned the chemistry of photography, and on her return to the United States opened a portrait studio in New York in 1897. From this point she began to work primarily with photography, but with the influence of her artistic education clear in many the images she produced. Alfred Stieglitz was an admirer, and she later become a founding member of Stieglitz's Photo Secession group, which championed Pictorialism and the potential of photography as a fine art. Later she broke away from Stieglitz's circle, helping to establish the Women's Professional Photographers Association of America in 1910.

Edward VII becomes King of the United Kingdom and the British Dominions and Emperor of India following the death of Queen Victoria.

The first Nobel Prizes are awarded.

Guglielmo Marconi receives the first transatlantic radio signal.

Georges Méliès directs *Voyage to the Moon*, one of the first science-fiction films.

1901

1902

1903–1905

New technologies continue to dazzle the public and open new frontiers of exploration and knowledge.

In 1903 the Wright brothers make the first ever flight in a heavier-than-air craft, which paves the way for everything from new tourist travel to a frightening era of aerial warfare. Within five years these new aeroplanes will be combined with cameras in order to create photographic maps of unparalleled detail and accuracy. In the realm of art photography, Alfred Stieglitz begins publication of *Camera Work*, his enormously influential journal on photography, which also champions Pictorialism and his Photo Secession movement. In world affairs, war between Japan and Russia hastens the decline of Russia's Romanov dynasty, and the end of the war sees a partial revolution, with a coalition of reformers gaining new constitutional rights. In the same year Einstein first publishes his theory of special relativity, which addresses key inconsistencies in Newtonian mechanics and paves the way for new approaches to physics. LB

Frederick H. Evans – *A Sea of Steps*

Frederick H. Evans (1853–1943) began his career as a bookseller but in 1898 gave this up to work as a photographer. He acquired a reputation for photographing architectural subjects, and made use of the platinotype technique to produce prints with extraordinary detail and tonal range. He also advocated a purist approach to photography, refusing to retouch his photographs, unlike many other photographers of the time. Evans's photographs of cathedrals, cloisters and churches, such as this one showing part of Wells Cathedral in Somerset, England, were particularly celebrated for their technical perfection. In 1903 he wrote, 'The beautiful curve of the steps on the right is for all the world like the surge of a great wave that will presently break and subside into smaller ones.'

The first controlled heavier-than-air flight is carried out by the Wright Brothers.

Marie Curie is awarded a Nobel Prize, becoming the first woman to receive one.

A Japanese surprise attack on Port Arthur starts the Russo-Japanese War.

1903

1904

Jacques Henri Lartigue–*My Cousin Bichonnade*

Born into a wealthy French family, Jacques Henri Lartigue (1894–1986) started photographing his family and friends at an early age. While he considered himself primarily a painter, he took photographs throughout his life, and sometimes sold them. He was discovered at the age of sixty-nine, when his photographs, many taken decades earlier, were introduced to John Szarkowski, an influential curator at New York's Museum of Modern Art, who arranged an exhibition. This photograph, showing his cousin Bichonnade leaping down a flight of stone steps outside the family home in Paris, was taken when Lartigue was about eleven, and is typical of many he took depicting his relatives and close friends at play.

Edward S. Curtis–*Jicarilla Apache Cowboy*

Edward S. Curtis (1868–1952) was an ethnologist who used photography extensively to document the American West. In 1895 he took his first portrait of a Native American, inadvertently initiating a project that would absorb much of the rest of his life, as he documented Native American peoples and practices which were disappearing at the hands of European settlers. In 1906 the financier J.P. Morgan sponsored Curtis to produce a massive work on Native Americans, eventually encompassing 40,000 photographs. This image is uncharacteristic of Curtis's work because the man in it wears clothing from both Native American and settler culture.

Albert Einstein formulates his theory of special relativity.

A revolution in Russia leads to constitutional reform and a weakening of the monarchy.

1905

PICTORIALISM

The Pictorialist movement sought to affirm the creative process of photography as a way of producing a unique artistic vision, not just a recording of reality.

In the mid- to late nineteenth century, Pictorialism grew out of a sense that photography could be more than just a straightforward method of documentation, and that the medium could be used as an interpretative art form in its own right. Influenced by painting and fine art, the Pictorialists drew inspiration from artists such as James Abbott McNeill Whistler, John Singer Sargent and the Impressionists, as well as by Art Nouveau and Japanese art, with photographers like George Davison and Clarence Hudson White deploying soft focus to create an impressionistic effect. Many of its leading exponents were amateur photographers unburdened by any prejudices about what a photograph could represent. The movement celebrated the photographic print as its ultimate expression, with its proponents like Frenchman Robert Demachy and the German Heinrich Kühn using the gum bichromate process, while others like the Russian Sergei Lobovikov used further darkroom techniques including the bromoil process, carbon printing, the oil print process and platinum printing to create exquisite final images. One of the leading lights of the movement, Alfred Stieglitz, argued that the soft and delicate feel of the images was essential to their representation of the world, maintaining that 'Atmosphere is the medium through which we see all things … Atmosphere softens all lines … what atmosphere is to Nature, tone is to a picture.' To promote the Pictorialist approach in America, Stieglitz established the Photo-Secession group in 1892 in New York, and included in its hand-picked membership Edward Steichen, Alvin Langdon Coburn, Gertrude Käsebier, Eva Watson-Schütze and Joseph Keiley. This close-knit group who published and exhibited together had a huge influence on the acceptance of photography as an independent medium of artistic expression.

BELOW. Clarence Hudson White – *Morning* (1905)
Already a successful photographer and leader of the Pictorialist movement, in 1907 Clarence Hudson White (1871–1925) was appointed as the first photography teacher at Columbia University, and in 1914 established a school under his own name, the alumni of which include Dorothea Lange, Margaret Bourke-White and Paul Outerbridge. White's use of soft focus and delicate tones gave his photographs an intimate, ethereal air, with clear references to Impressionism and Japanese painting.

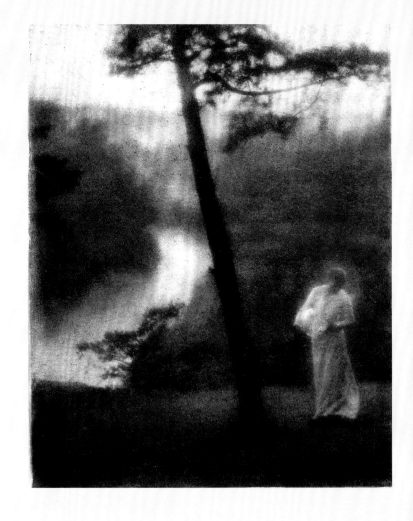

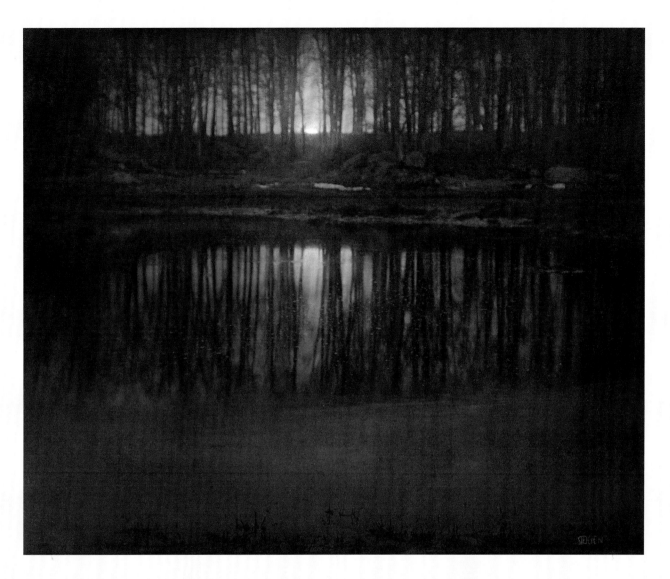

Camera Work

In 1902 Stieglitz decided to devote his energy to the publication of a magazine intended to promote the art of photography at the highest levels. When the first issue was launched in January 1903, its manifesto stated that 'Only examples of such work as gives evidence of individuality and artistic worth, regardless of school, or contains some exceptional feature of technical merit, will find recognition in these pages.' With an Art Nouveau-inspired cover, *Camera Work* was printed to the highest possible standards, with its hand-finished photogravures overseen personally by Stieglitz himself, showcasing the photographs at a quality previously unseen in print. The magazine ceased publication in 1917, with the fifty-three issues becoming highly sought-after collectors' items.

ABOVE. Edward Steichen –
***The Pond, Moonlight* (1904)**
Edward Steichen (1879–1973) helped to convince the world that photography was a valid art form. This painterly image of soft light coming through trees to reflect on water was the most valuable photograph in the world in 2006, when one of the three existing prints sold at Sotheby's in New York for $2.9 million (£2.2 million). Each of the three is subtly different in tone, due to slightly different processing techniques of the negative. *The Pond, Moonlight* was created by putting multiple layers of gum bichromate over an initial platinum print. Each layer could be modified with a brush or sponge to adjust shapes and shadows, making each version of the image unique.

1906–1908

These years are typified by the appearance of ever more modern technologies, including significant advances in photography.

In France, the Lumière brothers, who had previously pioneered moving images, reveal their Autochrome process, which will become the first commercially successful colour process. Also in France, the first photographs are taken from an aeroplane, piloted by Wilbur Wright. Meanwhile, technology continues to advance in other areas, with the Ford Motor Company revealing the Model T, the first mass-produced car, and the first AM radio broadcast also taking place. Alongside these new advances, the old political orders struggle to keep up. Attempts to reform the political and economic system in Russia prove ineffective, creating a class of wealthy peasants and alienating many from the Tsarist monarchy. In the Balkans, the Austro-Hungarian Empire annexes Bosnia-Herzegovina, an event that will lead indirectly to the start of the First World War. LB

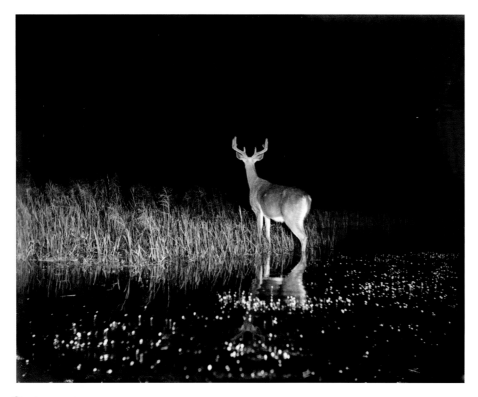

The French post-impressionist painter Paul Cézanne dies.

The Autochrome plate is commercially marketed by the Lumière brothers. It becomes the first commercially successful colour photography product.

George Shiras III – *Deer at Night*

Early wildlife photography was constrained by the technical limitations of cameras, with slow exposures and short lens focal lengths. George Shiras III (1859–1942) is widely credited with overcoming these limitations to become the first modern wildlife photographer. A keen hunter when young, he started to take photographs in 1889, and he later made use of the first commercially available flashguns combined with camera traps to capture photographs of wild animals in the area around Lake Superior. These images were unlike any that had been seen before and played an important role in advocating for the protection of wildlife.

1906

George H. Seeley – *The Brass Bowl*

Seeley (1880–1955) trained as an artist, and after meeting the photographer F. Holland Day became a member of the Pictorialist Photo Secession group which Day had co-founded with Alfred Stieglitz in 1903. Seeley's photograph *The Brass Bowl* typifies many of the preoccupations of the movement; with its soft focus and muted tones, and its complicated platinum printing process, the image makes as strong a claim for photography as a fine art as any. Seeley remained loyal to the tenets of Pictorialism long after many other members of the Photo Secession group had drifted away from it, but changing fashions saw his style become increasingly outdated. He continued to exhibit photographs, but largely abandoned producing new ones and gradually returned to painting.

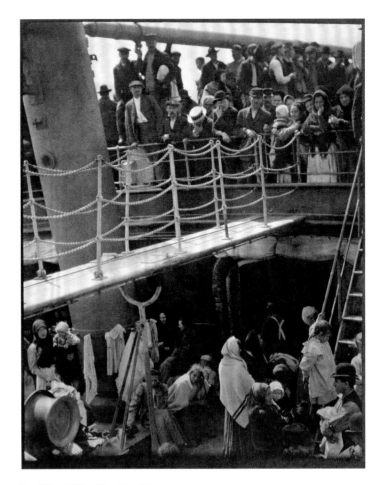

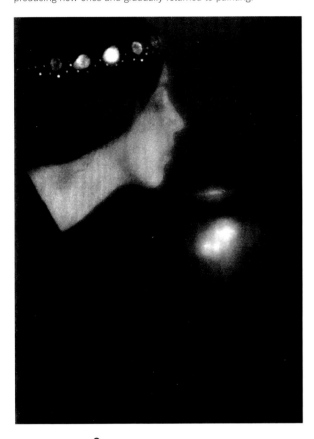

Alfred Stieglitz – *The Steerage*

A key figure in the promotion of photography as a fine art, and a founder of the Photo Secession movement, Stieglitz had been best known for an approach that emphasized the aesthetic qualities of photography. *The Steerage* represents a marked departure from this approach. Showing the lower-class deck on a transatlantic liner, it combines formal excellence with a documentary relationship to the world it depicted, which was radical for its time. Stieglitz later claimed he had recognized its importance immediately, but other accounts suggest he set the image aside for up to four years before publishing it in the 1911 edition of *Camera Work*, the quarterly photographic journal he edited.

Elections to the new Parliament of Finland are the first in the world with women candidates.

The Ford Motor Company's Model T is the first mass-produced motorcar.

Pu Yi, the last Emperor of China, assumes the throne.

1907

1908

1909–1911

As the first decade of the twentieth century ends, entrenched political systems continue to be upset around the world. In Latin America the Mexican Revolution begins, a seismic event which ends the regime of Porfirio Díaz. This event profoundly transforms Mexican politics, society and culture, including photography, which becomes a key means of forging a new vision of Mexican society. In China revolution also sees the overthrow of the child Emperor Pu Yi, and the demise of the Qing Dynasty, which had ruled the country for nearly 300 years. In photography Kodak pioneer a new form of 35 mm film, which uses an acetate base. Replacing the earlier nitrate film, which was dangerously flammable, this new acetate film will later become the basis for 35 mm still photography. Meanwhile, in science and technology more broadly, Heike Kamerlingh Onnes discovers superconductivity, a key principle behind many modern technologies, and Ernest Rutherford identifies the atomic nucleus, further expanding the contemporary understanding of physics. LK

Filippo Marinetti publishes the *Futurist Manifesto*.

Kodak announces a 35 mm 'safety' motion picture film on an acetate base as an alternative to the highly flammable nitrate base.

○ **William Downey –** *Nine Sovereigns at Windsor for the Funeral of King Edward VII*
William Downey (1829–1915) had been a carpenter but established a photographic studio in 1855, making it among the earliest. He established important connections, particularly with the Royal Family, leading to a Royal Warrant and Downey being nicknamed 'the Queen's photographer'. This photograph by Downey was taken on the occasion of the funeral of King Edward VII, and shows nine European sovereigns wearing state dress, from King Haakon VII of Norway to Wilhelm II of Germany, and Alfonso XIII of Spain. England's King George V sits in the middle of the group.

1909

Sergey Mikhaylovich Prokudin-Gorsky – *Russian Portrait*

Sergey Prokudin-Gorsky (1863–1944) was born into the Russian nobility, and studied chemistry in St Petersburg. As a young man he became interested in photography and pioneered an innovative form of colour process, which made it possible to capture red, green and blue images of the same scene, recombining these images through projection in order to create a single full-colour image. Having impressed Tsar Nicholas II with his invention, Prokudin-Gorsky was commissioned to travel through the Russian Empire documenting it, a project which began in 1909, took six years to complete, and resulted in a remarkable colour archive of the world's largest country.

Herbert Ponting – *Grotto in a Berg, Terra Nova in the Distance*

One of the most significant feats of endurance and photography was achieved by Herbert Ponting (1870–1935), who accompanied the ill-fated *Terra Nova* expedition of 1910 to Antarctica, led by Robert Scott. He was almost killed when in 1911 the ice floe on which he had positioned himself to take photographs was broken up by a pod of eight killer whales, but he returned safely to England on the *Terra Nova* with 1,700 glass-plate negatives, hoping to use them when Scott returned successfully from his epic adventure. Tragically his dramatic photographs of the vast icy wastes instead became a testament to the memory of Scott and his fellow explorers.

The Mexican Revolution begins.

Leo Tolstoy, Russian novelist, dies.

Ernest Rutherford identifies the atomic nucleus.

The Xinhai Revolution in China overthrows the Qing Dynasty.

1910

1911

SPORT

The action and aesthetics of the human form in motion combine in sports to provide photographers with endless opportunities to create stunning images of the spirit of human competitiveness.

Combining technology and aesthetics to great effect to capture the myriad team and individual sports, photographers must not only understand the game and have a sixth sense for where the action will unfold, but also be masters of the technical aspects of the medium to be able to focus on fast-moving subjects. They have been innovators in the use of super-telephoto lenses to get visually up close and personal with the players, and super-wide angles to show the full field of view of the venue. Heinz Kluetmeier (1943–) is one of the most adept technically, and specializes in the use of remote cameras with wireless triggers to capture unusual angles. In his coverage of the swimming in the 2008 Olympic Games, he worked with an assistant in scuba gear to place his camera at the bottom of the pool. He then used his remote to fire the camera at the exact moment in 2008 when US swimmer Michael Phelps' fingertip touched the wall to win Olympic gold ahead of Serbian Milorad Čavić. But sports have also been the subject of politics, as when US photographer Anthony Camerano shot the African American sprinter Jesse Owens on the podium to receive one of his four gold medals at the 1936 Berlin Olympics, while behind him the German athlete Carl Ludwig (Luz) Long gave the Nazi salute.

ABOVE. Robert Demachy – *Speed* (1904)
Although perhaps best known as part of the Pictorialist movement, and for his heavily worked and atmospheric prints made using the gum bichromate and bromoil printing processes, Robert Demachy (1859–1936) was also fascinated with the advent of the age of the internal combustion engine. He was one of the first Frenchmen to own a car, obtaining a Panhard in around 1890. In *Speed* he captured the spirit of the new technology of the automobile, using his trademark manipulation of the print to create a sense of dramatic movement across the frame. As well as being a celebrated photographer with prestigious exhibitions of his work, including five one-man shows organized by the Royal Photographic Society in London, he was the author of over 1,000 articles on the aesthetics and techniques of the photographic print. Despite his success, he suddenly abandoned photography without any explanation in 1914, never to return to the medium.

ABOVE. Neil Leifer–*Muhammad Ali vs. Sonny Liston* (1965)

This dramatic image captures the moment when Muhammad Ali knocked out Sonny Liston in the first round of their second fight for the world heavyweight boxing title. A technical master, Leifer used a series of powerful flashguns set above the ring to provide enough light to capture the moment on Kodak Ektachrome slide film, freezing the action as Ali towered over his opponent right in front of his camera, challenging him to 'Get up and fight, sucker!' Leifer shot this defining image of Ali on assignment for the seminal American magazine *Sports Illustrated*, for which he shot 170 cover images, documenting seven Olympic Games and the whole of Ali's career.

Leni Riefenstahl (1902–2003)

Riefenstahl's work in collaboration with the Nazi party in Germany in the 1930s is highly controversial, with her documentary propaganda film *The Triumph of the Will* (1935) criticized as propaganda for Adolf Hitler's regime, but also celebrated for its innovative and revolutionary aesthetic style. She applied some of the same techniques to her later work on the 1936 Olympic Games in Berlin, where she employed a crew of forty-five cameramen to produce *Olympia*, released in 1938. The strong visuals of the film and of the photography, with their dramatic camera angles and graceful yet dynamic sense of movement, had a huge influence on sports photography thereafter.

1912–1914

Revolution gives way to war in the middle of the 1910s, as old political regimes and radical new ideas come into violent conflict with each other, all documented by the growing number of cameras in private hands. In China, the Xinhai Revolution leads to the establishment of the Republic of China, led by Sun Yat Sen and, later, the Kuomintang, or Chinese nationalist party. In Bosnia the assassination of Archduke Franz Ferdinand of Austria-Hungary pushes European states towards war. The armies of Germany and the Western Allies collide soon afterwards in France and Belgium, but neither proves able to gain the upper hand, leading to a protracted stalemate and trench warfare. Internationally the Panama Canal opens in Central America, and the RMS *Titanic*, the largest and most luxurious passenger ship in the world, collides with an iceberg in the Atlantic, sinking with the loss of 1,500 lives. LB

Alvin Langdon Coburn – *The Octopus*

Alvin Langdon Coburn (1882–1966) was born into a middle-class family in Boston, and first encountered photography at the age of eight. He took to it immediately, and was encouraged to pursue it as a career by his cousin F. Holland Day, one of the founders of the Photo Secession group. Coburn studied in Europe and New York with other important photographers, continuing to develop his style and distinctive vision and gaining in renown. While often associated with Pictorialism, Coburn was also important for his experiments in abstraction, using unconventional vantage points and photographic techniques to render the familiar strange, as he does in this photograph of New York's Madison Square. In creating photographs like this one, Coburn rather anticipated the radical abstraction of later movements like Constructivism.

The end of the Chinese Empire and establishment of the Republic of China.

1912

A. H. Robinson – *Bridlington Beach*

Alfred Hind Robinson was a pioneer of panoramic photography, using an early Kodak panoramic camera in combination with the autotype process, which made use of a form of carbon process to create very long-lasting prints. He is credited with producing over 2,000 panoramas between 1903 and 1930, travelling all over the United Kingdom and north-western Europe, often focusing on seaside resorts and beaches. At the time this photograph was taken, Bridlington in Yorkshire was a major resort, a location where workers from the industrial towns of the north of England sought respite and relaxation away from the often soot-choked towns where they lived and worked.

Igor Stravinsky's *The Rite of Spring* premieres in Paris to hostile reviews.

The Armory Show, a groundbreaking exhibition of modern art, is held in New York.

Gavrilo Princip assassinates Archduke Franz Ferdinand in Sarajevo, triggering the start of the First World War.

Arrest of Gavrilo Princip, Assassin of Archduke Franz Ferdinand

On 28 June 1914, Archduke Ferdinand of Austria-Hungary and his wife were shot dead in Sarajevo, Bosnia-Herzegovina by Gavrilo Princip, a Yugoslav nationalist. Austria-Hungary declared war on Serbia in response, which as a result of the complex network of alliances active in Europe at the time drew much of the continent into the conflict and triggered the First World War. Princip attempted suicide after the assassination, but his cyanide pill failed to work and he was apprehended. After a twelve-day murder trial in Sarajevo, Princip, who was too young to receive the death penalty under Austrian law, was sentenced to twenty years' imprisonment, the maximum penalty. This photograph, which was long thought to show Princip soon after his arrest, in fact probably shows the arrest of an innocent bystander named Ferdinand Behr, who was wrongly implicated in the plot.

1913 **1914**

1915–1917

Despite early suggestions, by 1915 it is evident that the First World War will not be over by Christmas, and ever more countries, men and materials are drawn into it.

In an attempt to break the stalemate of trench warfare, terrifying new weapons are fielded by both sides, including the first use of poison gas at the Battle of Neuve Chapelle and the Second Battle of Ypres, and the first use of tanks at the Battle of Flers–Courcelette in 1916. Another new technology is photography, which plays an increasingly important role in military strategy, being employed to plan attacks and assess damage in the aftermath of bombardments. At the start of the war the technologies used are basic, with pilots and observers often simply leaning out of their aircraft and shooting with commercially available cameras. By 1915 the first school of aerial photography is established in Farnborough, United Kingdom, and by the final years of the conflict aerial photography has evolved into a highly sophisticated practice, which will change the course of warfare. LB

August Sander – *Young Farmers*

August Sander (1876–1964) initially worked in the mining industry but, after assisting a photographer, decided to enter the profession himself. Sander worked for a while at a studio in Austria, and later established his own in Cologne specializing in portraiture. In 1911 he began to take photographs for what would become *People of the 20th Century*, an enormous portrait project which aimed to capture a cross-section of German society at the time. This photograph, taken in 1915, shows three young farmers in the Westerwald, the region where Sander was born. What appears to be a simple, candid photograph is actually a posed and highly complicated image.

A group of artists including Tristan Tzara found the Dada art movement in Zurich.

The first use of poison gas occurs at the Battle of Neuve Chapelle and the Second Battle of Ypres.

1915

J. W. Brooke – *Stretcher Bearers, Battle of Pilckem Ridge*

John Warwick Brooke (1886–1929) was a photographer for the Topical Press Agency, and was the second British official war photographer to go to the Western Front. In July 1916 the Third Battle of Ypres began, and continued until November of the following year. The Allies suffered 448,000 killed and wounded, and the Germans suffered 260,000 casualties. Despite the dangers of conflict and the restrictions and demands imposed on him (he worked through heavy rain and shelling), Brooke produced some of the defining photographs of the Western Front.

Elsie Wright – *The Cottingley Fairies*

In 1917 two young girls perpetrated a hoax which became a sensation and fooled thousands of people. Using a borrowed camera, cousins Elsie Wright (1901–88) and Frances Griffiths (1907–86) produced a series of images which appeared to show fairies near the stream at the bottom of the family garden in the north of England. The photographs became a *cause célèbre* of the spiritualist movement, drawing interest from admirers including the novelist Sir Arthur Conan Doyle and the spiritualist leader Edward Gardner. It wasn't until 1985 that Wright admitted the photographs had been faked.

The Russian Revolution
leads to the overthrow of the Romanov Dynasty and the start of the Russian Civil War.

The Easter Rising
takes place in Ireland.

1916

1917

DADAISM AND SURREALISM

Inspired by the experiments of Dadaism and Surrealism, photographers began to tap into a more psychological interpretation of images using a range of juxtapositions and post-production techniques to create disturbing yet powerful images that were intended to work in purely visual terms.

The experimental nature of the Surrealist and Dadaist movements led artists to experiment with how photography could be used to make expressive images that tapped into the unconscious, combining dreams and fantasy with a range of photographic techniques to create challenging and complex images that were intended to work visually without the need for text to support or explain them. In many ways this was a response to the horror of the First World War, and the breakdown in perceptions of normality that it brought about. By processing trauma through the subconscious, the Surrealists attempted to open up new interpretations of reality, either by combining strange and unsettling elements together or by discovering strange juxtapositions in the everyday banality of the real world. One of the earliest examples connecting photography with Surrealism was Man Ray's 1992 book, *Les Champs délicieux* ('The Delightful Fields'), in which he combined his rayographs with text by the influential Dada artist Tristan Tzara, while in works like *Cut with the Kitchen Knife Dada through the Last Weimar Beer-Belly Cultural Epoch in Germany* (1919), Hannah Höch used photomontage and collage to create politically changed yet impossible images that challenged perceptions with uncanny and unusual combinations of elements within the frame. Journals and publications became central to the movement, with the publication in 1924 of André Breton's *The Surrealist Manifesto* followed by a journal entitled *La Révolution Surréaliste*

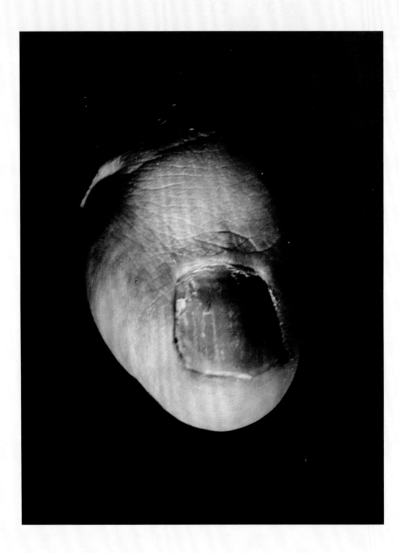

LEFT. Jacques-André Boiffard –
***The Big Toe* (1929)**
Jacques-André Boiffard (1902–61) met the Surrealist André Breton in 1924 while still a medical student, but, inspired by their encounter, he suspended his studies and began to work as a writer and then a photographer with the wonderfully titled Bureau of Surrealist Research. He became part of the group around the controversial writer Georges Bataille and his new publication *Documents*, for which Boiffard made this study for an essay written by Bataille entitled 'The Big Toe'. *Documents* combined high intellectualism with popular culture, and summed up its editorial policy by claiming that the 'most provoking as yet unclassified works of art and certain unusual productions, neglected until now, will be the object of studies as rigorous and scientific as those of archaeologists'. The image is striking in its abstraction, taking a usually ignored part of the human form and elevating it to the status of a dark sculpture, seemingly disembodied and floating in space.

that made extensive use of photographs, as did Georges Bataille's *Documents*. The work of Eugène Atget was championed for its depiction of the ordinary streets of Paris as latent with meaning, and acted as a link between the topographic photography of the nineteenth century and the Modernism of the twentieth, motivating later photographers to explore the strangeness of the ordinary, such as Dora Maar, whose *Père Ubu* (1936) depicting a baby armadillo created a simultaneously disturbing and compelling photograph. Henri Cartier-Bresson was also heavily influenced by the movement, with his early images in particular celebrating the energy of the everyday.

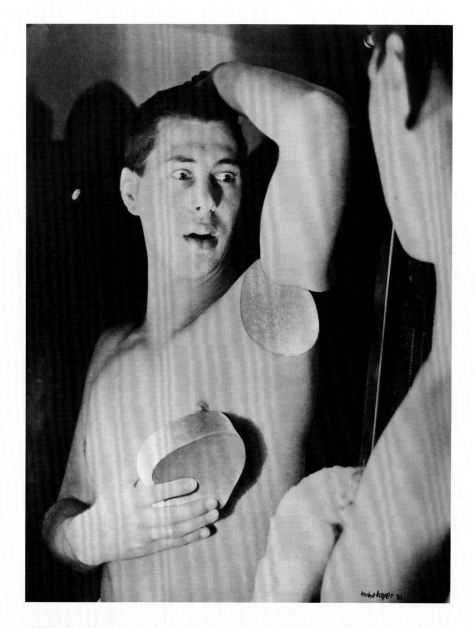

ABOVE. Herbert Bayer – *Humanly Impossible (self-portrait)* **(1932)**

Surrealist photographers often played with the visual expectations of the image, making visual puzzles and conundrums that surprised and challenged the viewer. Herbert Bayer's (1900–85) self-portrait is both humorous and disturbing, referencing classical sculpture but also the pain of amputee soldiers from the First World War. Taken from the series *Mensch und Traum* ('Man and Dream'), Bayer carefully painted over the original print of himself looking into the mirror, then airbrushed the image and re-photographed it twice to create the illusion. Bayer studied and then later taught at the Bauhaus, and was a creative polymath, who worked as an art director, graphic designer, painter and sculptor as well as a photographer.

1918–1920

The end of the decade sees the final stages of the First World War, and the struggle to deal with its aftermath. A series of decisive victories on the Western Front and a tightening blockade on German ports leads to revolution inside Germany, the abdication of the Kaiser, and the Armistice treaty of 11 November 1918, ending the conflict. Cameras in both private and official hands record each step, with an image emerging of a continent that has been battered and demoralized by four years of continuous conflict. In 1919 the Treaty of Versailles is signed, marking the official truce between Germany and Allied powers, and imposing severe reparations on Germany as punishment for its role in starting the First World War. These momentous developments give rise to an array of social changes, including reform to child employment laws in the United States, spearheaded by the photography of Lewis Hine, and votes for women, documented by an array of photographers including the United Kingdom's first female photojournalist, Christina Broom. LB

Arthur Mole – *The Human American Eagle*

Arthur Mole (1889–1983) was born in the United Kingdom but emigrated to the United States, where he worked as a commercial photographer. Today he is remembered for a series of 'living photographs', in which thousands of soldiers were positioned into massive formations which, when photographed from 25 m (80 ft) above, formed recognizable images. Mole's subject matter was invariably patriotic, with images of the Statue of Liberty, Uncle Sam, and in this case an American bald eagle, which was created from 12,500 officers, nurses and men at Camp Gordon, Atlanta. Planning these arrangements required weeks of preparation, followed by hours positioning people.

The First World War ends.

Mehmed VI becomes the last Sultan of the Ottoman Empire and the last Caliph.

1918

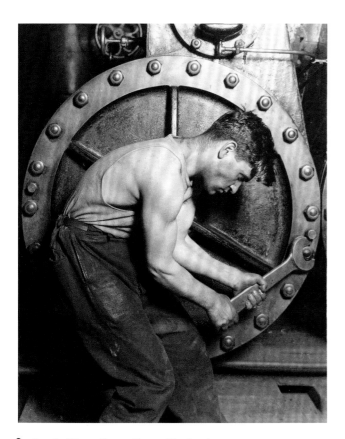

Lewis Hine – *Power House Mechanic Working on Steam Pump*

A sociologist by training, Lewis Hine (1874–1940) viewed the camera as a research tool and as a means of advocating for social reform. He is probably best remembered for an extended project he undertook to publicize the extent of child labour in the United States. This photograph of a mechanic was carefully constructed, intended to celebrate the workers who were increasingly diminished by mechanization. The image is ambiguous, however, and the mechanic appears both contained by the shape of the machine, and to be fighting against it.

Houdini and the Ghost of Abraham Lincoln

The early twentieth century saw a marked revival in spiritualism, manifested in the genre of spirit photography, which appeared to reveal supernatural forces and apparitions. These photographs were in fact often created by unscrupulous mediums and photographers looking to exploit public interest for their own economic gain. During this time the escapologist and performer Harry Houdini began a personal crusade to debunk these mediums and psychics. This image, which appears to show Houdini conversing with a deceased US President, was created as a demonstration of quite how easy it was for a skilled photographer to create spirit photographs.

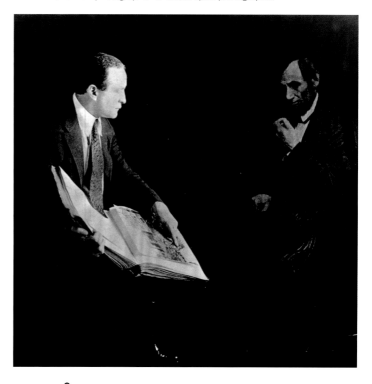

Walter Gropius founds the Bauhaus school in Weimar.

The Treaty of Versailles imposes harsh reparations on Germany.

Prohibition of the sale of alcohol begins in the United States.

1919

1920

1921-1923

The early 1920s are a period of tumultuous change and a new post-war political order, but they also see a flourishing in art and culture, not least in photography. Avant-garde art movements emerge across Europe, with hotspots in Paris, where the Surrealists use photography to tap the creativity of the unconscious mind, and in Berlin, where the Dada group use photography and collage to critique the new democratic society and consumer culture that has taken the place of the conservative German Empire. At the same time in Germany the demands of reparations from the First World War and a politically weak government lead to economic problems and a period of massive hyperinflation, with currency losing value faster than people are able to spend it. This event discredits the democratic government and leads to growing public support for the political extremes of right and left. In Russia the Civil War reaches its conclusion, with victory for the Bolshevik revolutionaries pushing pro-Tsarist supporters into exile. LB

Man Ray – *Rayograph*

Man Ray's (1890–1976) life and career as an artist were typified by constant reinvention. Born in the United States, he spent much of his life in France, where he was associated with the Surrealist and Dada movements. He was primarily a painter but worked across a wide variety of media including sculpture and photography. Among his many innovations was the popularization of photograms (or 'rayographs' as he named them) – a technique for creating images without a camera by placing an assortment of objects on light-sensitive paper, and then exposing that paper to direct light.

Mussolini comes to power in Italy following his march on Rome.

Adolf Hitler becomes leader of the German Nazi Party.

1921　**1922**

○ **Paul Outerbridge – *Ide Collar***

Paul Outerbridge (1896–1958) began to work as a photographer after being discharged from the United States army in 1921, soon attracting *Vanity Fair* and *Vogue* as regular clients. At the same time, he also maintained an artistic photographic practice which brought him into contact with figures including Edward Steichen, Marcel Duchamp and Berenice Abbott. This photograph was the result of his first advertising assignment, and was published in *Vanity Fair*. Outerbridge went on to become a pioneer of colour photography, as well as producing nude photographs regarded as indecent at the time, many of which remained unexhibited until after his death.

Testing a Bulletproof Vest

Photography was widely used in vernacular advertising to provide visual evidence of the quality of goods and services, perhaps no more arrestingly than in this demonstration of the efficacy of a newly patented bulletproof vest. The original caption stated 'W. H. Murphy of the Protective Garment Corp. of New York stood less than ten feet [3 m] from (Frederick County, Md.) Deputy Sheriff Charles W. Smith in police headquarters Wednesday and let the deputy fire a .38 caliber revolver straight at his chest. When the bullet hit, Murphy never batted an eye.' Photography's potential value to advertisers was widely promoted by journals such as *American Photographer*, *Abel's Photographic Weekly* and *Commercial Photographer*, with the Photographers' Association of America claiming that potential buyers 'believe what the camera tells them because they know that nothing tells the truth so well'.

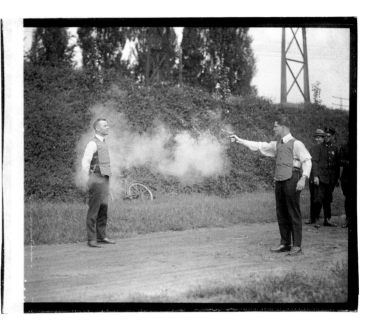

James Joyce publishes *Ulysses*.

The Union of Soviet Socialist Republics, the world's first communist state, is formed.

Kemal Atatürk becomes the first President of the Republic of Turkey.

1923

FASHION

The rise of the fashion magazine in the early twentieth century created a new market for photographers to use their creativity in myriad ways to explore the human form draped in the latest designer clothing.

Fashion as a genre has drawn many of the greatest photographers, attracted by the aesthetic opportunities of the combination of beautiful models, large budgets and creative freedom to create striking images in an incredible range of styles, from naturalist to fantastical. Edward Steichen's photographs of the dresses of couturier Paul Poiret, published in 1911 in *Art et Décoration*, marked one of the first publications of photographs in a fashion magazine, and the rise of *Vogue* and *Harper's Bazaar* soon afterwards generated a huge market for images, employing Steichen, Baron Adolph de Meyer, Horst P. Horst and George Hoyningen-Huene to create striking and meticulously composed photographs that combined advertising with art. Cecil Beaton was given free rein to indulge his fantastical vision, creating elaborately staged and constructed photographs, foreshadowing his work as a set designer for films such as *My Fair Lady*. In the post-war period, a new aesthetic of naturalism was pioneered by photographers such as William Klein and Richard Avedon, who took the models out of the studio and into the streets to create dynamic images full of lively energy. In the 1980s Nick Knight's work with *i-D* magazine and his collaborations with designer Yohji Yamamoto combined a strong sense of form and graphics with a stunningly original use of colour. The 1980s also saw the rise of the supermodel, with Herb Ritts' celebrated image *Stephanie, Cindy, Christy, Tatjana, Naomi, Hollywood, 1989* helping to define the style of the decade. The 1990s saw a more documentary approach emerging, with Corinne Day's collaboration with Kate Moss published in *The Face* in 1990 establishing both of them as the defining arbiters of the 'grunge' style.

ABOVE. George Hoyningen-Huene–*Divers, Horst with model, Paris* **(1930)**
George Hoyningen-Huene (1900–68) became chief photographer for *Vogue* in 1926, where he was celebrated for his stylish studio images, rich with allusions to classical art. He brought these sensibilities to this dreamy image, which despite appearances was not shot on a beach in the South of France, but was in fact made on the roof of the *Vogue* office in Paris, with clever composition creating the illusion. The photograph is also notable because the male model was Hoyningen-Huene's lover, fellow photographer Horst P. Horst.

LEFT. Horst P. Horst–*Mainbocher Corset* (1939)
Horst P. Horst's (1906–99) career spanned six decades, establishing his reputation as one of the great fashion photographers, working for both the French and American editions of *Vogue*. This memorable image was taken in Paris just before he fled the rise of Nazism for America, recalling that 'it was the last photograph I took in Paris before the war. While I was taking it, I was thinking of all that I was leaving behind.' His visual influences in Greek sculpture and the Surrealism of Man Ray and Salvador Dalí resonate in the composition and wit of the image. The latent eroticism of the photograph became the inspiration for the video for Madonna's 1990 song 'Vogue'.

David Bailey (1938–)

David Bailey is one of the archetypal fashion and portrait photographers, and his graphic, clean aesthetic and irreverent sense of humour came to dominate the look of the 1960s and 1970s. Bailey joined British *Vogue* in 1960, and in his heyday shot more than 800 pages of images for the magazine in one year. Together with Terence Donovan and Brian Duffy, he helped to establish London as the centre of the 'Swinging Sixties', with his iconic portraits of celebrities such as Michael Caine, Terence Stamp, the Beatles and the Rolling Stones, and launched the career of his muse and girlfriend, fashion model Jean Shrimpton.

1924–1926

Momentous changes in world politics continue to occur throughout the mid-1920s, with new photographic technologies emerging to document them. The Ermanox camera is introduced in 1924. It uses miniature photographic plates and a lens capable of operating in low light, allowing photographers to capture photographs quickly and in places they would previously not have been able to. The following years see the introduction of the Leica 1, a still more revolutionary camera which employs 35 mm film in a compact form, enabling photographers to take many photographs without reloading. Related technologies continue to evolve with the first television image created by the Scottish scientist John Logie Baird in 1925, an innovation which hints at the possibilities of photography without film. The far right gain momentum worldwide, with Hirohito becoming Japanese emperor, Mussolini gaining dictatorial powers in Italy, and Adolf Hitler publishing *Mein Kampf*, an autobiographical political manifesto, in Germany. LB

Man Ray – *Ingres' Violin*

The Surrealist artist Man Ray was a consummate experimenter who employed a wide range of media in often surprising ways to create his artworks. That was particularly true of photography, which he approached in anything but a conventional way. Inspired by the nudes of painter Jean-Auguste-Dominique Ingres, Man Ray produced a series of photographs of Kiki de Montparnasse, an actress, singer and artist's muse. Painting the f-holes of a violin on to the photographic print, Man Ray then re-photographed it to create this final image. The photograph is visually surreal, and also somewhat disquieting. The title hints at Ingres's favourite musical pastime, and also suggests that in contrast Man Ray's favourite instrument or plaything is Kiki herself. In this way it raises subtle tensions about the line between appreciation and objectification, and the relationship between an artist and their muse.

The death of Vladimir Lenin triggers a power struggle between Leon Trotsky and Joseph Stalin.

André Breton publishes the first *Surrealist Manifesto*.

1924

Tina Modotti – *Workers' Parade*

Tina Modotti (1896–1942) was born in Italy and later
emigrated to the United States. She worked in a number
of roles as an actor and model, and began a relationship
with the photographer Edward Weston, with whom she
later moved to Mexico. Photography, always a part of
Modotti's life, became increasingly important to her during
this time, and while she left a relatively small body of work
at the time of her death, she is remembered for the way
she combined her work as a photographer with strong
political convictions, and her later work as an activist with
the international communist movement, the Comintern.
This photograph, which depicts a workers' march in Mexico
City, exemplifies Modotti's combination of formal rigour with
documentary impulse and political agenda.

László Moholy-Nagy – *Fotogramm*

The American photographer Man Ray was not the only artist to pioneer and
experiment with the photogram, a technique for creating photographs without a
camera by laying objects directly on to photographic paper. The Austro-Hungarian
artist László Moholy-Nagy (1895–1946) also experimented with them extensively
around the same time. Moholy-Nagy was fascinated by the properties of light, and
much of his creative output also focused on the relationship between the arts and
the new industrial and scientific technologies like photography. Moholy-Nagy's
photograms, which often use mechanical objects and angular forms, can be seen
as a combination of these two pursuits.

The Leica camera is introduced,
using the 35 mm film format
originally designed for cinema.

The first television image is
created by John Logie Baird.

Hirohito becomes
Emperor of Japan.

1925

1926

1927–1929

The 1920s come to an end with photography reaching new levels of maturity as an art form and as a technology. In 1929 the exhibition 'Film and Photo' opens in Stuttgart, Germany, bringing together one of the most extensive collections of modern photography of the time, and linking photography to the emerging field of cinematography in a way that is highly innovative. In the same year the Rolleiflex camera is launched. Using medium-format roll film in a compact form, it becomes widely used by photographers. In science and technology more broadly, Charles Lindbergh makes his first flight across the Atlantic, Alexander Fleming discovers the antibiotic penicillin, and *The Jazz Singer*, the first film with sound, is released. In the Soviet Union Joseph Stalin becomes leader. Finally, 1929 sees the prosperity of the 'roaring twenties' come to a sudden end with the Wall Street Crash and the start of the Great Depression in the United States – a period of mounting unemployment, inflation and economic stagnation. LB

Heinrich Hoffmann – *Hitler Rehearsing a Speech*

After training as a photographer, Heinrich Hoffmann (1885–1957) ran a photography shop in Munich. Following service in the First World War he joined a right-wing Bavarian group, and in 1919 met Adolf Hitler and became a member of the recently created Nazi Party. Shortly afterwards, Hitler took control of the party and Hoffmann was named his official photographer, a post he would hold until the end of the Second World War. This photograph was part of a series of nine taken by Hoffmann and intended to help Hitler refine the flourishes and gestures that were key to his speaking style. Hitler reportedly asked Hoffmann to destroy the photographs, but the photographer disobeyed, providing a chilling insight into the way Hitler meticulously constructed his public image.

The global population
reaches two billion.

Virginia Woolf publishes
To the Lighthouse.

Frank Whittle
develops the
concept behind
the jet engine.

1927

László Moholy-Nagy – *Berlin Radio Tower*

Like other artists of the time Austro-Hungarian artist László Moholy-Nagy did not restrict himself to a single medium and experimented tirelessly with sculpture, painting and photography. From 1923 he taught at the Bauhaus school, leaving in 1928 to live in Berlin. This photograph was taken from Berlin's radio tower, a major landmark completed two years earlier. As well as the radio tower itself being emblematic of Moholy-Nagy's interest in new technologies, the downward view makes the furniture on the ground below almost unrecognizable, resembling one of Moholy-Nagy's abstract paintings.

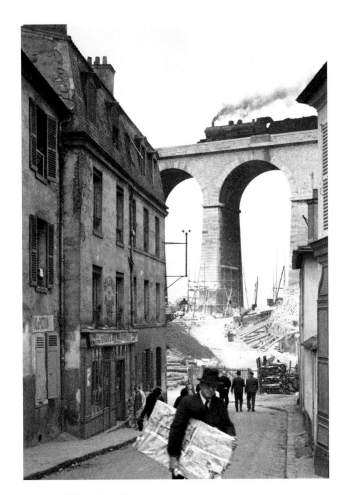

André Kertész – *Meudon*

Born in Hungary and destined for a career as a stockbroker, André Kertész (1894–1985) discovered photography while in his teens and showed a prodigious talent. He emigrated to Paris in 1925 and began to establish a reputation there. Of all his photographs this one is probably the most referenced. While apparently a photograph in the style of what Cartier-Bresson would later term 'the decisive moment', the photograph was in fact quite consciously set up by Kertész, who stood at this spot over an extended period waiting for just the right compositional elements to converge.

Alexander Fleming
discovers penicillin, revolutionizing the treatment of infection.

The Wall Street Crash
marks the start of the Great Depression.

1928

1929

PHOTOMONTAGE

Combining several images to make one photomontage was a technique invented almost as soon as the medium began. Often used to comment on social and political life, photomontage played a vital role in the inter-war period in challenging the rise of fascism, and again during the Cold War in protest against militarization and the arms race.

In the nineteenth century, the art of photographic collage quickly became popular as a way of extending the potential of the medium to create fantasies. A fine example of this trend can be seen in the numerous scrapbook albums produced by educated, society Victorian ladies such as Eva Macdonald of Brocklesbury and Mary Caroline, Lady Filmer. They combined cut-and-pasted photographs with hand drawings and watercolours to comment on their lives and on the social mores and values of the day. These fascinating albums now offer a rich source of insight into the everyday role photography played at the time, and are arguably an early form of social media and self-expression. The technique was further developed into a political weapon by the artist George Grosz, who recalled that 'When John Heartfield and I invented photomontage in my South End studio at five o'clock on a May morning in 1916, neither of us had any inkling of its great possibilities, nor of the thorny yet successful road it was to take. As so often happens in life, we had stumbled across a vein of gold without knowing it.' Heartfield and Grosz were

LEFT. John Heartfield – *Millions Stand Behind Me* (1932)
John Heartfield was especially adept at poking fun at the Nazis by subverting their own iconography and symbolism, as in this cover of *AJZ* entitled *Millions Stand Behind Me*. Heartfield alludes to the fact that Hitler was financed by a wealthy businessman who saw in him a means to solve labour problems being created by left-wing organizations like the German Communist Party.

Peter Kennard (1949–)

Peter Kennard is a British artist and educator whose work has dealt with highly charged political issues ranging from poverty and inequality to the recent wars in Iraq and Afghanistan. He often subverts newspaper imagery with an overt political message. His best-known photomontages were made in protest against conflict and nuclear war, often in alliance with groups such as the Campaign for Nuclear Disarmament (CND). One of his most powerful images reworks John Constable's famous painting as *Haywain with Cruise Missiles* (1980), while another entitled *Photo Op* (2003) depicted Tony Blair taking a selfie against a backdrop of burning oil during the Iraq War.

among a number of Dadaist and Surrealist artists who critiqued German society after the First World War. At almost the same time, Russian Constructivist artists such as Alexander Rodchenko, El Lissitzky and the husband-and-wife team of Gustav Klutsis and Valentina Kulagina created innovative and graphically powerful photomontage work as propaganda for the Soviet regime.

The technique involved taking original photographs, some specially shot in the studio but others taken from the press, carefully cutting them out with scissors and knives, and then sticking them down on to a sheet of card to create the composition. The composite image was then re-photographed to make a finished print that could be published.

During the Cold War period the approach saw a revival in the works of Martha Rosler – whose series 'Bringing the War Home' critiqued US involvement in Vietnam and the 'television war' – and Peter Kennard's vicious commentary on the Thatcher years and the threat of nuclear war.

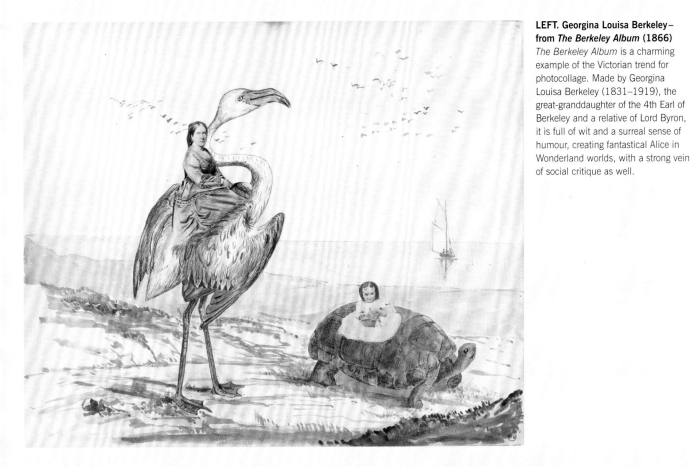

LEFT. Georgina Louisa Berkeley – from *The Berkeley Album* (1866)
The Berkeley Album is a charming example of the Victorian trend for photocollage. Made by Georgina Louisa Berkeley (1831–1919), the great-granddaughter of the 4th Earl of Berkeley and a relative of Lord Byron, it is full of wit and a surreal sense of humour, creating fantastical Alice in Wonderland worlds, with a strong vein of social critique as well.

1930-1932

The start of the 1930s is marked by economic chaos in some countries, and bold construction and development projects in others. The consequences of the Wall Street Crash are felt widely as the Great Depression takes hold across much of the world. In the United States economic stagnation combines with ecological disaster as large areas of the Midwest suffer droughts, dust storms and soil erosion. In Germany the economic consequences are similarly dire, and the inability of the democratically elected government to solve the crisis leads a growing number of people to side with politically extreme groups. By contrast, in the Soviet Union a massive project of construction is under way, modernizing and industrializing what had previously been a largely agrarian economy. Many of these projects are documented by Soviet photographers and featured in the publication *USSR in Construction*, a lavish magazine published in four languages and featuring designs and layouts by avant-garde designers such as Alexander Rodchenko. LB

The first issue of
USSR in Construction
is published in Russia.

Wanda Wulz – *Cat and Me*
Born in Trieste, Italy, Wanda Wulz's (1903–84) father and grandfather were both local commercial photographers. When her father died, Wulz took over running his studio and began to work as a photographer, while also experimenting extensively with the medium. She became associated with, and exhibited with, members of the Italian Futurist movement, who championed new technologies like photography and film, although she later drifted away from the movement as it became increasingly linked with militarism and fascism. In this photograph, certainly her best known, Wulz merges a portrait of herself with one of the family cat, to create a strange, dream-like self-portrait.

The Salt March, led by Mahatma Gandhi, marks the official start of civil disobedience in British India.

The Chinese Soviet Republic is proclaimed by Mao Zedong.

1930

1931

Brassaï – *Paris*

Gyula Halász, better known as Brassaï (1899–1984), was born in Hungary and studied painting, an education which he continued in Berlin and Paris. Here he discovered photography, which provided a source of income but which Brassaï also combined to great effect with his other passion, exploring Parisian night life. In particular he is remembered for his photographs of its seedier side. Gaining entry to brothels and illicit clubs through friends, he would spend many nights at these place before actually photographing anything, waiting until people became used to his presence. Many of these photographs were published in his classic 1933 book *Paris de Nuit*.

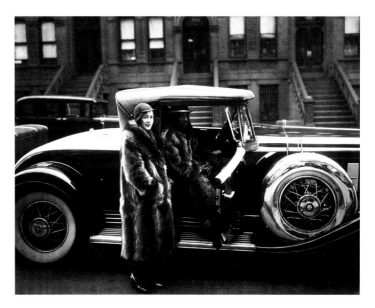

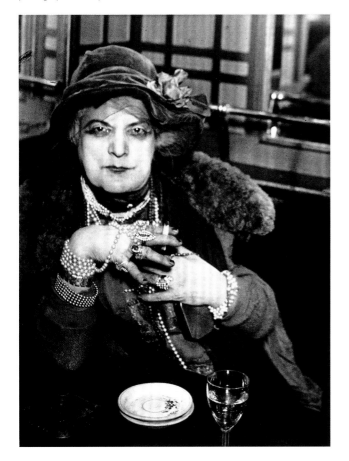

James Van Der Zee – *Harlem*

As a young man James Van Der Zee (1886–1983) found work in a photographic studio, first working in the darkroom before later taking over as photographer. In 1916 he established a studio of his own in Harlem, New York and during this time also widely photographed in the area, becoming a key figure in what later became known as the Harlem Renaissance. Today he is particularly remembered for the photographs he created of an emergent African American middle class, perhaps exemplified by this image of an affluent couple wearing raccoon coats and standing by a fashionable car. While it has sometimes been suggested that the image was staged by Van Der Zee, the message it sought to convey was unmistakable, and this image became something of a touchstone for African Americans dreaming of greater affluence.

The Nazi Party becomes the largest single party in the German Parliament.

1932

1933–1935

The consequences of the Great Depression continue to make themselves felt in the middle of the decade. In the United States, the government creates the Farm Security Administration, aimed at alleviating the crisis. As part of this project an innovative photography programme is established to document relief efforts, and employs a roster of important photographers including Dorothea Lange, Walker Evans and Gordon Parks. In Europe the far right continue to grow in power. In Germany, following two inconclusive elections, President Paul von Hindenburg appoints Adolf Hitler, leader of the Nazi Party, as Chancellor of Germany. In the two years following, Hitler gives himself dictatorial powers and introduces the Nuremberg race laws, which pave the way for the Holocaust. Hundreds of thousands of people flee Germany, including photographers and artists like Robert Capa and John Heartfield. Emigrating to countries like the United Kingdom and United States, they bring the influence of continental art with them. LB

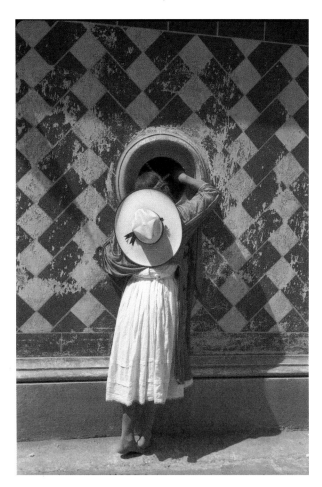

Manuel Álvarez Bravo – *Daughter of the Dancers*

Born in Mexico City into an artistic family, Manuel Álvarez Bravo (1902–2002) studied art and gradually became interested in photography. In 1927 he met Tina Modotti and Edward Weston, who had recently arrived in Mexico and whose encouragement had a significant influence on him. Bravo's career as a photographer developed from here, and coincided with the period after the Mexican Revolution, as the government attempted to promote an image of Mexico which synthesized both history and modernity. This photograph shows Bravo's talent for avoiding stereotypes often associated with his country, while at the same time blending elements of documentary with ideas drawn from art movements like Surrealism and Cubism.

Adolf Hitler is appointed Chancellor of Germany.

1933

Hans Bellmer – *The Doll*

Born in Germany and trained a draughtsman, following the rise of the Nazi Party to power Hans Bellmer (1902–75) initiated the creation of a series of works based around highly distorted dolls. A strident opponent of Nazism, his dolls are often interpreted as an intentional rejection of the cult of physical perfection celebrated by the Nazi regime, as well as being influenced by the plot of Jacques Offenbach's opera *The Tales of Hoffmann*, in which the main character falls in love with a life-sized doll. Bellmer produced a series of photographs based on this doll, which were published in the Surrealist publication *Minotaure*.

Margaret Bourke-White Atop the Chrysler Building

Margaret Bourke-White (1904–71) initially studied zoology but became increasingly interested in photography. Soon after graduation she established a studio and began to earn a reputation as a commercial photographer working in dangerous environments like the steel industry. In 1929 she took a position as a staff photographer at *Fortune* magazine and soon had a string of photographs to her name. She left in 1935 for a position at *Life*, and was one of the few Western photographers allowed access to the Soviet Union to document its development, and one of very few female war correspondents during the Second World War.

Bank robbers and cultural icons Bonnie and Clyde are shot to death in a police ambush.

Lev Vygotsky publishes *Thought and Language*.

The Second Italo-Abyssinian War concludes with the exile of Haile Selassie and the conquest of Abyssinia by Benito Mussolini.

1934

1935

GROUP ƒ.64

Group ƒ.64 promoted the idea that photography should be take a straight approach, claiming that 'Pure photography is defined as possessing no qualities of technique, composition or idea derivative of any other art form.'

The group first identified itself in 1932 at a show at the M. H. de Young Memorial Museum in San Francisco with the following statement: 'The name of this Group is derived from a diaphragm number of the photographic lens. It signifies to a large extent the qualities of clearness and definition of the photographic image which is an important element in the work of members of this Group.' The name ƒ.64 referred to the minimum aperture of a large-format camera lens, which gives photographs taken at that setting incredible depth of field and detail. Based in the Bay Area, the collective was unusual in that it was one of the earliest art movements to be defined by women as much as men, including Dorothea Lange, Imogen Cunningham, Consuelo Kanaga, Alma Lavenson and Sonya Noskowiak in its eventual membership as well as Ansel Adams, John Paul Edwards, Preston Holder, Henry Swift, Willard Van Dyke, Brett Weston and Edward Weston. Their work was Modernist in form, characterized by a sharp focus and clean aesthetic, and defined as 'straight photography' that ran counter to the Pictorialist genre popular at the time. In 1935 the impact of the Great Depression combined with Weston moving to Santa Barbara and Van Dyke to New York led to the dissolution of the group, but its members continued to define American and international photography for decades to come.

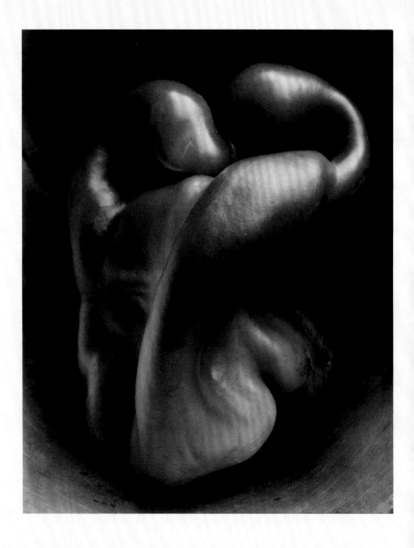

RIGHT. Edward Weston – *Pepper No. 30* (1930)
Although he originally fell under the influence of Alfred Stieglitz and the Pictorialists, Edward Weston (1886–1958) began to seek 'the stark beauty that a lens can so exactly render presented without interference of artistic effect'. In 1926 he began to explore how natural forms such as seashells and cabbages could produce sculptural photographs. Working with daylight and a 10 x 8 camera, he wrote in his *Daybooks*: 'I have done perhaps fifty negatives of peppers: because of the endless variety in form manifestations, because of their extraordinary surface texture, because of the power, the force suggested in their amazing convolutions. A box of peppers at the corner grocery hold implications to stir me emotionally more than almost any other edible form, for they run the gamut of natural forms, in experimental surprises.'

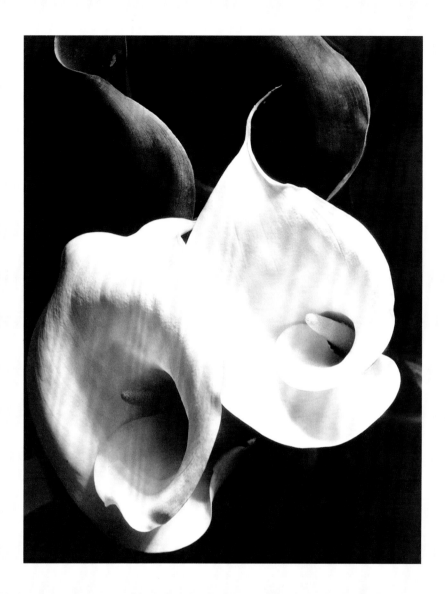

Imogen Cunningham's (1883–1976) range of subjects and approaches was extensive, and included nudes and portraits, landscapes and, as in this beautiful study, plants. She was a great role model, becoming one of the first women to open a photographic studio in 1910, and in 1913 publishing *Photography as a Profession for Women* to encourage other women to join her as professionals. She was a central figure in the *f*.64 group, with Edward Weston writing of her that 'She uses her medium, photography, with honesty – no tricks, no evasion: a clean-cut presentation of the thing itself, the life of whatever is seen through her lens.'

Ansel Adams (1902–84)

Ansel Adams was one the greatest exponents of the craft of photography, who demonstrated complete mastery of the technical and aesthetic aspects of the medium. Working mostly in black and white, he used large-format cameras that allowed him complete control over the developing and printing of each single sheet of film. He noted that the 'negative is comparable to the composer's score and the print to its performance. Each performance differs in subtle ways.' He was also a tireless campaigner for the preservation of the natural wildernesses of America, in particular Yosemite National Park, and the rest of the National Park system. His dramatic images of the vast vistas of the mountains and forests depicted the magnificence of nature with a sublime sense of beauty.

1936–1938

The aftermath of the Great Depression and conflicts between the political right and left continue, with the start of the Spanish Civil War.

The Civil War is arguably the first modern war in a news sense, with an international press corps descending on Spain to report events in this complex and rapidly changing conflict. Many of the major European news agencies send photographers to cover the conflict, alongside freelance photojournalists Robert Capa, David 'Chim' Seymour and Gerda Taro. The new compact cameras like the Leica and Contax enable these photographers to get closer to events than ever before, leading to the emergence of a new style of conflict photography completely unlike that seen during the First World War. Photographic and film technology continues to evolve meanwhile, with Kodak introducing one of the first colour transparency films to the market, and in 1937 Disney releases *Snow White and the Seven Dwarfs*, the first feature-length animated movie. LB

The Spanish Civil War begins.

○ **Robert Capa–*Loyalist Militiaman at the Moment Of Death,
Cerro Muriano, September 5, 1936***

Born in Hungary, Endre Friedmann (better known as Robert Capa, 1913–54) moved to Berlin, where he worked as a darkroom assistant and then as a photographer for the Dephot photographic agency. From 1936 Capa documented the fighting between the Republican and Nationalist sides of the Spanish Civil War, a conflict which this image perhaps more than any other has come to typify. Originally described as showing a Loyalist or Republican militiaman at the moment of being hit by a bullet, doubts have been raised about its authenticity since 1975, with research by a number of scholars suggesting that it is highly likely that the image was staged or miscaptioned by Capa.

1936

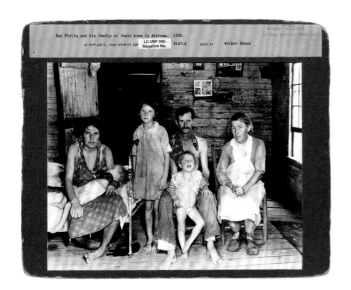

Walker Evans – *Let Us Now Praise Famous Men*

After travelling in Europe and working briefly in the stock market, Walker Evans (1903–75) took up photography in 1928. Following the start of the Great Depression he worked for the Farm Security Administration as part of its photographic unit. In 1936 Evans received leave from the FSA to undertake an assignment about impoverished families in the American South. Working closely with the writer James Agee, the piece grew into a book combining images and text, titled *Let Us Now Praise Famous Men*. While the book initially struggled to sell, it has since been reassessed as an important, ambitious work which challenged approaches to reporting, documentation and the relationship between photographs and words.

Margaret Bourke-White – *The Louisville Flood*

Having established her reputation as one of the leading photojournalists of her day during her period at *Fortune* magazine, in 1936 Bourke-White left for a position at *Life* magazine, where she remained for the rest of the decade. This photograph was produced while on assignment covering the consequences of the 1937 Ohio River flood, one of the largest natural disasters in American history at the time, which devastated the town of Louisville, Kentucky. This photograph depicts African American flood victims waiting for aid, and contrasts their looks of resigned exhaustion with the beaming smiles on an advertising hoarding behind them in order to reveal the still enormous gap between the public image of the United States and the reality on the ground.

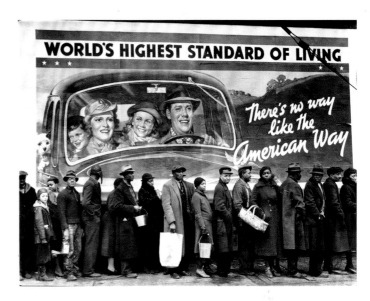

Pablo Picasso paints *Guernica*, a monumental tribute to a town bombed by German aircraft allied to the Nationalist cause during the Spanish Civil War.

The Anschluss unifies Germany and Austria, and the Munich Agreement hands Czechoslovakia to Nazi Germany.

1937

1938

1939–1941

The last years of the 1930s see the end of one heavily photographed conflict and the start of a new one.

In Spain the Civil War concludes with victory for the Nationalists, bringing Francisco Franco to power as dictator. In 1939, following a secret pact, Nazi Germany and Soviet Russia invade and divide Poland, triggering the Second World War. The following year much of Europe falls to Nazi Germany, whose army pioneers the use of photography and film as a battlefield weapon, using specially trained combat camera crews to record stills and footage, which are then used in propaganda newsreels. The image created of unstoppable German tanks and troops marching across Europe has a significant psychological value. Numerous civilian and army photographers are at the front lines of the war's succession of campaigns, marking a remarkable shift from the small number of heavily restricted photographers active during the campaigns of the First World War. LB

The Spanish Civil War ends, and Francisco Franco becomes dictator of Spain.

Lisette Model – *Reflections, New York*

Born in Vienna, Lisette Model (1901–83) studied music (including with the composer Arnold Schönberg) and later emigrated to Paris to train as a singer. Here she became interested in the visual arts and was introduced to photography through her sister Olga. Model developed a distinctive style of street photography during this time, characterized by close-cropped and unsentimental images. In 1937 she moved to the United States and worked for magazines while also continuing to develop her street photography. During the McCarthy era Model was blacklisted, and as her magazine work dried up she increasingly made a living from teaching, influencing several generations of photographers through her work at the New School.

1939

Anton Bruehl – *Vogue*

Anton Bruehl (1900–82) was born in Australia, trained as an engineer and moved to the United States. In 1926 he established a commercial studio specializing in elaborately constructed tableaux. He was in demand throughout the 1920s and 1930s, particularly by fashion title *Vogue*. Working with the colour specialist Fernand Bourges, Bruehl developed an innovative form of colour photography using four photographic plates which corresponded to each of the four colours of the CMYK printing process.

Fred Morley – *Delivery After A Raid*

The Battle of Britain in 1940 marked both the first military campaign to take place almost exclusively in the air, and also the first major defeat for the military of Nazi Germany. As the outcome became increasingly clear, daytime bombing raids on airfields gave way to comparatively random night-time bombing of urban areas, a period known as the Blitz. London was bombed for fifty-seven consecutive days, the aim being to demoralize the population, but the response was often one of quiet stoicism and an attitude that life should continue amid the chaos. This photograph was taken on 9 October, the morning after one such raid, and characterizes precisely this feeling. However, according to some accounts, the photograph was staged, with Morley's assistant standing in for the role using borrowed props.

Nazi Germany invades **France**, the Netherlands, Denmark and Norway.

Olivier Messiaen composes the *Quartet for the End of Time*.

Japan attacks Pearl Harbor naval base, leading the United States to join the war.

Nazi Germany invades the Soviet Union.

1940

1941

ARCHITECTURE

Spaces have a presence, containing the traces of those who built them and occupy them, often long after those people have passed into memory and history. From Frederick H. Evans's *Sea of Steps* to Walker Evans's engagement with the vernacular architecture of churches in America, to the Bechers' meticulous cataloguing of industrial forms, photographers have been fascinated with exploring how buildings can be used to represent society. The highly influential exhibition 'New Topographics: Photographs of a Man-Altered Landscape' of 1975 marked a key moment in combining landscape photography with a sense of how humans' thirst for development and relentless expansion of buildings were affecting the environment, and launched the movement of the same name that included the photographers Robert Adams, Lewis Baltz, Joe Deal, Frank Gohlke, Nicholas Nixon and Stephen Shore. The conceptual artist Thomas Demand, however, challenges our sense of what is real with his extended series of images that range from domestic spaces to seats of government power, all underpinned with social or political subtexts. The photographs appear to be of real architectural spaces but are in fact images of painstaking re-creations of real rooms made as models that he then carefully re-photographs. In *Presidency I*, 2008, he built a replica of the Oval Office at the White House, which at first sight appears totally convincing, but then reveals small inconsistencies that create a disturbing, uncanny effect for the viewer.

The camera has provided an ideal tool to explore the 'poetics of space', working with light and shade to give a sense of volume and three-dimensionality to buildings and interiors.

LEFT. Julius Shulman–*Case Study House #22* (1960)
Julius Shulman's (1910–2009) precisely composed images of iconic buildings by architects such as Frank Lloyd Wright and Charles Eames came to define the clean lines and formal beauty of the modernist architecture of the west coast of America. Shulman was adept at situating the buildings in the context of the landscapes they inhabited, perhaps most perfectly in this acclaimed photograph of the Stahl House, designed by Pierre Koenig, with its floor-to-ceiling glass walls overlooking the city of Los Angeles. The image helped to make the house famous, and it has been used in numerous movies, fashion and advertising campaigns, and became a Historic-Cultural Monument in 1999.

**RIGHT. Charles Sheeler—*Criss-crossed Conveyors,
River Rouge Plant, Ford Motor Company* (1927)**
Charles Sheeler (1883–1965) was an artistic
polymath, and a leading light of the American
Precisionist style of painting that sought to render
the landscape of urbanism in sharply defined
geometrical forms. He was also an acclaimed
photographer of industry and architecture, with
a meticulous eye for detail and for finding patterns
of light and shade to give the buildings he
photographed the illusion of volume and depth.
This image was the result of a six-week-long
commission by the Ford Motor company to promote
the launch of the new Model A automobile, but
transcended the original commercial intent to
become a symbol of the industrial might of the
United States.

Robert Polidori (1951–)

Canadian photographer Polidori has been fascinated by the way that interiors can retain
a sense of their inhabitants and the passage of time. Using a large-format film camera,
he has meticulously documented a wide range of architectural subjects, from the
restoration of the Château de Versailles and the decayed grandeur of Havana, Cuba, to
the devastated landscapes of Chernobyl and the tragic aftermath of Hurricane Katrina in
the city of New Orleans. He has characterized his approach as trying 'to deliver up to
some surface an epitome of something that occurred as an instant in the continuum of
time, and to somehow how have it represent all of time'.

1942–1944

A turning point in the course of the Second World War comes in 1942, with the Axis powers suffering important defeats, including at the Battle of Midway and the Battle of Stalingrad. Having recently entered the war, the United States brings with it huge industrial resources, waging war in the Pacific against Japan, a brutally violent campaign documented by photographers such as Joe Rosenthal and W. Eugene Smith. In 1943 the United States, United Kingdom and Soviet Union agree to launch a massive re-invasion of Europe. The following year Operation Overlord is launched, landing thousands of troops on the beaches of Normandy, and along with them photographers such as Lee Miller, Margaret Bourke-White and Robert Capa. Meanwhile, behind the front lines ordinary people make use of the wide availability of camera equipment, despite wartime restrictions, to document daily life, or in some cases to record war crimes and atrocities as evidence for the future. LB

Kodak launches Kodacolor, the first colour film that yields negatives for making colour prints on paper.

The German V-2 rocket becomes the first human-made object in space.

The Battle of Stalingrad begins in Russia.

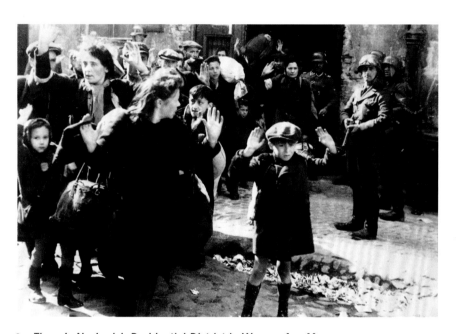

There Is No Jewish Residential District in Warsaw Any More

As part of the German occupation of Poland, Jewish residents in cities like Warsaw were rounded up into segregated areas known as ghettos. In 1942 deportations began from these ghettos to what were thought to be labour camps, but which – it became apparent – were part of the systematic extermination of European Jews. In response to this the Warsaw Ghetto rose in rebellion in 1943, leading to a violent response by German forces in Warsaw. The final stages of the crushing of the uprising and the deportation of the last inhabitants of the ghetto were photographed and compiled as a document originally titled 'The Jewish Quarter of Warsaw is No More!' but later known as the Stroop Report. It became key evidence at the Nuremberg war crimes trials that followed the war.

1942

John Rawlings – from American *Vogue*

John Rawlings (1912–70) began his career as a window dresser, only using a camera to document his work so that he could attract new clients. He began to photograph more and more, and some of these photographs found their way to Condé Nast, who in 1936 offered Rawlings a job as assistant to fashion photographers such as Cecil Beaton and Horst P. Horst. Rawlings progressed to full photographer, a meteoric climb perhaps best explained by the fact that his style was very much at odds with the prevalent tastes in fashion photography of the time. Rawlings offered something different, a sparse but eye-catching and witty take on fashion, which showed off the clothes and accessories that had in the past taken second place.

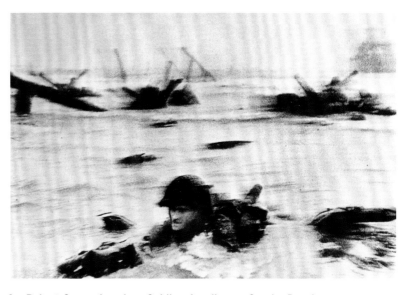

Robert Capa – *American Soldiers Landing on Omaha Beach, D-Day, June 6, 1944*

On 6 June 1944 the Allies launched Operation Overlord, the invasion of France and the start of the liberation of Europe from Nazi Germany. Seaborne landings along the coast of Normandy were a critical part of the plan. Capa arranged to go along, photographing the troops as they came ashore under fire. He later wrote in his autobiography: 'my beautiful France looked sordid and uninviting, and a German machine gun, spitting bullets around the barge, fully spoiled my return'. His photographs appear blurred, partly the result of the negatives being overheated while they were processed in the lab, destroying the majority of them and distorting the eleven frames that survived to be printed.

At the Tehran Conference
Franklin Roosevelt, Winston Churchill and Joseph Stalin agree to launch a re-invasion of Europe.

The D-Day landings take place in Normandy.

1943

1944

1945–1947

The Second World War reaches its conclusion, culminating in Europe with the Battle of Berlin and the surrender of Nazi Germany, while in Asia the United States drops two atomic bombs, leading to Japan's surrender and the end of the war. The following years see all sides attempting to recover, with the Nuremberg trials of war criminals. Photography plays a critical role as a silent witness to numerous crimes, and in particular to the Holocaust. The courtroom in Nuremberg is even reconstructed to make space for an enormous screen, where film and photographs of the camps can be projected before the court. 1946 also sees the first ever photograph taken of the Earth from space, after a camera attached to a captured German V-2 rocket is blasted into orbit during testing in the United States. The global order starts to undergo seismic shifts, most momentously as India becomes independent from the British Empire and Partition leads to the creation of Pakistan and the first Indo-Pakistani War. LB

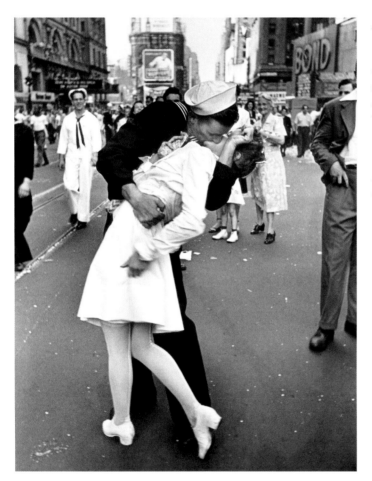

Alfred Eisenstaedt – *VJ Day in Times Square*

14 August 1945 saw the announcement that Japan had surrendered, marking the end of the Second World War and giving rise to spontaneous celebration across the United States. In New York's Times Square crowds gathered to celebrate, including a large number of service personnel. Alfred Eisenstaedt (1898–1995), a photojournalist with *Life* magazine, was on the search for images which caught the exuberance of the moment when a sailor in front of him grabbed a passing woman, tilted her back and kissed her. Eisenstaedt's photograph of that moment was published two weeks later in *Life* and became emblematic of the relief and celebration after years of war. The woman, a twenty-one-year-old dental assistant named Greta Friedman, was interviewed in 2005 and remarked that 'it wasn't that much of a kiss'.

Germany surrenders, marking the end of the Second World War in Europe.

The first use of atomic weapons on the cities of Hiroshima and Nagasaki leads to Japanese surrender and the end of the war in Asia.

1945

Frederick Sommer – *Coyotes*

Born in Italy, Frederick Sommer (1905–99) grew up in Brazil, studied in the United States and after returning home worked as a landscape architect. In 1930 he became ill and travelled to Europe to convalesce, where he became increasingly interested in art, experimenting with painting and photography. On his return to the United States Sommer dedicated himself to these new interests. Influenced by Alfred Stieglitz and Edward Weston, with whom he also met and corresponded, Sommer settled in Arizona in 1935 and pursued photography almost exclusively. As well as nudes and portraits of friends and fellow artists (including the Surrealist Max Ernst), the desert landscape, fauna and flora are recurring themes in his work, as in this photograph of drying coyote carcasses.

Frances McLaughlin-Gill – *Vogue Fashion Shoot*

In 1943 Frances McLaughlin-Gill's fresh and energetic vision so impressed the influential art director of *Vogue*, Alexander Liberman, that he offered her a contract at the age of just twenty-four, and she thus became the first female photographer to be formally employed by the magazine. Her informal approach embodied the post-war ethos of informality, characterized by Dior's New Look style. She worked for Condé Nast Publications into the 1960s, and this stylish image of the models Sally Parsons and Mrs George Carey Jr in elegant evening dresses, contrasted against the horses and the stables, is typical of her witty approach, with the models breaking the formal convention of most fashion photography at the time by not looking directly into the camera.

The Nuremberg war crimes trials conclude in Germany, with twelve prominent Nazi figures sentenced to death.

The first Cannes Film Festival opens in France.

India and Pakistan become independent and the First Indo-Pakistani War takes place.

The first photograph is taken of the Earth from space.

1946

1947

MAGNUM

Magnum Photos is the quintessential photo agency, whose photographers have chronicled the post-war world with vision and integrity.

Magnum was the brainchild of Robert Capa, who brought together his fellow photographers David 'Chim' Seymour, Henri Cartier-Bresson, George Rodger and William Vandivert to establish the agency as a co-operative in Paris in 1947. They started the agency because of a sense of strength in numbers, seeking to retain their copyright rather than ceding it to the magazines that published their work. This allowed them to work on long-term stories and sell the resulting images to multiple clients around the world. Initially, they divided the globe up between them, with Cartier-Bresson covering South and East Asia, Rodger in Africa and the Middle East, Seymour in Europe and Vandivert the United States, leaving Capa free to follow his curiosity wherever he felt most drawn.

With offices now in New York, Paris, London and Tokyo, the agency has grown over the subsequent seventy years, counting many of the world's most significant photojournalists and documentary photographers among its ranks, combining the best of journalism, aesthetics and storytelling. The agency is owned by the photographers who act as shareholders, and it is famously difficult to become a member, with a lengthy selection process in which the members vote on whether aspiring entrants will be admitted. Cartier-Bresson described the philosophy of the group thus: 'Magnum is a community of thought, a shared human quality, a curiosity about what is going on in the world, a respect for what is going on and a desire to transcribe it visually.'

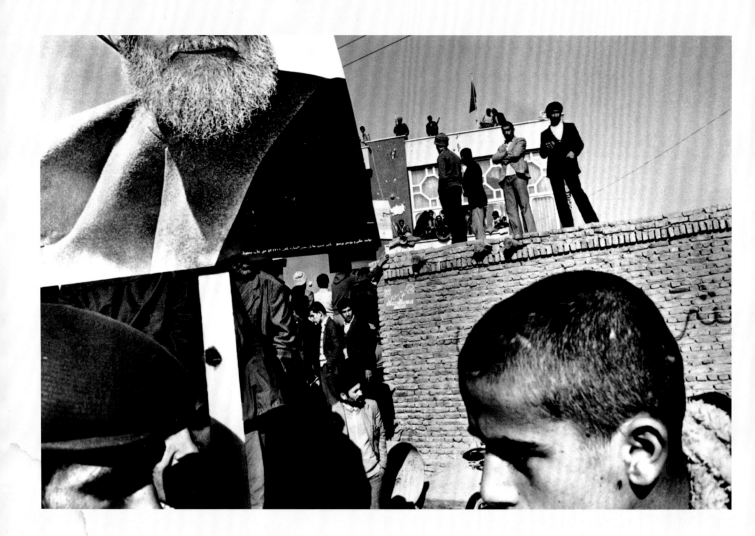

ABOVE. René Burri–*Men on a Rooftop,*
São Paulo, Brazil **(1960)**
In 1963, while on assignment in Cuba, Swiss-born René Burri
(1933–2014) made a portrait of Ernesto 'Che' Guevara with his
cigar that became a defining image of the revolutionary worldwide.
Three years earlier, he shot this dramatic interpretation of the
modern metropolis in São Paulo, using a telephoto lens to
compress the perspective of the city and create the compelling
sense of the men high above the city streets. However, in doing
so he broke one of the unspoken rules of Magnum, as he recalled:
'Henri Cartier-Bresson limited us to lenses from 35 mm to 90 mm.
When I showed him the photos he said, "brilliant René!" I went
outside and shouted "Hah!" He heard me and said "what was
that?" I said, "nothing, never mind". The lens I used was 180 mm
– I never told him! At that point I broke loose from my mentor.
I killed my mentor!'

LEFT. Gilles Peress–*Tabriz, Iran, A Demonstration in Favor of the*
Leading Opposition Figure, Ayatollah Kazem Shariatmadari **(1980)**
Along with fellow Magnum photographer Susan Meiselas, Gilles Peress (1946–)
was identified as one of the 'new photojournalists' of the 1970s, who deployed a
subjective and personal interpretation of the news in opposition to the traditional
position of neutrality and objectivity. His dense, fractured images take the viewer
on a journey where they have to try to make sense of the complexities of the
world by solving the visual puzzles Peress creates. This celebrated image was
used as the cover of his seminal book, *Telex Iran* (1984), his documentation of
his own personal odyssey through the turbulent times of the Iranian Revolution.
He explains how his aesthetic seeks to interpret the world: 'When I looked at
reality, I saw contradictions, confrontations between different meanings, different
processes, different individual histories, all occurring at the same time. At a
practical level, I've always tried to break the frame in little, physical ways, to
reflect those contradictions.'

1948–1950

The global political order continues to be reshaped in the years following the end of the Second World War. In 1948 the State of Israel is established, and numerous countries including Sri Lanka and Burma become independent from their former colonial rulers. Korea is divided into a communist North and a capitalist South, setting the stage for the Korean War, and Germany is also divided into East and West, heightening tensions and leading to the Berlin Airlift. Newly available cameras make press photographers ever more mobile and able to capture these fast-moving events. In 1949 Zeiss Ikon introduces the Contax S, one of the earliest cameras to use a pentaprism and a movable mirror to allow photographers to see directly through the shooting lens of their camera, allowing for greater accuracy in a compact form. In science and technology more broadly, the Soviet Union tests its first atomic bomb, a move which pushes the two global superpowers closer to the possibility of a future nuclear confrontation. LB

The beginning of the apartheid system in South Africa.

The Hasselblad 1600F camera is introduced in Sweden.

Edwin Land introduces the Polaroid, the first instant camera.

O **Philippe Halsman** – *Dalí Atomicus*

Philippe Halsman (1906–79) was born in Riga, lived in Austria and later emigrated to France, where he began to acquire a reputation as a fashion photographer. Halsman stood apart from many of his contemporaries for his tight crops and pin-sharp portraits, but perhaps no photograph exemplifies the effect that Halsman had on portraiture quite like the one he took of his friend and collaborator Salvador Dalí. A normal portrait would hardly suffice, so Halsman planned a complex interaction of elements, with multiple assistants poised to throw cats and water across the scene while Dali leapt into the air. It took twenty-six attempts to capture the image.

1948

W. Eugene Smith – *The Wake, Spanish Village*

In 1950 the veteran photojournalist W. Eugene Smith (1918–78) was commissioned by *Life* magazine to work on a story about the shortage of food in Franco's Spain. Smith, as he often did, had other ideas, wanting to make the story far more political. Photographing in the town of Deleitosa, Smith produced a series which has become known as 'Spanish Village' and which depicts an impoverished rural community. Particularly remarkable is a photograph showing a family clustered around the body of an elderly man. As well as being visually striking, it embodies many of the contradictions of Smith himself, a revered journalist who frequently employed practices uncharacteristic of photojournalism, like staging and manipulation of photos. In this case two of the women in the scene were looking directly at Smith, but the photographic print was manipulated to disguise this.

George Rodger – *Nuba Wrestlers*

Rodger (1908–95) began his career in the Merchant Navy, during which time he produced written travelogues accompanied by his photographs. Later he worked as a journalist photographing the Second World War in Africa, the Far East, and in Europe, where he was one of the photographers present following the liberation of Bergen-Belsen concentration camp. In 1947 Rodger founded the Magnum photography co-operative with Robert Capa and Henri Cartier-Bresson, and in the same year set off on an extended trip around Africa on assignment for *National Geographic*. By 1949 he had reached Sudan, and succeeded in documenting the remote Nuba tribe, the first Westerner to do so. This image, the best known from this assignment, depicts a victorious Nuba wrestler, dusted in ash, carried aloft by another.

Germany is partitioned into the Soviet socialist German Democratic Republic and the NATO-backed Federal Republic of Germany.

The Contax S camera is introduced, the first 35 mm SLR camera with a pentaprism eye-level viewfinder.

1949

1950

4

—

1950
TO 1975

The publication of Robert Frank's *The Americans* in 1958 was a landmark in the development of documentary photography, with a highly personal and poetic vision that broke many of the then-accepted rules of documentary and reportage photography.

Ironically, given its tremendous influence on subsequent generations, the book was heavily criticized at the time for making photographs that appeared technically flawed, out of focus and badly exposed. However, Frank (1924–) is a highly skilled photographer, and the form of the photographs was deliberately intended to produce a metaphorical vision of the flipside of the American dream, enhanced by the free-form text by Jack Kerouac. The non-linear structure of the book is a masterpiece of editing and juxtaposition, with the complexity and nuance of literature, with Frank claiming that 'When people look at my pictures I want them to feel the way they do when they want to read a line of a poem twice.' Frank trained as a photographer in his native Switzerland, emigrating to the United States in 1947.

He gradually established a reputation there, taking part in the landmark exhibition '51 American Photographers' at New York's Museum of Modern Art in 1950. In 1955 Frank received a Guggenheim Fellowship to travel across the United States photographing its people and society, a project that would absorb much of the next two years, and which resulted in *The Americans*. Frank had a difficult time finding an American publisher for the book, eventually publishing it in France in 1958 and only later in the United States. *The Americans* drew much criticism at the time of its publication for its expressionistic style, but has since become widely recognized as one of the most significant photography books of the twentieth century.

The gritty, energetic images of William Klein also challenged conventional reportage, with his use of wide-angle lenses, high contrast, visible grain and blur creating a more immediate, personal engagement with the subject. With no pretence of objectivity, his intensely personal vision was also criticized at the time, but is now seen as innovative and groundbreaking.

PREVIOUS PAGE. Danny Lyon
– *Crossing the Ohio* (1967)

LEFT. Bruce Davidson – *Brooklyn Gang. Coney Island. Kathy Fixing Her Hair in a Cigarette Machine Mirror* (1959)

RIGHT. Paul Fusco – *Robert Kennedy Funeral Train* (1968)

The post-war period saw documentary photographers undertaking extensive, long-term projects that engaged with social and political issues in depth. Bruce Davidson (1933–) worked with a teenage Brooklyn gang known as the Jokers in 1959, spending every day over the summer of that year hanging out with them in Coney Island and Prospect Park, getting to know them and becoming accepted as part of their world. At twenty-five, he was not much older than the gang members themselves, and his connection with them allowed him to capture the complexity of teenage life in America. He explained how he was able to get the extraordinary intimacy in his images by becoming a part of the story, maintaining that 'I start off as an outsider, usually photographing other outsiders, then, at some point, I step over a line and become an insider. I don't do detached observation.' Davidson became known for this type of immersive documentary project, with his *East 100th Street* book of portraits of ghetto life on one street in East Harlem, New York, published in 1970 and now seen as a classic of documentary practice. Made over two years, with a large-format camera, the book was radical at the time for its dignified representation of the African American community.

The decades after the Second World War were in many ways a golden age for photojournalism and documentary photography, with the picture magazines devoting time, money and space in their publications to extended bodies of work that explored every facet of human life. *National Geographic* and *Life* were to be found in every doctor's and dentist's waiting room across the United States. Despite the subsequent critique of *Geographic* as presenting a very Westernized view of the rest of the world that bordered at times on racism, it undoubtedly gave photographers a unique platform for undertaking and publishing extended photo essays. The visual innovations of the pictorial magazines saw photographers, editors, designers and journalists collaborating on sophisticated layouts in which text and images were related to one another in complex and creative ways. Photographers were encouraged to develop their stories in depth, and to 'shoot around' the subject, expanding the narrative of the story. The new, more fluid, visually energetic style of reportage photography reached a mass audience, and photographs became, for a period at least, the single most important means by which Westerners encountered the wider world in their daily lives. Photographers drew on more personal approaches to respond to the news events of the day in ways that transcended mere description. Paul Fusco (1930–), then a staff photographer at *Look* magazine, was assigned to travel with the train carrying the body of Robert F. Kennedy to Washington, D.C. after Kennedy's assassination in Los Angeles in June 1968. Fusco shot the thousands of mourners lining the train tracks using the blur caused by the moving train

LEFT. Philip Jones Griffiths
– *Vietnam* (1967)

RIGHT. Robert Frank – *Trolley*
– *New Orleans* (1955)

and the slow speed of his Kodachrome film to create a sense of the passage of time. Perhaps the epitome of the classic magazine photojournalist was the American W. Eugene Smith, who during the late 1940s and 1950s produced a series of photo essays including 'Country Doctor' and 'Nurse Midwife'. Smith spent an enormous amount of time researching his stories; for example, he visited dozens of villages in Spain before finding the perfect one for his essay 'Spanish Village', considered by many to be the 'perfect' photo essay (see p.161). The demand for photographs of news and current affairs was met by the growth of the picture agencies that acted as brokers between the photographers and the publications, with the foundation of Magnum in 1947 being followed by the French agencies Gamma, Sipa and Sygma in the 1960s and 1970s

The era-defining conflict in Vietnam raised many important questions regarding the role of the media in covering war. The impact of journalistic reporting on the course of this war, in particular in terms of the support of the domestic audience in the United States, has been hotly contested. A significant number of images emerged that have gone on to epitomize that particular

war, as well as to act as markers of the representation of violence more generally. The conflict in Vietnam was dubbed the 'Living Room War' because of its visibility on televisions in homes across the world, and this tension between domesticity and violence was explored by the artist Martha Rosler (1943–) in her *Bringing the War Home* series. Rosler used techniques of collage and photomontage to combine advertising images from *House Beautiful* magazine with photographs of American military casualties taken from *Life* magazine. As part of the anti-war movement Rosler sought to critique the media representation of the conflict. The Welsh Magnum photographer Philip Jones Griffiths (1936–2008) also regarded the American intervention as essentially a neocolonialist action, stating that 'I attempt to channel my anger into the tip of my forefinger as I press the shutter.' His seminal book on the conflict, *Vietnam Inc.*, published in 1971, combined his photographs with comprehensive captions exploring the social and political context of the conflict. It stands out as an example of how the combination of coherent, complete journalistic coverage with personal point of view can create a powerful statement.

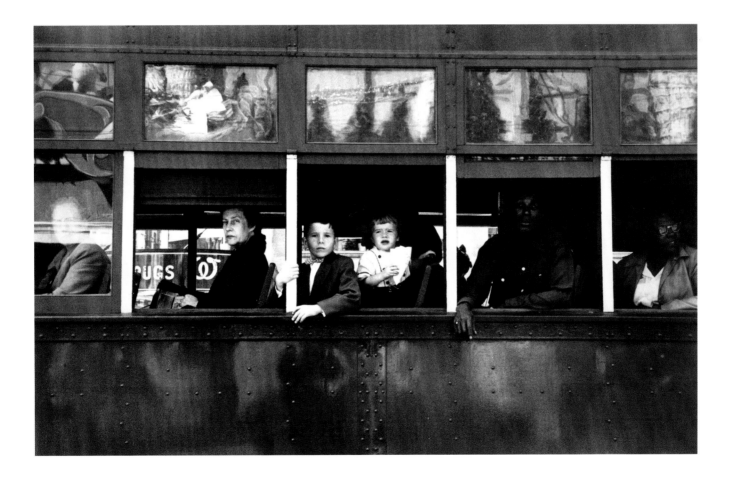

THE GOLDEN
AGE OF NEWS

In 1935 the Associated Press (AP) launched its Wirephoto service with a photograph depicting the crash of a light plane in New York's Adirondack Mountains on New Year's Day. The system allowed images to be transmitted over conventional telephone lines on the same day they were shot, which gave AP a huge commercial advantage over other media suppliers, with the network quickly growing to cover the whole of the United States. As the technology became more portable, it enabled photographers in the field to transmit their images straight to the newspapers. Subsequent advances in technology in the late 1980s allowed for digital scans to be made directly from a negative, which could then be transmitted over a satellite phone, allowing dramatic news events to be published almost as soon as they happened in a twenty-four-hour rolling news environment.

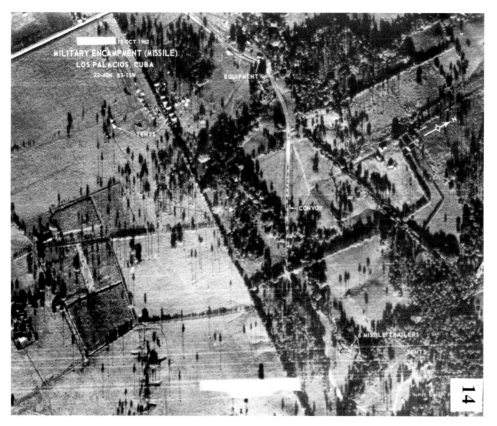

LEFT. CIA – *U-2 Photograph of First Intermediate-range Ballistic Missile Site Found Under Construction* **(1962)**
As with most technologies, the military have been at the forefront of the development of photography, and even the camera obscura was suggested as a useful tool to track hostile aircraft movements in the First and Second World Wars. Surveillance of enemy positions has been one of the main tasks, with the intricate patterns of trenches and shell holes of the First World War looking like abstract paintings when seen from above. 1955 saw the first test flights of the Lockheed U-2, an ultra-high-altitude reconnaissance aircraft commissioned by the CIA to fly higher than enemy missiles or fighter aircraft could reach. This image played a key role in the Cuban Missile Crisis, as it provided evidence of Soviet forces on the Caribbean island just 177 km (110 miles) off the coast of Florida.

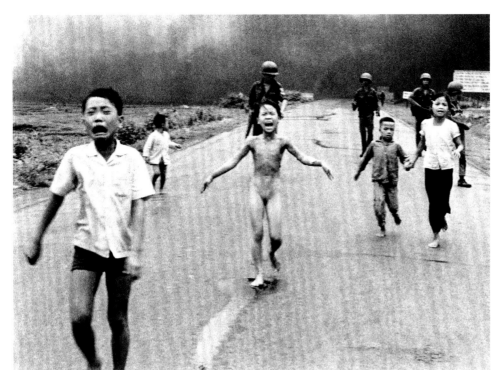

LEFT. Nick Ut – *The Napalm Girl* (1972)
This iconic image of the aftermath of a US napalm attack won every major photographic award in 1973, including the World Press Photo Award and the Pulitzer Prize, and has gone on to symbolize the terrible cost of the conflict. Taken by Vietnamese photographer Huynh Cong 'Nick' Ut (1951–), it shows Phan Thi Kim Phuc in the centre running from the destruction of her village. Ut was working for the Associated Press, and when he returned to his base with the negatives there was considerable debate as to whether the image should be transmitted on the wire machines that were used at the time to send photographs back to the newspapers in the United States, because of the full-frontal nudity it showed.

RIGHT. Nikon F camera
Introduced in April 1959, the Nikon F camera was the first SLR system camera, and rapidly became the tool of choice for professional photographers, especially those covering the war in Vietnam. Well made and durable, it had an interchangeable prism and screen, a depth-of-field preview button, a wide range of lenses from wide-angle to super-telephoto, and could be fitted with a motor drive to capture fast-moving subjects. Its rapid and widespread success established the Japanese camera manufacturer ahead of its European competitors.

THE PHOTOGRAPHIC BOOK

As a way to distribute their work to a wide audience, and to present their visual arguments in a coherent form, the photographic book has provided practitioners with a tangible material object that is more affordable and portable than original photographic prints. Many of these books have now become highly collectible and valuable, with Martin Parr and Gerry Badger establishing a canon of important works in their three-volume *The Photobook: A History* (2004–). In recent years, the 'photobook' market has exploded with the rise of digital self-publishing, providing artists with the ability to reach audiences more directly than through mainstream publishers.

LEFT. Dennis Stock – *James Dean, Haunted Times Square* **[printing mark-up sheet] (1955)**
Ansel Adams claimed that 'the negative is the equivalent of the composer's score, and the print the performance', and this printing mark-up sheet from the Magnum agency's archive of James Dean taken by Dennis Stock (1928–2010) shows just how complex the process of making a final print can be. The numbers show where the exposure for the final image has to be increased or reduced to create the full range of tones in the shadows and the highlights, a process known as dodging and burning. Magnum's darkroom printer Pablo Inirio explained the process: 'It's not an easy print! He's a little bit underexposed, and you want … enough information so he's still kind of moody. Even though it's kind of a rainy, cloudy day, the sky is … overexposed a little bit, so you kind of have to bring that down, you want to keep the contrast snappy … I have my notes and I follow them as much as I can.'

STANDARD, AMARILLO, TEXAS

LEFT. Ed Ruscha – *Phillips 66, Flagstaff, Arizona*, from *Twentysix Gasoline Stations* (1962)

Twentysix Gasoline Stations was one of a series of sixteen photobooks that Ed Ruscha (1937–) produced between 1963 and 1978, playing with the conventions both of photography and of the artist's book. Shot in a deadpan style, with simple descriptive titles such as *Some Los Angeles Apartments* (1965) and *Every Building on the Sunset Strip* (1966), they feature sequences of snapshot-like images in linear layouts. Their apparent lack of emotion or overt social message was in contrast to much of the other work produced at the time in the era of the 'concerned photographer'. Ruscha was a highly successful painter and conceptual artist as well, but revealed in 2008 that 'Although I was painting pictures at that time, I felt that the books were more advanced as a concept than the individual paintings I had been doing.' His exploration of the self-published book was original and remains hugely influential today.

BELOW. Josef Koudelka – *Slovakia. Zehra. 1967. Gypsies.* (1967)

When it was published by Aperture in 1975, the Czech Magnum photographer Josef Koudelka's *Gitans: La fin du voyage* ('Gypsies: The End of the Journey', 1938) instantly became a classic of the documentary genre. The book's layout was based on a maquette originally prepared in 1968 by Koudelka and graphic designer Milan Kopriva, which was further developed by Robert Delpire and Aperture. With its sixty-one lyrical, dream-like images of the Roma population of Eastern Slovakia, the book echoed Koudelka's own journey as an exile from his native Prague, which he was forced to flee after the 1968 Soviet invasion.

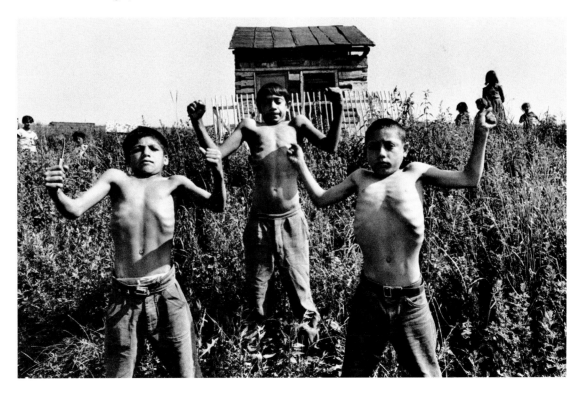

1950–1952

The hope of peace that followed the end of the Second World War proves short-lived, as tensions on the Korean Peninsula explode into a new war. An international roster of journalists, photographers and cameramen document the fighting on the ground, as the conflict stabilizes into a stalemate around the 51st parallel and an eventual, uneasy truce. In 1951 colour television is seen for the first time, and the ever-wider availability of television marks the start of a gradual shift away from photography as the pre-eminent source of visual news, towards televised reports, which are now broadcast soon after events, or sometimes even live. In the United States work also begins on a hydrogen bomb, a far more powerful version of the atomic bomb, a project that serves to escalate already deep tensions and mistrust between the United States and the Soviet Union. LB

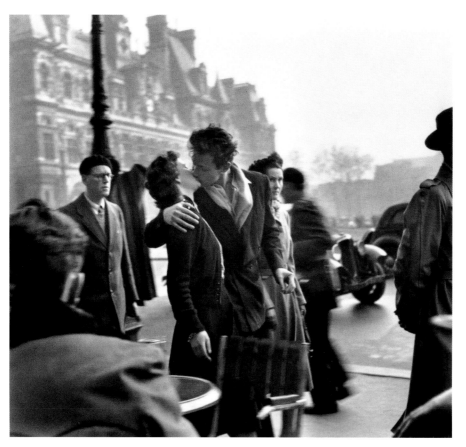

Robert Doisneau – *The Kiss at the Hôtel De Ville*

After studying art, Robert Doisneau (1912–94) began to practise photography – first as an amateur, and later finding work as a photographic assistant. By the early 1930s he was receiving commissions from magazines, and by the end of the Second World War he was working for major magazines like *Life* and *Vogue*. While these jobs sometimes entailed working in the studio, Doisneau remained a street photographer at heart and often went looking for his images outside. It was during one assignment for *Life* that Doisneau was instructed to look for photographs of couples in Paris, and he returned with this photograph of young couple Françoise Delbart and Jacques Carteaud kissing. The photograph became an icon of romance.

The Korean War begins.

1950

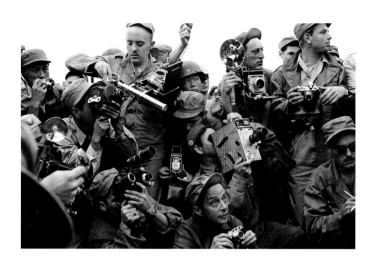

Werner Bischof – *Vultures of the Battlefield*

In 1949 Werner Bischof was one of the first photographers to join Magnum after its foundation. His work had a strong ethical perspective and a concern for social and political justice, as he recalled: 'I felt compelled to venture forth and explore the true face of the world. Leading a satisfying life of plenty had blinded many of us to the immense hardships beyond our borders.' He travelled on assignment extensively in India, Japan, Hong Kong, and South-east Asia. His unease at the ethics of his profession is expressed in this self-critical image, where he turned his camera on to the media itself, showing the chaotic scrum of press photographers covering the Korean War.

Andreas Feininger – *The Photojournalist*

Andreas Feininger (1906–99) was born into an artistic family. He studied a range of creative skills including graphic arts and architecture in Weimar, where his father Lyonel taught at the Bauhaus. With the start of the Second World War Feininger emigrated to the United States and established a career as a freelance photographer, later joining *Life* magazine as a staff photographer. His style is notable for its stark use of black and white, and his photographs of New York reflected his earlier interest in architecture. This photograph, of fellow *Life* photojournalist Dennis Stock, was one of Feininger's rare forays into portraiture, part of a series he produced highlighting the way professional instruments become almost part of the person using them.

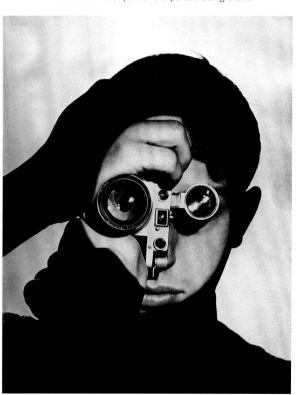

Elizabeth II becomes Queen of the United Kingdom and the Commonwealth.

Jonas Salk develops the first effective polio vaccine.

1951

1952

1953–1955

The middle of the decade sees clear contrasts between an optimistic photographic vision of the post-war world, and the often darker reality.

In New York, Edward Steichen's (1879–1973) landmark exhibition 'Family of Man' opens at the Museum of Modern Art. Drawing together hundreds of photographs by dozens of international photographers, the exhibition presents a humanist, optimistic view of the world, emphasizing the commonalities between different nationalities and ethnicities. It goes on tour globally and is seen by more than nine million people. Elsewhere in the world, the war in Korea ends in an uneasy truce, and following the death of Joseph Stalin in Russia, a power struggle for control of the Soviet Union ends with Nikita Khrushchev becoming First Secretary in 1953. The same year also sees the formation of the Warsaw Pact, a military alliance of Soviet states formed to counter-balance the military power of NATO. The events continue to strain relations between East and West. LB

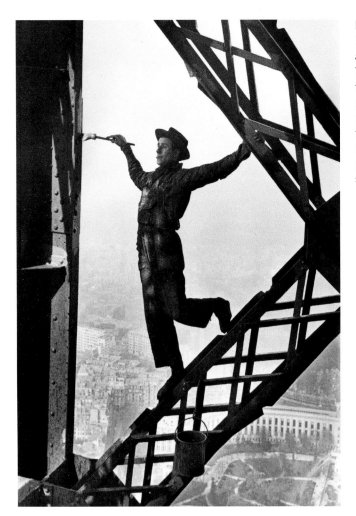

Marc Riboud – *The Painter of the Eiffel Tower*

Long interested in photography, Marc Riboud (1923–2016) trained as an engineer but moved to Paris to pursue photography professionally. This photograph shows one of the team of painters who maintained the Eiffel Tower, balanced and framed between three girders. This photograph was Riboud's first to be published, appearing in *Life* magazine, and it reputedly led Robert Capa to extend an invitation to Riboud to join the recently established photography co-operative Magnum. Riboud went on to have a successful career as a photojournalist, gaining particular acclaim for his work in countries such as China and Vietnam.

Edmund Hillary and Tenzing Norgay complete the first ascent of Mount Everest.

1953

William Klein – *Gun 1, New York*

William Klein (1928–) was born and grew up in New York City, but left to join the army, where he discovered photography after winning a camera in a game of poker. He later settled in Paris, studied art and exhibited paintings and sculpture, before returning to the US in the 1950s to work on a commission from *Vogue* to make a book about New York. Klein photographed the city using grainy, high-speed film, producing a response that was so uncompromising that the magazine turned it down. It was later published in France under the title *Life is Good & Good for You in New York*.

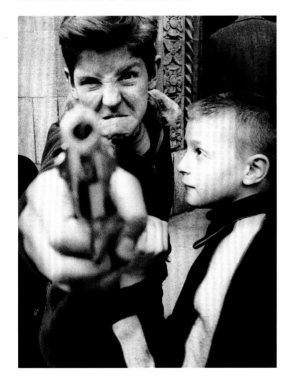

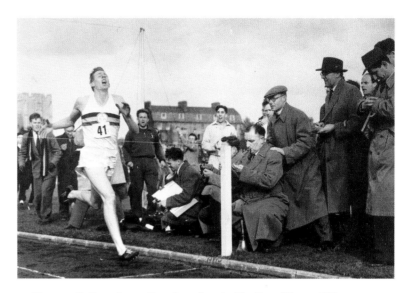

Norman Potter – *Roger Bannister Breaks The Four-Minute Mile*

One of photography's key functions has been the recording of historic events, as this sporting icon by Norman Potter of Roger Bannister breaking the four-minute mile at the Iffley Road track in Oxford on 6 May 1954 demonstrates. His timing and composition had to be perfect, as he was using a 9 x 12 cm Contessa Plate camera, giving him only one shot. He froze the moment just before Bannister hit the tape, with his lead foot in midair and his head thrown back in a painful grimace, forming a semicircular arc with the line of reporters on the side of the track. Bannister had been preparing for his record-breaking attempt for months, and recalled how 'I leapt at the tape like a man taking his last desperate spring to save himself from a chasm that threatens to engulf him.' It had been considered physiologically impossible for a human to run a mile in less than four minutes, but Bannister's time of 3:59.4 was soon superceded, and the record is currently held by Hicham El Guerrouj, with a time of 3:43.13.

High-speed Tri-X black-and-white film is introduced by Eastman Kodak.

The Supreme Court of the United States orders an end to racial segregation in public schools.

African American passenger Rosa Parks refuses to give up her seat to a white passenger on a bus, sparking the Montgomery Bus Boycott.

1954

1955

1956–1958

Technological innovations in photography and beyond continue to stagger the world and challenge perceptions of the possible.

In 1957 the Soviet Union launches *Sputnik 1*, the first artificial satellite. Despite its benign appearance it triggers panic in the United States, where there is a widespread fear that the country is lagging behind the Soviet Union in technology, and it serves to galvanize public interest in and support for space engineering. The same year, however, also sees a key American innovation which radically impacts on the future of photography, when Russell A. Kirsch (1929–) pioneers the first digital acquisition of a photograph, scanning an image of his son at the small size of 176 x 176 pixels. Modest as this image might seem today, Hirsch's innovation is critical for future developments in a range of fields, from medical imaging to space exploration. LB

The nationalization of the Suez Canal triggers the Suez Crisis in Egypt.

Albert Renger-Patzsch – *Fir Trees in Winter*

Born in Germany and originally trained as a chemist, Albert Renger-Patzsch (1897–1966) was one of a group of photographers associated with a movement known as 'the New Objectivity', which emerged in Germany in the inter-war period. Renger-Patzsch argued that photographers should try to embrace the qualities that made photography a unique medium, specifically its ability to document objects in detail, rather than trying to emulate or copy things from fine art. This preoccupation is evident in his precise and technically exacting photographs, like this one of a fir forest in winter. Fir trees were a recurrent theme in Renger-Patzsch's photographs, many of them taken in the Ruhr region of Germany where he spent much of his life.

1956

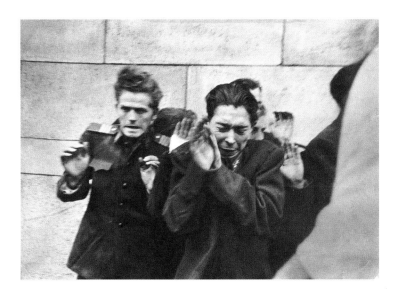

John Sadovy – *Hungarian Revolution*

Born in Czechoslovakia, John Sadovy (1928–2010) was a self-taught photographer. He later fought with Polish free forces during the Second World War, and remained in the United Kingdom afterwards and worked as a freelance photographer for a number of publications including *Life* and *Paris-Match*. In 1956 there was a violent uprising against the communist government in Hungary, and Sadovy was one of very few photojournalists able to reach Budapest and document it. The coverage provided by Sadovy and a small number of other journalists was instrumental in raising global awareness of what was happening, and particularly in providing evidence of the bloody repression that reinstated communist control of the country.

Roger Mayne – *Teddy Boy and Girl, Petticoat Lane*

Inspired by Cartier-Bresson's *Decisive Moment*, Roger Mayne (1929–2014) was one of Britain's pre-eminent social documentary photographers of the 1950s. He found a rich seam of material around Southam Street in London's Notting Hill, where he photographed between 1956 and 1960. Mayne summed up his philosophy of photography in 1960 thus: 'Photography involves two main distortions – the simplification into black and white and the seizing of an instant in time. It is this particular mixture of reality and unreality, and the photographer's power to select, that makes it possible for photography to be an art. Whether it is good art depends on the power and truth of the artist's statement.'

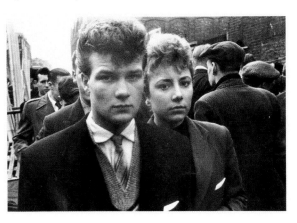

First digital computer acquisition of scanned photographs, by Russell A. Kirsch *et al.* at the US National Bureau of Standards (now the NIST).

Sputnik 1, the first artificial Earth satellite, is launched by the Soviet Union.

1957

THE STREET

The theatre of the street has provided a rich vein of material for photographers, who have sought to make sense of the visual chaos of the ever-changing world around them, instinctively responding to the serendipitous moments that life throws up.

The advent of the 35 mm Leica camera gave photographers the ability to roam the urban landscape, liberating them from tripods and bulky cameras to shoot the unfolding spontaneous action around them. In the 1930s photographers like Cartier-Bresson, Manuel Álvarez Bravo and André Kertész responded to the energy of the city, making surreal and psychologically charged images. Visual wit has also been a recurring theme of street photography, with Elliott Erwitt finding humour in bizarre and unpredictable juxtapositions of elements, often making connections that only the camera lens could produce. New York in the 1960s became a hothouse for the genre, with a generation of photographers inspired by Robert Frank taking to the sunlit canyons of the teeming city. Garry Winogrand, Lee Friedlander, Tod Papageorge, Tony Ray Jones and Joel Meyerowitz would often go out together to shoot, looking to capture the ever-changing dynamism of the energetic city, with Meyerowitz's 'Out to Lunch' project being a notable example. The sense that the unpredictable nature of the street can provide an inexhaustible supply of potential images has been carried on today by image-makers like Scotsman Dougie Wallace, dubbed 'Glasweegee' and known for his use of daylight flash, and Trent Parke, who saw in his home of Sydney the potential for the southern light to combine with the range of architectural styles to create a fantastical interpretation of the modern metropolis.

'New Documents'

'New Documents' was a hugely influential exhibition curated by then Director of Photography at the Museum of Modern Art in New York, John Szarkowski. Opening in 1967, it brought together the work of three relatively unknown photographers – Diane Arbus, Lee Friedlander and Garry Winogrand – establishing them as some of the most important voices in American street photography. In the catalogue, Szarkowski explained why he had brought them together in the exhibition, writing that what 'unites these three photographers is not style or sensibility; each has a distinct and personal sense of the use of photography and the meanings of the world. What is held in common is the belief that the world is worth looking at, and the courage to look at it without theorizing.'

BELOW. Lee Friedlander–*New Orleans, Louisiana* (1968)
Arguably more than any other photographer, Lee Friedlander (1934–) is the master of translating the three-dimensional world into the flat, two-dimensional surface of the photograph, which then retains the sense of three-dimensional space within it. His images are like visual jigsaws, where reflections, telegraph poles, cars and bystanders all combine into a seamless image that is uniquely photographic. Friedlander frequently included himself in the frame, in the pose characteristic of using the Leica rangefinder camera he favoured, using one eye to view from, leaving the other free to observe the scene directly.

1959–1961

As the 1950s come to an end, a new era of popular culture and protest emerges, particularly in the United States. In Greensboro, North Carolina, four black students stage a sit-in at a segregated Woolworth's lunch counter, triggering similar non-violent protests and drawing growing attention to the Civil Rights movement. In popular culture, Elvis Presley returns to music after two years in the army, and the first episode of *The Flintstones* airs on television. Elsewhere in the world, construction begins in Germany on what will become the Berlin Wall, a border barrier intended to restrict the flow of people from East to West. Many photographers are present and capture heart-rending scenes as families and friends find themselves caught on opposite sides of the wall. LB

Sergio Larrain – *London, England*

Sergio Larrain (1931–2012) was born in Chile and studied music before taking up photography in 1949. He studied photography in the United States and travelled in Europe, in this way gaining a foothold working as a freelance photographer, and later working as a staff photographer for the Brazilian magazine *O Cruzeiro*. In 1958 Larrain received a grant to produce a series of photographs of London, a project which resulted in this image, among many others which capture the grimy side of the city, and which led the following year to an invitation from Henri Cartier-Bresson to join Magnum. By 1968 Larrain had virtually given up photography, instead spending his time studying Eastern mysticism and practising yoga, and painting. Despite his short photographic career he is considered to be one of the most significant and influential Chilean photographers of the twentieth century.

AGFA introduces the Optima, the first fully automatic camera.

The Cuban Revolution brings the communist government of Fidel Castro to power.

1959

○ **Yasushi Nagao—*Assassination of the Socialist Party Chairman In Japan***

Yasushi Nagao (1930–2009) was a relatively unknown photographer when he was dispatched to cover a televised debate ahead of elections to Japan's lower house. Japanese politics were fraught at the time, and during the debate, Nagao caught the moment that Otoya Yamaguchi, a right-wing student, assassinated Inejiro Asanuma, the Chairman of the Socialist Party. The assassination was also captured live on television, causing shock and outrage across the country. Nagao's photograph was published around the world, winning him World Press Photo and Pulitzer prizes. Its success gave him greater autonomy as a photographer, and he travelled widely in the following years.

Eikoh Hosoe—*Ordeal by Roses (Ba-Ra-Kei) #15*

Growing up in the aftermath of the Second World War, Hosoe (1933–) encountered photography at an early age, and adopted the name Eikoh in recognition of the new Japan that was emerging at the time. He studied photography and worked as a freelance photographer, but was most heavily influenced by the Japanese avant-garde art movements of the time. While many of his contemporaries responded to the changes sweeping the country by going out and photographing in the streets, Hosoe preferred to work in his studio, constructing psychologically charged images which explored the inner landscape of his subjects. Many of his images employed the Japanese writer Yukio Mishima as a model, including this one, part of a series of the author posed and lit dramatically. Mishima would later commit suicide, imbuing Hosoe's photographs with added significance.

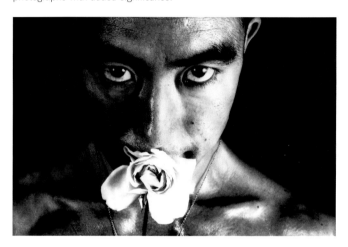

The Beatles form
in Liverpool,
United Kingdom.

Construction begins on the
Berlin Wall, separating East
and West Germany.

1960

1961

1962–1964

The counterculture of the Swinging Sixties starts to reach full volume as the decade progresses. In 1962 the first album by The Beatles is released by Polydor, and by 1964 the group achieve their first number one record in the United States. The Rolling Stones also make their debut in London, and the first James Bond film, titled *Dr. No*, screens in cinemas. In world affairs, a U-2 spy plane flying over Cuba photographs preparation of launch pads designed for Soviet nuclear missiles. The discovery provokes a blockade of the island by the United States, and brings East and West closer to nuclear war than ever before. Photography is increasingly used by both sides in the Cold War to second-guess what their opponents are up to. To counteract this, missiles and other military hardware are camouflaged, buried and moved around to make them harder to target. LB

National Geographic publishes its first issue with all-colour photographs.

The Cuban Missile Crisis brings the United States and Soviet Union closer to nuclear confrontation.

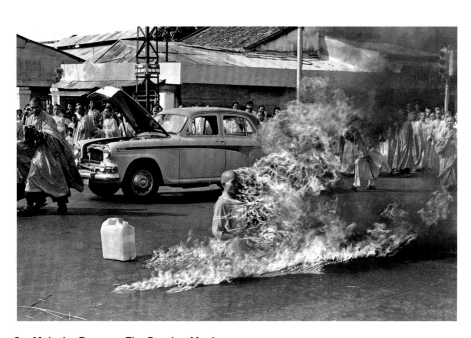

Malcolm Browne – *The Burning Monk*

Raised in New York, Malcolm Browne (1931–2012) studied chemistry and was drafted to fight in the Korean War. During this time he was assigned to work on *Stars and Stripes*, the US army magazine. He later joined the Associated Press, eventually becoming chief correspondent for Indochina. This photograph by Browne depicts Vietnamese monk Thích Quang Đuc self-immolating outside the Cambodian embassy in Saigon in protest at the persecution of Buddhists by the South Vietnamese government. Rumours had been circulating that something important would happen that day, but many journalists did not attend. Browne's photographs were published around the world, and President Kennedy commented 'No news picture in history has generated so much emotion around the world as that one.'

1962

Cecil Beaton – *Audrey Hepburn, My Fair Lady*

Cecil Beaton (1904–80) began taking photographs at a young age, continuing the pursuit while he was studying art and architecture at university. After graduating he decided to make a career of photography, leaving for New York and building up a reputation as a fashion photographer, which reached its peak with a lucrative contract to photograph for Condé Nast Publications. Returning to the United Kingdom, Beaton worked for the Ministry of Information documenting the war effort, and then went back to fashion after the Second World War. This photograph of Audrey Hepburn exemplified the elaborate studio photographs that typify Beaton's style, and for which he remains best known today.

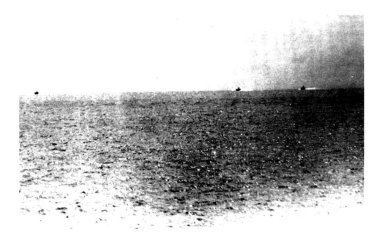

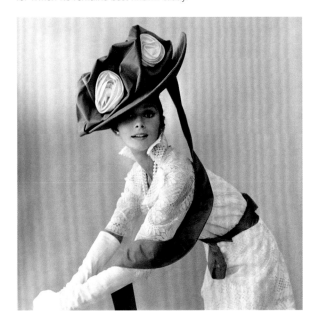

Tonkin Gulf Incident

In 1964 the conflict in Vietnam was at a critical point, with a new president in the White House following Kennedy's assassination the previous year, and uncertainty about whether the conflict would escalate or American involvement would be reduced. On 2 August, while patrolling in the Gulf of Tonkin, the USS *Maddox* was pursued by three North Vietnamese torpedo boats, leading to an exchange of fire between the ships and the deaths of at least four Vietnamese sailors. The result of the incident was the passage of the Gulf of Tonkin Resolution, which increased the President's powers to lend military support to countries threatened by communism, leading ultimately to a massive build-up of military forces and the escalation of the conflict into the Vietnam War.

Polaroid develops the first instant colour photography process.

1963

1964

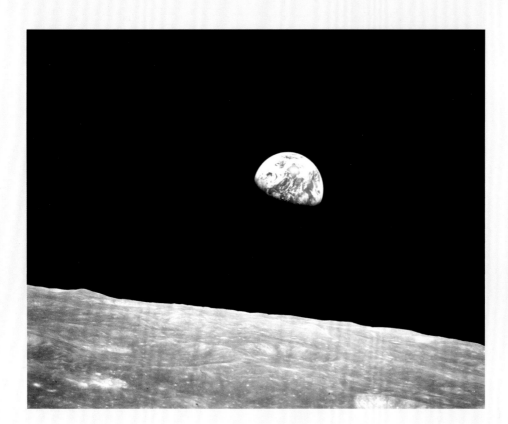

SPACE

The moon and stars have provided endless fascination for photographers, with many of the early pioneers being astronomers who recognized the value of the camera for recording the night skies.

As an astronomer, Sir John Herschel's early experiments with photography were largely driven by the potential of the photographic process to record the observations made through a telescope more accurately than by drawing. James Nasmyth and James Carpenter collaborated in the production of *The Moon: Considered as a Planet, a World, and a Satellite*, published in 1874, which used the ingenious idea of printing photographs of plaster models of the moon based on drawings made through a telescope. Soon afterwards, Lewis Morris Rutherfurd built the first telescope intended for astrophotography. Equipped with a 28.5 cm (11¼ in) diameter lens with a focal length of about 4.5 m (15 ft), he used it to create around 500 detailed images of the surface of the moon. On 24 October 1946, a camera fitted into the nose cone of a modified V2 rocket, launched from the White Sands Missile Range in New Mexico, succeeded in taking the first images of Earth from space from an altitude of 105 km (65 miles). On a more tragic note, the 1986 *Challenger* disaster was captured by Bruce Weaver, whose dramatic image of the Space Shuttle exploding in a fireball just seventy-seven seconds after take-off from the Kennedy Space Center was a testament to the price paid by the astronauts in their endeavours to explore the heavens. Digital technology has now allowed NASA to produce a compelling image of the Earth seen from space without cloud cover by combining the vast number of images taken by the Terra satellite into one composite photograph. Entitled *Blue Marble: Next Generation*, and intended as a reworking of the original *Blue Marble* photograph of Earth taken in 1972 by the crew of the *Apollo 17* mission, the image is a haunting reminder of the fragility of the planet.

BELOW. Neil Armstrong–*Buzz Aldrin on the Moon* (1969)
This is the visual evidence of the famous statement made by
Apollo 11 mission commander Neil Armstrong on 20 July 1969,
'… one small step for man, one giant leap for mankind'. Depicting
his fellow astronaut, lunar module pilot Edwin E. 'Buzz' Aldrin Jr
on the surface of the moon in the Sea of Tranquillity region during
the first lunar landing mission, Armstrong can be seen reflected in
Aldrin's visor. Although conspiracy theorists have argued that the
mission was faked in a studio, the image provides visual proof of
one of mankind's greatest achievements of exploration.

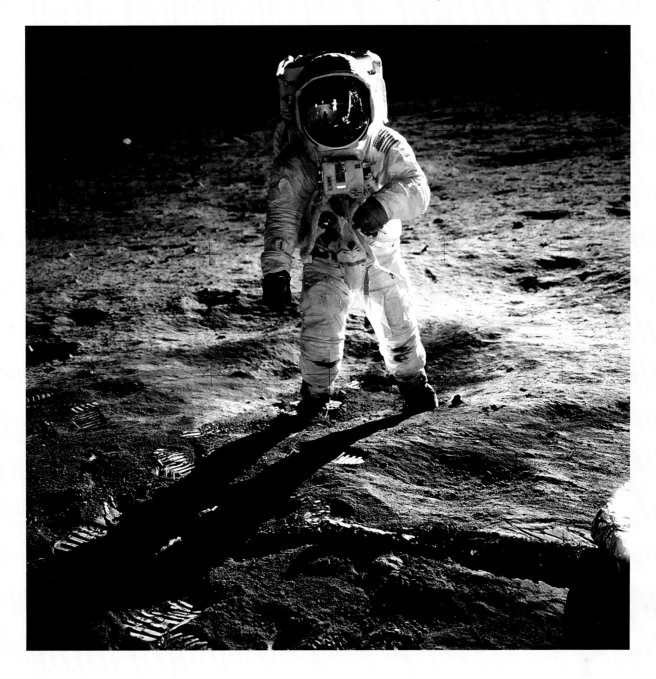

1965–1967

The latter part of the 1960s sees counterculture become increasingly mainstream, partly aided by a plethora of photographers who document the lives of people living at the edges of society. A hippy subculture starts to emerge in cities like San Francisco and New York's East Village, while author Ken Kesey holds the first of his Acid Tests, a series of parties centred on the use and promotion of the psychedelic drug LSD. Counterculture and popular culture increasingly merge. Bob Dylan releases his first electric album, and the Beatles play their final concert. Meanwhile protest movements against the Vietnam War and in favour of Civil Rights gain ever-greater momentum, but the latter also suffers a major loss with the assassination of black nationalist and former Nation of Islam leader Malcolm X in New York. LB

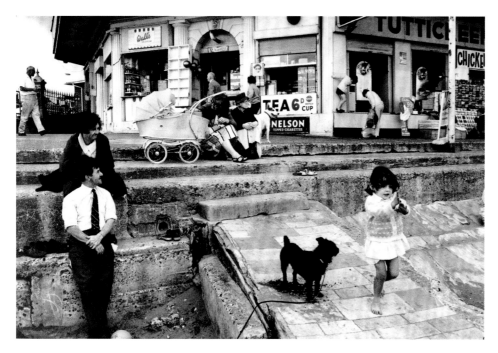

Winston Churchill
dies.

The Beach Boys release
Good Vibrations.

Tony Ray Jones – *Margate*

Tony Ray Jones was one of the most influential post-war British photographers, and his images of the English seaside and traditional customs are full of dry wit and subtle, clever and often surreal compositions. Ray Jones trained as a graphic designer at the London School of Printing, and then moved to New York where he studied with the legendary art director Alexey Brodovitch at the Design Laboratory. There he encountered Garry Winogrand and Joel Meyerowitz, who inspired him to start shooting with a Leica on the streets of Manhattan. On his return to England, he began a mission to 'communicate something of the spirit and the mentality of the English, their habits and their way of life, the ironies that exist in the way they do things, partly through their traditions and partly through the nature of their environment and their mentality.'

1965

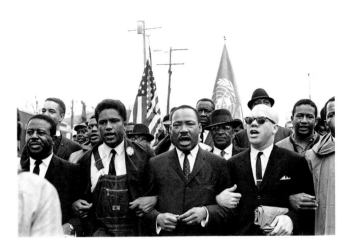

James 'Spider' Martin – *Dr Martin Luther King Jr Leads the March to the State Capitol in Montgomery, Alabama*

Born in Alabama, Spider Martin (1939–2003) found work as the staff photographer at the *Birmingham News*. His work there coincided with a momentous period in American history, as the Civil Rights movement intensified. In 1965 the shooting of a young African American man by an Alabama state trooper led to a series of protest marches from Selma to Montgomery. Martin was one of the few photographers on the scene for the first of these on 7 March 1965: a peaceful protest that turned violent as police attacked demonstrators. Martin's photographs documented this unprovoked violence by agents of the state, and were hailed by the march leaders including Martin Luther King Jr as having been instrumental in drawing wider attention and support to the cause.

Danny Lyon – *Crossing the Ohio*

A self-taught photographer, Danny Lyon (1942–) first encountered the medium as a member of the Student Nonviolent Coordinating Committee, where he photographed Civil Rights demonstrations against racial segregation in the American South. He went on to photograph a range of subjects, including the US penal system and more recently the anti-capitalist Occupy movement, but is perhaps best known for his work with the Chicago Outlaw Motorcycle Club, of which he was himself a member. Published in 1968 as the book *The Bikeriders*, Lyon's gritty photographs helped to sear biker gangs into the popular imagination as countercultural icons and rebels.

The Six-Day War takes place between Israel and neighbouring Arab states.

1966 **1967**

1968–1970

The Vietnam War escalates, with the North Vietnamese Tet Offensive of 1968 catching the United States and South Vietnam off-guard.

Richard Nixon is elected President the same year and pledges to end the war, but instead escalates it further, expanding it into Cambodia and Laos. Political protests in the United States against the war escalate, with the public increasingly polarized. With the introduction of the draft in 1969, thousands burn their draft papers and refuse to fight. The latter part of the decade was also marked by a blossoming of the genre of street photography, particularly in the United States, where photographers like Joel Meyerowitz, Lee Friedlander, Vivian Maier and Diane Arbus carve out a distinct vision on the streets of cities like New York. Many of these photographers, as well as recording the realities of the street, capture the final moments of the remarkable, transgressive countercultural decade that had been the 1960s. LB

Bill Eppridge–*Assassination of Robert Kennedy*

On 5 June 1968, less than five years after the assassination of his brother, President John F. Kennedy, the Democratic presidential candidate Robert F. Kennedy was shot and killed at the Ambassador Hotel in Los Angeles. He had been speaking to campaign supporters at the hotel, and after finishing began to exit through the hotel's kitchen area, greeting staff and well-wishers as he went. Just after shaking hands with hotel busboy Juan Romero, a Palestinian immigrant named Sirhan Sirhan shot Kennedy twice at point-blank range. Hearing the shots, numerous journalists and photographers rushed into the kitchen, but Eppridge's photograph of a bewildered-looking Romero cradling the dying Kennedy is the image which has come to define this second Kennedy family tragedy.

Martin Luther King Jr
is assassinated in
Memphis, Tennessee.

Bill Anders takes *Earthrise*, a
photograph of the Earth from lunar
orbit which becomes an icon of the
environmental movement (see p.184).

1968

John Paul Filo—*Shooting at Kent State University*

John Paul Filo (1948–) was a photojournalism student at Kent State University when Ohio National Guardsmen opened fire on unarmed students protesting against the Vietnam War, killing four and wounding nine. Filo was working in the university photography lab when he heard shots, and after running outside he found guardsmen firing what he initially assumed were blank rounds at students, until a shot narrowly missed him. Filo continued to photograph the shooting, which lasted for around one minute, and then turned his camera to the aftermath. One photograph in particular has become defining of this event, showing Mary Ann Vecchio screaming and kneeling over the body of Jeffrey Miller, one of the victims. This photograph was widely published in the following days and went on to win Filo a Pulitzer Prize later that year.

Minor White—*Power Spot*

Born in the United States, Minor White (1908–76) studied botany but lacked interest in the subject. He had been introduced to photography by his grandfather and was also a keen writer, and he began to teach photography, write about it as a critic, and develop his own photographic vision. Over the course of a long career White developed a complex relationship with photography. As he got older his photographs became increasingly abstract, as in this image, and he experimented with creating groupings of photographs which he termed 'sequences' and which were intended to have a similar effect on viewers as the sequence of shots in a cinematic film.

The Apollo 11 **mission** lands the first men on the moon.

1969

The maiden **flight** of the Boeing 747 takes place.

1970

CONCEPTUAL PHOTOGRAPHY

Artists have used the camera to record their performances and as a tool to explore concepts and ideas, playing with the nature of how the camera describes the world.

Ever since Hippolyte Bayard's *Self-portrait as a Drowned Man* (1840), artists have used the unique qualities of the photograph to play with the idea of what is real and what is not, what is staged, what is fiction and what is fact. In the 1960s, with the rise of conceptual art, the term 'conceptual photography' came into use to describe the work of a range of artists who used the camera as an integral part of their practice. For performance artists, the camera became a way of recording their interventions, often using a deadpan, documentary aesthetic that exaggerated the 'truth value' of their work. While still a student at St Martin's School of Art, London, Richard Long (1945–) made his *A Line Made by Walking* (1967), where he trampled down a straight path across a grassy field, and then photographed the resulting trace of his passing. The performative and transient nature of the artwork is preserved in the photograph, raising the question of where exactly is the actual artwork: was it in the act of walking, in the photographic documentation of it, or somewhere in between?

ABOVE. Eleanor Antin – *100 Boots on the Road* **from the series** *100 Boots* **(1971)**
Eleanor Antin's (1935–) *100 Boots* series featured fifty pairs of rubber boots that she took on a 'road trip' to fifty-one different locations, where fellow artist Philip Steinmetz photographed the arrangements. Antin then made postcards of each scenario, and mailed them to artists and art-world professionals all over the United States over a period of three years. The series raises the question of where the actual work of art resides; is it in the images, the postcards or the performance of arranging the boots in each tableau – or in the act of posting them to the audience?

John Hilliard (1945–) explored the nature of performance and questioned the veracity of the photograph in his 1974 work *Cause of Death*, where four photographs cropped from the same negative show a body lying covered in a white sheet, with each image bearing a different one-word possible cause of death. This combination of performance and questioning the nature of photography can also be seen in the self-portraits of Cindy Sherman, and in Gillian Wearing's (1963–) *Signs that say what you want them to say and not Signs that say what someone else wants you to say* (1992–93), in which she asked strangers she met on the street to write what they were thinking on a white piece of paper. She then photographed them holding the paper up to the camera. The influence of these approaches on contemporary photographic practice is significant, with photographers like Adam Broomberg and Oliver Chanarin combining conceptual thinking with a documentary aesthetic to make thought-provoking and complex works that question our idea of what is true and what is not.

BELOW. John Baldessari–*Throwing Three Balls in the Air to Get a Straight Line (Best of Thirty-six Attempts)* [detail] (1973)
John Baldessari (1931–) set himself the challenge of throwing three balls in the air thirty-six times (the number of frames on a roll of 35 mm film), and then published fourteen of them in a limited-edition book. The simplicity of the game and its inherent structure was repeated in his other works, *Three Balls in the Air to Get an Equilateral Triangle* (1973) and *Throwing Four Balls in the Air to Get a Square* (1974), where an arbitrary set of rules produced images with inherent beauty. Baldessari used conceptualism to critique the nature of art, and the process of being an artist, playing with language, games and rule-based methodologies.

1971–1973

The start of the new decade sees the counterculture and political freedoms of the 1960s increasingly losing ground to political conservatism and authoritarianism.

In Chile, the government of Salvador Allende is overthrown by a military coup, backed by the United States, which fears the spread of communism in Latin America. In Northern Ireland, British soldiers open fire on a peaceful civil rights protest on a day which becomes known as Bloody Sunday. Some of the positive legacies of the 1960s live on, however, and in the United States, the successes of the feminist movement in fighting for equal rights and pay for women are mirrored in a wave of radical photographic work by feminist artists like Hannah Wilke, Cindy Sherman and Martha Rosler. Many of these artists critique assumed gender roles and challenge the male gaze, which had long dominated many photographic genres. LB

Penny Tweedie – *Bengali Soldiers Abuse Prisoners*

Photographers covering conflict often have to confront ethical dilemmas around the representation of violence and its victims, but few have been as complex as those faced by a group of photojournalists who were covering the Bangladesh War of Independence from Pakistan in 1971. The British photographer Penny Tweedie was with Magnum's Marc Riboud, Horst Faas of the Associated Press and French photojournalist Michel Laurent, when during a victory celebration soldiers of the Mukti Bahini, the Bengali guerrilla army, began to torture and execute captured prisoners in front of the assembled journalists. Tweedie and Riboud felt that the event was being staged for the cameras, and left in disgust after taking a few images, including this one of the terrified captives. Others felt that it was their journalistic duty to remain and tell the story, with Faas and Laurent going on to win a Pulitzer Prize for their coverage of the brutal event.

Intel releases the Intel 4004, its first commercially available microprocessor.

1971

Kurt Strumpf – *Hostages Murdered at the 1972 Munich Olympics*

In 1972 West Germany hosted the Olympic Games for the first time since 1936, which had been used as a propaganda opportunity by Adolf Hitler. Intended to be a gesture of peace and tolerance, the 1972 Olympics instead became the scene of terrible violence after eight members of the Palestinian terrorist group Black September seized a number of Israeli athletes and held them hostage, eventually killing them. With the world's press already in attendance the siege was televised live, drawing huge audiences. However, it is this grainy photograph by Associated Press photographer Kurt Strumpf that more than any other image represents the hostage-taking, and the face of terror more generally.

Luis Orlando 'Chico' Lagos Vásquez – *Allende's Last Stand*

In 1970 Salvador Allende became the first Marxist to become president of a Latin American country. In the context of the Cold War and fears about the spread of communism, this led to growing external pressure on Chile. Following a period of social unrest, Allende was overthrown by a US-backed military coup led by army chief Augusto Pinochet, who then ruled as head of a repressive military junta until 1990. Lagos (1913–2007) had a long working relationship with Allende, and was present during the coup as Allende emerged with his bodyguards from the presidential palace during a lull in the fighting. It is thought to be the last photograph of Allende alive. Lagos's photograph was later published anonymously in the *New York Times*, which had agreed not to disclose his identity within his lifetime.

Bloody Sunday, the shooting of civil rights protesters, takes place in Northern Ireland.

Skylab, the first space station, is launched by the United States.

Pablo Picasso dies.

1972

1973

1974–1975

By the early 1970s it is clear the United States will not win the Vietnam War, despite enormous escalation and the extension of the war into Cambodia and Laos. Public support for the war evaporates as nightly bulletins broadcast footage of the countless civilians who are most often the casualties. Photographers continue to photograph from the front line, producing spot news images and longer-term projects. The end of the war in 1975 leaves the United States embarrassed – but a hostile media, rather than an inept military strategy, soon becomes the scapegoat for the failure of the US to prevail, a perception which will dramatically affect the ability of journalists to cover future conflicts. Meanwhile camera technology continues to advance, with the development of the first digital camera by Steve Sasson, an engineer at Kodak. Weighing 3.6 kg (8 lb) and taking around 23 seconds to record an image, which is saved to a magnetic cassette tape, this camera nonetheless signals the future for photography. LB

The Carnation Revolution in Portugal begins the transition to democracy.

Richard Nixon resigns following the Watergate scandal.

Ian Berry – *Whitby*

Originally from England, Ian Berry (1934–) moved to South Africa and established a reputation as a photographer while working for titles that included the influential magazine *Drum*. He was also the only photographer present during the Sharpeville Massacre, when the police opened fire on unarmed protesters demonstrating against the pass laws. In 1964 Berry returned to the United Kingdom and began working for the *Observer* magazine, leading to numerous assignments around the world. Berry also continued to work on personal projects, including *The English*, an extended study of his homeland which also functioned as an opportunity for Berry to rediscover his own country after many years working abroad.

1974

Patty Hearst, Surveillance Camera

The great-granddaughter of publishing magnate William Randolph Hearst, Patty Hearst shot to fame in 1974 when she was kidnapped by the Symbionese Liberation Army, a terrorist group. They aimed to get two imprisoned members of the SLA released, which failed, but the authorities were unable to locate Hearst. After over a year in captivity she sided with her captors and was later seen on closed-circuit television taking part in bank robberies. She claimed she had been brainwashed, but was convicted of bank robbery before later being pardoned by President Jimmy Carter.

Elliott Erwitt–*Felix, Gladys and Rover*

Elliott Erwitt (1928–) was born in France, but his family later emigrated to the United States where he studied photography and cinema. Drafted into the army following university, Erwitt served as a photographer's assistant and continued to explore the medium after he was discharged, meeting photographic luminaries like Edward Steichen and Robert Capa, the latter of whom invited Erwitt to join Magnum. Dogs have been a recurring theme in Erwitt's career, with the photographer producing four books on the subject. This image is almost certainly his most famous, a brilliant visual gag which plays off size and shape to great effect.

The Fall of Saigon to North Vietnamese forces ends the Vietnam War.

An engineer at Kodak builds the first digital camera, recording black and white images to a cassette tape.

1975

5

1975
TO 2000

In the latter part of the twentieth century, photography became accepted as a major art form, entering into the discourse of the museum and gallery world.

Photographers adopted an increasingly fine-art approach to the conceptual and aesthetic underpinnings of their work. Postmodernism challenged the conventions of photographs as truthful documents of the world, opening up and questioning the very process of image-making. Often referring to the history of photography, image-makers used strategies of staging, appropriation and montage to question our beliefs in the photograph as a document. Others employed rigorous and precise techniques using large-format cameras to record the world in a highly detailed and seemingly neutral way that often concealed a subtle political and social message beneath an apparent veneer of objectivity. A prime example of this combination of ideas and execution can be found in the work of the Japanese photographer Hiroshi Sugimoto (1948–), combining a deep understanding of the craft of photography with a philosophical investigation into photography's transformation of both temporal and spatial dimensions through the action of pure light. In *Theatres*, his

extended series on the interiors of cinemas, he made a single exposure on a sheet of large-format film for the entire duration of a movie that was playing to the audience. The flickering projection exudes a blinding light that wraps softly around the ornate surfaces of the space, emphasizing the flat two-dimensionality of the screen against the three-dimensionality of the interior. Sugimoto displays an extremely high level of formal skill, producing exquisite black-and-white prints that challenge Postmodernism's concentration on ideas over technical execution, saying that 'I really respect my craftsmanship and my hands. So, even though I've lived in this postmodern time, I probably call myself a postmodern-experienced pre-postmodern modernist!'

Art photographers began to explore their own lives, documenting their relationships with their families and friends, often using a loose, amateur-like approach that drew on the aesthetic of the family photograph album, but challenged the conventions of only recording the celebratory moments, instead focusing on the complexities and challenges of life. Often intensely intimate, the work of Nan Goldin (1953–) is a sprawling autobiographical document of the lives of her New York social

PREVIOUS PAGE. Alex Webb
– *Gouyave Bar* (1979)

LEFT. Hiroshi Sugimoto – *Radio City Music Hall* (1978)

RIGHT. Nan Goldin – *Nan One Month after Being Battered* (1984)

milieu of friends and lovers that she brought together into *The Ballad of Sexual Dependency* (1985). Goldin shot on colour slide film because she couldn't afford to make prints, but this allowed her to create a multimedia slide show, projecting her images in a series of improvised live performances where she advanced the slides by hand, accompanied by a soundtrack prepared by collaborators and friends such as the Velvet Underground and Maria Callas. Her images were unflinchingly honest, including this powerful self-portrait (above) she took of herself after being beaten by her boyfriend – with her direct gaze, bruised face and red lipstick, enhanced by the direct flash, an act of defiance to her abuser. Goldin's work tapped into a range of emerging themes in photography, with its combination of performance, the family and a colour snapshot aesthetic. A decade later, Richard Billingham (1970–) began to photograph the daily life of his alcoholic father and mother in their tiny

council flat in the English Midlands. As an art student, he began the series as source material for his paintings, using a cheap 35 mm compact camera and out-of-date film. His deeply personal images captured both the pathos and the humour of the lives of his parents, and when they were published as a book entitled *Ray's a Laugh* (1996) they immediately gained widespread acclaim for their radical and raw intimacy.

The 1970s and 1980s marked a key period of critical engagement with the nature of photography from a range of writers and thinkers, with the publication in 1977 of Susan Sontag's (1933–2004) highly influential and often-quoted *On Photography*. In this collection of essays on the medium, she questioned the effectiveness of photojournalism and the ethics of documentary, arguing forcefully that 'There is something predatory in the act of taking a picture. To photograph people is to violate them, by seeing them as they never see themselves,

by having knowledge of them they can never have; it turns people into objects – that can be symbolically possessed. Just as the camera is a sublimation of the gun, to photograph someone is a sublimated murder – a soft murder, appropriate to a sad, frightened time.' She did, however, acknowledge the power the photograph can have on the viewer, recalling her transformative encounter as a young girl with images of the Holocaust. *On Photography* was followed in 1980 by Roland Barthes' meditation on memory, *Camera Lucida* (*La chambre claire*), in which he developed his concepts of studium and punctum, with studium denoting the overall content and interpretation of a photograph, and punctum referring to the often-minor detail that might wound the viewer, creating a personal connection with an element of the image. Another highly significant book was *Thinking Photography* (1982), written by the critic, educator and photographer Victor Burgin (1941–). He combined semiotics, feminist and Marxist theories with conceptualism, both in his

writings that were highly critical of the intertwining of mainstream photographic production and capitalism, and in his photography that used text and image together to critique both the medium itself and modern society. In his *US 77* series he referenced both commercial advertising imagery and the great American photographic road trip in the spirit of Evans and Frank, but subverted both of them with his intelligent pairing of words and pictures.

The engagement and exploration of mainstream culture became a central theme of many artists, with some drawing on the visual language of advertising and cinema, while others used found images. The artist Richard Prince (1949–) freely appropriated the work of other photographers, copying images from magazines and then re-photographing and cropping them to create large-scale works that playfully disrupted mythological figures of American culture. In his *Cowboy* series Prince took images from the Marlboro cigarette advertisements and reworked

LEFT. Victor Burgin – *Flights of Fancy* from *US 77* (1977)

ABOVE. Richard Prince – *Untitled (Cowboy)* (1989)

them to undermine the fantasy they were purporting to portray. He explained how 'the pictures I went after, "stole", were too good to be true. They were about wishful thinking, public pictures that happen to appear in the advertising sections of mass-market magazines, pictures not associated with an author ... It was their look I was interested in. I wanted to re-present the closest thing to the real thing.' His cavalier approach to the copyrighted images of others was condemned by some as the theft of

intellectual property, but his works became symbolic of the complex relations and interconnections between commerce, art and culture. Ironically, given their critique of consumer culture, his photographs have become a highly sought-after commodity on the collectors' market, with his work *Spiritual America* (1981) becoming the second most expensive photograph of all time when it was sold for $3,973,000 in 2014, a marker of the respect that the art market has developed for photography.

COLOUR BECOMES ACCEPTED AS ART

As colour printing in magazines became more widespread after the Second World War, colour photography became widely used in advertising, commercial and fashion photography, and in photojournalism through publications like *Life*, the *Sunday Times Magazine* and *National Geographic*. The world of fine art and documentary photography was slower to accept colour, seeing it as vulgar and brash. However, in the 1970s photographers began to explore how colour could be used to go beyond mere description, and to add an emotional, psychological and visceral depth to their work. This movement was encouraged by the influential director of photography at New York's Museum of Modern Art, John Szarkowski, who in 1962 curated a retrospective of the innovative work by Magnum's Ernst Haas, which was the museum's first solo-artist retrospective exhibition dedicated to colour work. Szarkowski went on to work with William Eggleston to produce his seminal book and exhibition in 1976, entitled *William Eggleston's Guide*. Eggleston's use of the painstaking, complex and expensive dye-transfer printing process enabled him to create a body of work that transcended the apparent 'snapshot' aesthetic he deployed, producing a series of images that gradually reveal a complex and multi-layered exploration of the American social landscape. At around the same time, a new generation of American photographers began to explore how the detail of the large-format 10 x 8 view camera that traditionally was used with black-and-white film could instead be used to describe the subtleties of light and colour, with Joel Meyerowitz publishing *Cape Light* in 1979, while Stephen Shore (1947–) embarked on an epic road trip across America to produce *Uncommon Places* (1982), followed soon after by Joel Sternfeld's (1944–) satirical *American Prospects* in 1987. Taken together, these books became highly influential for the development of colour as a serious art form, and for subsequent generations of photographers, especially in Britain and Germany.

LEFT. Richard Misrach – *Tracks, Black Rock Desert, Nevada* (1987)
For some forty years, Richard Misrach (1949–) has been documenting the harsh yet beautiful landscapes of the American West in his ongoing series of works entitled *Desert Cantos*. Begun in 1979, the project comprises over thirty separate bodies of work that are all self-contained yet together form an extraordinarily rich and deep investigation into both the impact of man on the environment, and the nature of light, colour and form. Misrach typically works with a 10 x 8 large-format camera and colour negative film, giving his images a high level of detail and intense saturated colours. He sees the combination of aesthetics and a political undertone as extremely effective, arguing that 'beauty can be a very powerful conveyor of difficult ideas. It engages people when they might otherwise look away.'

RIGHT. Martin Parr –
from *The Last Resort* (1985)
Influenced by photographers such as
William Eggleston and Garry Winogrand,
the British photographer Martin Parr
(1952–) is known for his documentary
images that use garish colours, with his
subjects often chronicled in extreme, often
absurd, close-ups. In this image from his
controversial but groundbreaking 1985
book, *The Last Resort: Photographs of
New Brighton*, he used daylight flash, and
a medium-format Plaubel Makina camera
loaded with colour negative film to capture
two children enjoying a moment during a
family day-trip to an English coastal resort
that is past its prime.

LEFT. William Eggleston –
The Red Ceiling (1973)
To make his exhibition prints, William
Eggleston (1939–) used the complex
dye-transfer process to give an
unparalleled level of saturation and
richness to his colour images, perfectly
exemplified in this unsettling composition
of a ceiling painted the colour of fresh
blood. Each print cost hundreds of dollars,
and the multiple-step process took three
days per print. The printing press uses four
separate printing plates (magenta, yellow,
cyan and black), and each plate was
engraved with a halftone image for each
colour, which was in turn covered with a
thin layer of ink. The plates were then
carefully placed in sequence on to the
paper to create the final print.

THE ADVENT
OF DIGITAL

The ubiquity, quality and affordability of digital cameras today is a testament to the speed at which technology has improved the quality of digital capture. The early digital cameras were heavy, large, had very low resolution, shot in black and white, and were extremely expensive. However, the advantages of digital photography were rapidly apparent, as it allowed images to be generated without the need for the complex and time-consuming processing of film. In January 1989, Associated Press photographer Ron Edmonds (1946–) made history when he used a filmless Nikon QV-1000C still video camera to capture President George H. W. Bush's inauguration. He followed this with another first in 1992 when he used the new Kodak DCS camera to photograph the then presidential candidate Bill Clinton's acceptance speech at the

Democratic Party National Convention; the images were distributed via the AP news stream to newspapers around the world within five minutes of the event. The development of digital photography was greatly assisted by the creation of agreed file formats that meant files could be transferred easily between cameras and computers. These included the Joint Photography Experts Group (JPEG) standard, which became the most common file format for storing image data, Tagged Image File Format (TIFF), which became the industry standard for lossless storage, and various RAW image formats created by the digital sensors in cameras. The rise of digital cameras has gone along with the expansion of personal computers, with the Apple Mac becoming the most frequently used tool in professional publishing, photography and graphic design.

LEFT. Prototype digital camera (1975)
In 1975 Steven Sasson (1950–), an engineer at Eastman Kodak, constructed a prototype for the world's first self-contained digital camera. It used the new solid-state CCD image-sensor chips developed by Fairchild Semiconductor in 1973 to record black-and-white images with a resolution of just 0.01 megapixels on to a compact cassette tape. It weighed 3.6 kg (8 lb), and the process took 23 seconds to capture an image. In 2009 Sasson was awarded the National Medal of Technology and Innovation by President Barack Obama. Despite Kodak's innovations in digital technology, the company filed for bankruptcy in 2012, after struggling to adapt to the changing industry.

ABOVE. Photoshop

The digital image-editing software program Photoshop is now so dominant that it has even become a verb, so that to 'photoshop' an image has become shorthand for any form of digital manipulation. Created in 1988 by Thomas and John Knoll, it quickly became the industry standard in raster graphics editing, with a range of built-in tools enabling images to be worked on to change their exposure and colour, and the clone stamp tool to remove, duplicate or alter areas of the image. A vast array of plug-ins for the program allows traditional film formats to be simulated, and for a range of special effects to be added to photographs.

LEFT. Kodak DCS fitted to Nikon F3 camera (1990s)

In the 1990s Kodak led the field in developing professional digital cameras, launching the Kodak DCS in 1991. This was the first digital SLR, and used a Nikon F3 body, which was attached to a camera back fitted with a CCD imager that recorded data on to a 1280 x 1024 pixel matrix, producing a 1.3-megapixel file. The camera was tethered to a separate digital storage unit (DSU) that could be slung over the shoulder to store the data, and that had its own keyboard to enter the caption information. This was the first of a series of Kodak DSLRs that were produced until 2005, which included the 6-megapixel DCS 460 based on a Nikon N90 body that initially retailed for the staggering sum of $35,600.

1975–1977

The mid-1970s are years in which the world faces significant changes in politics, culture and the world of photography. The Vietnam War ends, the Khmer Rouge in Cambodia rise to power to exterminate more than 1.7 million Cambodians, or nearly 21 per cent of the population, and Apple is created in Cupertino, California. In 1976 colour photography gets its first solo exhibition at New York's Museum of Modern Art. The work of William Eggleston, 'the godfather of colour photography', is panned by most critics. Just a year later, in 1977, cultural critic Susan Sontag publishes *On Photography*, a seminal collection of essays on contemporary photography that sets the stage for photography criticism and theory in the late twentieth century. SY

Nhem Ein – *Victims of the Khmer Rouge*

The ruthless Khmer Rouge regime ruled Cambodia between 1975 and 1979, and it is estimated that more than 14,000 prisoners were killed at Pol Pot's infamous Tuol Sleng prison, known as S-21. The Khmer Rouge were also bureaucrats who carefully kept written documents and photographed every inmate who came through the gates of the prison. This image is by Nhem Ein, who took 10,000 portraits of prisoners. As he took these images, he was aware that they were going to their deaths, yet he had no power to help.

The Vietnam War officially ends on 30 April with the fall of Saigon.

Home videotape systems (VCRs) are developed in Japan by Sony (Betamax) and Matsushita (VHS).

1975

Martine Franck – *Pool Designed by Alain Capeillères*

Belgian photographer Martine Franck (1938–2012) was one of the first female photographers to join Magnum in 1980, and she paved the way for other women. Her subject matter is eclectic, including this study in line, curve, light and shadow. The beauty of the image is that it is simple and unstaged, yet captures a decisive moment. Although she was the second wife of Henri Cartier-Bresson, she was able to create her own niche in the world of photography, and even cancelled her first solo exhibition in London after she discovered that her husband's name was used on the invitations.

Masahisa Fukase – *The Solitude of Ravens*

This image is by Japanese photographer Masahisa Fukase (1934–2012), taken as part of a series he created between 1975 and 1982 following a devastating separation from his wife. In the wake of this loss, he became obsessed with ravens, feeling an affinity for these solitary and brooding animals. For years he took black-and-white photos of them where they gathered at a railway station near his childhood home in Hokkaido. In this, his last image before his death in 2012, we see only the mysterious silhouette of a lone raven: a telling end to his career and life as an artist.

The Apple Computer company is formed by Steve Jobs and Steve Wozniak.

William Eggleston is granted the very first one-man exhibition of colour photography at the Museum of Modern Art in New York City.

Susan Sontag publishes her seminal work *On Photography*.

1976

1977

1978–1980

These years are marked by events that include the start of the Iran–Iraq War, the Three-Mile Island nuclear accident, the eruption of Mount St Helens, the invasion of Afghanistan by the Russians, and the launch of Ted Turner's CNN network to cover it all. The world of photography is also rocked by the release of the hand-held Sony Camcorder. This small, portable item becomes a household necessity for amateur filmmakers and radically changes the way that events are recorded. Yet the incident that garners the most attention is not political or technological, but rather the murder of ex-Beatle John Lennon by an obsessed fan outside the Dakota Building in Manhattan. Just hours before the shooting he and Yoko Ono had posed for what would be their last photoshoot with portraitist Annie Leibovitz. SY

Konika introduces the first point-and-shoot auto-focus camera.

At Jonestown in Guyana cult leader Jim Jones and his followers drink poisoned Kool-Aid, committing mass suicide. A total of 918 die, including at least 270 children.

Raymond Depardon – *Gunman in Beirut*

Raymond Depardon (1942–), a self-taught photojournalist and documentary filmmaker, began shooting images in Lebanon during a trip to Beirut in 1965. When the Frenchman returned in 1978, he was confronted by a very different city in the midst of a brutal civil war. He embarked on a project to document the Beirut he found. This image is of a sniper from the right-wing Christian Phalangists group that Depardon shadowed through the streets of the city. His other photographs show the city's shell-marked and ruined buildings, local men walking through the streets with semi-automatic weapons in broad daylight, and bombed-out cars. Yet he also depicts how daily life continues in spite of the violence in his images of weddings, religious services, and even picnics on the Mediterranean.

1978

Leonard Freed – *'Handcuffed', New York City*

This image comes from Leonard Freed's (1929–2006) collection 'Police Work'. Originally focused on civil rights, the American photographer continued to pursue his interest in societal violence in 1972 when he began documenting the New York Police Department for the British *Sunday Times*. This, perhaps his most famous image, is a black-and-white photograph of an unidentified man under arrest.

Alex Webb – *Gouyave Bar*

Inspired by Graham Greene's book set in Haiti, *The Comedians*, photojournalist Alex Webb (1952–) spent thirty years travelling and shooting images of the Caribbean and Mexican border towns. This compelling photograph was taken in a small-town bar on the west coast of Grenada as Webb sought shelter from the searing heat of the midday sun. He looked up and saw these men quietly standing in front of the intensely colourful translucent windows. He took the shot, and not a word was exchanged between the photographer and his subjects. This powerful image graces the cover of his book *Hot Light/Half-Made Worlds: Photographs from the Tropics*.

The Shah of Iran and his family flee to Egypt, and the Ayatollah Khomeini is brought back from exile, calling for the expulsion of all foreigners.

In Nicaragua the Marxist Sandinistas force out the Somoza regime and take the capital city, Managua.

Robert Mapplethorpe publishes his most iconic image – a black-and-white self-portrait in which the photographer, wearing make-up, toys with sexual identity.

1979

1980

CINEMA

The relationship between photography and cinema is symbiotic, in a dialogue that explores the differences between the two mediums as well as their similarities.

As well as being integral to the promotion of movies by making images on set for publicity, photographers have often also been the subject matter for films. Sometimes the photographer is the hero, such as James Stewart in Hitchcock's *Rear Window* or Nick Nolte as grizzled photojournalist Russell Price in *Under Fire*, set during the Nicaraguan conflict in 1979; sometimes they are the villain, such as Carl Boehm in *Peeping Tom*. Several notable actors have also been keen photographers, with Jeff Bridges using a widelux panoramic camera to shoot behind the scenes images of his films, while Dennis Hopper documented the wild times of the 1960s and 1970s, including intimate portraits of Andy Warhol and James Brown. Film directors too have been heavily influenced by still photography. Stanley Kubrick initially worked as a photojournalist, and in 1946, at just eighteen years of age, he became the youngest ever staff photographer at *Look* magazine. In 1951 he turned one of his assignments for the magazine about the boxer Walter Cartier into his first short film documentary,

LEFT. Tazio Secchiaroli –
On the Set of Blow-Up **(1966)**
A cult classic of the 1960s, Michelangelo Antonioni's *Blow-Up* featured David Hemmings as a hedonistic fashion photographer, allegedly modelled on David Bailey. He thinks he has witnessed a murder when he sees what appears to be a gunman in the corner of one of his photographic prints, and enlarges his negatives to try to find the evidence of a crime. During the filming, the Italian Tazio Secchiaroli (1925–98) took this iconic image of Hemmings shooting the model Veruschka von Lehndorff from above as he towers over her, illustrating how 1960s fashion photographers often worked in a freer, more liberated way than before. Secchiaroli himself was a celebrated paparazzo, and the inspiration for the photographer in Fellini's *La Dolce Vita* (1960).

entitled *Day of the Fight*, using his skills to create a dramatic black and white narrative. The German director Wim Wenders used the camera as a way of connecting with the light and landscape of America in preparation for his landmark 1984 film *Paris, Texas*, later publishing the evocative colour images as a book entitled *Written in the West, Revisited* (2000). The visual style of cinema has influenced numerous photographers, from Cindy Sherman's *Untitled* film stills series of the 1970s and 1980s to Gregory Crewdson's elaborately staged and lit twilight images of suburban America. Many photographers have also turned to filmmaking, from Paul Strand's 1921 collaboration with Charles Sheeler, *Manhatta*, about New York, to Robert Frank's groundbreaking *Cocksucker Blues* (1972) about the Rolling Stones. Magnum's Raymond Depardon has made eighteen feature-length films, and even Henri Cartier-Bresson experimented with film in the 1930s, working as an assistant director with Jean Renoir and making a series of short documentary films about the Spanish Civil War.

BELOW. Eve Arnold – *Marilyn Monroe on the Set of The Misfits* (1960)
Magnum photographer Eve Arnold (1912–2012) developed a close relationship with Marilyn Monroe that began when the star teasingly congratulated Arnold on her photographs of Marlene Dietrich by asking 'If you could do that well with Marlene, can you imagine what you would do with me?' Over a decade-long collaboration, they produced a series of intimate and telling insights into the vulnerability of the actress, with Arnold feeling that Monroe was 'in total control … she manipulated everything – me, the camera.' As part of the promotion for the 1961 movie directed by John Huston, *The Misfits*, Magnum was given exclusive access for nine of its photographers to document the filming. Arnold captured Monroe in what was to be her final film role, framed against the empty desert landscape, emphasizing the loneliness of the life of a major Hollywood star.

1981–1983

Scientists discover the virus that causes AIDS; Anwar Sadat, president of Egypt, is assassinated in Cairo by the group the Egyptian Islamic Jihad; the word 'internet' is first mentioned; and the US successfully launches the first flight of the Space Shuttle *Columbia*.

Some of the most moving photographic images from these years are captured in the wake of the 1982 massacres of Palestinians at the Sabra and Shatila refugee camps in Beirut, Lebanon. Photographer Robin Moyer wins World Press Photo of the Year for his harrowing images of the slaughter of hundreds, including women and children, that was led by the Lebanese Christian Phalangist militia during the Israeli invasion of the country. In *Man's Best Friend*, American photographer William Wegman (1943–) publishes Polaroid images of his Weimaraner, Man Ray, which become iconic (see p.248). SY

The Iran Hostage Crisis ends, and fifty-two Americans who have been held for 444 days in the US embassy in Tehran are sent home.

○ **Manuel Pérez Barriopedro–*Attempted Coup in the Spanish Parliament***
On just another day in the afternoon proceedings of the Spanish Parliament, 200 members of the Francoist Spanish Civil Guard attempt a coup and hold the members of Parliament hostage for nearly twenty-two hours in total. Photographer Manuel Pérez Barriopedro (1947–) takes eleven shots, but is able to hide the film in his shoe. When he and the other journalists are finally released, he sends this image out to the world by midnight. The next day the coup leaders surrender, marking the end of the influence over the country of the deceased dictator Francisco Franco, and solidifying the power and future of Spanish democracy.

1981

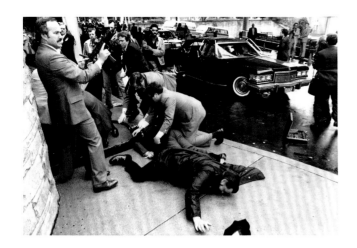

Susan Meiselas – *Cuesta del Plomo*

One morning as photographer Susan Meiselas (1948–) was driving on the outskirts of Managua, the capital city of Nicaragua, she came upon the remains of a body that had been half-eaten by vultures. She took only two shots, one in colour and one in black and white, and then fled the scene. The setting for her powerful image is a notorious site known as Cuesta del Plomo ('Lead Hill'), a place where many assassinations occurred during the Nicaraguan revolution at the hands of the National Guard of dictator Anastasio Somoza, and where many who are still classified as missing by their families probably took their last breath.

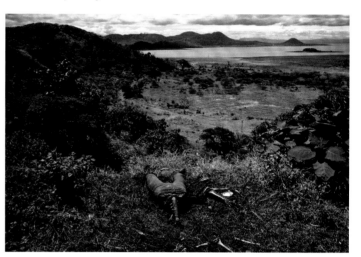

Mike Evans – *Reagan Assassination Attempt*

On 30 March 1981, there was an assassination attempt on US President Ronald Reagan outside the Hilton Hotel in Washington, D.C., by John Hinckley Jr. The official White House photographer captured the immediate aftermath, as White House Press Secretary James Brady and police officer Thomas Delahanty lay wounded. It was reported that Hinckley was obsessed with Martin Scorsese's film *Taxi Driver* and had been stalking its star, Jodie Foster. In the movie, the main character attempts to assassinate a US senator who is running for President, and Hinckley believed that if he attempted the same he would grab the attention of Foster.

Sony introduces the Mavica (Magnetic Video Camera). Not strictly a digital camera, it is an analogue television camera and stores pictures on two-inch floppy disks for playback on a television.

David Bowie embarks on his Serious Moonlight Tour for his album *Let's Dance*.

After the worst drought in history, the death toll in Ethiopia reaches four million.

The first compact disc player and the commercial compact disc, Billy Joel's *52nd Street*, are debuted in a collaboration between Sony and Philips.

1982

1983

1984–1986

The mid-1980s sees the opening up of the Soviet Union with *perestroika* and *glasnost*. In the United Kingdom 'mad cow disease' is identified and this leads to major reforms in the farming industry. Smoking is banned on public transport, including planes, in the United States, and Mexico City is hit with an 8.1-magnitude earthquake that kills nearly 9,000 people. In the world of photography Pixar introduces the digital imaging processor while Fuji puts the first disposable camera on the market just a year later. This is a revolutionary move: disposable cameras are cheap and extremely easy to use. They become a staple at events such as weddings, where guests are encouraged to shoot from their point of view and give the undeveloped roll of film to the new couple as part of the documentation of the day. In the art world, Richard Avedon (1923–2004) publishes his seminal work *In the American West*, which depicts the unsmiling, shattered culture of Fort Worth, Texas, in stark life-sized black-and-white portraits. SY

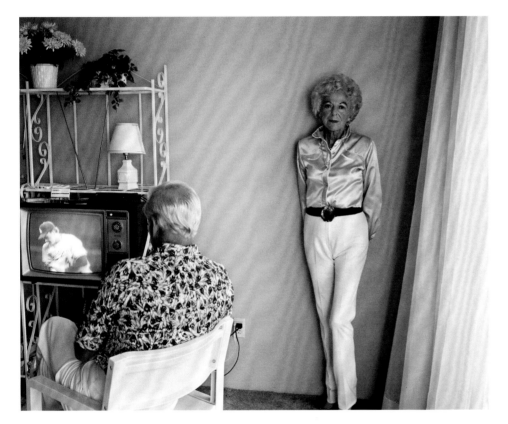

Indian prime minister Indira Gandhi is assassinated.

Larry Sultan–*My Mother Posing for Me*

Between 1975 and 2009 Larry Sultan (1946–2009) created six foundational bodies of work exploring both the psychological and the physical terrain of suburban family life, inspired by his upbringing in California's San Fernando Valley. Sultan's intimate, domestic and personal approach, blending documentary and staged photography, influenced generations of photographers that followed. *My Mother Posing* belongs to Sultan's pioneering book and exhibition *Pictures from Home* (1983–92). In this decade-long project, Sultan's own mother and father are primary subjects and active participants, exploring photography's role in creating familial mythologies.

1984

Tom Wood – from *Looking for Love*

Tom Wood was one of a group of photographers working in Britain in the 1980s that included Peter Fraser, Paul Graham, Martin Parr and Paul Reas, who began to work in colour, breaking away from the traditional documentary approach of black and white that had been used to depict the working classes. Wood lived and worked in Liverpool, where he was quickly nicknamed 'photieman'. This image is from his first book, *Looking for Love* (1989), a chronicle of the social world of the New Brighton nightclub, the Chelsea Reach. Wood's use of flash gives the images an energy that perfectly captures the hedonism of the period.

Joel Meyerowitz – *Bay/sky, dawn, fall*

This picture of Cape Cod is part of Joel Meyerowitz's (1938–) collection *Bay/Sky*. During the 1970s the photographer used a large-format camera to take pictures of the sea from the porch of his house overlooking Cape Cod Bay in Massachusetts. His images are a meditation on colour and light, and are very different from the street photographer's other work such as documenting the aftermath of 9/11.

The Greenpeace ship *Rainbow Warrior* is sunk when French agents plant a bomb on the hull, killing photographer Fernando Pereira.

A Soviet nuclear reactor at Chernobyl explodes on 26 April causing the release of radioactive material across much of Europe.

Mikhail Gorbachev replaces Konstantin Chernenko as the Soviet leader.

The Space Shuttle *Challenger* disintegrates 73 seconds after launch, killing all seven astronauts on board.

1985

1986

CENSORSHIP

Photography has always been subject to censorship, either by governments wanting to cover up evidence of abuse or negative political news, or because of issues of public taste and decency.

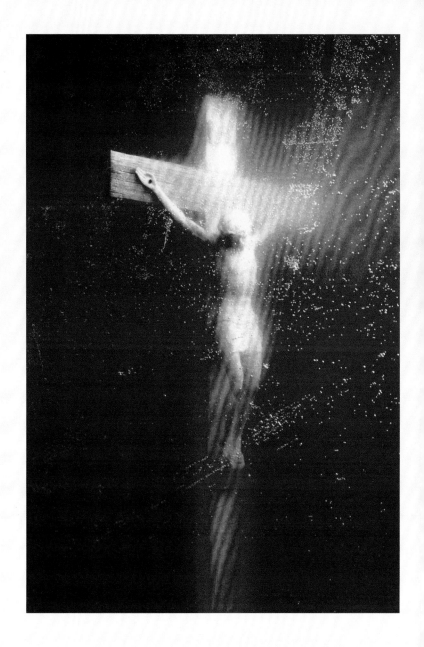

Photographers have frequently challenged the accepted limits of what can and cannot be seen, whether combat photographers on the front lines shooting military and civilian casualties, or fashion and art photographers skirting the fine line between pornography and eroticism. In the aftermath of the US airstrikes on the Basra road on retreating Iraqi forces in 1991, the American photographer Kenneth Jarecke shot a horrific image of the face of a soldier burnt alive at the wheel of his truck, his charred face fixed in a skeletal grimace. The image was deemed too disturbing to be published by *Time* magazine, and the Associated Press also would not distribute it, claiming that 'Newspapers will tell us, "We cannot present pictures like that for people to look at over their breakfast"'. In the end, only the *Observer* newspaper in London printed it with the caption 'The real face of war'. In *War Porn* (2014), the German photographer Christoph Bangert confronted the issues of self- and media censorship by collecting together the unpublished images he had shot on assignment in Iraq and Afghanistan of extremely graphic violence. In order to view the photographs, the reader has to physically tear the pages open in a conscious act of witnessing.

ABOVE. Andres Serrano – *Immersion (Piss Christ)* **(1987)**
Made as part of Andres Serrano's (1950–) 'Bodily Fluids' series (1987–90), this image challenges the orthodoxy of religious iconography in its depiction of a cheap plastic and wood crucifix submerged in a bottle containing the artist's own urine. The work was funded by the National Endowment for the Arts, which drew heavy criticism from senators Al D'Amato and Jesse Helms, and elicited hate mail and death threats. In 1997, when the work was exhibited in a retrospective of Serrano's work at the National Gallery of Victoria, Australia, the Catholic Church unsuccessfully sought an injunction from the Supreme Court of Victoria to prevent display of the work, which was later vandalized in the gallery. The gallery cancelled the show, raising more controversy over issues of artistic freedom and freedom of speech.

Known as the *yezhovshchina* ('the times of Yezhov') after its architect, Nikolai Yezhov, People's Commissar for State Security and head of the secret police (NKVD), Stalin's Great Purge of the 1920s and 1930s saw five million citizens arrested and as many as a million dead. Even Yezhov himself fell foul of Stalin, and was secretly tried and executed in 1940. As a result, his image had to be literally expunged from history, so any photographs of him were censored to remove his visage; as this pair of photographs shows, he became an Orwellian 'unperson' and vanished from existence.

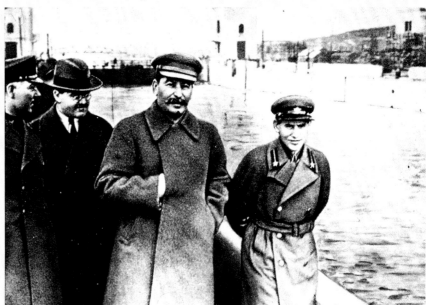

Robert Mapplethorpe (1946–89)

The American Robert Mapplethorpe challenged social norms of what is acceptable more than most in his celebrated yet infamous image, *Man in Polyester Suit* (1980), a three-quarter-length study of his then lover, whose penis is exposed from his trousers. Part of his 'X Portfolio' series, the image caused controversy when conservative North Carolina senator Jesse Helms attacked it in 1989 after it was exhibited at the Cincinnati Contemporary Arts Center. Offended by its graphic depiction of bondage and same-sex relationships, Helms was critical that it had received funding from the National Endowment for the Arts. The case was tried by jury, and the Arts Center was acquitted on charges of obscenity. The status of the photograph as a seminal statement on sexuality was cemented when a print of it sold for $478,000 at auction in 2015.

1987–1989

There are radical political shifts in the late 1980s, the most famous of which are the massive protests at the Berlin Wall that bring about the collapse of the East German government and the opening up of Eastern Europe to the West after nearly three decades. In Tiananmen Square in Beijing, China, hundreds of demonstrators are killed by Chinese troops during student protests, and Stuart Frank publishes his iconic image, *Tank Man*, of the lone activist in front of a tank. James Nachtwey's book *Deeds of War* is published in 1989 to critical acclaim. Covering the years 1981–88, it shows the photographer's breadth and depth of war journalism in places such as Nicaragua, Haiti, Sudan and Sri Lanka. In the world of fashion and advertising photography the documentary *Helmut Newton: Frames from the Edge* is released, covering everything from the notable black-and-white erotic images he is known for in magazines such as *Vogue*, to his childhood memories about his growing up in a Jewish family in Germany and fleeing the Nazis in 1936. SY

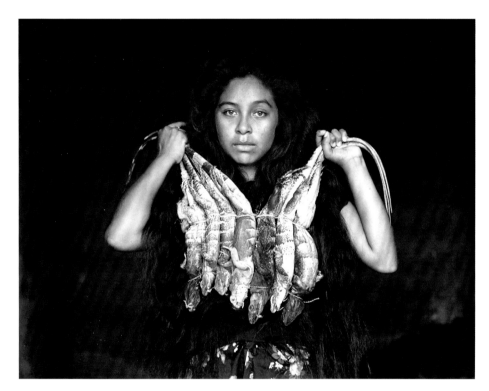

US President Ronald **Reagan** delivers his famous speech at the Berlin Wall in West Berlin on 12 June.

Flor Garduño–*The Woman*

Heavily influenced by Mexican photographer Manuel Álvarez Bravo, Flor Garduño (1957–) attempts to witness the everyday realities of the descendants of those who suffered violent changes throughout the last few centuries in the Americas. This image is of a young woman from Juchitán, Oaxaca, a southern region in Mexico where indigenous women support their households in a matriarchal society. This woman is holding a string of iguanas that she is taking to the market to sell. It is a critique of loss of identity related to the violent past, but it is also about the importance of the survival of tradition in the present.

1987

Eugene Richards – *Mariella*

Eugene Richards has been documenting the lives of ordinary Americans as they struggle with the challenges of poverty, drug addiction and violence. Richards creates powerful and visually compelling compositions in incredibly intimate moments, as in this 1988 image of Mariella, an addict about to shoot up crack cocaine. It was used as the cover of his book, *Cocaine True, Cocaine Blue* (1994), one of seventeen he has published, which also include *Exploding Into Life* (1986), documenting his wife Dorothea Lynch's struggle with breast cancer, *The Knife & Gun Club: Scenes from an Emergency Room* (1989), on life and death in an inner-city hospital, and *War is Personal* (2010), on the human cost of the war in Iraq and Afghanistan.

Maud Sulter – *Terpsichore*

In her series *Zabat* (an ancient ritual dance that women perform), Maud Sulter (1960–2008) portrays black women dressed as muses to reconsider the near-absence of these women in the history of photography. This photograph shows performance artist Delta Streete as Terpsichore, the muse of song and dance. The artist wears a costume she designed for her dance installation about the relationship between slaves and their mistresses. Sulter prepared this moving series of portraits for the 150th anniversary of photography celebrated at the Rochdale Art Gallery in England to offer this subtle commentary.

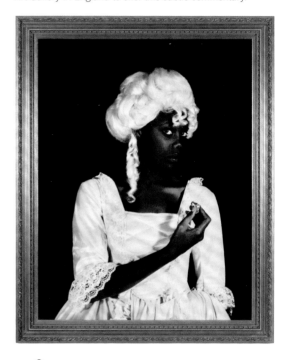

There is an attempt to censor Robert Mapplethorpe's sexually charged photography when the Corcoran Gallery in Washington, D.C., cancels his National Endowment for the Arts-funded show due to pressure from conservative lobbyists who object to the federal funding of the arts.

Iraq attacks the Kurds with poison gas.

A bomb is exploded on Pan Am flight 103 over Lockerbie in Scotland on 21 December.

The first DSLR camera prototype is launched by Eastman Kodak.

1988

1989

1990–1992

In the early 1990s the first web page is published on the World Wide Web, the public is told that there might be a hole in the ozone layer above the North Pole, _The Simpsons_ is seen for the first time on Fox TV in the US, the first GPS satellite navigation system goes on sale to the public, and Freddie Mercury, the lead singer of Queen, dies of the AIDS virus. Riots break out in Los Angeles in the wake of the acquittal of the police officers who were filmed beating Rodney King. Pop-culture queen Madonna releases her controversial coffee table book _Sex_. Shot in early 1992, the photographs by Steven Meisel cause a sensation for their softcore pornographic content, including sadomasochism and simulations of sexual acts. SY

Photo compact disc is introduced as a medium of storage by Kodak.

Channel Tunnel workers from the United Kingdom and France meet beneath the English Channel, marking the first ground connection between the UK and mainland Europe since the Ice Age.

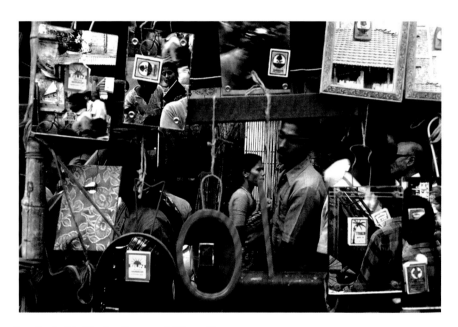

Raghubir Singh – _Pavement Mirror Shop_

Politically aware, and a sharp commentator on the legacy of colonialism in his country, Raghubir Singh's (1942–99) photograph of this street scene in India typifies his work. As an artist concerned with how British Christian ideas were alien to those of his own culture, he preferred to always shoot in colour because he believed that it was intrinsic to an Indian way of seeing the world. In this image Singh avoids stereotypes of typical India such as a woman in a sari or a monument such as the Taj Mahal. Instead he searches for dynamic and surprising perspectives. His point of view is unorthodox, as he creates an impactful image of a sales stall using mirrors to fragment the picture.

1990

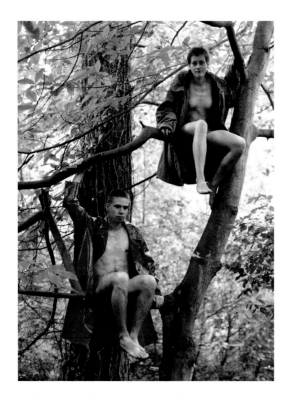

Wolfgang Tillmans – *Lutz & Alex sitting in the trees*

Along with Corinne Day and Jürgen Teller, Wolfgang
Tillmans (1968–) radically changed the face of
fashion photography in the late 1980s and early
1990s with his informal, documentary-style
approach, working for magazines like *i-D* and
The Face. This image of his childhood friends
Alex and Lutz was part of a campaign promoting
raincoats, but its relaxed, snapshot aesthetic has
made it an iconic image, typical of how Tillmans'
work has transcended the commercial world of
fashion to enter the realm of fine art.

David Turnley – *US Sergeant Ken Kozakiewicz Mourns the Death of Fellow Soldier Andy Alaniz, Killed by Friendly Fire*

On the last day of the Iraq War in 1991, David Turnley (1955–) was covering the
work of a mobile medical unit on an evacuation mission to pick up wounded soldiers.
They arrived at the scene of a 'blue on blue' or 'friendly fire' incident, in which a US
Bradley fighting vehicle had been hit by a missile fired by their own side. Turnley
captured the dramatic moment when one of the survivors realized that his friend
had been killed, and was lying in a body bag on the floor of the helicopter. The
media during the first Gulf War was heavily controlled, and initially the US military
tried to censor the dramatic image, but it was distributed globally on the news wires.
The photograph embodied the human cost of war and the close camaraderie of
soldiers, and went on to win the World Press Photo of the Year in 1992.

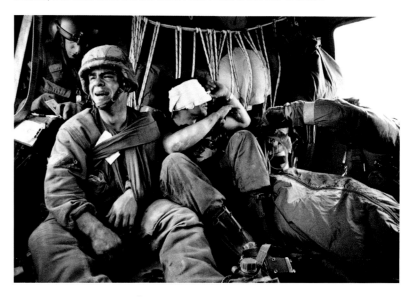

JPEG, the standard
image compression
and codification
format, is created.

South Africa forms a
new constitution for a
multicultural society
after many years of
apartheid.

The Balkan War rages during
the break-up of Yugoslavia.

1991

1992

CELEBRITY

Photographers and stars have always had a love/ hate relationship, with images essential to their marketing and promotion, but with the sometimes questionable ethics of the paparazzi raising questions of intrusion and exploitation.

Photography and the famous have been inextricably intertwined since the birth of the medium, with *cartes de visite* of well-known faces selling by the thousands in the nineteenth century, and magazines like *Variety*, *Hello!* and even *Vogue* promoting the cult of celebrity with their covers. But this has often been a tense relationship, as publicity agents have tried to control the public image of their clients, while the paparazzi have tried to get exclusive images of the stars, often in compromising situations. The infamous term for celebrity photographers was first coined in Federico Fellini's 1960 film *La Dolce Vita*, which included the character of a news photographer called Paparazzo, reportedly named after the noise made by a buzzing mosquito. While there have been several high-profile cases of the paparazzi being accused of excessive intrusion into the private lives of the famous, the most notable was in the aftermath of the deaths in 1997 of Diana, Princess of Wales and Dodi Fayed, who were killed when the limousine they were travelling in was pursued through the streets of Paris by photographers. Although several paparazzi were taken into custody after the crash, no one was convicted. On the other hand, photographers are routinely tipped off as to the whereabouts and movements of famous clients desperate for publicity to boost their careers. The rise of digital media and platforms like Twitter and Instagram have short-circuited the mainstream media, allowing overnight celebrities to emerge with a global audience hungry to consume the latest selfie.

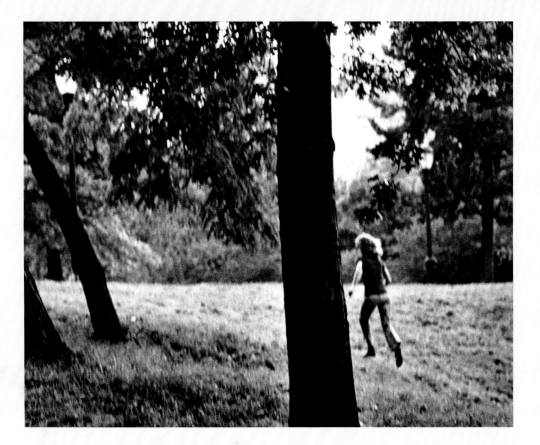

LEFT. Ron Galella – *What Makes Jackie Run? Central Park, New York City, October 4* (1971)
Ron Galella (1931–) had the perhaps unenviable title of 'the King of the Paparazzi', and built his reputation on getting intimate images of the famous whether they wanted to be photographed or not, with Marlon Brando punching out five of his teeth and Jackie Onassis taking out a restraining order against him. She often resorted to running away from Galella to protect her children, as in this moment captured in Central Park. He reflected later on his relentless pursuit of her, asking himself 'Why did I have an obsession with Jackie? I've analysed it. I had no girlfriend. She was my girlfriend in a way.'

ABOVE. Anwar Hussein – *Princess Diana at the Taj Mahal* (1992)

Anwar Hussein (1948–) became one of the rare photographers to have been officially sanctioned by the British Royal Family, and has documented their lives for decades, with Prince Charles, Queen Elizabeth II, Princess Anne and the Queen Mother all using his images on their official Christmas cards. He covered the life of Diana, Princess of Wales from her days as an eighteen-year-old nursery teacher to her funeral. He took one of his most poignant pictures of her alone at the Taj Mahal in 1992, predicting the royal couple's eventual breakup just four months later, with the bench she was sitting on now known locally as 'Lady Di's Chair'.

Andy Warhol (1928–87)

Famous for his 1968 quip that 'In the future everybody will be famous for 15 minutes', Warhol predicted the explosion of self-made minor celebrities in the late twentieth and early twenty-first centuries. As well as using photographs for inspiration for some of his most famous paintings like *Double Elvis* (1963), he was also a prolific photographer himself, recalling that 'A picture means I know where I was every minute. That's why I take pictures. It's a visual diary.' He used Polaroids, photo booths and a 35 mm snapshot camera to record the minutiae of his daily life, albeit peppered with pictures of celebrities such as Mick Jagger, Alfred Hitchcock, Jack Nicholson, Yves Saint Laurent and Debbie Harry.

1993–1995

These years witness an attack on the World Trade Center in New York City, the assassination of the Israeli prime minister Yitzhak Rabin and the end of the war in the Balkans with the signing of the Dayton accords. In East Africa, the world watches as chaos is unleashed in Rwanda and thousands are murdered in a bloody civil war, which is ultimately declared a genocide. In the art world, death also continues to be the subject of attention. In 1993 controversial artist Andres Serrano's photography exhibition opens at the Paula Cooper Gallery in SoHo, New York City. Titled *The Morgue*, his Cibachrome images highlight death in very large, slick representations of unidentified bodies in various stages of decomposition. These years also see significant changes to technology in the world of photography, including Nikon's production of the first optical-stabilized lens, which reduces blurring during exposure. SY

Gillian Wearing—*I'M DESPERATE*

This is from Gillian Wearing's (1963–) series *Signs that say what you want them to say and not Signs that say what someone else wants you to say*. A winner of the Turner Prize in 1997, for this project the British conceptual artist approached strangers in the streets of London and asked them to write their feelings on a piece of white paper. The results are often surprising, as with the snapshot of this man who appears well-off and confident in his dark suit and neat tie. His sign reveals something else. Wearing took 600 portraits in total, which show the complex makeup and ironies of appearance of Londoners at this time.

The Maastricht Treaty formally establishes the European Union.

1993

Joan Fontcuberta – *Mu Draconis* (MAGS 5.7 5.7)

Through his work Spanish photographer Joan Fontcuberta (1955–) challenges notions of truth. His scepticism is perhaps best viewed in this image from his series entitled *Constellations*, in which he appears to use a high-powered telescope to show something that looks like the night sky. In reality, the 'star systems' are dirt and splattered bugs that he made by taping contact prints on a sheet of photographic paper to his car window, driving around, and then developing it. His project questions the veracity and accuracy of photography to narrate the world we see before us.

Kevin Carter – *The Vulture and the Little Girl*

This famous photograph was taken during Kevin Carter's (1960–94) trip to Sudan in 1993. As he was about to shoot an image of this starving girl who was trying to reach a nearby United Nations feeding centre, a vulture happened to land on the ground nearby. He reported that after he took the picture he chased the bird away and watched the girl stand up and slowly walk away on her own. The publication of his image in the *New York Times* led to public uproar. Hundreds of readers called the paper to question the circumstances of the image and the ethics of Carter, who admitted that he purposely left the feeding centre out of the frame for a stronger effect. Despite the controversy, Carter won the Pulitzer Prize for this image, which also led to widespread awareness of the plight of Sudan.

O. J. Simpson is found **innocent** of the murder of his ex-wife Nicole Brown Simpson and her friend, Ronald Goldman.

A magnitude 7.3 **earthquake** occurs near Kobe, Japan, killing 6,433 people.

Kodak and Apple release the first digital cameras for the public.

Bosnian Serbs take control of the enclave of Srebrenica and commit the worst case of ethnic cleansing in Europe since the Second World War, killing approximately 8,000 Bosnian Muslims.

1994

1995

PORTRAIT

The photographic portrait offers the chance of connecting the viewer directly with the essence of the subject, with the camera promising to teach us about the character and personality of the sitter.

The human face and figure have always held a fascination for photographers and artists, with the eyes often being regarded as 'windows to the soul'. But beyond its philosophical appeal, the portrait is used in almost every publication, every day, everywhere in the world. We are endlessly fascinated by how people look, hoping to see in their faces some hint of their character, or simply try to know them better. Celebrities and the unemployed, rich and poor, famous and unknown, are all subjects for portraits. Some photographers, like Steve Pyke who shoots on a Rolleiflex camera with a close-up attachment against a black background, rely on an intense concentration just on the face of the subject to gain insights, while others, like Arnold Newman and Annie Leibovitz, use composition and elaborate staging to create environments that express an aspect of the subject's character. Newman's famous image of Igor Stravinsky seated at his piano exemplifies his structured approach; he recalled how it was a 'symbolic portrait. I designed the whole picture around my concept of Stravinsky: the harshness, the beauty … all of which reflect and express the same strength and beauty of his music.'

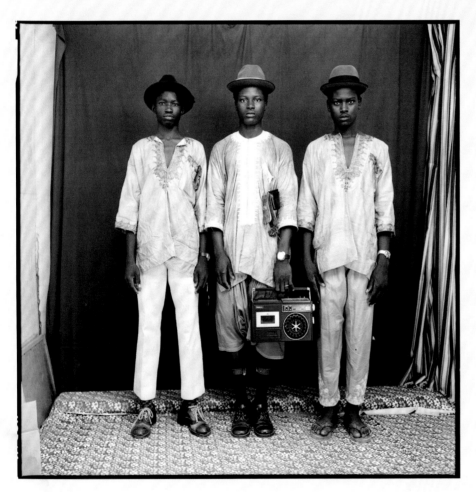

LEFT. Malick Sidibé – *Young Fulani Shepherds* **(1972)**
Malick Sidibé (1936–2016) was one of the most significant African photographers. He opened his famous photography studio in Bamako, Mali in 1962, and it became a mecca for locals to come to have their portraits taken, posing with their possessions and their fashionable clothes. These three shepherds from the nomadic Fulani, or Peul, ethnicity are displaying their treasured radio, a symbol of modernity and popular music, and wearing fashionable Homburg hats instead of the more traditional straw headgear. Sidibé's studio was full of the energy and life of the city, with him claiming that 'I wanted to be the photographer of happiness'. His work was recognized in 2007, when he received a Golden Lion Award for Lifetime Achievement at the Venice Biennale – making him both the first African artist and the first photographer to receive the prize.

Harry Callahan (1912–99)

Over a period of fifteen years Harry Callahan created an extraordinary photographic portrait of his wife, Eleanor. Using almost every format of camera imaginable, he incessantly photographed her in a wide range of environments, styles and situations, with her face as the constant theme. Callahan's agent, Stephen White, explained how she was his muse; he saw her as an 'additional f-stop on his lens. Through her, he saw form and structure more clearly, both in nature and in the world. She was present in his photographs even when she wasn't in them.' Eleanor herself recalled how image-making was central to their lives, and 'He'd photograph me while I was sleeping. Or he'd just sneak up on me. I never protested. Photography was as much a part of our lives as getting up in the morning.'

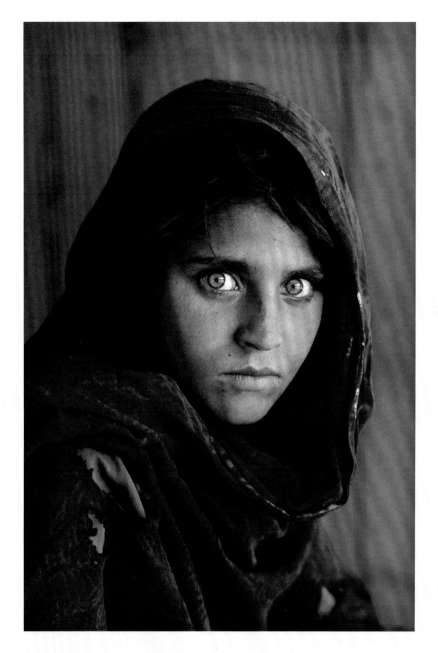

ABOVE. Steve McCurry – *Afghan Girl* **(1985)**
When he made this striking image of a blue-eyed Afghan girl, Sharbut Gula, in a refugee camp, Magnum photographer Steve McCurry (1950–) could have had no concept of how famous the portrait would become. It was published on the cover of *National Geographic* magazine in June 1985, and immediately tapped into global concerns about the cost of the ongoing conflict in Afghanistan. However, although Gula became a symbol of the plight of refugees worldwide, little was known of who she was until McCurry tracked her down again in 2002. The image raises important and troubling ethical questions about how an individual can become an icon for a larger cause, without having any say in the matter.

1996–1998

During these years Great Britain gives Hong Kong back to China, Carlos the Jackal is caught and sentenced to life in prison by a French court, and after Prince Charles and Princess Diana are divorced, she is subsequently killed in a car accident in Paris along with Dodi Fayed.

Important history of photography books are published including *Mathew Brady and the Image of History* by Mary Panzer, *Gordon Parks, Half Past Autumn: A Retrospective* by Philip Brookman, and *Berenice Abbott: Changing New York* by Bonnie Yochelson. In Latin America, Argentine photographer Marcelo Brodsky exhibits his most famous work to date, *Class Photo 1967*, in which he enlarges his eighth-grade class photo and identifies, by writing directly on the image, which of his classmates survived the brutal military dictatorship that plagued his country from 1976 to 1983 and which 'disappeared' along with nearly 30,000 others in his country. SY

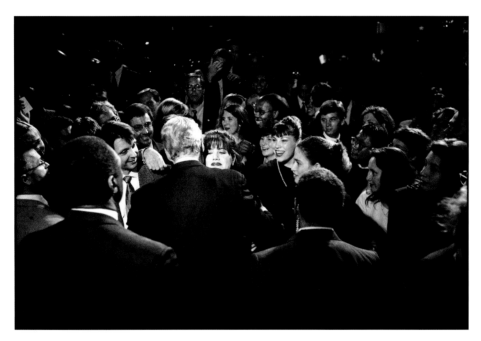

Dirck Halstead – *Bill Clinton Hugs Monica Lewinsky*

As *Time* magazine's White House photographer, Dirck Halstead (1936–) thought nothing of the photo that he shot of the US President hugging his young intern at a fundraiser in 1996. Yet his photograph took on significant meaning two years later when Clinton finally admitted to the world that he had sexual relations with Monica Lewinsky. *Time* put this photo on the cover of the 10 August 1998 issue; Halstead said that it only survived because he used film and kept it in his files. If he had used a digital camera he might have erased it, as did many other photographers who shot similar images at the time.

The first digital **camera** with an LCD screen is launched.

In the Battle of Grozny, Chechen rebels regain and then keep control of Chechnya's capital in a surprise raid against Russian Federation troops.

In Lima the Peruvian guerrilla group 'Shining Path' take hundreds of people hostage at the official residence of Japan's ambassador to Peru.

1996

Alfredo Jaar – *The Eyes of Gutete Emerita*

In 1994 more than one million Rwandans were killed in a genocide, and Chilean photojournalist Alfredo Jaar (1956–) was there to witness the atrocities committed. He took thousands of pictures in his attempt to document the horrors, but when he returned home he felt that none of the images conveyed the truth of what he had seen there. He opted for a different, more individual and personal approach. Rather than show an array of images he instead created an installation called *The Rwanda Project*. This image is a lightbox showing only the eyes of a woman who had witnessed the execution of her family, accompanied by the text of her personal testimony.

Boris Mikhailov – *Case History*

Boris Mikhailov (1938–) documents the hardships of daily life under communism and its aftermath in his hometown of Kharkov, Ukraine. In this photo, from his series *Case History*, he shows the desperation of the homeless following the collapse of the Soviet Union. In this scene a man who is carried through the snow stares directly into the camera, recalling paintings of Christ. Yet he is a contemporary subject who must pay for the sins of a society he did not create.

Mars Pathfinder lands on the surface of Mars.

Several European states **agree** on a single currency, the euro.

1997

1998

1999–2000

During a raid on a Miami home in 2000, Alan Diaz takes a Pulitzer Prize-winning photo of armed US federal agents facing six-year-old Elian Gonzalez and a man who saved him when their boat capsized. By international law, Elian must be returned to his father in Cuba. The map of photography fundamentally shifts when in 1999 the Kyocera Corporation introduces the VP-210 visual phone – the first mobile phone with a built-in camera. A year later Sharp releases the J-SH04 in Japan and Samsung releases the SCH-V200 in South Korea. The 2000s also kick off an array of Hollywood films about war photographers, including *Harrison's Flowers*, about a female reporter who travels to the former Yugoslavia in the midst of the raging war in search of her traumatized husband, a photojournalist. SY

A magnitude 7.4 earthquake kills more than 15,600 and leaves 600,000 homeless in Turkey.

Danish photographer Claus Bjørn Larsen captures an image of a wounded Kosovar Albanian among a group of refugees fleeing Kosovo, for which he will win the World Press Photo of the Year in 2000.

○ Yann Arthus-Bertrand – *Grand Prismatic Spring, Yellowstone National Park, Wyoming, USA*

Yann Arthus-Bertrand (1946–) first became interested in aerial photography when he shot lions from a hot-air balloon. Now his amazing aerial photography can be seen in *National Geographic*, *Paris-Match* and many other publications. To mark the Rio Environmental Summit in 1992 he began a project on the state of the planet. This is a stunning scene of Yellowstone National Park – the oldest national park in the world – from his 1999 book *The Earth from the Air*. The rainbow colours are produced by microscopic algae located in Yellowstone's thermal basin, which is the third-largest such formation on Earth.

1999

Edward Burtynsky – *Oxford Tire Pile #8*

As part of a larger project about the widespread impact of the international oil industry on modern landscapes, Canadian photographer Edward Burtynsky (1955–) searched for ways to creatively present its environmental run-off in the world. To remind us of the bigger problems associated with the use of petrol and oil, he presented a sinister-looking graveyard of tyres that was only made possible by the discovery of oil. The documentary image of the old, dirty rubber tyres makes a tense contrast to the natural setting, emphasizing the negative impact that industrial evolution has on the natural world.

Cornelia Parker – *Einstein's Abstract*

Cornelia Parker (1956–) is known for her art installations such as *Cold Dark Matter: An Exploded View* (1991), for which she had the British Army blow up a garden shed and then she suspended the wood fragments as if they were dramatically trapped in time. Here is an image from her 'Abstracts' series in which she took macro-photographs of objects that were used by great thinkers, such as Einstein and Charlotte Brontë. This is a photograph of the chalkboard on which Einstein wrote his theory of relativity at Oxford University in 1931. Chalk particles allude to a solar system and the way that science challenges our perceptions of reality.

Control of the Panama Canal is handed over to Panama after seventy-five years of US control.

Opening in Berlin, Leni Riefenstahl begins a world tour with her exhibition of images made during the Berlin Olympics in 1936.

The concerns over Y2K pass without the serious, widespread computer failures and malfunctions that had been predicted.

2000

6
__

2000
TO PRESENT

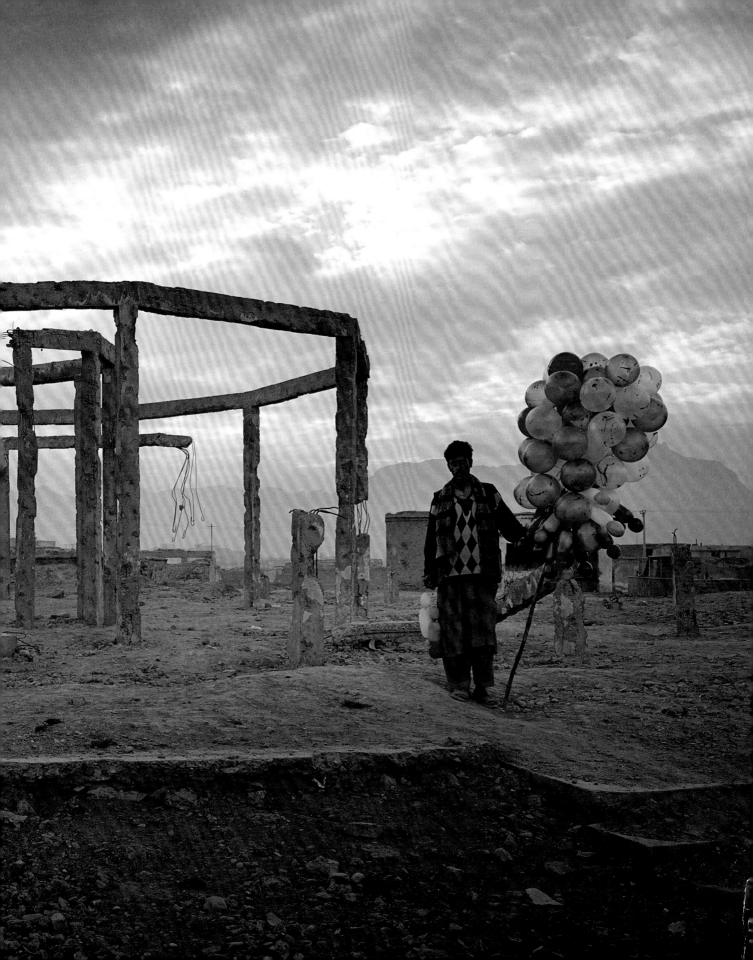

The arrival of the new millennium was a cause for widespread celebration and optimism, with technology creating a renewed sense of global unity and togetherness. The apocalyptic predictions that a 'Millennium Bug' would cause global technological collapse proved unfounded, and instead of a new Dark Age, the continued spread of digital technology only served to open up new possibilities and frontiers as it proliferated in the following decade. This technological optimism and advancement was however also tempered by the first global conflict of the new millennium, a war very different from the ones that had preceded it, and which in turn produced new types of images.

The digital revolution of the new millennium changed the ways people did many things, not least the way that they photographed. With the arrival of ever more affordable and usable digital cameras, traditional film photography was clearly on the way out, at least for consumers. This was as true in China as anywhere else, where a newly affluent middle class, which had emerged since the start of liberalization in the 1970s, used photography to document their lives and new-found wealth. As they switched from film to digital photography, vast quantities of 35 mm film negatives were discarded, ending up in Beijing's vast municipal tips, where they were often melted down for the silver they contained.

Recognizing this as the loss of a vast communal archive, the French photographer Thomas Sauvin began to collect discarded films from Beijing's dump, buying over a million negatives from the recyclers, who would otherwise have destroyed them. Working with these images in the mode of a curator rather than photographer, Sauvin creates thematic sets and collections under the overarching project title of *Beijing Silvermine*. The resulting images offer unique insights into a particular moment in China's history, as economic liberalization reached its peak. Sauvin's collection also shows the intersection between China and the

West, as the former started to open up and the influences, fashions and brands of the latter became increasingly common.

Advances in technology also led to a new connectedness in photography, with a greater awareness of global cultures and practices of photography as a result. A particular example of this was the greater penetration of Chinese arts and culture into Europe and North America, with Chinese photographers gaining wider recognition, exhibitions and publication in the West. This new awareness represented partly the proliferation of new technologies and modes of display, but also the emergence of a new generation of Chinese artists and photographers, who were creatively ambitious and internationally minded, and reluctant to accept the creative limitations that had been imposed on the previous generation.

Like many of these photographers, Wang Qingsong's (1966–) works explore the consequences of change in China over recent years. He was born in the same year that China's

Cultural Revolution began, and his works frequently reflect on the state of China in the wake of its economic liberalization. To create these images Wang constructs complex tableaux, populated with multiple actors. In some cases, these images humorously reflect on the perversity of changes in China and the contrast between old traditions and new fashions. In other examples, they hint at those who were left behind or who have not benefited from the country's new-found prosperity, and show that for all the benefits of Chinese development in the new millennium, there have also been casualties.

The proliferation of digital technology and the potential of photography to bring people together across vast distances also found darker uses in this new millennium. The 11 September attacks by the terrorist group Al-Qaeda marked the start of a new global conflict, often dubbed the 'War on Terror'. Images of the attacks, in particular those on the Twin Towers of New York's World Trade Center, radiated around the planet, giving the sense

PREVIOUS PAGE. Simon Norfolk – *Balloon Seller, Kabul* (2000)

LEFT. Thomas Sauvin – *Chinese Wedding* (2005)

BELOW. Wang Qingsong – *Follow Him* (2010)

of an attack not on a single building or city, but on the wider Western world. The attacks were noted for the way their psychological impact was amplified by the endless repetition of images of them in the following days and weeks, and the countless photographs taken that day have become etched into the memories of everyone alive at the time.

The War on Terror that followed was also intensely photographed, with the invasion of Afghanistan later in 2001, and then the invasion of Iraq in 2003, drawing a press corps and photographers from around the world. Befitting the differences between the War on Terror and previous conflicts, this period saw the emergence of new practices such as 'embedding' – a way to restrict and control the press. Despite this, droves of journalists photographed the brief fighting and the much longer instability that followed in both countries. These short periods of

conventional fighting in countries like Iraq were exceptions among years of asymmetric warfare against an enemy using unconventional tactics. This saw the rise of drones as a weapon of war, again a technology dependent on the long-distance transmission of images, allowing a weapon flying over Afghanistan to be controlled by people in the United States or Europe.

The War on Terror also saw the widespread use of covert operations against Al-Qaeda and affiliated groups. White House photographer Pete Souza's (1954–) image of the White House Situation Room catches key protagonists in the war as they watch the unfolding raid on Al-Qaeda leader Osama bin Laden's compound in Abbottabad, Pakistan, in 2011. While images and video of the raid were never released, Souza's photograph captures the high stakes involved, with each person's expression telling a different story, from President Barack Obama's look of

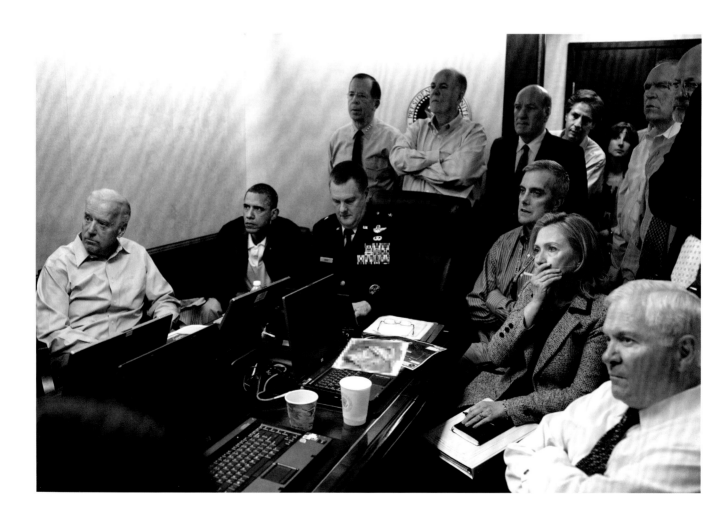

careworn concern, to Secretary of State Hillary Clinton's hand-at-mouth expression of shock or apprehension. The subsequent death of Bin Laden, who had successfully eluded capture for nearly a decade, was seen as a key milestone in the global War on Terror, even if the conflict continued relentlessly afterwards.

Partly in response to the new limitations imposed on the reporting of war and the increasingly abstract nature of many important issues, the 2000s saw the clear emergence of new ways of approaching photography, with photographers and artists increasingly drawing on ideas and practices from other fields. One in particular is the field sometimes termed 'conceptual documentary' for the way its proponents successfully blended journalistic subject matter with production techniques and modes of dissemination more often associated with fine art. Marcus DeSieno's project *No Man's Land* combines modern technology with traditional nineteenth-century photographic techniques to create a unique commentary on state control and supervision. DeSieno hacked into surveillance cameras positioned in remote wilderness locations, looking for compositions that captured the natural beauty of the scenes. He then took screengrabs from his computer, which he then re-photographed with a large-format film camera, and then made salt prints from the resulting negatives. His work thus combines a considered, conceptual fine art aesthetic that references the history of the medium, but also asks troubling questions about the role of the visual in modern society, as he claims his work 'falls into an indeterminate and contested territory where the results of how this technology has shaped us remains nebulous and unclear. We are currently, as a civilisation, already standing in the middle of this No Man's Land.'

LEFT. Pete Souza – *Situation Room* (2011)

RIGHT. Marcus DeSieno – from *No Man's Land: Views from a Surveillance State* (2017)

TOWARDS A
BIGGER PICTURE

As digital capture for photography became the norm, so digital printing took over from the conventional darkroom, with the enlarger being replaced by large-format printers capable of outputting photographs on continuous rolls of paper. As well as the digital C-print chromogenic process, which uses conventional photographic paper – also called Lambda or LightJet – the invention of inkjet or Giclée printers, using ink or dye sprayed on to the surface of the paper from as many as twelve nozzles, allowed photographers to more easily make giant prints of their work. This combined with innovations in mounting materials to which the paper could be directly bound, enabling photography at last to rival painting in the scale of its presentation within the gallery space. As photography became more and more accepted in the world of fine art, the lines between artists and photographers became increasingly blurred, and less and less relevant. This was reflected in the prices that photographs began to achieve at auction, with Andreas Gursky's *Rhein II* (1999) selling at Christie's New York in November 2011 for the record price for a single photograph to date of $4,338,500, and with photographs by Cindy Sherman, Richard Prince and Jeff Wall also being sold for over $3 million.

LEFT. Richard Mosse – *Safe from Harm*, **from** *The Enclave* **(2012)**
In an attempt to find a way to provide a new insight and engagement with an important but under-reported issue, Irish photographer Richard Mosse (1980–) used a now-obsolete infrared military film to photograph the conflict in the eastern Democratic Republic of Congo (DRC). The film was originally intended to uncover enemy positions in forests by capturing parts of the spectrum that are invisible to the human eye, and turns the greens of the African landscape into vivid reds, purples and crimson hues. Mosse presented the work as an immersive multimedia installation entitled *The Enclave* that used sounds and video as well as stills to try to engage with the audience and overcome the dangers of compassion fatigue.

LEFT. NASA – *The Orion Nebula* **(2006)**
This mesmerizing image consists of 520 separate photographs that were combined to produce the sharpest photograph yet made of the Orion Nebula, over 1,500 light years from Earth. The Orion Nebula is almost twenty-four light years across, consists of thousands of stars, and is one of the most photographed objects in the night sky. The photographs were taken by NASA's Hubble space telescope, launched in 1990 on a mission to image the galaxy. Hubble is equipped with a 2.4 m (7.9 ft) mirror that enables it to record light in the near infrared and near ultraviolet spectra as well as the visible light spectrum. Orbiting outside of the Earth's atmosphere, the telescope is capable of producing extremely high-resolution images, many of which have led to breakthroughs in astrophysics.

BELOW. Andreas Gursky –
May Day IV **(2000)**
Andreas Gursky works at a huge scale, in terms of the ambition of his ideas, the subjects he documents and the sheer size of his photographs for exhibition. This striking image of revellers at a techno rave party was made up of several large-format photographs that were then digitally stitched together in post-production to create a final panoramic chromogenic colour print that is a staggering 5 m long and 2 m high (16 ft 8 in x 6 ft 10 in), a scale comparable to the Abstract Expressionist paintings of Jackson Pollock, which this piece in particular references in its flowing patterns of the human form. Gursky uses his high vantage point to create a sense of an almost god-like perspective, stating that 'I stand at a distance, like a person who comes from another world.'

THE RISE OF THE CAMERA PHONE

Since the launch of the first digital camera phone in 2000, the Sharp J-SH04 J-Phone, the quality and resolution of the photographs taken by mobile devices has increased exponentially, to the extent that modern phones are capable of taking professional-quality images. The vast marketplace of social media has led to the emergence of a multitude of apps that enable users to manipulate and modify their images from smartphones, including Hipstamatic, which – somewhat ironically – can recreate the look of vintage film cameras by applying digital software filters. Launched in October 2010, Instagram has established itself in the world of social media as the leading photo- and video-sharing platform. Owned by Facebook, by the start of 2018 it had over 800 million regular users and over 40 billion total uploads. Content can be tagged with keywords, and users can 'like' other people's images and feeds. Professional and amateur photographers have used it as a way to build an audience that can directly connect to their work, bypassing traditional media outlets. However, these too realize its potential, with *Time* magazine commissioning five photographers who had established Instagram followings – Michael Christopher Brown, Benjamin Lowy, Ed Kashi, Andrew Quilty and Stephen Wilkes – to cover the breaking news of the devastation caused by Hurricane Sandy in 2012, with their editor, Kira Pollock, explaining that 'we thought this is going to be the fastest way we can cover this and it's the most direct route. It wasn't like, "Oh, this is a trend, let's assign this on Instagram." It was about how quickly can we get pictures to our readers.' Instagram's rival Snapchat, with 187 million daily active users at the time of writing, has the unique feature that images posted to it are deleted after a short time, encouraging users to be more active in their responses to uploaded content by using likes and interactive stickers.

LEFT. Jacqui Kenny (@streetview. portraits) – *Google Street View Scene – Camels in Sharjah, United Arab Emirates* **(2017)**
Jacqui Kenny created the Instagram account @streetview.portraits after she began to explore the world vicariously through Google Street View. Kenny suffers from agoraphobia, so finds travelling immensely difficult. Instead she uses the app to explore exotic and remote parts of the world that she would love to visit, taking screenshots that capture a unique perspective. With a consistent palette of pastels and intense, bright light, she has built a coherent visual identity that has brought her almost 100,000 followers on Instagram. The process has been liberating and very beneficial to her, as she explains she was 'worried that this project would close my world down even more, because I'd just be inside, screen-grabbing. But I've realized that it's the complete opposite. I've got this community of people now that I talk to on a daily basis, other people that have agoraphobia, and I really enjoy that.'

LEFT. Ben Lowy – *Libya* (2011)

Ben Lowy (1979–) has found the advent of high-quality smartphones liberating to his craft as a photojournalist, recounting that being able 'to "point and shoot" has been a liberating experience. It has allowed me to rediscover the excitement of seeing imperfections and happy accidents rendered through the lens of my handheld device.' Lowy used his camera phone to great effect to document the uprising against Colonel Gaddafi in Libya in 2011, explaining how he was able to communicate directly with his audience by 'embracing this new paradigm of journalism – no middle man, no publisher – I posted images from Libya and gained over 500 followers in a week.'

LEFT. Martin Parr – *Selfie Sticks Outside the Vatican Museum* (2014)

Martin Parr has documented the world of consumer culture for decades, and has seen the rise of the camera phone as the defining technology of modern-day tourism. In a feature he shot specifically on the selfie stick, he describes how 'outside in the street, especially in front of that iconic monument or landmark, the stick comes into its own. Getting the photo of you and your loved one(s) with the landmark in the background is de rigueur. The tourism industry, which is the biggest in the world, now dictates that the first requirement of any trip is to prove you were there with the necessary photo. It connects you to the world that we know and understand, and is a vital part of any successful holiday experience. We used to have to ask a passing tourist to take the photo, but thanks to the selfie stick those days are over and we are now self-sufficient.'

2000–2002

These years are shaped by what has come to be called simply '9/11' – the 11 September 2001 Al-Qaeda terrorist attacks on the World Trade Center in New York and on the Pentagon in Virginia in the United States, leaving nearly 3,000 people dead. In the wake of this the American government declares a 'War on Terror' and invades Afghanistan in search of Osama bin Laden. Images by John Labriola of a firefighter in despair, Stan Honda's woman in dust, and Richard Drew's *The Falling Man* are all iconic images of the moments just after the attacks. In that same year the award-winning documentary about photojournalist James Nachtwey, *War Photographer*, is released. The film is partially a debate about the photographer's potential exploitation of his distressed subject, and its director, Christian Frei, attaches a small video camera to Nachtwey's camera to let the audience attempt to see the world from the photographer's point of view. SY

Former Yugoslav President Slobodan Milošević is arrested and charged with corruption, theft of state funds and war crimes.

The first reflex camera with full-frame digital sensor is released to the market by Canon.

An earthquake hits Gujarat, India, killing more than 20,000 people.

Simon Norfolk – *Balloon Seller, Kabul*

Simon Norfolk (1963–) is one of the most gifted artists of his generation and is known as a specialist in 'aftermath' photography. Using a large-format camera to gain as much detail as possible, he visits sites of environmental disaster, conflict, and other kinds of human-made violence after the event has occurred to show us the lingering effects. This image of the balloon seller among the ruins of a teahouse is from his project *Afghanistan: Chronotopia*, which was created in the aftermath of the allied invasion in 2001. Norfolk felt that this was an optimistic time for a country that had suffered ten years of war, but when he returned a decade later he found that things had only worsened.

2000

2001

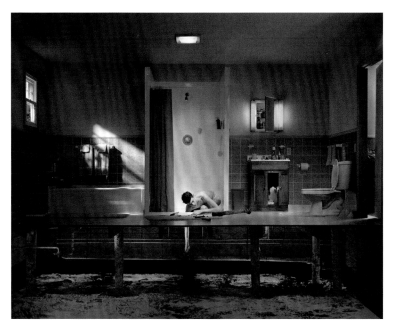

Gregory Crewdson – *Untitled*, from *Twilight* (2001)

Gregory Crewdson's (1962–) work takes themes from American social documentary photography, and concentrates them into highly constructed and elaborate large-scale images inspired by cinema. Crewdson's production values are on a Hollywood scale too. Working often around the magic 'twilight hour' between dusk and darkness, he spends months researching and planning his shoots, working with a team of technicians, set designers and builders, lighting assistants and producers to make his cinematic photographs. His images connect with feelings of alienation, loneliness and the fear that lies beneath the veneer of suburban America. Describing his photographs as 'frozen moments', Crewdson seeks a sense of an interrupted narrative, leaving space for the viewer to construct their own sense of what might be occurring.

Chechen rebels take 800 theatre-goers hostage in Moscow and threaten to blow up the theatre. Special forces storm the building, resulting in the deaths of 128 hostages and 41 rebels.

Thomas Hoepker – *9/11*

The photograph of this animated scene with the smoke of 9/11 billowing in the background was taken by chance as German photographer Thomas Hoepker (1936–) was walking by in the aftermath of the attack. He was in New York City as part of a Magnum members' meeting, and his photo has become a controversial image about truth and objectivity in image-making. One of the subjects in the scene, Walter Sipser, objected to how this photo was seen as callous. He said that he and his friends were in a state of shock like everyone that day and were in the middle of a lively conversation about the disaster.

The Brazilian film *City of God* is released, about growing up in the *favelas* and streets of Brazil, and how one boy grows up to be a photographer.

2002

2003–2005

These years see the Space Shuttle *Columbia* disaster, the last commercial flight of the British-French Concorde plane, the establishment of the Department of Homeland Security in the US in the wake of 9/11, the mapping of 99 per cent of the human genome, and the launch of Facebook at Harvard University by Mark Zuckerberg. The world also watches as more than one million people flee their homes in the wake of ethnic cleansing in Sudan by the government-backed militia. The Academy Award-winning documentary film *Born into Brothels* is released. With the guidance of documentary photographer Zana Briski, the children of prostitutes who live in Sonagachi, Calcutta's red-light district, are given film cameras, taught the basics of photography, and then asked to go out and capture images of one of the poorest cities in the world from their perspective. The results are often astonishing, and the images are exhibited around the world. SY

Massimo Vitali – *Little Animals*

Italian photographer Massimo Vitali (1944–) went to the Mediterranean coast of his homeland to observe his compatriots and try to understand why they had first elected someone like Silvio Berlusconi back in 1994. At the beach he said that he found the 'best and the worst' of the population. He tried to equalize these differences by shooting from above in direct sunlight with little or no shadow. This image, with the scattered subjects splashing in the clear water on the white sand, has an almost translucent, otherworldly quality to it. Yet the title alludes to the possibility that the photograph is more than a mere beach scene of summer holidaymakers, but instead questions human intent and judgement.

Saddam Hussein, former President of Iraq, is captured in Tikrit by the US 4th Infantry Division.

The strongest earthquake in forty years hits the Indian Ocean close to Indonesia, measuring 9.3 on the Richter Scale, killing at least 290,000.

2003 **2004**

Tomoko Sawada – from *School Days*

This photograph is part of Tomoko Sawada's (1977–) series called *School Days*, in which she played on the formal portraits that are so prevalent in parts of Japanese society. At first glance this appears to be just another banal group portrait of a female school group – yet, on close inspection, one sees that all of the images are of Sawada herself. In each self-portrait she has a different expression, pose or hairstyle, which alludes to the complexities of both conformity and individuality in contemporary Japanese society.

Antoine D'Agata – *Japan*

This image of a Japanese prostitute is representative of much of the French photographer's work, which looks at people living on the margins of society and examines how they search for different realities through escapism. Antoine D'Agata (1961–), who is referred to in one interview as a 'biographer, humanist and savant', says that he participates in the scenes where his subjects are often sex workers and drug addicts. He calls these 'ignored communities'. In his work he uses an aesthetic technique that lends an ethereal quality to the brutal reality in which many of these people live.

Kodak ceases the production of film cameras.

Hurricane Katrina strikes the Louisiana, Mississippi and Alabama coastal areas, flooding roughly 80% of the city of New Orleans and killing more than 1,500.

The video-sharing website YouTube is founded.

2005

PHOTOJOURNALISM

The first use of photography for depicting a news event was in May 1842, when the German portrait photographer Hermann Biow made daguerreotypes of the ruins of Hamburg after the fire that destroyed over a third of the city. However, it was the advent of halftone printing that allowed images to be directly reproduced in newspapers and magazines, with the American newspaper the *Daily Graphic* publishing the first photograph of *A Scene in Shantytown, New York* in 1880. News magazines like *Collier's* began to publish narrative series of images, which became known as photo-essays, with James Hare's 1889 coverage of the decisive Battle of San Juan Hill in the Spanish-American War published over several pages of the magazine – one of the earliest attempts to tell a story through photographs. However, the heyday of photojournalism began in earnest in the 1920s, with a number of technological developments accelerating the dominance of visual material in mainstream media publications. Wire transmission of photographs became possible in 1921,

Photojournalists have been at the forefront of history, acting as eyewitnesses to dramatic events, and telling stories about issues of social, political and economic relevance.

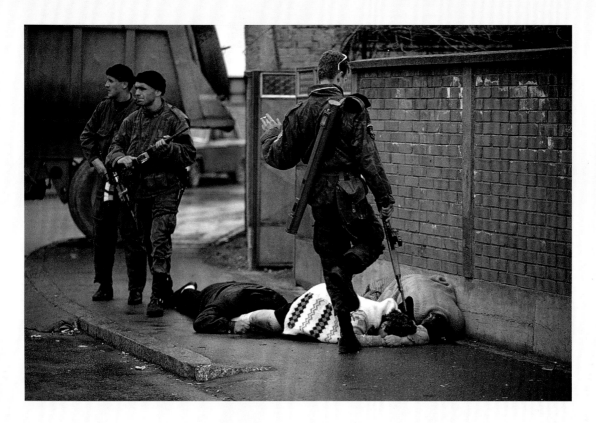

ABOVE. Ron Haviv – from *Blood and Honey* (1992)
During the early stages of the conflict in Bosnia and Herzegovina in 1992, Ron Haviv (1965–) secured access to a Serbian paramilitary unit led by the criminal Željko Ražnjatovi, known as Arkan. He followed them as they carried out what was one of the first instances of 'ethnic cleansing' when they took over the town of Bilijenia, where he witnessed the summary executions of civilians in the streets. This horrific image of the casual violence was widely published at the time, and was later used as evidence in war crimes trials held by the International Criminal Tribunal for the Former Yugoslavia (ICTY).

and new printing processes enabled cheaper, higher-quality reproductions. The advent of smaller 35 mm roll film cameras like the Leica and Contax allowed photographers such as Robert Capa, David 'Chim' Seymour, Felix Man and Kurt Hutton to shoot stories from a variety of angles and with wide coverage of the situation. At the same time, the rise of picture-led magazines such as the German *Berliner Illustrirte Zeitung*, the French *Vu*, the British *Picture Post* and the American *Life* created a whole new form for the medium to develop; the illustrated news magazine transformed photojournalism's distribution, and the extended photo-essay transformed its aesthetic and structural features. Photographers, designers and editors collaborated to develop this new visual language, mixing text and images in innovative layouts that still look fresh today. At its peak, *Life* sold more than 13.5 million copies a week, permeating deeply into American culture and society, and maintaining a position as the leading source of information about the world until the advent of the television age in the 1950s.

Sebastião Salgado (1944–)

Trained originally as an economist before becoming a photographer, Sebastião Salgado worked for the International Coffee Organization, travelling to South America and Africa. This gave him a unique perspective on the inequalities of the world economy, and led him at the age of twenty-nine to pursue a new career as a photojournalist. Since then, he has become one of the world's leading documenters of social and economic change and the impact it has on the human and natural world, producing a series of monumental bodies of work including *Other Americas* (1986), *Sahel: l'homme en détresse* (1986), *Workers* (1993), *Terra* (1997), *Migrations* (2000), and his latest work on the environment, *Genesis* (2013).

BELOW. Raymond Depardon – *The Fall of the Berlin Wall* (1989)
Raymond Depardon co-founded Gamma Photos in 1966, which went on to become one of the leading French photojournalism agencies. He left Gamma to join Magnum in 1978, covering the civil war in Lebanon (see p.208). On 9 November 1989, he witnessed the fall of the Berlin Wall, making this dramatic visualization of the historic moment when thousands of East Germans climbed over the concrete barrier to meet their fellow West Germans after the East German government declared that the border crossings could be opened. He captures the sense of brotherhood between the *Ossies* and *Wessies* who helped each other over the barrier. Depardon is also celebrated as a renowned documentary filmmaker.

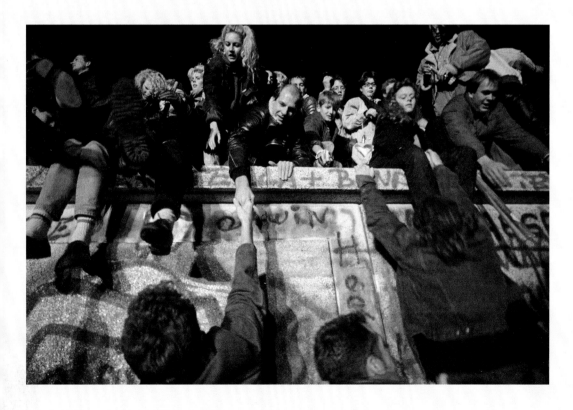

2006–2008

In these years there is a truce between the Tamil Tiger rebels and the Sri Lankan government, which will lead to the end of a twenty-five-year civil war. An earthquake strikes Sichuan province in China killing at least 60,000 and leaving another 5 million homeless; the war continues to rage in Iraq; and US President George W. Bush signs a $700 billion bailout in the wake of the onset of the global financial crisis. One of the most important global changes is the release of the first Apple iPhone, which will lead to a revolution in the way that photographs are taken in the next decade, especially the 'selfie'. In the art world, two notable films are produced about women: *Annie Leibovitz: Life Through a Lens* (2008), which traces the development of the photographer from childhood to the death of her partner Susan Sontag, and Paul Hasegawa-Overacker's film interviews with the reclusive artist Cindy Sherman in *Guest of Cindy Sherman* (2008). SY

Several European newspapers reprint controversial cartoons depicting the Prophet Muhammad, generating anger and rioting in the following weeks.

Hamas, the Palestinian militant Islamist organization, wins the Palestinian parliamentary elections.

William Wegman – *Ray*

In 1970 William Wegman (1943–) took home his first Weimaraner puppy and named it after the American photographer Man Ray. Since this time his photographs of these dogs have become a part of popular culture. There are books, calendars and other ephemera starring these famous canines, often amusingly posed in various costumes – dressed up in women's clothing, on roller skates, even wearing a tie. Yet some of his other images are much subtler, such as this one in which Ray wears a thick triangulated mat on top of his head, alluding to a medieval monk or a Madonna in a Renaissance painting.

2006

Adam Broomberg and Oliver Chanarin –
The Press Conference, June 9, 2008 [detail]
from *The Day Nobody Died*

The Day Nobody Died is a combination of photogram images
and a short 23-minute film taken by two photographers, South
African Adam Broomberg (1970–) and Briton Oliver Chanarin
(1971–). The two travelled to Helmand province in Afghanistan
to photograph the British Army and during their stay they
witnessed several deadly attacks. They also brought a long roll
of photo paper, cut into 6-metre lengths, which they exposed to
the sun to capture unique abstract images of the world around
them. They call this 'an evacuation of content' – to them it is
a true recording of the light and heat in the desert but also a
commentary on war reporting and photographic 'fact' or 'truth'.

Robert Polidori – ***1923 Lamanche Street***

In 2005 Hurricane Katrina struck New Orleans, Louisiana
causing one of the greatest natural and human disasters that
the United States had seen in its history. Robert Polidori, who
is best known for his architectural images of abandoned spaces
such as those of the aftermath of the Chernobyl disaster, was
sent by the *New Yorker* to New Orleans two weeks after the
hurricane to photograph the devastated city. He returned over
the next two years to record homes, shops and other spaces in
their various stages of destruction, demolition and, sometimes,
renewal, as at 1923 Lamanche Street. These images were
published in his book *After the Flood* (2006).

**Apple releases the ultra-thin
MacBook Air notebook** that is
less than an inch thick and turns
on the moment it is opened.

The final Harry Potter book,
*Harry Potter and the Deathly
Hallows*, is published,
marking the end of an era.

Polaroid discontinues
the production of all
instant film products.

2007

2008

2009-2011

During these years Barack Obama is inaugurated as the 44th President of the United States, singer Michael Jackson dies in strange circumstances at the age of fifty and Kodak decides to discontinue Kodachrome film. The continued importance of photography is also noted in several films, including the biopic *Bill Cunningham New York* about the endearing *New York Times* photographer who rides his bike around New York City taking shots for his own fashion page in the newspaper, and also in the *National Geographic* documentary *Search for the Afghan Girl*. This film follows the hunt for the young Afghan girl with the blue eyes photographed by Steve McCurry, who graced the cover of the magazine back in 1985 (see p.227). Also notable is the film *The Bang Bang Club*. Based on Greg Marinovich's and João Silva's autobiographical book, it is the story of four conflict photographers in the townships of South Africa during apartheid, and the extremes to which they go to get their shots. SY

Rinko Kawauchi – from *Illuminance*

Trained as a graphic designer, Japanese photographer Rinko Kawauchi (1972–) turned to image-making, inspired by a photography class at university. She uses ordinary, somewhat banal objects, but illuminates them for an unearthly, ethereal quality. She sometimes uses a medium-format camera for better detail and quality, as is seen in this image, where she photographs a triangular structure with a beam of light emanating from it. She also includes short texts alongside many of her works, leading her images to be described as 'visual haiku'.

FujiFilm launches the world's first digital 3D camera with printing capabilities.

After being hit by a flock of birds during takeoff, US Airways Flight 1549 piloted by Captain Chesley B. 'Sully' Sullenberger lands safely on the Hudson River.

2009

Zhang Xiao–*Coastline No. 14*

Chinese photojournalist Zhang Xiao (1981–) photographed all towns and cities along China's 9,000 miles of coastline to expose the rapid changes occurring in the environment. As a large sector of the rural Chinese population moves to the coast in search of a better life, the seaside is transformed rapidly from a serene, mostly abandoned space to a centre of activity. Rather than showing the actual new buildings that are radically changing the landscape, images such as *Coastline No. 14*, with colours and tones reminiscent of an old family album, reveal people enjoying the seaside foregrounded by the detritus that accompanies these rapid changes.

Michael Christopher Brown–*Photographer*
Michael Christopher Brown in an Ambulance After Being Hit by a Mortar Shell

When fellow photojournalists Tim Hetherington and Chris Hondros were killed in a mortar attack in Tripoli, Libya, Michael Christopher Brown (1978–) was with them. This disturbing image was taken by him with his camera phone and shows his extreme distress; he is covered in his own blood in the wake of the explosion. He did not willingly choose to use the phone as his medium, but he mistakenly dropped his digital camera on arrival in Libya and had to switch to his phone out of desperation. This became his way of photographing the conflict and his own unfortunate role in it.

The Burj Khalifa opens in Dubai, United Arab Emirates, as the world's tallest building.

Lytro introduces the first pocket-sized consumer light-field camera, which has the capability to refocus images after being taken.

A huge underwater earthquake hits off the coast of Japan, causing a tsunami that triggers a nuclear disaster at the Fukushima Daiichi nuclear power plant.

2010

2011

MANIPULATION

Photography is always an abstraction and an interpretation of reality, and every photograph manipulates its subject in some way, through the choice of camera format, the use of black-and-white or colour, what is included or excluded in the frame, how much is staged and whether elements are added or taken away in post-production. This creates a series of complex ethical problems around the truth of a photograph. The boundary between what is viewed as acceptable and what is not is often blurred and context-driven; what is acceptable in fine art or conceptual photography would normally be viewed as fakery in news or documentary practice. However, the example of W. Eugene Smith raises interesting questions around whether the authenticity of the photographer's experience or the technical limitations of the medium are more important. Regarded as one of the greatest photojournalists of all time, he felt that using darkroom techniques of extreme dodging and burning, and even combining negatives together and removing parts of an image, was totally acceptable as long as he remained faithful to his interpretation of the reality of what he had seen. Although his techniques produced compelling and powerful images, the extent to which he worked on his photographs in the darkroom is now considered to be deeply problematic in photojournalism, where a series of high-profile photographers have been accused of over-manipulating their images. This has led the major photographic competitions like World Press Photo to insist on viewing original, unedited RAW files of the winning entries to combat the extremes of manipulation made possible by Photoshop.

Photographic 'truth' is hard to determine, with myriad ways in which the image-maker can manipulate the picture, before, during and after it is taken.

LEFT. LoL Missiles (Clickabiggen)–*Are We Lumberjacks?* (2008)
Photography has long been used by governments to promote their interests, and the ability to alter and modify images to tell the right story has always played a part in state propaganda. However, the rise of digital technology and social media has made this process both easier to undertake and easier to critique. In 2008, Sepah News, the information arm of the Iranian Revolutionary Guard, released to global media a set of images purporting to show a successful missile launch in which four rockets streak into the sky. However, it was soon discovered that one of the rockets had actually misfired, and the fiery trail had been added in post-production. This attempt at fakery was quickly picked up by satirical social media, as in this humorous spoof where a LOL kitten, a staple of online feeds on photography, seemingly reaches out to play with the deadly weapon.

ABOVE. Frank Hurley–*Over the Top* (1917)
Frank Hurley's (1885–1962) extraordinary tableaux of the horrors of the First World War were his response to the frustrations he felt in trying to represent the scale and reality of the conflict with the limited technical apparatus of the period. He was an official war photographer for the Australian Army, and wrote extensively in his diaries of how he felt that he was unable to capture the essence of what he was seeing and experiencing in a single frame of film, and so made this elaborate composite of multiple photographs stitched together, combining as many as twelve separate negatives into one wall-sized print. However, his approach brought him into conflict with Australia's official war historian, Charles Bean, who called his works fake, leading Hurley to leave the Western Front in 1917 to continue to photograph in the Middle East. His dramatic tableaux raise the question of whether the authenticity of the experience of the photographer and the impact on the audience are more important than how the photograph is made.

2012–2014

The world of war photography takes a heavy blow in 2012 as Syrian dictator Bashar al-Assad's government planes destroy a building used by journalists in Homs, Syria, killing American war reporter Marie Colvin and French photographer Remi Ochlik. In 2013 Brazilian photographer Sebastião Salgado publishes his remarkable photobook *Genesis*, part of a series of images on global environmental issues. It includes stunning images of primordial landscapes, wildlife and indigenous peoples, to raise public awareness of crises we are facing, such as climate change and other ecological disasters. Beginning in 2004, Salgado went out to document landscapes such as tropical rainforests and the Arctic to capture nature in its original state and to testify to the fact that the world still harbours these kinds of territories. *Genesis* is featured in *Salt of the Earth*, a 2014 documentary about Salgado's intriguing life and work directed by Wim Wenders and Salgado's son, Juliano Ribeiro Salgado. SY

Roger Ballen–*Die Antwoord: Shack Scene*

Since its first upload on YouTube in 2012, the video 'I Fink U Freeky' has received more than 55 million hits and has catapulted both the video's director, photographer Roger Ballen (1950–), and the South African hip-hop group, Die Antwoord, to fame among young people around the globe. Entirely filmed in black and white, the video highlights Ballen's astounding photography, including the image called *Shack Scene*. This is one of Ballen's photographs of Die Antwoord, which is used in the video. It is a good example of his images, which have become part of an edgy project that meets at the intersection between high art and popular culture.

McCullin is released, a documentary about British war photographer Don McCullin.

The Syrian war rages on as its largest city Aleppo is attacked – one of the oldest continuously inhabited places in the world.

2012

Shirin Neshat – *Sara Khaki ('Patriots'),* from *The Book of Kings*

Shirin Neshat (1957–) uses a variety of art forms including video and photography to explore the contested relationship between femininity and Islamic fundamentalism. Born in Iran, she has lived in exile in the United States since the 1979 Revolution. Her work *The Book of Kings* was inspired by the eleventh-century epic poem *Shahnameh* (*The Book of Kings*), which narrates the history of Persia, interweaving fact and fiction. Neshat created portraits of three groups entitled the 'Masses', the 'Patriots' and the 'Villains', over which she laid verses from the poem. Deliberately ambiguous, the work questions the nature of the resistance to the regime and who are the true heroes and villains of contemporary Iran.

Donald Weber – *Ukraine Petrol Bomb*

Photographer Donald Weber (1973–) spent many years in Ukraine documenting the revolt from November 2013 to February 2014. Kiev's Euromaidan protesters created thousands of Molotov cocktails to set fire to armoured vehicles and buses. They had no other weapons at their disposal against the government's forces. The simplicity of Weber's image contrasts with the powerful message that these little bombs sent out to the world. This image went on to be published in his 2015 photobook *Barricade: The Euromaidan Revolt*.

The papal conclave elects Cardinal Jorge Mario Bergoglio, 'Francis', Archbishop of Buenos Aires, as Pope to succeed Benedict XVI following his resignation in February 2013.

The prize-winning photobook *Genesis* by Sebastião Salgado is published by Taschen.

Crimea is annexed by the Russian Federation.

2013

2014

2015–2018

A major human rights and refugee crisis begins in Myanmar, where more than 600,000 refugees cross into Bangladesh and accuse the government of the ethnic cleansing of Rohingya Muslims. Paris, France, is faced with terrorist attacks throughout the city in restaurants, a football stadium and a concert venue, leaving 130 people dead. The Islamic State group claims responsibility. Real-estate tycoon and former reality television star Donald Trump becomes the US President. In photography, the documentary *Hondros* is released about the conflict photographer Chris Hondros, who was killed on assignment in Libya. Burhan Ozbilici wins the World Press Photo of the Year award in 2017 for his photograph of the assassination of Russian ambassador Andrey Karlov in Ankara, Turkey. British photographer Edmund Clark's exhibition 'The Day the Music Died' opens in January 2018 at the International Center of Photography in New York. It represents a ten-year project that explores the structures of power and control in the so-called global War on Terror. SY

An anonymous photographer captures the shocking image of the ancient Temple of Baalshamin in Palmyra, Syria, being blown up by Islamic State.

Nilüfer Demir – *Death of Alan Kurdi*

At the end of summer 2015 three-year-old Alan was killed along with his brother when he drowned on the beach of a resort in Bodrum, Turkey, while trying to escape to safety from Syria in a small boat. The arduous trip across the Mediterranean killed many that summer, and the photographer said that she could do nothing but take the photo and 'express the scream of his silent body' lying there at the edge of the waves. Nilüfer Demir's (1986–) photo caused an uproar about the refugee crisis, leading to a heated debate in Europe and the United States about refugee status and how to handle the growing catastrophe.

Satirical newspaper *Charlie Hebdo*'s office in Paris is attacked. Twelve are killed and eleven are injured. Al-Qaeda claims responsibility.

2015

Nicholas Nixon – *The Brown Sisters*

This intimate portrait is of Nicholas Nixon's (1947–) wife and her three younger sisters in Massachusetts. Since 1975 he has been taking a yearly photograph to document their lives. The women are always standing in the same order, with his wife, Bebe, third from left, and he always uses the same camera and eye-level angle in natural lighting. He says that the photographs show changes in their appearances as they grow older, but also subtly reveal the relationships of the women. Some years they stand further apart, other years they are closer together.

Jonathan Bachman – *Baton Rouge, Black Lives Matter Protest*

The United States faces an ongoing crisis with regard to how many unarmed young black men are being killed by law enforcement. A movement has arisen called Black Lives Matter, in response to the deaths of Michael Brown in Ferguson, Missouri, and Erica Garner in New York City in 2014. It is meant to bring attention to human rights violations committed within the borders of the country on a specific population. Jonathan Bachman's (1984–) protest photo of Lesha Evans calmly facing white policemen was taken in Baton Rouge, Louisiana, and is a statement about her humanity and vulnerability in the face of racism and violence in the twenty-first century.

The United Kingdom votes to leave the European Union in a controversial move referred to as 'Brexit'.

Susan Meiselas's retrospective opens at the Jeu de Paume in Paris, which highlights her career, including important work on Nicaragua in the 1970s.

A constitutional referendum is held in Turkey which abolishes the parliamentary system and strengthens the executive power of the presidency of conservative leader Erdogan.

Incumbent Russian President Vladimir Putin is re-elected with 76.69% of the vote.

2016 **2017** **2018**

WHAT IS A
PHOTOGRAPHER?

The advent of smartphones and the internet has challenged the conventional view of who a photographer is and how they work with images.

The rise of citizen journalism, with on-the-spot documentation of news events by passers-by, has become commonplace, with their often-dramatic eyewitness images hitting social media well before professional news organizations can reach the scene. A prime example is the smartphone image made by Janis Krums of the crash landing on the Hudson River of a US Airways plane piloted by Captain Chesley B. 'Sully' Sullenberger, after it hit a flock of Canada geese shortly after take-off. He sent it directly to his Twitter account, and was surprised by how it quickly went viral, being seen and published globally. He remarked that 'I posted to my 170 followers and did not send it to any news outlets. It was incredible to see the power of Twitter and how news can spread around the world in a matter of minutes.' Photographers have also become curators in a sense, using platforms like Google Satellite and Street View, and found material from archives, to explore how images intended for one purpose can be radically re-interpreted and re-presented as aesthetic objects with deep social meaning. As the twenty-first century continues, and the number of images available increases exponentially, what becomes increasingly important is not who took the photograph, but how it can be used and to what end.

ABOVE. Mishka Henner – *Coronado Feeders, Dalhart, Texas* **(2012)**
Mishka Henner's (1976–) work deploys a range of strategies to interrogate contemporary society, uncovering material that would otherwise be difficult to photograph by traditional means. In *51 US Military Outposts* (2010) and *Dutch Landscapes* (2011) he used Google Satellite images to reveal secret sites around the world that are not marked on conventional maps. He used the same technique of building up composite photographs made up of hundreds of screengrabs from satellite images taken at maximum resolution to create this disturbing and dystopian vision of industrial-scale livestock production in America, with the final file reaching three gigabytes in size. Henner operates largely from his base in the UK, travelling to distant locations solely through the use of the internet. As he explains, 'if you followed me for two weeks you would not in a million years think of what I do as photography. It's something else. It's an amalgamation of intelligence gathering, data aggregation, image-making and packaging.'

Michael Wolf (1954–)

Originally a photojournalist, the German Michael Wolf has more recently investigated how Google Street View can reveal surprising juxtapositions. He spent hours scouring the mapping platform with the eye of a classic street photographer, and then making screengrabs of moments when the geometry of the frame made for an intriguing image. He collected the work into a book entitled *A Series of Unfortunate Events* (2011), which challenges the traditional role of the photographer as the observer of urban experience. He has gone on to produce several bodies of work based on found imagery, including *F*** You*, which consists of screengrabs of people giving the finger to the camera.

BELOW. Alexander Chadwick – *7/7 London: Evacuation of Passengers* (2005)
On the morning of 7 July 2005, Alexander Chadwick was travelling on the Piccadilly Line of the London Underground, on his daily commute, when a bomb went off, bringing the train to a halt. The explosion was part of a coordinated terrorist suicide bomb attack across London that targeted public transport. Chadwick used his mobile phone to record this dramatic scene, with the blurry and degraded image capturing the chaos and fear of the situation. His image was widely published online and in traditional print media including *The Times* and *New York Times* newspapers, along with many others also taken by survivors of the atrocity. More than twenty videos and 1,000 images were sent to the BBC newsroom that day.

Glossary

35 mm

Introduced originally for motion picture use, 35 mm film's format, frame and sprockets were standardized in 1909. It was adopted for still picture use and became the most popular film format producing a standard negative or transparency of 24 x 36 mm. The format and size have been retained in 'full-frame' digital cameras.

albumen print

Albumen derived from egg whites was first used in 1848 for dry plates, before being superseded by the wet-collodion process from 1851. Albumen had far greater success for coating on to paper, where it provided a smooth surface for the photographic emulsion. This was described by Louis Désiré Blanquart-Evrard in 1850 and albumen paper remained popular until the 1890s.

aperture

The opening through which light passes to expose sensitized material or a sensor. It is usually located behind or within a lens mount, originally as removable 'stops' and later as an iris diaphragm. The size of the aperture is defined in f-numbers.

Autochrome

Patented in 1904 by Auguste and Louis Lumière and manufactured from 1907, the Autochrome process was the first practical system of colour photography using dyed starch grains and a panchromatic emulsion to produce colour transparencies

with a distinctive colour palette. Production ceased in the 1930s.

backlighting

Describes lighting from a source behind the subject. It is usually used in conjunction with other lights, but by itself it can separate the subject from a dark background or create a halo effect around it.

calotype

A photographic process patented by William Henry Fox Talbot in England and Wales on 8 February 1841, also known as Talbotype. The process was a significant enhancement of Talbot's photogenic drawing process and used silver iodide combined with gallic acid to enhance its sensitivity. After exposure the paper was developed to produce a negative and then chemically fixed to make it permanent. The calotype was the first negative/positive process and it provided the basis of modern photography.

camera angle

Describes the position of the camera relative to the subject. Where the camera is placed and the type of lens being used will determine how the viewer perceives the subject.

camera lucida

An optical device used by artists that employs a prism to superimpose a virtual scene or subject image onto a drawing board so that an outline can be traced on to paper. It was invented by William Hyde Wollaston in 1807.

camera obscura

An optical device that came into use during the Renaissance. It consists of a box or a darkened room with an opening on one side projecting an image on to the facing side. It was used by artists as a drawing aid because it preserved perspective. By the eighteenth century the use of lenses and a mirror set at 45 degrees made for smaller, portable camera obscuras.

candid photographs

Unposed images often taken without the knowledge of the subject. They were made possible by small hand cameras; the first was reputedly taken in 1892. The term was first used in 1930 by the *Weekly Graphic*.

carbon print

A number of carbon processes were described before Sir Joseph Swan patented a process in 1864. Swan's was introduced the following year and found commercial success by providing the photographer with ready-made materials. His patents were bought out by the Autotype Company. The process produced a print using carbon, which made it permanent and not susceptible to fading. Carbon prints typically have a matt finish from black, grey to sepia and other tones.

chromogenic print

A print made by the chromogenic development process and also known as a dye-coupler print. The process was developed in the mid-1930s and is the basis of the majority of modern colour silver-based photographic materials,

such as Kodachrome, Ektachrome, Kodacolor and Agfacolor producing both negatives and direct positives. The prints are often incorrectly referred to as C-[Type] prints, which refers, precisely, to a negative-positive chromogenic paper called Kodak Color Print Material Type C available from 1955 to c.1959.

chronophotography

A method of analysing movement by taking a series of still pictures at regular intervals. It was pioneered separately by Étienne-Jules Marey (see p.85) and Eadweard Muybridge (see p.51) among others from the early 1870s. In 1877 Muybridge was able to confirm by chronophotography Marey's assertion that a horse lifted all four hooves off the ground at once when trotting.

close-up lens

A supplementary lens fitted to a camera lens that changes the focal length. For close-up work, a positive lens effectively shortens the focal length so that with a given lens-to-subject distance the near focusing limit is reduced.

collodion process

A dry – or more commonly – a wet process using collodion as a medium to support a light-sensitive emulsion. The wet-collodion process was described by Frederick Scott Archer in 1851 and, after refinement, came in to widespread use from c.1854. It remained dominant until the mid-1870s. Collodion was also used to produce direct positives on glass (ambrotypes) and tin (tintypes).

collotype
A screenless printing process invented by Alphonse Poitevin in 1856 and commercially popular from the 1870s to 1920s.

combination printing
A technique using two or more photographic negatives or prints to make a single image. It was suggested by Hippolyte Bayard in 1852 for improving the appearance of skies. It was first shown by William Lake Price in 1855. Oscar Gustave Rejlander's *Two Ways of Life* (see p.70) of 1857 and Henry Peach Robinson's *Fading Away* of 1858 are the best known examples. The technique was revived in the 1920s and 1930s often to produce surreal work. Digital techniques have made it obsolete.

compound lens
A lens combining two or more individual elements, usually cemented together.

copper plate
A printing plate used by any method of intaglio printing, etched or engraved to take ink for transferring on to paper. Although the term 'copper plate' is widely used, plates are commonly made from copper or zinc.

cropping
Altering the boundaries of a photograph, negative or digital image to improve the composition, remove unwanted elements, or to fit a method of display.

cyanotype
A process invented by Sir John Herschel and reported in 1842. The prints are also known as blue-prints. The process is simple and produces a characteristic blue image on paper or cloth. It was popular in the 1840s and the 1880s. Its main use has been for the reproduction of architectural or technical drawings.

daguerreotype
Announced on 7 January 1839 and presented to the world in August 1839 (except in England and Wales where it was patented), the daguerreotype produced a unique image on a silver-coated copper plate. The process was popular until the mid-1850s, although for longer in the United States, until it was superseded by the more sensitive wet-collodion process.

darkroom
A space in which there is total darkness or limited illumination by red or orange safelights so that light-sensitive materials such as film or paper can be handled, processed or printed without being affected by unwanted light.

depth of field
The zone of sharp focus seen in the camera. Manipulation of this zone by extending or reducing it can be an important aspect of creative control and view cameras have evolved to facilitate this.

digital print
In photography this refers to a photograph produced from either a conventional negative or a digital file by a digital printer. This includes various fine art digital printing techniques, inkjet and laser printing.

documentary photography
A photographic depiction of the real world intended to show the subject in a literal and objective way. Early examples include the work of Maxime du Camp in recording the Near East (see p.54), Roger Fenton in the Crimea (see p.57) and Mathew Brady (see p.63) in the American Civil War. An important sub-genre is social documentary photography, which records the human condition within a wider context. Examples range from Thomas Annan in 1860s Glasgow (see p.73) to Jacob Riis in 1890s America (see p.92) and the Farm Security Administration photographers of the 1930s (see p.149).

double-exposure
The recording of two superimposed images on the same piece of photo-sensitive material. This may be through error or as part of the creative process.

dry plate negative
Although produced from the late 1850s, they were more successfully introduced from the early 1870s and quickly supplanted wet-collodion plates. Dry plates matched and surpassed the sensitivity of wet-plates and were more convenient to use.

Düsseldorf School
A group of students who studied at the Kunstakademie Düsseldorf in the mid-1970s under the influential photographers Bernd and Hilla Becher, producing clear, objective, black-and-white images of industrial structures (see p.12). Among its best-known students are Thomas Struth and Andreas Gursky (see p.239).

dye transfer print
This is a subtractive process for making colour prints from colour positives or negatives. There were processes from 1875 but Eastman Kodak's wash-off relief process of 1935, which was improved and reintroduced in 1946 as the dye transfer process, was the most successful. Although complex, it produced attractive permanent prints with strong colours.

emulsion
A light-sensitive colloid usually of silver halide grains in a thin gelatin layer, and coated on to glass, film or paper base.

exposure
The process of allowing light to act on a sensitive material. Within the camera this is controlled by the shutter and aperture.

field camera
Usually refers to a large-format camera that can be folded to reduce its size making it easier to transport.

filter
An optical coloured or neutral glass or plastic usually mounted in front of the camera lens. Most remove or reduce particular parts of the light spectrum; others such as neutral density or polarizing filters affect light absorption in other ways.

fine art photography
Photographs that are made by a photographer as art work and usually intended to be offered for sale.

frame
A term that has a number of meanings within photography. It can refer to a single image within a series on a length of film or a single digital image; a border made from one of a number of materials to enclose and protect a photograph; or the boundaries of a subject seen through a camera viewfinder.

humanist photography
A photographic approach that

places the human subject within his or her everyday life. It uses photography's descriptive power and emotional immediacy to inform the viewer. It was particularly popular among French photographers between the 1930s and 1960s, although it arguably informs many styles of photography.

ink-jet print

A print made up from tiny droplets of ink being expelled on to paper using electromagnetic fields to guide charged ink streams. The technology was developed commercially from the 1950s and for digital photographic printing from the 1970s.

Kodachrome

A colour transparency film invented in 1933 by Leopold Mannes and Leopold Godowsky, Jr and introduced by Eastman Kodak in 1935 in 35mm, sheet and motion picture film formats. For many photographers it was the standard by which all other films were judged. Manufacture ceased in 2009.

mammoth-plate

An outsize plate format approximately 18 x 21 in and used by some nineteenth-century outdoor photographers, notably Carleton E. Watkins (see p.6) and William Henry Jackson (see p.73) working in the American West. Some contemporary photographers continue to use very large formats.

over-exposure

The exposure of light sensitive material with too much light. With negative film this has the effect of increasing shadow contrast and the total density range. They require longer printing times and appear grainier.

photobook

Traditionally referred to as photographically illustrated books and then illustrated books, the term photobook has become popular since the 1980s to refer to a book in which the photographs make a significant contribution to the content. Important examples include Henri Cartier-Bresson's *The Decisive Moment* (1952) and Martin Parr's *The Last Resort* (1986). The term is also a commercial one applied to single or very short run digitally printed books.

photogram

An image produced without a camera or lens by placing an opaque, translucent or transparent object between, often directly on, a piece of photographic paper or film and a light source. These were among the earliest photographic images from Thomas Wedgwood and Humphry Davy, and William Henry Fox Talbot, who called them photogenic drawings. Photograms had renewed popularity as a creative technique in the 1920s with Man Ray, who called them Rayographs.

photogravure

A photomechanical intaglio ink printing process capable of rapid, high-quality reproduction of photographs preserving detail and tone on paper.

photojournalism

The term was coined in 1924 to designate a sequence of photographs that emphasized photographic reportage, requiring the skills of both photographer and journalist. This distinguishes it from press or news photography. It thrived with the rise of illustrated news magazines, such as *Picture Post* and *Life* from the 1920s to

1960s, and is now best seen in newspaper colour supplements.

photomontage

An image created by assembling several different images, sometimes in other media, by cutting and pasting, projection or digital techniques.

Pictorialism

A term that was used generally by photographers from the late nineteenth century and was popular until World War I to define an artistic approach to photography. Pictorialism was part of a larger debate around art and photography that had preoccupied photographers since the 1850s and it was, in part, a reaction against the ease of taking photographs from the mid-1880s. In the 1920s Pictorialism gave way to realism and objectivity in photography, although it never quite disappeared and interest in it continues today.

Polaroid

The Polaroid Corporation was founded by Edwin Land in 1937 to produce polarizing glasses for three-dimensional applications. In 1948 Land launched the Polaroid Model 95 camera, which offered almost instant photography. In 1963 instant colour film was introduced and in 1972 the iconic Polaroid SX70 camera was introduced, which gave true instant photographs that developed without the need for peeling or the subsequent coating of the photograph. The 1978 launch of Polavision instant movies system failed as video proved more attractive to consumers. In 2001 the company filed for Chapter 11 bankruptcy protection as digital photography eroded its traditional markets.

Post-processing

A term that refers to the work traditionally done on a negative or print after the normal process has been completed. With the digital era the term is more usually associated with adjustments made to the raw image file using software such as Photoshop.

Resin-coated (RC) paper

A paper that has been sealed on both sides with a pigmented polyethylene resin and has the light sensitive emulsion coated on to one side. RC paper does not absorb water or chemicals making it quick to process and dry. It was widely introduced from *c*.1968. With traditional fibre-based papers the emulsion is absorbed into the paper, which gives more depth to the image. It is considered more archivally stable than RC paper. Fibre papers are generally preferred by photographic artists.

retouching

With film and paper this referred to work done with a brush or knife to the emulsion of a negative or print to remove parts or add to it. The advent of digital working has added these and other tools via software of which Photoshop is the best known. Photoshop has become a verb in its own right.

roll film

A length of light sensitive film rolled on a spool usually with a backing paper and able to be loaded into a camera in daylight. Cellulose nitrate roll film was commercially introduced in 1889, daylight loading film cartridges in 1891 and paper-backed film, which remains in production today, in 1892. A large number of roll film formats and lengths have appeared since 1889 with the most common being 120, 620 and 127 sizes. The safer

film base cellulose acetate was increasingly used from 1934; in the late 1940s, cellulose triacetate was introduced, and in the 1980s polyester bases became the norm.

salted paper print
The earliest form of silver halide printing paper developed by William Henry Fox Talbot around 1834. Talbot used paper soaked in salt; this was dried and then brushed with silver nitrate before being exposed and subsequently fixed with a concentrated salt solution or, later, sodium thiosulphate ('hypo').

saturation
A setting on a digital camera or in image editing software that adjusts the intensity of colour relative to its own brightness. A desaturated image will appear with grey tones.

silver print
Also known as a gelatin silver print, this refers to photographs mainly produced since the early 1870s using gelatin as a colloid. More recently the term has been applied within the photographic art market to differentiate photographs produced using traditional silver-based techniques from digital printing.

solarization
A photographic effect achieved in the darkroom or digitally where an image on a negative or photographic print is wholly or partially reversed in tone. Dark areas appear light or light areas appear dark. It can be created in error but is also used for creative effect.

staged photography
A posed scene or performance enacted before the camera similar to *tableaux vivants* (living pictures). It can include studio portraiture

and scenarios involving people that are directed or manipulated by the photographer.

stereograph
A pair of photographs mounted together that are designed to be viewed with a stereoscope. The term applies to any medium used to create the pair of images, but can be refined to be process specific, for example, stereo-daguerreotype.

stereoscope
An optical instrument with two viewing lenses that fuses two images so that a single three-dimensional image is perceived. The three principal designs have been the Wheatstone (1838); the Brewster lenticular (1838, but popular from *c*.1849) and the Holmes-pattern (*c*.1895).

straight photography
Photography that attempts to depict a scene or object as realistically and objectively as possible. Straight photography rejects the use of manipulation; the term first emerged in the 1880s as a reaction to manipulated photography. In 1932 Group *f*.64 defined it as: 'possessing no qualities of technique, composition or idea, derivative of any other art form'.

street photography
A style of documentary photography that features subjects in public spaces. Street photography became popular from the 1890s with the introduction of hand cameras. The genre has attracted renewed interest since the early 2000s.

under-exposed
The exposure of light sensitive materials with too little light. In negative film this reduces density

with a resultant loss of contrast and detail in the darker subject areas. In transparency film it results in an increase in density.

vernacular photography
Refers to images usually created by amateur or 'unknown' photographers and often depicts family or people in everyday and domestic situations. Their frequent banality, humour or photographic errors and occasionally artistic merit can give them an unintentional artistic quality or charm. They have attracted increasing interest from collectors and galleries.

view camera
Also known as a technical camera. The term refers to a large-format camera usually with lateral and vertical movements plus swing or tilt adjustment on the camera back and/or front lens standard. Traditionally the image was viewed on a ground glass screen on the camera back. Increasingly this has been replaced with a digital back with the subject viewed on a monitor.

waxed-paper negative
The waxing – usually with beeswax – or oiling of negatives that was undertaken by William Henry Fox Talbot to calotype negatives aimed to improve their translucency and minimize a lack of sharpness. In 1851 Gustave Le Gray's waxed paper process proposed waxing the paper base of the negative before it was sensitized. The finished negatives secured better detail and tonal range comparable with the wet-collodion negative, which used glass as its base.

wide-angle lens
A lens of shorter than normal focal length to give a larger angle of view.

Woodburytype
Refers to both the process and print. The process is a photomechanical intaglio ink process. It was developed by Walter B. Woodbury in 1864 and was used for book illustration from 1866 until around 1900. It was commercially successful and capable of reproducing detail and the tonal range in a photograph.

Zone System
A system designed to bridge the gap between sensitometry and creative photography. It was developed by Ansel Adams and Fred Archer in 1939–40. It relied on empirical testing by the photographer of film and paper to provide information about the characteristics of the materials to support the photographer in defining the relationship between the way a subject was visualized and the end result.

Further reading

Abbott, Berenice & Yochelson, Bonnie (1997), *Berenice Abbott: Changing New York*, The New Press

Agee, James & Evans, Walker (1941), *Let Us Now Praise Famous Men*, Houghton Mifflin

Arthus-Bertrand, Yann (2017), *The Earth from the Air*, Thames & Hudson

Badger, Gerry & Parr, Martin (2004), *The Photobook: A History*, Vols 1–3, Phaidon Press

Bain Hogg, Jocelyn (2001), *The Firm*, Westzone Publishing

Barthes, Roland, trans. Stephen Heath (1977), 'The Photographic Message' and 'The Rhetoric of the Image' in *Image Music Text*, Fontana Press

Bate, David (2009), *Photography (The Key Concepts)*, Berg

Berger, John (1972), *Ways of Seeing*, London, Penguin (Chapters 2 and 3, pp.36–64)

Billingham, Richard (1996), *Ray's a Laugh*, Scalo

Brassaï (1932), *Paris de Nuit* (Paris by Night), Arts et Métiers Graphiques

Brothers, Caroline (1997), *War and Photography: A Cultural History*, Routledge

Burgin, Victor (ed.) (1982), *Thinking Photography*, Macmillan

Campany, David (2012), *Art and Photography (Themes & Movements)*, Phaidon

Campany, David (2018), *David Campany: So present, so invisible: Conversations on photography*, Contrasto

Capa, Robert & Whelan, Richard (2001), *Robert Capa: The Definitive Collection*, Phaidon

Cartier-Bresson, Henri (1952), *The Decisive Moment*, Simon and Schuster

Cotton, Charlotte (2014), *The Photograph as Contemporary Art*, Thames & Hudson

Davidson, Bruce (1970), *East 100th Street*, Harvard University Press

Eggleston, William (2002), *William Eggleston's Guide*, Museum of Modern Art

Elkins, James (2011), *What Photography Is*, Routledge

Emerson, P. H. (1889), *Naturalistic Photography for Students of the Art*, Searle & Rivington

Evans, Walker (1989), *American Photographs*, Museum of Modern Art

Frank, Robert (1989), *The Americans*, Secker & Warburg

Franklin, Stuart (2016), *The Documentary Impulse*, Phaidon

Frizot, Michel (1998), *A New History of Photography*, Konemann UK Ltd

Fulton, Marianne (1988), *Eyes of Time: Photojournalism in America*, Little, Brown & Co.

Gardner, Alexander (1959), *Gardner's Photographic Sketch Book of the Civil War*, Vols 1–2, Courier Corporation

Gernsheim, Helmut & Gernsheim, Alison (1969) *History of Photography*. Thames & Hudson

Goldin, Nan (2005), *The Ballad of Sexual Dependency*, Aperture

Guadagnini, Walter (2015), *Photography: A History 1839–Now* (History of Photography Vols I–IV), Skira Editore

Hacking, Juliet (ed.) (2012), *Photography: The Whole Story*, Thames & Hudson

Jeffrey, Ian (1981), *Photography: A Concise History*, Thames & Hudson

Jones Griffiths, Phillip (1971), *Vietnam Inc.*, Macmillan

Klein, William (1956), *Life is Good & Good for You in New York*, Editions du Seuil

Koudelka, Josef (2011), *Gypsies*, Aperture

la Grange, Ashley (2005), *Basic Critical Theory for Photographers*, Focal Press

Linfield, Susie (2010), *The Cruel Radiance: Photography and Political Violence*, University of Chicago Press

Lowe, Paul (2016), *Photography Masterclass: Creative Techniques of 100 Great Photographers*, Thames & Hudson

Lyon, Danny (1968), *The Bikeriders*, The Macmillan Company

Meiselas, Susan (1981), *Nicaragua*, Random House Inc.

Meyerowitz, Joel (1978), *Cape Light*, Little Brown & Company

Muybridge, Eadweard (1893), *Descriptive Zoopraxography, or the Science of Animal Locomotion Made Popular*, University of Pennsylvania

Nachtwey, James (1989), *Deeds of War*, Thames & Hudson

Nasmyth, James (1885), *The Moon: Considered as a Planet, a World, and a Satellite*, J. Murray

Newhall, Beaumont (1978), *The History of Photography from 1839 to the Present Day*, Museum of Modern Art

Panzer, Mary (2004), *Mathew Brady and the Image of History*, Smithsonian Books

Panzer, Mary (2006), *Things As They Are: Photojournalism in Context Since 1955*, Chris Boot

Parks, Gordon (1997), *Half Past Autumn: A Retrospective*, Bulfinch Press

Parr, Martin (1998), *The Last Resort: Photographs of New Brighton*, Dewi Lewis Publishing

Peach Robinson, Henry (1869), *Pictorial Effect in Photography*, Piper & Carter

Peress, Gilles (1998), *Telex Iran*, Scalo

Polidori, Robert (2006), *After the Flood*, Steidl

Ritchin, Fred (2009), *After Photography*, W. W. Norton & Company

Ruscha, Ed (1963), *Twentysix Gasoline Stations*, National Excelsior Press

Salgado, Sebastião (2013), *Genesis*, Taschen

Schaaf, Larry J. (2018), *Sun Gardens: The Cyanotypes of Anna Atkins*, Prestel Verlag

Shore, Stephen (2004), *Uncommon Places*, Aperture

Shore, Stephen (2010), *The Nature of Photographs: A Primer*, Aperture

Sontag, Susan (1979), *On Photography*, Penguin

Sternfeld, Joel (2004), *American Prospects*, D. A. P.

Sultan, Larry & Mandel, Mike (1977), *Evidence*, Clatworthy Colorvues

Szarkowski, John (1999), *Looking at Photographs: 100 Pictures from the Collection of the Museum of Modern Art*, Bulfinch Press

Tagg, John (1988), *The Burden of Representation: Essays on Photographies and Histories*, Macmillan

Talbot, William Henry Fox (1844), *The Pencil of Nature*, Longman, Brown, Green & Longmans

Thomson, John (1877), *Street Life in London*, Sampson Low, Marston, Searle and Rivington

Trachtenberg, Alan (ed.) (1980), *Classic Essays on Photography*, Leete's Island Books

Trachtenberg, Alan (1989), *Reading American Photographs: Images as History Mathew Brady to Walker Evans*, Hill and Wang

Warner Marien, Mary (2002), *Photography: A Cultural History*, Laurence King

Webb, Alex (1989), *Hot Light. Half Made Worlds*, Thames & Hudson

Weber, Donald (2015), *Barricade: The EuroMaidan Revolt*, Schilt Publishing

Weegee (1945), *Naked City*, Da Capo Press

Wegman, William (2017), *Being Human*, Chronicle Books

Wells, Liz (ed.) (2003), *The Photography Reader*, Routledge

Wells, Liz (2009), *Photography: A Critical Introduction*, Routledge.

Wenders, Wim (2015), *Written in the West, Revisited*, D. A. P.

Wood, Tom (1989), *Looking for Love*, Cornerhouse

Index

Page references to illustrations are in **bold**.

Picture credits

The publishers would like to thank the museums, artists, archives and photographers for their kind permission to reproduce the works featured in this book. Every effort has been made to trace all copyright owners but if any have been inadvertently overlooked, the publishers would be pleased to make the necessary arrangements at the first opportunity.
Key: top = t; bottom = b; left = l; right = r

6 The J. Paul Getty Museum, Los Angeles **7** © Henri Cartier-Bresson/Magnum Photos **8** Joe Rosenthal AP/Press Association Images **9** Courtesy CAAC – The Pigozzi Collection © Seydou Keïta/SKPEAC **10** Michael Ochs Archives/Getty Images **11** © Robert Adams, courtesy Fraenkel Gallery, San Francisco **12** Christie's Images, London/Scala, Florence. Copyright Estate Bernd & Hilla Becher **13** Courtesy Wikipedia.com/Zuma Press/PA Images **14** Ellen DeGeneres/Twitter via Getty Images **15** © Taryn Simon. Courtesy Gagosian **18** Science & Society Picture Library/SSPL/Getty Images **19** J. Paul Getty Museum, Los Angeles, gift of Samuel J. Wagstaff, Jr **20** GraphicaArtis/Archive Photos/Getty Images **21** Boyer/Roger Viollet/Getty Images **22** Universal History Archive/UIG/Getty Images **23 t** Science & Society Picture Library/SSPL/Getty Images **23 b** George Eastman House/Getty Images **24** Science & Society Picture Library/SSPL/Getty Images **25 t** Hulton Archive/Getty Images **25 b** Science & Society Picture Library/SSPL/Getty Images **26** Science & Society Picture Library/SSPL/Getty Images **27t** Hulton Archive/Getty Images **27 b** Universal History Archive/UIG/Getty Images **28** Royal Photographic Society/SPPL/Getty Images **29 l** William Henry Fox Talbot/Getty Images **29 r** Science & Society Picture Library/SSPL/Getty Images **30** William Henry Fox Talbot/Getty Images **31** Société française de photographie **32** The J. Paul Getty Museum, Los Angeles **33** © Peter Fraser **34** Wikipedia.com **35 l** Library of Congress, LC-DIG-ppmsca-40464 **35 r** Collection Société française de photographie (coll. SFP) **36** SSPL/Getty Images **37 l** The J. Paul Getty Museum, Los Angeles **37 r** The J. Paul Getty Museum, Los Angeles **38** Photo © BnF, Dist. RMN-Grand Palais/image Bn **39** Photo © Centre Pompidou, MNAM-CCI, Dist. RMN-Grand Palais/Jacques Faujour **40** Hulton Archive/Getty Images **41 l** Museum für Kunst und Gewerbe Hamburg/Department of Photography and New Media **41 r** The Metropolitan Museum of Art/Art Resource/Scala, Florence **42** Universal History Archive/UIG via Getty Images **43 l** Southworth & Hawes/George Eastman House/Getty Images **43 r** Photo © RMN-Grand Palais (Musée d'Orsay)/Hervé Lewandowski **46** © Victoria and Albert Museum, London **47** The J. Paul Getty Museum, Los Angeles **48** Interim Archives/Getty Images **49** Sean Sexton/Hulton Archive/Getty Images **50** The New York Public Library **51 t** The J. Paul Getty Museum, Los Angeles **51 b** The J. Paul Getty Museum, Los Angeles **52** George Eastman House/Getty Images **53 t** The Metropolitan Museum of Art/Purchase, The Horace W. Goldsmith Foundation Gift, through Joyce and Robert Menschel, 1995 **53 b** Universal History Archive/UIG/Getty Images **54** The J. Paul Getty Museum, Los Angeles **54** The J. Paul Getty Museum, Los Angeles, The Museum of Modern Art, New York/Scala, Florence **55 t** SSPL/Getty Images **56** Yokohama Museum of Art **57 l** The J. Paul Getty Museum, Los Angeles **57 r** Library of Congress, LC-USZC4-9217 **58** Digital image courtesy of the Getty's Open Content Program **59** Larry Burrows/Time Magazine/The LIFE Picture Collection/Getty Images **60** Paris – Musée de l'Armée, Dist. RMN – Grand Palais/Christian Moutarde **61** l Google.com **61** SSPL/Getty Images **62** Tallandier/Bridgeman Images **63 l** Getty Images **63 r** Granger Historical Picture Archive/Alamy Stock Photo **64** SSPL/Getty Images **65** Hulton Archive/Getty Images **66** The J. Paul Getty Museum, Los Angeles **66 l** Wellcome Images **67 r** The Metropolitan Museum of Art/Gift of George Davis, 1948 **68** Alinari Archives, Florence/Alinari via Getty Images **69 l** The J. Paul Getty Museum, Los Angeles **69 r** SSPL/Getty Images **70** Google.com **71** Courtesy of the artist **72** © RAI **73 l** The J. Paul Getty Museum, Los Angeles **73 r** The J. Paul Getty Museum, Los Angeles **74** © Victoria and Albert Museum, London **75 l** Eugene Appert/Getty Images **75 r** IanDagnall Computing/Alamy Stock Photo **76** Courtesy of the artist and Metro Pictures, New York **77** Photo © BnF, Dist. RMN-Grand Palais/image BnF **78** George Eastman House/Getty Images **79 l** Science & Society Picture Library/SSPL/Getty Images **79 r** Royal Photographic Society/SPPL/Getty Images **80** The J. Paul Getty Museum, Los Angeles **81 t** The Society of California Pioneers, restored by Gawain Weaver **81 b** Photo © Beaux-Arts de Paris, Dist. RMN-Grand Palais/image Beaux-arts de Paris **82** SSPL/Getty Images **83** Galerie Bilderwelt/Getty Images **84** Library of Congress, LC-DIG-ppmsc-04884 **85 l** Roger-Viollet/Topfoto **85 r** Library of Congress, LC-DIG-ppmsca-13274 **86** The J. Paul Getty Museum, Los Angeles **87 l** Mary Evans Picture Library **87 r** The Library of Congress, LC-DIG-ds-07833 **88** © Archives de la Préfecture de Police. All rights reserved/Alphonse Bertillon **89** Weegee (Arthur Fellig)/International Center of Photography/Getty Images **90** The J. Paul Getty Museum, Los Angeles **91 l** The Marjorie and Leonard Vernon Collection, gift of The Annenberg Foundation, acquired from Carol Vernon and Robert Turbin (M.2008.40.2223.23). Los Angeles County Museum of Art **91 r** In the Twilight, 1890 (b/w photo), Sawyer, Lyddell (1856–1927)/British Library, London, UK/© British Library Board. All Rights Reserved/Bridgeman Images **92** Google.com **93 l** Library of Congress, LC-USZ62-44458 **93 r** Collection of Historic Richmond Town **94** The New York Public Library **95** Courtesy #NotABlugSplat **96** © Victoria and Albert Museum, London **97 l** © National Media Museum/Science & Society Picture Library – All rights reserved **97 r** The J. Paul Getty Museum, Los Angeles **98** Photo © BnF, Dist. RMN-Grand Palais/image BnF **99l** George Eastman House/Getty Images **99 r** V&A Images/Alamy Stock Photo **100** © National Science & Media Museum/Science & Society Picture Library – All rights reserved **101 l** Library of Congress, LC-USZC4-6184 **101 r** SSPL/Getty Images **104** The Museum of Modern Art, New York/Scala, Florence **105** The Museum of Modern Art, New York/Scala, Florence **106** Private

Collection/Photo © Christie's Images/Bridgeman Images **107** NARA **108** The Metropolitan Museum of Art/Art Resource/Scala, Florence **109 t** The Washington Post/Getty Images **109 b** Library of Congress, LC-DIG-fsac-1a34140 **110** Ulstein Bild Dtl/Getty Images **111 t** bpk/Salomon/ullstein bild/Getty Images **111 b** PHAS/Universal Images Group/Getty Images **112** George Eastman House/Getty Images **113 l** Library of Congress, LC-USZC4-8176 **113 r** The J. Paul Getty Museum, Los Angeles **114** National Media Museum/Royal Photographic Society/SSPL/Getty Images **115 l** Library of Congress, LC-USZ62-112205 **115 r** © The Lartigue Foundation **116** Princeton University Art Museum/Art Resource NY/Scala, Florence **117** The Metropolitan Museum of Art/Art Resource/Scala, Florence. © The Estate of Edward Steichen/ARS, NY and DACS, London 2018 **118** George Shiras/National Geographic Creative **119 l** Universal History Archive/Getty Images **119 r** The J. Paul Getty Museum, Los Angeles **120** W. & D. Downey/Getty Images **121 l** Library of Congress, LC-DIG-prokc-21620 **121 r** Scott Polar Research Institute, University of Cambridge/Getty Images **122** SSPL/Getty Images **123** Neil Leifer/Sports Illustrated/Getty Images **124** Historic Collection/Alamy **125 t** Alfred Hind Robinson/Stringer **125 b** Universal History Archive/UIG via Getty Images **126** © J. Paul Getty Trust **127 l** Universal History Archive/Getty Images **127 r** SSPL/Getty Images **128** Photo © Centre Pompidou, MNAM-CCI, Dist. RMN-Grand Palais/Philippe Migeat **129** The Museum of Modern Art, New York/Scala, Florence. © DACS 2016 **130** Arthur S Mole & John D. Thomas/Chicago History Museum/Getty Images **131 l** The J. Paul Getty Museum, Los Angeles **131 r** Bettmann/Getty Images **132** Peter Horree/Alamy Stock Photo © Man Ray Trust/ADAGP, Paris and DACS, London 2018 **133 l** © 2018 G. Ray Hawkins Gallery, Beverly Hills, CA **133 r** Library of Congress, LC-DIG-npcc-09503 **134** © Horst **135** Horst P. Horst, Vogue © Condé Nast **136** © 2016. BI, ADAGP, Paris/Scala, Florence. © Man Ray Trust/ADAGP, Paris and DACS, London 2018 **137 l** Galerie Bilderwelt/Bridgeman Images **137 r** Museum of Fine Arts, Houston, Texas, USA/museum purchase funded by the Caroline Wiess Law Accessions Endowment Fund, The Manfred Heiting Collection./Bridgeman Images **138** Universal History Archive/UIG via Getty Images **139 l** Photo © Ministère de la Culture – Médiathèque du Patrimoine, Dist. RMN-Grand Palais/André Kertész **139 r** The Art Institute of Chicago, IL, USA / Julien Levy Collection, Special Photography Acquisition Fund / Bridgeman Images **140** The Metropolitan Museum of Art/Art Resource/Scala, Florence/© The Heartfield Community of Heirs/VG Bild-Kunst, Bonn and DACS, London 2018 **141** Photo © RMN-Grand Palais (Musée d'Orsay)/Hervé Lewandowski **142** Museo di Storia della Fotografia Fratelli Alinari, Florence/Alinari/Bridgeman Images **143 l** Photo © Centre Pompidou, MNAM-CCI, Dist. RMN-Grand Palais/Jacques Faujour/© Estate Brassaï – RMN-Grand Palais **143 r** Minneapolis Institute of Arts, MN, USA/The Stanley Hawks Memorial Fund/Bridgeman Images **144** © Archivo Manuel Álvarez Bravo, S.C. **145 l** © Tate, London 2018 **145 r** Oscar Graubner/The LIFE Images Collection/Getty Images **146** The Museum of Modern Art, New York/Scala, Florence. © Center for Creative Photography, The University of Arizona Foundation/DACS 2016 **147** The Museum of Modern Art, New York/Scala, Florence **148** © Robert Capa © International Center of Photography/Magnum Photos **149 l** Library of Congress LC-USF342-008147-A **149 r** Margaret Bourke-White/Time & Life Pictures/Getty Images **150** © The Lisette Model Foundation, Inc. (1983). Used by permission, courtesy of Bruce Silverstein Gallery **151 l** Anton Bruehl/Condé Nast via Getty Images **151 r** Fred Morley/Getty Images **152** © Getty Research Institute **153** Charles Sheeler/Conde Nast via Getty Images **154** Imagno/Getty Images **155 l** John Rawlings/Condé Nast via Getty Images **155 r** © Robert Capa © International Center of Photography/Magnum Photos **156** Alfred Eisenstaedt//Time Life Pictures/Getty Images **157 l** Frederick & Frances Sommer Foundation **157 r** Frances McLaughlin-Gill/Condé Nast via Getty Images **158** © Gilles Peress/Magnum Photos **159** © Rene Burri/Magnum Photos **160** Library of Congress, LC-DIG-ppmsca-09633 **161 l** © W. Eugene Smith/Magnum Photos **161 r** © George Rodger/Magnum Photos **164** © Bruce Davidson/Magnum Photos **165** © Paul Fusco/Magnum Photos **166** © Philip Jones Griffiths/Magnum Photos **167** © Robert Frank; courtesy Pace and Pace/MacGill Gallery, New York **168** U.S. Air Force **169 t** George Rose/Getty Images Entertainment **169 b** Press Association **170** © Dennis Stock/Magnum Photos **171 t** © Josef Koudelka/Magnum Photos **171 b** © Ed Ruscha. Courtesy Gagosian **172** Robert Doisneau/Gamma-Rapho/Getty Images **173 l** © Werner Bischof/Magnum Photos **173 r** Andreas Feininger/The LIFE Picture Collection/Getty Images **174** © Marc Riboud/Magnum Photos **175 l** © William Klein **175 r** Central Press/Getty Images **176** Photo © Centre Pompidou, MNAM-CCI, Dist. RMN-Grand Palais. © Albert Renger-Patzsch Archiv/Ann and Jürgen Wilde/DACS, London 2018 **177 l** John Sadovy/The LIFE Images Collection/Getty Images **177 r** Roger Mayne/Mary Evans Picture Library **178** © Lee Friedlander, courtesy Fraenkel Gallery, San Francisco **179** © The Estate of Garry Winogrand, courtesy Fraenkel Gallery, San Francisco **180** © Sergio Larrain/Magnum Photos **181 l** Bettmann/Getty Images **181 r** © Eikoh Hosoe/Courtesy of Studio Equis **182** Malcolm Browne/AP/Press Association Images **183 l** Cecil Beaton/Condé Nast via Getty Images **183 r** Naval History and Heritage Command **184** NASA **185** NASA **186** Bill Eppridge/The LIFE Picture Collection/Getty Images **187 l** © Danny Lyon/Magnum Photos **187 r** © James Martin **188** Bill Eppridge/The LIFE

Contributors

Dr Paul Lowe (PL) is a Reader in Documentary Photography and the Course Leader of the Masters programme in Photojournalism and Documentary Photography at the London College of Communication, University of the Arts, London, UK. Paul is an award-winning photographer, whose work is represented by Panos Pictures, and who has been published in *Time*, *Newsweek*, *Life*, the *Sunday Times Magazine*, the *Observer* and the *Independent* among others. He has covered breaking news the world over, including the fall of the Berlin Wall, Nelson Mandela's release, famine in Africa, the conflict in the former Yugoslavia and the destruction of Grozny.His book *Bosnians*, documenting ten years of the war and post-war situation in Bosnia, was published in April 2005 by Saqi books. His research interest focuses on the photography of conflict, and he has contributed chapters to the books *Picturing Atrocity: Photography in Crisis* (Reaktion, 2012) and *Photography and Conflict*. His most recent books include *Photography Masterclass* published by Thames & Hudson, and *Understanding Photojournalism*, co-authored with Dr Jenny Good, published by Bloomsbury Academic Press.

Lewis Bush (LB) is a photographer, writer, curator and educator exploring the workings of contemporary power. His work has explored topics including the aggressive redevelopment of London and the democratic deficit of intelligence gathering. He has exhibited, published and taught internationally and is lecturer in documentary photography at London College of Communication.

Dr Jennifer Good (JG) is a writer and Senior Lecturer in History and Theory of Photojournalism and Documentary Photography at London College of Communication, University of the Arts London. She is the author of *Photography and September 11th: Spectacle, Memory, Trauma* (Bloomsbury 2015), co-author of *Understanding Photojournalism* (Bloomsbury 2017), co-editor of *Mythologizing the Vietnam War: Visual Culture and Mediated Memory* (CSP 2014) and writes regularly for photography magazines and journals.

Stephenie Young (SY) is a professor of comparative literature at Salem State University (SSU) in Massachusetts, USA, where she lectures on topics including visual and material culture and contemporary literature from Latin America and Eastern Europe in the context of war and its aftermath. She has published widely in international venues including in journals such as *Dissidences*, *The New Centennial Review* and *Asymptote*.

Front Cover: Horst P. Horst – *Mainbocher Corset* (1939),
Horst P. Horst, Vogue © Condé Nast

Page 2: Eadweard Muybridge – *Sallie Garner at a Gallop* (1878),
The J. Paul Getty Museum, Los Angeles

First published in 2019 in the United States of America by
Thames & Hudson Inc., 500 Fifth Avenue
New York, New York 10110

www.thamesandhudsonusa.com

© 2018 Quintessence Editions Ltd.

This book was designed and produced by
Quintessence Editions, an imprint of The Quarto Group
The Old Brewery
6 Blundell Street
London N7 9BH

Senior Editor	Michael Brunström
Editor	Liz Jones
Senior Designer	Josse Pickard
Picture Researcher	Emma Brown
Production Manager	Rohana Yusof
Editorial Director	Ruth Patrick
Publisher	Philip Cooper

Library of Congress Control Number 2018945503

ISBN 978-0-500-54503-4

Printed in China